A Philosophy of Practising

A Philosophy of Practising with Deleuze's *Difference and Repetition*

Antonia Pont

EDINBURGH
University Press

Edinburgh University Press is one of the leading university presses in the UK. We publish academic books and journals in our selected subject areas across the humanities and social sciences, combining cutting-edge scholarship with high editorial and production values to produce academic works of lasting importance. For more information visit our website: edinburghuniversitypress.com

Edinburgh University Press Ltd
The Tun – Holyrood Road, 12(2f) Jackson's Entry, Edinburgh EH8 8PJ

First published in hardback by Edinburgh University Publishing Press 2021

Typeset in 10/12 Goudy Old Style by
Servis Filmsetting Ltd, Stockport, Cheshire, and
printed and bound by CPI Group (UK) Ltd
Croydon, CR0 4YY

A CIP record for this book is available from the British Library

ISBN 978 1 4744 9046 7 (hardback)
ISBN 978 1 4744 9047 4 (paperback)
ISBN 978 1 4744 9048 1 (webready PDF)
ISBN 978 1 4744 9049 8 (epub)

Contents

With gratitude to Orit, who showed me how;
to Ellen, who asked and then remembered;
and to LV – for practising love and silence with me.

Acknowledgements

I would like to thank the following people and organisations for the tangible and less tangible support over time that enabled this book and its underlying project to come together: Clifton Hill Zendo and MZG (Paul, Julia, Artur, Sandy, Dorothy, Barbara and others); Vijnanis the world over, and my Immenstadt colleagues, especially Lindsey Syred, Ute Wohlmuther, Hanna Caspi and Bettina Thiel; Shirley Woods at *Inner Space* Yoga, Amsterdam; Alexandra Brown at University College in Amsterdam and to the Stedelijk Library; my students and fellow practitioners at *Vijnana Yoga Australia*; Jocelyn Bennett and Paul McGregor at Clearview Retreat; Carol MacDonald, James Dale, Naomi Farmer, Bekah Dey and all the staff at Edinburgh University Press and my anonymous reviewers, whose astute suggestions and comments improved the work markedly; Graham Jones, Rebecca Hill, Jana Verhoeven, Stefan Siemsen, Jane Connell, Ruby Todd, Joshua Comyn, Stu Mannion, Gidi Lev.

My gratitude goes to Lenart Škof, for the invitation to Ljubljana in 2015; and to Nahum Brown, for the invitation to Macau in 2015; to my past and current colleagues in the School of Communication and Creative Arts at Deakin University, notably Matthew Allen, Ann Vickery and Geoff Boucher (for support, administrative and intellectual), as well as to my PhD students; to the *Alfred Deakin Institute* (ADI), *Deakin Motion Lab* (DML), and the *Philosophy and History of Ideas* (PHI) group.

I'm thankful to William Franke and Nahum Brown, whose invitation to contribute to their book project – *Immanence, Transcendence and Intercultural Philosophy* (2017) – prompted the initial writing of what would become Chapter 1 of this work, and thus to Palgrave Macmillan and Springer Nature for permission to republish my chapter from that publication here, in an edited version here.

I'm ever grateful to live in Naarm, Australia, where I have been able to

participate in the *Melbourne School of Continental Philosophy* (MSCP) seminars, and in the reading groups at University of Melbourne (on Badiou, Spinoza, Deleuze, Lacan . . .). I thank all my fellow readers for their patience and brilliance, as well as the group convenors (Joe Hughes, Justin Clemens, John Cleary, Jack Cao and others). I thank, too, the *Australasian Society for Continental Philosophy* (ASCP), and Jack Reynolds and Sean Bowden, for early and on-going encouragement.

Thanks to my co-writers of *Practising with Deleuze* (EUP): Philipa Rothfield, Jon Roffe, Suzie Attiwill, Terri Bird and Andrea Eckersley. Thanks also to my editors, Zoe Dzunko and Justin Wolfers, at *The Lifted Brow*, and to Jonny Diamond at *Literary Hub*, for enabling elaborations on this scholarly research to reach a wider audience.

A number of close people have supported me during the writing of this book: Orit Sen-Gupta; Justin Gosker; Ellen Smith; my parents and sister – Margaret, Warwick and Kaleena Pont; as well as Cara Brough, Skye Baker, Louisa Duckett, Sibylla Vaughan, Arne Diehl, Ben Woods, Chris McCaw, Tim McNamara, Oliver Driscoll, Corinna Wenzelburger, Sanne and Dieter Mazur, Anne-Laure Couineau, Olga Kotnowska and Joseph Fonti. Humbled and astonished, I thank Lou Verga, for reading every word, and for everything else.

I'm grateful to the Wurundjeri people of the Kulin nation and to all the custodians of country across this ancient continent on which I've lived my life, ambivalently and with unearned privilege. To their Elders and all First Nations practitioners through time, I pay my sincere respects.

Introduction

... life goes beyond the limits that knowledge fixes for it, but thought goes beyond the limits that life fixes for it. Thought ceases to be a *ratio*, life ceases to be a reaction. The thinker thus expresses the noble affinity of thought and life: life making thought active, thought making life affirmative.

Deleuze, *Nietzsche and Philosophy*, p. 101

This book is about something called 'practising'. It asks what practising is, how it works, what it unleashes and enables, while also querying the precise mechanisms that underpin its strange logics and spin-offs. It hopes to *say* practising better. To this end, it puts to work (and owes much to) the two concepts that make up the title of Gilles Deleuze's famous work: 'difference' and 'repetition'. It reads these two concepts in conversation with a framework of four moments – or defining *criteria* – that mark practising, irrespective of its particular mode.

I argue here that the Deleuze of *Difference and Repetition*[1] provided a precise language for that series of operations which can be gathered together under the nomination 'practising'. By exploring these operations – and framed by Deleuze's creativity and rigour in what Williams calls 'a revolution in philosophy', 'one of the great philosophical works of the twentieth century'[2] – we can begin to think and account for practising's bearing on habit, on identity, on time, relaxation and rest, on change and on what constitutes a stable-enough present and an open future, among other things.

[1] Deleuze, *Difference and Repetition*. Here and throughout this book, this title is referred to as DR.
[2] Williams, *Gilles Deleuze's* Difference and Repetition, p. 1.

Is practising a name for one way in which the provocations and new concepts set out in *Difference and Repetition* are lifted off its pages and set in movement, out among the events and particulars of a never-yet-determined life?

Thanks to its offerings, confrontations and generativities, *Difference and Repetition* has rendered more available to thought, and therefore to articulation, the subtending operations that constitute this important and enduring – but also often unexplainable – mode of doing that is practising.

There is a long-standing convention in certain fields, most notably the creative arts, some artisanal occupations, and in various spiritual traditions, of referring unselfconsciously to one's engagement over time in certain activities (or circumscribed *sets* of activities) as 'practising' or as one's 'practice'. It did not, then, seem a distortion to call on this word for the purpose of a productive delimitation. In what follows, this gerund/present participle will stand in for something quite specific, seeking a more precise thinking – and therefore saying – of that which is shared between otherwise seemingly disparate examples of doing. Viewed through the lens that the notion of practising provides, these 'doings' display salient alignments with each other. Rather than to the *content* of such activities ('what is done'), the alignment pertains to registers of their operations which subtend, as well as generate, their more explicit aspects and effects.

If this clarified thinking and saying of practising turn out to be enabled by moments in Deleuze's thought and the vocabularies that he uses in his philosophical works, *that which they think and say* – this shared, fluid yet consistent mode – pre-exists any emergence of Deleuzian scholarship, and indeed itself informs the very engagement and long-standing doings of philosophy worthy of the name.

In this Introduction, I will offer an initial sketch of what I mean by practising (which we will later complicate and clarify) alongside a concrete example. I will then give some background to Gilles Deleuze, as a thinker, considering why his recasting of difference and repetition as more rigorous and vivid concepts was so important for his wider philosophical project, and how it assists the current one.

Practising

In this work, the term 'practising' is used to highlight a distinct way of approaching a select number of our doings. It takes an interest in how we do things, hence the gerund construction. In a life of countless doings, we may end up practitioners in at best several, but often only one, *practice*.

Even this would be dependent on a combination of luck, privilege and tenacity.

Sometimes we are actively practising for a certain phase of our lives. Sometimes we transfer a capacity for practising in one modality (for example, playing violin) to another (say, cooking). Practising, then, can persevere as a cultivated mode, as a sensibility within doing, despite a change of content. It is – as way – carried along within its content without (strictly speaking) depending on the latter's particulars.

Since practising is a mode of doing that we can inhabit or not, there are by implication many doings in the lives of practitioners that aren't practising (and don't need to be). A practitioner in dressage, for example, might not approach lap swimming as practising, whereas another person who engages with horses pragmatically for transport might be a serious practitioner of lap swimming in the pool. A self-conscious perception of one's activities as practising is also unnecessary for practising to obtain (although it can be helpful). Practising is most crucially determined by the nuances of the hows-of-doing, and other factors we shall meet.

Practising – as we approach a definition – does not coincide, then, with our doing of every kind of doing. On the other hand, because practising pertains to the 'how' or way of doing, its inclusivity – in terms of things we can do as practising – is surprisingly broad and encouraging. Practising as mode or way does not depend, in any gross sense, on the grandeur (or austerity!) of the content or shape of the activity. Our practices, in other words, need in no way be obviously arcane, exclusive, horrible or erudite in order to qualify *as practising*. We bring to practising what we can – with all of our personal and inherited (physical and other) limitations. Thus practising per se has a constitutive relation neither to virtuosity nor to suffering. Practising, if viewed through the lens offered here, tends to be inclusive, sustainable and (if we believe the texts[3]) pleasant.

Let's take a specific example of a shape in which practising can happen: yoga. I choose it not to suggest it as exemplary – I will suggest another in this regard – only because I can describe it from my own experience with some nuance. (It is also crucial for the purposes of this book's project that we don't get mired too much in one practice, at the expense of thinking practising per se.)

The practising of yoga, like the practising of any mode, involves an interweaving of differences expressing themselves among intentional repetitions.

[3] In *Patanjali's Yoga Sutras* (Sen-Gupta 2013), regarding the practising of postures, it is said that it should be 'stable and pleasant' or (alternative translation) 'stably pleasant' – Sutra II.46 ('sthira-sukham . . .').

Yoga, specifically, sets working a vast repertoire of technologies of the body, breath and heartmind (as it's called). There is also a long and complex history of dispute and evolution of these very doings. Nevertheless, there are likely to be some steady aspects in any yoga-ing that are typical. A yoga practitioner is likely to practise regularly some timed periods of quiet stillness of the body – 'meditation' or 'sitting practice'. This might be each day, or on a regular selection of days each week. They might also grab times at which they simply can, if they have a dense life, or caring responsibilities and so forth. Perhaps the person will attend spaces organised for the practice (such as retreats or weekly classes) in order to support the practising in the company of others or a more experienced teacher. The practising of yoga might involve *pranayama*, that is, working and listening closely to the breath mechanism using a series of honed exercises, constrained by timings or freer and more observational. This might also happen on a regular basis, and the latter will allow for an accretion over time that makes insights or a deeper understanding possible. Practising yoga will also (probably) involve the curriculum of poses (or *asana*) that were systematised anew in the later part of the twentieth century (by yogis such as B. K. S. Iyengar or K. Pattabhi Jois, supported by their traditions and serious students), in conversation with long histories of these sets of movements (that mark Buddhist and Taoist practices, among others). The practising of asana is likely to be a more or less daily involvement and would follow the specificities of a chosen style or tradition. As we shall see, difference and repetition – even at the most obvious level – mark what is described above. The sets of practices have some continuity and similarity over time (repetition), even as they shift and modify (difference), either intentionally or unintentionally on the part of the practitioner. To practise, there must be repetition. And if there is sincere, long-standing and sustainable repetition, difference at many registers may begin to be courted, which in turn can weave different kinds of repetition.

So, yoga is one *mode* in which practising can obtain, but its meta-operations are what I wish to focus on here. In this way, I've been most curious throughout this long-standing inquiry to seek out and follow the deeper logics at work in so-called smaller, often 'invisible', behaviours and approaches to doing that tend to be denied the lofty title of 'practice'. These modest modes – throughout history – have often been the available shapes that quite serious ontological and creative engagements have taken for those situated in less dominant positions structurally. Rigorously articulated, these doings might, I've hoped, be understood as a different kind of work – in the spirit of Arendt and quite distinct from labour – via their

reinflection through practising's lens. (Practising asks unexpected questions of your action, of the notion of 'you' as a purportedly enduring, knowable entity, and of common-sense attitudes to outcome, esteem and to identity at every level.) This reframing might then contribute to an acknowledgement of what people are up to in activities that otherwise could be seen as, or deemed, trivial, or as no valid activity at all: a dignifying. If practising has a clearer vocabulary, the space and time for these so-called minimal doings can arguably be better named, cared and allowed for.

Generally speaking, practising involves doings – often tangible bodily movements – that are inflected in certain ways, where a relatively stable set of approaches is operating, has insinuated itself, is known about (whether tacitly or explicitly) and taken up.

Practitioners, then, are *those who practise* – who have a consistent approach (identified or otherwise) to specific instances or sets of doing, among the other doings that make up their life.

Although commonly identified as a philosopher (as in, vocationally), Deleuze can also be considered – in light of his life-long activity of philosophy: thinking, reading, writing, discussing – as having *practised thought*. It is undoubtedly Deleuze's own consistent and serious engagement with this inflection of activity, his intimacy with how newness obtains, and with the stability that practising affords, that lends to *Difference and Repetition* its uncannily deft articulation of practising's moments, even while it discusses and invents concepts for many other processes and happenings.

Gilles Deleuze's 'Difference' and 'Repetition'

Practising is arguably a relation to happening itself. It is the cultivation of an intentional relation to *how* things happen, rather than being the habit of reacting to *what* is happening.

Certain moments, marking Deleuze's conceptual trajectory in *Difference and Repetition*, align quite blatantly with moments – or what I'll call *criteria* – of practising itself. By turning to Deleuze, practitioners find a clearer lexicon, both revealing and consistent.

Rather than describing or representing particulars or *denominations of* practising, Deleuze's writing in his 1968 intervention accompanies practising's enduring meta-operations, those which practitioners can, for good reason, seldom quite speak of or account for. The Deleuze of *Difference and Repetition*, we discover, furnishes practising – whether he intends to or not – with the means to say itself. To a large degree, this is due to his rigorous explorations of the nature of and the relationship between difference and

repetition – two operations that, along with their crucial role in the history of philosophy, and in its critique and reinvention, also underpin practising in any guise and which constitute a kind of ontological weave out of which temporality itself, and the register of representation, emerge. In *Difference and Repetition*, Deleuze invents and offers a way to think/say the *hows* of continuity, generativity and the future as pure, empty form.

Deleuze wrote and published most of his philosophical texts in the second half of the twentieth century. Famously, the work that was to become *Difference and Repetition* – the principal thesis for his doctorate at the Sorbonne – was defended among continuing upheavals around Paris after the events of May '68.[4] He wrote it in the wake of a number of other landmark works, which followed closely, but not necessarily typically, crucial contributors in the history of Western thought – his books on Baruch Spinoza, David Hume, Immanuel Kant, Friedrich Nietzsche and Henri Bergson. In *Difference and Repetition*, Deleuze arguably extends what will become a systematic and complex oeuvre (with the sibling 1969 work *The Logic of Sense*) addressing the most intricate and volatile concepts and issues in metaphysics. As Roffe reflects:

> [Deleuze's] ambitions are considerably greater than two bits of precise conceptual work [namely 'pure difference' and 'complex repetition']. Another [. . .] way of introducing the project of the book is to imagine that it bore a different, albeit famous and familiar, title: *Being and Time*. (WGD 158–9)

(Pure) difference (or *difference in itself*, as Deleuze will call it) and (complex) repetition (or *repetition for itself*) are – as well as interesting and precise in themselves – also decisive due to their operational enmeshment in any project that wishes to think seriously being, change, structure, time and creation, among others. It is for this reason that in order to think practising, we will want to explore 'difference', 'repetition' and their interactions in the company of someone like Deleuze, who tracked them with such nuance, playfulness and rigour.

Deleuze's more pressing philosophical concern in *Difference and Repetition*, furthermore – that the overturning of prevailing formulations of difference and repetition will serve to wrangle – is the dominance (throughout history, beginning with Aristotle) of a certain kind of habit in thinking, in the *way* we think, including assumptions that have been made about the nature of

[4] Roffe, *The Works of Gilles Deleuze – Volume I*, p. 157, hereafter referred to as WGD.

thought itself. In chapter III, we read: 'we may call this image of thought a dogmatic, orthodox or moral image' (DR 167). This kind of thinking is one for which we are all mostly well trained, due to being embroiled in a history that upholds the dogma of Descartes – *Good sense is the best distributed thing in the world* (DR 169) – and which involves an insistence that common sense is obvious and accessible, rather than being a fudge at the level of generalised recognition and apparent resemblance. Finally, what passes as thought has assumed the world to be, a priori, one that consists of pre-existing entities or 'things', rather than of generative processes that precede and found identity as such.

So-called 'thought', therefore, in this dogmatic sense, is dominated by some lingering and tenacious habits that Deleuze wishes both to point out and – possibly – to shake us free from. Of course, for good reasons as we'll see, a habit is no easy thing to lose. It may be that without the crucible of practising's fine-grain operations, such inventions and provocations are less likely to blossom into, and find traction as, transformed conditions and new ways of living and thinking.

Deleuze supplies the field of practising, then, with a precise vocabulary with which to articulate its ways. These ways (or approaches to activity and its particulars) can be steeped in tradition or shrouded in allusion, and often seem unnecessarily or clumsily opaque. The latter, I'd suggest, is less the case than the fact that their articulation is delicate and that a precise set of terms and concepts – independent of a gesturing-towards or poetic register – had not, prior to Deleuze, really been available. Deleuze, among other things in *Difference and Repetition*, articulates for practitioners (and as one himself[5]) what happens in practising's closest mechanisms. The latter tend towards the miraculous (to borrow his term – DR 3) with implications that are arguably ontological, pragmatic and, more importantly, if we follow a certain definition, political. [6]

[5] See, on this question, Roffe, 'Practising Philosophy', in Attiwill et al., *Practising with Deleuze*.

[6] We can borrow from Byung-Chul Han, after Arendt, for a definition of a 'political life', where he writes: 'Das Handeln im emphatischen Sinne macht das Leben des Politikers (*bios politikos*) aus. Es ist nicht dem Verdikt der Notwendigkeit und Nützlichkeit unterworfen. [. . .] Politisches Handeln heißt, etwas ganz Neues beginnen lassen oder einen neuen gesellschaftlichen Zustand hervorzubringen.' [Acting, in its emphatic sense, constitutes the political life (*bios politikos*). It is not subject to the imperatives of usefulness or necessity. Political action means to start something entirely new or to bring forth new social conditions.] (Han, *Müdigkeitsgesellschaft Burnoutgesellschaft Hoch-Zeit*, 97–8 (translation mine).

The current book seeks to offer existing or newer readers of *Difference and Repetition* – who might be practitioners in modes other than philosophy – a fresh reading of, and a certain way into, Deleuze's rich text. For all its notoriety, it is not an impossible text to unravel, although, like any serious creation, it never fully yields to any particular traversal. Deleuze is a clear and elegant writer, and he explains himself on the whole without extraneous obfuscation. He is playful, however, and sometimes he plays with references that, in the absence of familiarity, could confound a new reader. The text also approaches a constellation of subtle and abstract preoccupations that aren't easy: time, being and becoming, thought itself and the register of appearance and representation, and, inadvertently – as I propose – practising.

The current volume seeks to bring into dialogue something very much in the world, something happening all the time – often quietly and without a name – with one of the most virtuosic sites of its articulation, namely *Difference and Repetition*. This is an open invitation to readers of various kinds – those who consider their regular activities and investments in terms of practising, and those who are interested in ideas, especially those of Deleuze. It also speaks to makers at every register: artists, makers of times, affects and atmospheres, makers of new ways of being together. For readers who had not previously considered themselves practitioners, this book may also impact that very perception (as well as making them indifferent to acquiring any such label).

Practising happens in the world, even if it is, arguably, not quite of it. It has serious implications for our lived experiences of time. It's entangled with our rhythms, our fluctuating repertoires of habits, our inertias, and with moments of flight, transformation, emancipation, and vital unmoorings. Practising has to do with the future and its non-relation to a certain kind of present. It can coax us to meander within our deep past, making leaps within its vast archive. Practitioners – those who set going the operations of difference and repetition within a particular framework of intent – sometimes drift into practising. When this happens (since they don't really quite *do* it), shifts of register, operations and processes happen, which Deleuze details, sometimes only intimates, and often accounts for thoroughly, in *Difference and Repetition*.

The eternal return (as Nietzsche revises it and as Deleuze rereads it) has its laboratory – or if you prefer, its theatre – in practising. Practitioners might be those who sometimes align, but not in terms of any identity, with the atmosphere or timbre of Nietzsche's *Übermensch*. As Tomlinson writes in his Preface to the English translation of *Nietzsche and Philosophy*: 'The Overman is the focal point, where the reactive (*ressentiment* and bad conscience) is

conquered, and where the negative gives way to affirmation.'[7] The practitioner is always embarking on an apprenticeship in leaving her heavy self behind, one that she has nevertheless worked to cultivate and to know closely in the earlier moments of practising (those moments which, as we'll see, run parallel to habit, even if they are not entirely of it).

The Übermensch, considered from this angle, would not equate to any identity. One could not *be* it, rather one might be swept up in the modes of its becomings, blessedly evaporated by movements more interesting than the accumulation of any self, while also having no resentful investment in (identities of) self-erasure. The Übermensch, then, might stand for the embodiment of what it means to be able to self-transform.

By looking closely at the startling articulations of *Difference and Repetition*, we may be able to cast some light on our denominations of, and engagements with, practising. Assisted by Deleuze, we can begin to clarify its long-standing communalities (across forms), as well as dignifying its less lauded, minor shapes. Fine artists often know to use the term 'practising' in relation to their activities, but would a serious music appreciator, or a sincere gardener, or a enamoured bird-watcher, or an unassuming cook, know how to say what they already know: that practising (in their chosen form, modest or virtuosic) transforms, as well as *constitutes*, that which they might risk calling their most intensive life? Practising is less entangled with representation, as we'll see, and therefore only awkwardly sits within *bios* (as we might understand it after Arendt, and Kristeva's reading of her, as storied, meaningful life[8]). If we borrow from James Williams's vocabulary, practising might be one way to invite a life that lives its intensities *well*.[9] Always non-natural, practising would seem to give onto a modality of being/becoming at once vital/raw as well as refined. In other words, when you devote to practising, the registers of esteem, status and fickle approbation lose their alluring hold.

Practising, you'll have noted, is framed as both not uncommon but also non-natural; it arises via an unconventional relation to intent. We engage in our practices (structured repertoires of behaviours) intentionally, and/ but we drift into practising (this strange mode) with, at best, an artful and honed serendipity. The spin-offs of practising, then, are more courted than coerced, and the reasons for this will become clearer as we read Deleuze's early work.

[7] Deleuze, *Nietzsche and Philosophy*, p. x.
[8] Kristeva, *Life Is a Narrative*, p. 8.
[9] Williams, *Gilles Deleuze's* Difference and Repetition, p. 52.

Practising, cf. Practice(s)

Practising, as a notion, attempts to speak to particular nuanced modes and operations at play in doing's ambit in a meta-sense. Practising – one could say – is at once nestled within, but by no means reducible to, *practice* (as the latter has been variously understood). Its use here is to be distinguished, for example, from its use in the social sciences, and in the field of practice theory, as Pierre Bourdieu, Andreas Reckwitz, T. R. Schatzki and others have articulated it in various fields, but primarily social theory.

Practices, as activities, are to practising as the ontic is to the ontological register.[10] When one engages in one's repertoire of practices in such a way that the operations of difference and repetition come into play more explicitly, then one can be said to have drifted into the register of practising.

In his survey of the term 'practice' as well its relation to the older term 'praxis' and their relation to philosophy, Gregory Flaxman points out a tension within the term that merits attention insofar as it resonates with the focus of the current volume. He notes that the word 'practice' has both transitive (more common) and intransitive uses,[11] with an interesting dichotomy playing out within the latter. The transitive form has tended to pertain simply to the practice of a skill or profession (medicine, law and so on). To practise *intransitively*, on the other hand, has meant 'to repeatedly perform (an activity) or regularly exercise (a skill) in order to improve, maintain or ready oneself', aligning itself with the other definition of 'activities or exercises that are recurrent, habitual, often continuous, and ultimately drawn out into a kind of convention'.[12] This all sounds straightforward, but then Flaxman, via some common adages, recalls us to the curious fact that practice 'comprise[s] nearly opposed perspectives'. It both 'pertains to the material reality of our existence and *the will to alter it*' where the mettle of one's talk and theoretical position is tested – *practise what you preach* – and, at the same time, it 'seems to consist in a kind of preparation'[13] – *practice makes perfect.* We are familiar with both these inflections but often manage to elide bringing them to bear on each other.

Is practice, then, after Flaxman, a kind of rehearsal for real life, or does it concern the pathways through which we *create what will be* our real lives? Is it possible that these two options need not be joined with an 'or', that is,

[10] That is, the difference between beings of many kinds and Being itself.
[11] 'Introduction', Attiwill et al., *Practising with Deleuze*, p. 9.
[12] Ibid. p. 9.
[13] Ibid. pp. 9–10 (emphasis added).

that they do not operate as contradictions, but rather paradoxically, in a Deleuzian sense?[14] Is it, then, more the case that it is only via a certain kind of dramatic repetition, which could look like play or rehearsal, that we could ever, really, intervene in the nature of the continuity of the status quo, if 'we' can intervene at all? What we understand about change from the outset is that it defies our usual logics. It does not operate as we assume it surely must. For change to be effected, and perhaps understood, requires – to echo the Deleuze of *Difference and Repetition* – a departure from, even a withdrawal of confidence in, common sense. The current book, at its core, constitutes part of the ongoing inquiries into this question, a question which, one speculates, also inhabited Deleuze's own project.

If the term 'practice', after Flaxman, hints at this curious paradox at work in the ways things change, in that which constitutes and generates a 'reality' and the various natures of repetition, then what follows here – via the disambiguation of the term 'practising' – is an attempt to clarify the nuances of that *mode* of activity, the *inflection* of that 'doing' which is involved in this constellation. It seeks to make available to thought why practising – which somehow courts newness and, at once, cultivates stability – is miraculous and involves marvellous logics. Practice, after Flaxman's reading, when put under a little pressure, discloses its unusual nature. To take this structural intimation further, the term 'practising' and its criteria – as known by practitioners in their laboratories of action, and after Deleuze's efforts of articulation – might help us become a little clearer about how things change, why they often don't, and how we cultivate or preclude the future in its empty, generative form.

Summary

A persistent observation, gleaned from my own long-standing engagement with practising, animates the current book, namely: *practising tends to invite (or at least not preclude) radical transformations and at the same time is not incompatible with stability*. Common-sense logics might assume that transformation is more likely to happen when there is an instability operating; however, these brash 'transformations' (if they are that at all) may not serve us very well. We can also ask at what register transformation obtains and, at what other register stability might be operating and might be simultaneously

[14] Deleuze has explained: 'The force of paradoxes is that they are not contradictory; they rather allow us to be present at the genesis of the contradiction.' *The Logic of Sense*, p. 86.

cultivated. The answers to these questions will involve grappling with time. Practitioners, as I'll suggest throughout this work, might playfully be seen as time-workers. To practise involves cultivating temporal nimbleness: an ability to widen the kinds of temporalities that we are able to access and inhabit. Deleuze, notably, as we see in *Difference and Repetition*, outlines three of these possible modes, three *syntheses* of time, that weave difference and repetition in various ways.

Unsurprisingly for Deleuze readers, this mobility in time(s) will go via a disambiguation in relation to the register of representation and the mechanisms that bed down identity – again, difference and repetition. This dual character of practising – transformation *and* stability (rather than 'or') – will provoke and frame various clarifications about practising, as the latter's mechanisms are explored here with respect to Deleuze's thought.

Difference and Repetition might be approached as a book that performs philosophy *as practice*, as discrete and defined activity. In it, Deleuze interrogates what would constitute philosophy's practising of genuine thought itself, what he has called 'involuntary thought' (DR 175). I read his to be a book which explores that which makes practising possible – in the set of behaviours known as 'philosophy' – while also naming behaviours and habits within philosophy's own conventions, which have tended to preclude genuine thought from the outset. This has much to do with being marooned within representation's order and what is hindered by this. The current book seeks to take these observations, contributions and precise vocabularies and to extend them to practising per se, to make them available to those who may not be philosophers ('those who practise thought'), but rather people who wish to open their everyday practices (doings that can be barely legible or outright nullified within the logics of, say, a neoliberalisation) to the wilds of what practising invites, steadies and unleashes.

The work that follows here is structured according to the moments of practising: its four criteria. Chapter 1 begins with an overview of how the criteria have been derived, and then the following chapters address each criterion in turn. Going via Deleuze's syntheses of time and their modes of difference and repetition, the movements of practising, their entanglements and implications – both theoretical and lived – will be explored and clarified.

Having a more precise set of criteria might allow a practitioner or creative researcher – in the visual arts or dance, for example – to think about their own doings in a less imprecise or generalised way. Via the lens of practising's four criteria, lapsed or absent criteria can be spotted, or imbalances in emphasis understood. This may account for why transformation is hindered,

or for why stability is elusive, or for what is precluding the emergence of newness or the dropping-away of old selves that our creativities and times desire.

When we practise, we are necessarily also always practising difference and repetition.

1

A Framework for Practising: Deriving the Four Criteria

The extreme formality is there only for an excessive formlessness.

Deleuze, *Difference and Repetition*, p. 114

About Practising

Many people have sets of practices in which they engage on a regular basis and unassumingly.[1] Having a set of practices, or a repertoire of actions, or a particular skill is crucial for, but not coextensive with, *practising*. Put simply, one can have some practices – learned in childhood, acquired via a fortunate education, picked up in a community or social milieu – but one might not necessarily end up (or wish to end up) practising.

Practising, I will argue, involves four moments or criteria. One of those pertains to having a practice you can do or enact, and the others involve how one engages with the fact of having this repertoire of doings. Practising pertains to that strange inflection of action, which involves precise intentionality and particular rhythms of engagement. The latter are linked to practising's tendency to unleash transformation and openings onto the future, while also allowing for modes of steadying continuity, as well as access to certain modes of reminiscence and what we might call the erotic.

Practising initially relies upon the existence of identifiable *practices* that form the basis of, are the conditions for, these aforementioned operations. *For practising to happen, one needs a practice that one inflects in a specific way.*

[1] The current chapter was adapted from and extends an earlier published chapter by permission from Springer Nature: Palgrave Macmillan, in the edited collection *Immanence, Transcendence and Intercultural Philosophy*, by William Franke and Nahum Brown, 2017.

Thanks to these identifiable practices and the fact of their being performed over time and with a certain consistency, a contextual stability obtains in practising's wake. In relation to life's changes, in other words, something also steadies and continues. Or, a further way to say it is that merely having (or doing) a practice synthesises one kind of time. Practising, on the other hand, synthesises this same mode of time as well as a number of further temporalities.

To venture an initial definition: practising is an inflection of activity or doing which produces at once a stabilisation within the context of doing (including of the so-called self-that-does) and simultaneously manages *not-to-preclude* transformation or radical newness within that very context. Practising is that mode of doing which doesn't, in fact, sabotage what action wants. It would designate a mode of inhabiting activity which, by dint of how it does/acts, does not preclude the very change it seeks or might be curious to court. In this way, it has everything to do with desire.

Practising can be said, then, to include those conditional 'moments' or criteria that logically precede its more dramatic aspects. The former we can designate as practising's *habitual* moment. Furthermore, evidence of processes of transformation (taking place, having taken place) is not always immediately available within the register of representation (that is: we can struggle to notice or mark them). Thus, we cannot always say for certain whether or not practices are drifting, or have drifted, into the register we might rigorously deem practising. What this means will become clearer as we move further into this book.

To state it modestly, a certain inflection of engagement with tangible practices sometimes courts the operations that we might group together under the name of practising proper.

Many people, then, are likely from time to time, and not necessarily randomly, to be operating in the register of practising, and potentially, to be cultivating their own intelligence concerning, and capacity for, what constitutes the difference between just 'doing' practices, and practising per se. Depending on their tradition, or shape in which their practice comes (contemporary dance, sculpture, crochet, cooking, ikebana, hiking, rowing, lithography and so on), they may or may not have available to them reliable accounts of what makes this other, stranger inflection more likely. Zen practitioners can more easily access targeted literature that gestures (as clearly as it can) towards practising per se; golfers, on the other hand, can be derailed by the activity's competitive aspects and be less able to articulate the other register that is also available for someone engaging in this iterative and consistent set of behaviours.

People are practising all the time – quietly, with precision and a variety of rhythms and consistencies. Rhythm and consistency, as we'll see in Chapter 3, form a crucial part of one of practising's criteria.

If asked what practising is, or why they practise, the same dedicated people may struggle with a coherent reply. They might name a number of reputed and tangible 'benefits' of their specific practice (health, awareness, alignment, refined sensibility, beautiful objects, happier relationships, better parenting etc.); or they may list changes in their lives that have taken place in parallel with their having had a regular practice; or they may describe how it makes them feel. In other cases, as mentioned, they may reach for ready-made explanations provided by the specific tradition in which they practise or by their broader cultural, or even religious, context.

In other instances, and often having become more seasoned and 'literate' practitioners, they may be reluctant to speak about this both strange and mundane doing at all. Suspecting – and not without grounds – that what constitutes their practising is more robust when protected from attempts at classification or representation, they may prevaricate or be evasive in their replies about it, and thus come across as esoteric, or even smug, regarding what they're up to.

They may suspect that to talk further into the *practising* aspects of practice also risks something perhaps unseemly and – even less desirable – dissipating.

Finally, the practitioner may hesitate out of fear that their listener is less curious about practising and rather keener to embroil them in a certain kind of argument on certain kinds of terms, in which practising – due to its unruliness in relation to the usual terms of representation – will fare badly.

It can seem better to abstain from recounting our more elusive relations to our practices and incidents of practising than to do this in unsteady, ill-fitting terms. One of the arguments of the current book is that Deleuze has made a significant contribution to our being able to articulate with more precision the mechanisms of, and what's at stake in, practising. (His uptake by practitioners in fine and liberal arts disciplines goes some way to evidencing that.)

Just as philosophy, social sciences and political economy, as well as the arts, among other fields, have traditions of theorising 'practice' and praxis, the terms 'practice' or 'practising' also feature heavily in the vocabularies of many spiritual or wisdom traditions. For this reason, (spiritual or esoteric) practice can appear to be just another established vehicle of moral law. For many, this renders it suspect, or reparatory at best. Denominations of trending practices or structured behaviours – 'mindfulness', cross-fit, minimalism, various dietary approaches (the list is lengthy) – can seem to be mere des-

tinations whence people, who wish to 'fix' their lives on terms that remain unexamined, flock. These lives, if indeed broken, are likely to have become that way not in small part due to current neoliberal logics and conditions, as well as due to other more ahistorical conditions of being alive, of being a desiring creature that is also formed through habit's momentums. And one cannot deny that many people will derive tangible benefits that may well qualify as reparative (or 'healing') by engaging in well-chosen practices. (We will explore this in our discussions in Chapter 2 about the role and place of habit in the criteria of practising.)

Practising, however, doesn't only or primarily *repair*. It affects and it generates. It creates conditions for newness and gives access to registers of more varied sensibility. In other words, it involves an operation or operations that interrupt, unravel or simply *pay no heed to* the continuities of the status quo, of our drier inertias. Furthermore, I'll argue, it does this in ways that can't be conflated with destruction.

Which practice we choose, at the outset, can pertain to banal or more meaningful affinities – tools, outfits/clothing, settings, types of people doing the practice, behavioural trends. Experienced practitioners tend to say that the shape of the practice is less important than *that it become established*. I will add that the benignity of its content is also crucial and will say more about this soon.

In this chapter, we will meet the four criteria that I am arguing constitute or are the conditions for practising (in itself). The criteria can inflect – into practising's mode – a wide range of possible practices-as-tangible-forms. These criteria mark the moments of practising irrespective of the shape it comes in. In other words, if the criteria are operating, this may inflect the behaviour/form as practising, rather than being just – following Flaxman's survey – a series of behaviours pertaining variably to convention, continuity, improvement, moral law, and so on. One can perhaps listen to a lot of 'serious' music without the mode of its doing necessarily shifting into practising. By the same token, one can take up an extremely 'humble' activity – say, doing housework or cleaning public toilets[2] – and shift it into another register altogether, via practising's criteria and the inclusion of the unusual intention central to them.

The other difficult aspect of any discussion about practising is seeking the right verb to sit in the place of more usual, causal ones. Even if one is tempted

[2] Ai Weiwei, the Chinese-born artist, recounts his own father, subjected to 're-education' during the cultural revolution, as raising toilet cleaning (his assigned work) to the level of what one imagines approached (and probably coincided with) practising.

to say in an accessible way that 'practising has effects', this is not quite it. While practices might produce identifiable outcomes, does *practising* strictly speaking 'produce' things? Generativity seems to arise in its vicinity, but one might hesitate to claim that it makes generativity in a direct way and, in any case, generativity isn't a *something*. It is rather that which conditions the generation of things. If we are being strict, we could risk the claim that practising produces (or allows for?) Nothing(ness) itself (some practitioners use the term 'spaciousness') as a condition for Somethings, while the practice, as tangible set of actions, does incidentally produce knitted garments, delicious food, serene floral arrangements, flexible bodies or even 'health'.

When, over long periods, consistently and seriously,[3] a person inflects their doings in the ways of practising, a certain steadiness can emerge alongside a loosening of entrenched and typically unmoveable operations that constitute their 'I'. The person can feel as if they are accessing more modes of time than an habitual present. If they have also lost this present, due to trauma, for example, they may regain access to this crucial temporality, too.

Personality (or we could say a particular expressive labour of the generalised self) would not appear to be ramified by practising, but neither does the practitioner – who remains in the world, participating and implicated – become colourless or insipid. The kind of difference at play when doings are inflected as practising would seem to pertain to something other than modifications of the day-to-day; practising's intervention is not a tinkering within the continuities of resemblance. It's as if practising manages to access a different order of the physics of change (to risk a poetics), which can't be accessed when we proceed according to the logics of the order of representation. Deleuze, of course, is the perfect companion for research into what these non-representational logics might be, given his extended critique of representation's 'shackled' thinking.[4]

To borrow from Deleuze, we can say that the stability which practising cultivates does not fixate on notions of sedimented *identity*, on thinking through *oppositions*, on *analogy* in relation to judgement, or on seeking to find *resemblances* in relations to objects. These are the elements that Deleuze identifies as marking the register of representation (DR 174). For him, the dogmatic image of thought, as explored in chapter III of *Difference and Repetition*, involves a thinking that is dependent on these categories, one which relies on and assumes category, rather than being able to think *the operation that is category*, as that which is the condition of category, as such.

[3] This echoes the wording of the *Yoga Sutras* of Patanjali, sutra I.14.
[4] As he calls it, in chapter III of *DR*.

The question of how to account for this cluster of 'effects', 'arisings', 'spin-offs' (and so on) of practising (that is: transformation, wider sensibility, *and* stability, stability in the face of transformation, without a shutting-out) persists throughout this book. The criteria of practising align themselves with this strange, almost embedded, set of tendencies, helping us to think the *how* of practising more clearly.

The Four Criteria of Practising

The criteria of practising are as follows:

1. **Structural form**: There is a set of behaviours, a form of doings/activity or 'a practice' of some kind, ideally benign for the practitioner and others.
2. **Intentional repetition**: This practice (which tends also to involve repeated sub-activities) is intentionally repeated at regular intervals over time.
3. **Relaxation**: The repetition is performed with a minimum of effort without compromising the form of the practice.
4. **Repeating repetition**: The repetition eclipses the doer and even the content of the practice, becoming itself the 'content' – *doing*-the-practice slips into sheer *practising*.

The criteria can also be approached as two broader moments or halves.

Criteria 1 and 2 seem to align – if we set aside for the moment the role of intentionality – with what various lineages of scholarship have deemed the mechanisms of habit, and with the temporality Deleuze has called the 'living present' (DR 284). Chapters 2 and 3 of this book take these up. Criteria 3 and 4, taken as whole, will manifest resonances with other syntheses of time (the pure past and the empty future) and will inform the discussions in Chapters 4 and 5 of this book. These two later criteria mark a departure from habit's ubiquitous register, one which goes via an unusual mobilising of intentionality. This very intentionality operates like a hinge, marking in principle the threshold between habit and practising. In lived practising, however, the line is less distinct.

Curiously, in his essay 'Of Habit' from 1838,[5] Félix Ravaisson intimated that there can be something-other at work in habit, which – without contradicting its usual mechanisms – can allow a departure from, or

[5] Ravaisson, *Of Habit*. Here, and hereafter, referred to as OH.

extension of, its usual logics and directions (OH 101). He gestures, in other words, towards what I consider here under the clarified operations of criteria 3 and 4. In Ravaisson, this strange direction that habit *may* take is intimated without really being accounted for. I'd suggest that Deleuze, 130 years later, does the conceptual work that allows an account to be ventured. This extension or reinflection of the habitual register deserves to be thought, and this book attempts to do it. Habit's mode of 'grace'[6] may be more helpfully given the designation 'practising', thereby distinguishing it from inventories of discrete practices, and from the usual logics of, and temporality proper to, habit.

Practising, for its part, constitutes an intentional accompanying of habit's disposition, cultivating – via certain intentionalities – this 'gracious' side of habit and diluting its harsher and more gruelling tendencies. Practising neither prevents nor resists habit's mechanisms. Rather it senses and then rides the uncommon arisings that emerge from a going-along-with, to which Ravaisson himself was evidently awake. If one wished, one could argue that practising constitutes a kind of deconstructing of habit's edifice, since as we know from Derrida, deconstruction should not be confused with any simple destructiveness. It is far more a kind of de-sedimentation.[7]

Many activities that people do – often loosely called practices – have the potential to shift their register towards *practising*.[8] These same activities, or repertoires of doing, in the absence of this minimal difference – which is effectively a kind of subtraction, the addition of *nothing* – can simply be stuff

[6] To use Ravaisson's term – OH, p. 57.

[7] Derrida, *Of Grammatology*, p. 10.

[8] I wish to acknowledge and thank the readers of early drafts of this work, and Roger Ames for conference discussion in 2015 in Macau (from which emerged the edited volume *Immanence, Transcendence and Intercultural Philosophy*, Brown and Franke, 2017). Their combined suggestions have led me to distinguish practice (n.), as in *a* or *one's* practice, from *practising*, allowing for the latter to constitute the inflection or mode of any practice that manifests these four criteria. Earlier research publications of mine on this question have tended used the terms 'practising' and 'practice' interchangeably, which reflected vernacular usages of these terms in various fields (fine arts, yoga, especially). However, this also tended to leave room for confusion, muddying explorations of *practising* with adjacent but distinct lineages of scholarship that deal with praxis and practice (Marx, Foucault, Lefebvre and so on). The distinction, as used in the current work, and prompted by the above scholars' intellectual generosity, is more precise and thus will hopefully aid readers' access to the central concept of this book. When reading earlier published work of mine on this topic, keeping this clarification in mind may be helpful. Practising and practice(s) remain, of course, inextricably linked, but are more usefully used as distinct terms, as this book seeks to articulate.

people are doing: entertainments in some cases; distractions; compulsions or routine. And, of course, the things we do, more generally, continue to matter in their various ways and according to our investments and preferences. Practising, then, should not be positioned as some ideal way of approaching action. It is, on the other hand, something discrete and precise, with singular, arguably ontological, spin-offs. When one seeks such spin-offs, or is simply curious about them, then it would seem important to understand how practising operates.

Practising, I'd argue, is happening in many contexts and often goes under the radar. Although our activities, echoing Ravaisson's musings, may drift into it, it is not really something that we – to use the language of habit – *contract* (in the way we might *contract* a cold, a tendency, a routine, and so on.) It is, furthermore, neither natural nor arbitrary.

Although not accidental at all, practising also has everything to do with not-precluding, not-shutting-out the accidental or contingent. In practising, *we intend that which we cannot foresee*, in the curly but not inconsistent logic that is proper to it. Practising is what leaves a gap for newness (or, said differently, for immanent deaths, for 'unpresentation').[9] Finally, practising may be marked by a kind of heightened ordinariness, and this very quality, rather than contradicting what practising entails, is a hallmark of its unusual operations.[10]

Longer-term practising seems also to reveal a number of paradoxical aspects to its mechanisms and 'effects'. In *The Logic of Sense*, Deleuze makes clear that 'paradox' is not to be aligned with the contradiction, as it might be in quotidian usage. The two cannot be used interchangeably in any rigorous way. Their relation is more interesting again: 'The force of paradoxes is that they are not contradictory; they rather allow us to be present at the genesis of the contradiction.[11] The paradoxicality of that which practising 'prompts', 'courts', 'doesn't-preclude' or 'unleashes' (the terms continue to fail), has something to do with the fact that its mechanisms operate at a register that is logically prior to the order of representation, the order within which contradiction operates and makes sense. Deleuze states plainly: paradox allows us to be present at the genesis of contradiction, and one wonders if this extends to other kinds of geneses. This is the very question into

[9] As gestured via vocabulary here, this recalls the contingency and undecidability that also characterises the event for Alain Badiou – see *Being and Event*, pp. 191ff. and further 173ff.

[10] On a related query, readers may find Leonard Koren's, *Wabi-Sabi: Further Thoughts* of interest.

[11] Deleuze, *The Logic of Sense*, p. 86.

which practising, experientially and in real time, offers a glimpse. Practising involves inviting an encounter with sense or the imperceptible, outside of common sense, subtracted from the logics of the order of representation. Being prior to the sensible, sense – as Deleuze explains in chapter III of *Difference and Repetition* – 'is not a quality, but a sign' (DR 176), and thus:

> [s]ensibility, in the presence *of that which can only be sensed* (and is at the same time imperceptible) finds itself before its own limit, the sign, and raises itself to the level of a transcendental exercise: to the 'nth' power. (DR 176, emphasis added)

Whether practising might constitute something akin to what Deleuze intends by 'transcendental exercise' we can leave open; his poetics, however – of raising an action or behaviour *to the 'nth' power* – offers a robust framing of what is at stake in practising.

Let's consider now, as a kind of ontic inventorying, what kinds of doings might be ripe for reinflection as practising. Arguably, we could say any kind of doing, and the reader may wish to take this question up for themselves. Some activities, however, lend themselves more readily to practising's mode, due to the inherent repetition and consistency within their forms that work together sustainably as a kind of generative constraint.[12]

Activities or practices available to practising's mode would include cross-country skiing, knitting, yoga, cooking, writing, close listening to music, reading/studying (which would include learning a new language, human or computer), walking, learning and playing a musical instrument, woodwork, sex, meditation, golf, swimming, calligraphy, fencing, prayer, gardening, dancing, rowing, sculpture, running, flower arrangement, tea-making, bonsai, cleaning, lithography, bird-watching and countless others. Practising is best suited to activities that are, in their contents, *benign*. This is because practising requires repetition, over long periods of time, and if the activity is too harsh, even a little damaging (to self or others), then we are less likely to be able to sustain it. (On the other hand, practising's mechanisms do not strictly guarantee any straightforward pursuit of 'the good' – a discussion beyond the scope of the current work.) Furthermore, its activities may involve some level of risk. Usually the practice itself has an element of serious difficulty, even when it can appear simple at the start. Practices suited to practising, then, tend to have the dual quality of not breaking

12 See Deleuze, *Difference and Repetition*, p. 175: practising echoes the necessity which Deleuze names for involuntary thought, that it be 'aroused but constrained'.

down the organism who practises (if she practises intelligently, which in turn becomes part of practising's challenge), while being inherently complex enough that one never seems to 'touch bottom'.

Of all the repertoires of doing/making[13] listed above, one of them stands out as exemplary, as a practice that, with regard to its content (or lack thereof), slips inevitably into practising. The line, in other words, between its repertoire proper and the inflection of that repertoire as practising is the thinnest of those listed here.

It is the practice of 'just sitting' or *shikantaza*.

Shikantaza, from the Soto tradition in Zen, is almost always already within practising's ambit. In the next section, I want to read this plainest but exemplary of practices closely, with the aim of demonstrating how the criteria come out of solution. In shikantaza, we see the behavioural content of its practice, like a limit function, approaching – while not coinciding with – the x-axis of doing nothing.

Shikantaza and the Four Criteria

Sitting silently in a stable posture is often termed 'meditation'. In some traditions, the word 'meditation' may also include walking, or lying, or doing other activities, where a certain attitude is assumed during the behaviour.

The word, as it is used in English, usually implies a grammatical transitivity. Transitive verbs are ones which take an object, either directly or indirectly. 'To meditate' usually works as an indirect verb, due to the preposition which accompanies it: one meditates *on* something or other. Just what this indirect object is will vary depending on the tradition in which one practises. It might be the breath (counting it in cycles), or it might be the sensations in the body; it might be a mantra, or even an image of a deity or mandala. Various Christian prayer practices approach this kind of meditation, the rosary of Catholicism being arguably a structurally similar version of what goes by the name of *japa* ('muttering' in Sanskrit) using beads, or which approaches the use of *subha* or *tasbih* in Islamic faith. In any case, 'meditation' is a very broad term, and tends to have transitive inflections.

[13] For the purposes of discussing practising, it is not necessary to distinguish especially, or at this early point, between activities that explicitly make 'something' and those that do not. This ground for distinction can actually introduce a fixation at the level of representation that is not clarifying. As it will be argued, practising is by definition an opening onto the generative, and it is simply that some practices also have obvious outcomes (an artefact: a meal, a cup, a sculpture, a 'healthy' body), while others produce their 'effects' or creations in less tangible ways.

Intransitive verbs, however, and even within grammar, are more unusual, and might imply less usual operations at work. English has very few strictly intransitive verbs, and although it falls outside of the scope of this discussion, it would be interesting to query their incidence in other languages. It might suggest, however, that English, at least, offers scant ways to articulate and therefore to think doings (verbs) that don't operate *on*, or produce, something material and nominal.

Transitivity and intransitivity offer us a lens through which we can disambiguate what is happening in meditations more broadly and, then, what is going on in the practice called shikantaza. The latter can be understood most simply as the mode taken by zazen (or seated mediation) in Zen generally, but more centrally in the Soto lineage. Zazen is the base practice for both main lineages of Zen (Soto and Rinzai).[14] True to its name, shikantaza – as we'll see below – is interesting for my purposes because it can be distinguished on the basis of its radical intransitivity. Soto's shikantaza has no accompanying techniques or supplements at all. It is a form that contains only the most minimal specifications as to its repertoire of actions. In this way, it calls to mind, as mentioned above, an asymptote – that strange curve in calculus whose equation approaches the x-axis without ever meeting it.

Shikantaza, it will be argued, constitutes the exemplary action which gets as close to being *no action* while still satisfying the requirements of constituting a 'structured doing'. Approaching via Ravaisson's frame (whose work is the focus of the next chapter), shikantaza could be read as the activity of taking up a habit on purpose, and one that is all the stranger for its consisting of sheer form – that is, without having a content or stipulated activity per se. In shikantaza, the doing that one practises, is non-doing.

Shikantaza, then, is both a verb that has no object, while also being a form that has little (to no) content. In moments of intensity of practising, it is also – strictly speaking – a verb with no subject.[15] Why this is will become clearer as we move into discussions of the final criterion.

[14] Due to this chapter's emphasis on the first criterion as structured behaviour, mention of shikantaza and zazen is to serve our discussion and is presented in terms of them as examples of technique. There is no real scope here to examine closely their place within the culture and tradition of Zen in Japan or elsewhere, nor will we look at Zen as a broader field, given its long and extremely complicated history. Its contemporary associations, as unwieldy as they are, will be left alone, neither challenged nor endorsed.

[15] For more on this, see Franke and Brown (eds), *Immanence, Transcendence and Intercultural Philosophy*, chapter 9, and specifically the cited correspondence with scholar Hans-Rudolph Kantor, whom I have to thank for clarifying particular details, sourced from the Chinese, regarding shikantaza's intransitivity.

Where in *trataka*, from the curriculum of Hatha practices, one meditates on a candle flame, or in Vipassana, one observes the rising and falling of sensations around the body, in shikantaza one neither meditates nor concentrates *on* anything at all. Sometimes in English the term 'attention' is used to surmount an inadequate vocabulary, offering the notion of something broader – a state, rather than an acting-on. It gestures at an action without a narrow object, a kind of dispersed but not scattered perceiving. (Another common understanding of what zazen involves is that it pertains to a 'state of absorption'.)

Scholar Hans-Rudolph Kantor reads a shift or progression within the practice itself, which resonates with our interest in the way practising can emerge as a mode or inflection. Zazen's attention or absorption might begin with a more transitive inflection, sometimes just an awareness of the sitting posture itself (and still technically a regular, if minimal, kind of 'doing-something'), before unfolding towards a greater intransitivity. 'Attending' or 'absorption' then corresponds more clearly to the second moment in the trio of practices nestled later within the Eight-Limbed Path of Patanjali's Sutras.[16] Forming the final three of the eight limbs, and together called *samyama* ('integration'), there is firstly *dharana* (concentration), then *dhyana* (meditation/absorption), and finally, *samadhi* (usually untranslated).[17]

Zazen is the word 'dhyana', from Indian Yoga, taken up in the Japanese, and so already we have a hint about this hinge-like moment in the trio. One can't 'practise' samadhi, but one can prepare the way for its arising, in a way not dissimilar to what will be designated as practising in this book.

'Dharana' trains the practitioner in an initial kind of productive *excluding*, and is itself preceded by *pratyahara*, the sixth limb ('withdrawal of the senses from their objects'), as its preliminary effort or attitude.[18] (This is not technically a withdrawal of interest, but a steering of interest, attention to new locations inside the body. It is also a disengaging from the 'gravitational' effect that external objects/happenings exert on us as organisms.) Pratyahara, however, mostly serves to establish the conditions for what will come and, once stable, give way to, or intensify into, a radical kind of inclusion – a boundless absorption, or broadening of awareness. Dhyana, therefore, *includes* more and more, verging asymptotically towards excluding nothing. One could say, turning to a Badiouian vocabulary, that by excluding nothing

[16] See Sen-Gupta, *Patanjali's Yoga Sutras*, chapter 2.

[17] Ibid. III.1–III.6.

[18] We could read 'objects' here as that which registers within representation.

– strictly and rigorously – one incidentally gives Nothingness a chance to appear, illegally, within the register of representation.

Another way to say it, which is slippery within language, is that mostly we are caught in the habit of very actively and insistently (if unthinkingly) excluding Nothingness and that practising – most obviously in the tradition of shikantaza – restrains (or loosens our grasp on) our tendency to do this. As a result, Nothingness can or might appear.

So, although all forms of meditation are definitely practices which might be able to inflect as practising, it is shikantaza, in particular – a form which does without objects and which entails for its 'action' a strictly minimal form almost devoid of content – which can assist with thinking practising per se. Shikantaza, I contend, is the exemplary form of practising itself. A close analysis of it enables us to bring out of solution its sheer criteria.

In the thirteenth century, the founder of the Soto lineage, legendary teacher, poet and philosopher Eihei Dogen, wrote this on the question of the technique of zazen:

> Having adjusted your body in this manner, take a breath and exhale fully, and then sway your body to left and right. Now sit steadfastly and think not-thinking. How do you think not-thinking? Beyond thinking. This is the essential art of zazen.[19]

And in the next paragraph:

> The zazen I speak of is *not learning meditation*. It is simply the dharma gate of enjoyment and ease. It is the practice-realization of complete enlightenment. Realize the fundamental point free from the binding of nets and baskets.[20] (emphasis added)

[19] Dogen, *Enlightenment Unfolds*, p. 33. We can also note that the term *hishiryo* which, in this translation from the edited collected by Tanahashi, has been rendered 'beyond thinking', is elsewhere translated as 'without-thinking' (Kasulis 1985: 71). In Kasulis's commentary, he surveys the ways in which commentators have approached this third option, after thinking and not-thinking (1985: 72). Noting the commentaries of Terada and Mizuno, he explains that, as opposed to negation, this 'without' gestures towards the Buddhist doctrine of emptiness, or *ku*, in Japanese, or in Sanskrit, *sunyata* (1985: 72). Citing Takahashi, Kasulis notes that 'without-thinking' neither negates nor affirms the products of ideation (1985: 72). And finally, he notes that for Akiyama, not-thinking is arguably another form of thinking (1985: 73). Aligned with a dialectics, 'without thinking' for Akiyama includes *and unifies* both thinking and not-thinking (1985: 73).

[20] Dogen, *Enlightenment Unfolds*. One can ponder how to read Dogen's 'nets and baskets'. In reference to the point made earlier about practising's quite unusual relation to striv-

Dogen's intriguing crypto-poetics don't always clarify the matter for some-one seeking an accessible account or picture of what this zazen entails. Shikantaza, as mentioned earlier, involves something that looks a lot like meditation (that is, one usually sits in a stable posture with a straight-enough spine for a defined amount of time); however, the moment one asks pragmatically, *But what is the practitioner doing?*, solid answers melt into air. Where other forms of meditation use this posture as the simple base upon which other doings are layered, shikantaza, true to its translation as 'just sitting', begins and ends there.

One just sits.[21]

In terms of things that a human could do with their time, shikantaza is potentially one of the most baffling. It is strictly and expressly without aim, ambition or obvious usefulness. It seems difficult even to divine or specify its intention. In Dogen's version of Zen, and which becomes a hallmark of the Soto line, enlightenment and the thus-ness of practising are deemed to coincide. As we read in the above quote, practising *is* enlightenment. The practitioner is discouraged from thinking in terms of any path from and to, of any interval to be overcome, or of any causal relation between them.[22] There is a kind of almost-simultaneity. At the very least, this idea is put to work pedagogically to frustrate efforts by newer or more established students of setting up enlightenment as the goal, an attitude which immediately under-mines shikantaza. Practising, in this way, is not positioned as logically or practically preceding enlightenment, instead (as when we note how causal verbs fail to speak of what practising does), this order remains undecidable, or even beside the point. Shikantaza becomes something harder to mobilise as a generalised behaviour among others that 'gets things done' or helps one to reach a desired state (moral or otherwise). Shikantaza remains its own raison d'être, and not a means *to* anything.[23] If anything, it intimates only perhaps being a path to (a non-resentful) Nothing.

ing, we can read 'nets' as relating to getting, and 'baskets' to keeping. Practising changes the terms entirely on which one relates to things, with its own emphasis more clearly placed on processes, rather than the things that the latter (also reliably) throw up.

[21] And as Sen-Gupta writes, finally even the straight spine is not strictly necessary, since something more fundamental stabilises in the practitioner. *The Heart of Practice*, p. 25.

[22] This recalls section II of Ravaisson's *Of Habit*, p. 61, where he writes of a coinciding of desire and outcome. Echoing the asymptotic line, Ravaisson explains that as habit progresses (*with*, I'd supplement, a particular *inflection*), there is a coinciding of will and goal, desire and possession, which is deemed to correspond to the structure of love.

[23] This marks the Soto tradition as being deemed *advaita*, or a non-dual path. This is in contrast to the Raja Yoga of Patanjali, for example, a *dvaita* tradition, which makes

Dogen's provocation (which founds to some extent the singularity of the Soto tradition) is that the pair (practising and enlightenment) are deemed either to coincide, or – even more curiously – that enlightenment logically *precedes* practising. The latter becomes (strikingly for the Deleuze reader) the *expression* of realisation. Here we see causality replaced by a logic of expression.[24]

There has been a realisation, and one practises. (We might recall here what Deleuze says about the conditions which force us to think: 'the contingency of an encounter'; 'absolute necessity' – DR 176.) Would an encounter with the 'impasse', the shock of 'enlightenment', force something else, another kind of grounds for action?

The contents of such realisations are seldom articulable; it recalls Artaud's 'thought without image' (DR 185). However, the realising might be accompanied by another thought, which has a filament of the recognisable, of the kind: *one now sets about practising*. This would be a decision with regard to how to behave – to repeat intentionally, and to intend one's repetitions.

Shikantaza, I'm arguing, offers ideal 'laboratory conditions' for distilling the criteria of practising due to its almost absent content, consisting as it does of a repertoire of almost no action. Given this, we can examine what kinds of features are operating in this minimal doing, a doing which tends to be described – in Dogen's and other's writings – almost entirely in 'negative' terms.[25] This reliance in the literature on terms that render negatively in

a clear separation, following its roots in *Samkhya*, between this world of appearance and another register that one seeks to 'realise'. The subtle differences and resonances between these paths fall outside of the present discussion.

24 See generally *The Logic of Sense*, and in particular, 'Nineteenth Series of Humor', where we read in a passage by Deleuze referencing the Zen master and the koan: 'The negation no longer expresses anything negative, but rather releases the purely expressible with its two uneven halves [. . .] We can see this clearly in the Zen arts: not only in the art of drawing, where the brush controlled by an unsupported wrist balances form and emptiness and distributes the singularities of a pure event in fortuitous strokes [. . .] but also in the arts of gardening and flower arranging, in the tea ceremony, and in the arts of archery and fencing, where the "flourishing of iron" arises from a marvelous vacuity.' p. 155.

25 In this vein, we note Deleuze's painstaking efforts in chapter IV of *Difference and Repetition* to step his reader through the difference between non-being – a negative of being – and (non)-being or what he writes as ?-being. This is not a negativity, but something which 'corresponds to the form of a problematic field' and one can read the 'non-'s that litter descriptions of zazen with such a spirit. Zazen is not a negation of action, but rather 'beyond' it (to borrow from the Dogen translation) or simply a strange operation subtracted from a register delineated by the opposition of acting/not-acting. See Deleuze, *Difference and Repetition*, p. 253.

the English ramifies my claim that there has been, until Deleuze, a relative dearth within Western paradigms of ways to speak of how practising operates, of what it's really up to. Deleuze makes precise forays into thinking what he calls 'the virtual plane of the problematic', and 'the intensive', registers which I'd suggest offer the closest intimations of the field in which shikantaza operates. This would require a digression into some aspects of Deleuzian scholarship that fall beyond the scope of this chapter, for now I turn to thinking the first criterion, using shikantaza – which I explore at length – as frame.

The First Criterion: Form – a Practice or Structured Behaviour

Students who attend a Zen centre to seek instruction in the practice of shikantaza may – if the centre adheres to the stricter texts and resists the urge to make things more palatable for the newcomer – find themselves guided along the following lines:

- sit quietly (in any stable, upright posture) with the spine aligned;
- place the hands in the zazen mudra – right hand below left, palms up, thumbs lightly touching without pressing (traditional, but optional);[26]
- (sometimes) let the tip of the tongue rest behind the front top teeth
- allow the eyes to let in a sliver of light and to softly focus on a spot a metre or so ahead (recommended, but optional);
- do this for a period of time specified in advance;
- repeat this at regular intervals.

No other instructions are necessarily offered or required. Suggestions as to the breath (often anticipated, being typically associated with meditation) are, if at all, mostly only suggested to stabilise very new practitioners, and are relinquished as soon as possible. Shikantaza ('just sitting'), after all, is not the yogic breathing practice of *pranayama*, and so – it is often said – like a crutch for someone learning to walk, breathing techniques are similarly to be relinquished once the practice settles.[27]

[26] Statues of the Buddha show the other way around, but the Buddha would be enlightened, and the student of Zen not – hence the convention of reversing the hand position.

[27] In my experience, using strong breath in sitting creates problems for the body – namely, pain. Sitting is mostly motionless and for this one needs only the requisite amount of breath for the activity. To breathe more than needed, or in special ways, exceeds what's required for the form.

Notably minimal, the instructions for shikantaza are clear in relation to form (spine, hands, eyes, tongue), and for our purposes conspicuously devoid of direction as to what happens or emerges from the practising. One can only, as a practitioner, adhere to the formal requirements of this practice; one can't attempt to make happen any anticipated content. Of course, students do, because they have listened to a programme about meditation on the radio, or have read a popular book, and so they try to 'produce' no thoughts, or to 'suppress' them; or they try to 'find calmness' and so on. These attempts get in the way until the student realises that they are not the point, and that to impose an image of what's happening in shikantaza actually undermines or even hinders it entirely.

Whereas other practices have a form (verb) that seems to (causally seek to) produce an obvious content (noun) – such as knitting (garments); golf (balls in holes); sculpture (traditionally, a tangible object of some kind) – shikantaza is arguably sheer form, with no nominal content, even incidentally, as a recognised outcome. A certain ilk of Zen practitioner, when they want to be really infuriating, will constantly interrupt talk of the 'benefits' of practising shikantaza (and, of course, it is annoying because there do exist so-called spin-offs). Despite being no fun at parties, if one is seeking rigorous engagement with the thought of practising, this caution regarding instrumentalising sitting is technically astute and tends to support more sustained practising.

In Dogen's version (above), the practitioner also sways from side to side, in order to find a stable centre for the torso, and then the body stills. This, however, is less of a 'doing' than a getting-ready or arranging of the body, before the practising begins. It is a pre-action to the stranger activity of doing (practically) *nothing* – 'just sitting'. The practitioner's action, if there is any at all, is solely to attend to this scaffolding, or to this sheer form, and to cultivate (if this is the right word) a kind of disinterest or equanimity as to any (mental or physical) content which might arise.

It is not, therefore, that there is content to be discovered that is hidden from the neophyte. Shikantaza, as practice, is not esoteric in this way. It is simply that there is no content that is relevant, or – to put it more philosophically – any content exists in a subtractive relation to the practising itself.[28] The latter has no position on the kinds of contents that might

[28] Alain Badiou has helped clarify the difference between negation, destruction and subtraction. See his most accessible talk on the issue, from European Graduate School talks (2007), available at https://www.youtube.com/watch?v=4UD0EvkOvKc (last accessed 10 February 2021), or web search: 'Badiou EGS Subtraction, Negation'.

inhabit its form. Another way to say this is that in shikantaza, there is an attending to *the field in which* content(s) will arise, not to the contents themselves. Its actions pertain only to cultivating that field, or maintaining it, not to coercing or curating any particular contents. The content, to borrow from a Deleuzian vocabulary, is not relevant due to its operating necessarily at the level of generality and particulars. Whether I constantly think of what to cook for dinner or have an image of stabbing the person at the supermarket with a fork or fantasise the restfulness that might or might not accompany a week's holiday, all of this constitutes a mere stream of particulars, none of any singular interest.[29] They are all, also, very recognisable. To echo Deleuze, this is unlikely to be any kind of real thought. It can be considered just the innocuous secretions of the cognitive function.[30] These are to be included, not demeaned nor overvalued.

This is one way to understand Dogen's instruction of non-thinking. Shikantaza is not busy with content, and also has no argument with any particular content. Whatever content inevitably inhabits its structure (the heart's pumping, the brain/body's generating of countless images, ripples of sensation, and so on) is simply without import, neither aimed for, nor evaded or repressed. Some teachers, in order to impress very clearly on their students that all content is fine, will humorously celebrate every content, and with radical undiscernment: *So, you imagined murdering your ageing mother. Great! Fine. So you pondered leaving your marriage for the millionth time. Great! No problem. So, you planned an entire meal and budgeted for it, and then fantasised a fight with the guest that you secretly desire. Great! Nothing unusual. So you worried and worried and worried about your job security. Wonderful! All good and very ordinary.* And so on. This is one style of the pedagogy of the practice itself, and there are others.[31]

It is this combination of neither encouraged/nor forbidden that can be

[29] There is a way that psychoanalysis also reads beyond such particulars, while also not discounting them. A very specific parsing of detail, with clear emphasis on *structural* repetitions and anomalies, are arguable spaces of overlap of the two fields of inquiry.

[30] They are innocuous insofar as they 'do' nothing, technically. What we can do with them, however, as Sen-Gupta notes, is to allow them to activate us too much, and then they begin to have real effects in the world. Sen-Gupta, *The Heart of Practice*, p. 26.

[31] And it is not to say that the surfacing of these preoccupations is not also able to inform actions or decisions off the cushion at a later time. To always worry about an employment situation can signal that dealing with it could be a wise direction. This use or otherwise of the content thrown up by the sitting bears little relation to shikantaza's more ontologically interesting mechanisms.

maddening for newer students, who – without some sense of the rubric for failing or succeeding at shikantaza – may find the whole business deeply uneasy. For others (and in Zen, this 'other' might be yourself at any moment), the lack of stipulation might also manage to function as a gate of 'ease and joy', as the texts say. Of course, this lack of interest in content can be a source of disappointment, too, for ambitious beginners who are drawn by the reputation of meditation as means to open themselves to psychic phenomena. For the purposes of zazen, lights and explosions, dark nightmares (called *Makyo*), or epiphanies of any kind, are also completely irrelevant. The teacher will steadily show no interest in such tales,[32] which are likely to be viewed as noisy, benign enough and unrelated to the practising going on in shikantaza. Similarly, although the practice may have various impacts on the practitioner's psyche, it does not have any explicit psychological inflection or agenda. (I've noted that among established practitioners, any co-opting of shikantaza for stress relief or wellness is usually viewed with disinterest, or in some cases, concern. It does indeed miss the point.)

Shikantaza, furthermore, usually arrives in the English solely in the shape of a qualified gerund. In 'just sitting', a space is established, or its scaffolding, within which action will tend towards a pure intransitive verb. This starts to clarify our first criterion, namely, that practising – as distilled through the lens of this exemplary form – is a mode of action or behaviour initially to be defined in structural (rather than content-focused) terms. In its indifference to *what* happens (or to what is produced), it grooms an environment or context in which one might be able to observe, or derive *nothing*'s generation taking place. The representational silence that attends the producing-of-nothing arguably leaves the verb alone to operate unadorned. This would be the *how* that practising brings out of solution, in its suitedness as a laboratory for processes, and for processes subtending processes.

The whittling down to a sheer form, as the quote at the start of this chapter implies, is not for itself, but rather for its potential to expose the operations proper at work in activity itself; that is, in activity per se, not activities as we might (ontically) inventory them. We glimpse something of this in the important passages in 'The Image of Thought' chapter in *Difference and Repetition*, where Deleuze is at pains to account for the distinction – of register and in kind – between *sensing* and the *sensible*. His prose turns and turns, trying to prise his reader's mind away from the register of representation and its habitual approaches. His account, I contend, runs parallel to what we are

[32] This lack of interest in epiphanies can also be a hallmark of psychoanalytic practice.

trying to emphasise just now, regarding that with which practising concerns itself:

> It is not a sensible being but the being *of* the sensible. It is not the given but that by which the given is given. It is therefore in a certain sense the imperceptible [*insensible*]. It is imperceptible precisely from the point of view of recognition [. . .] (DR 176, emphasis original)

As instructions in shikantaza are whittled to their pure minimum, *the fact of form's operation* is highlighted, rather than any particular case of form. This is why I argue that shikantaza gets us as close as possible, in an empirical way, to being able to observe this very operation operating. It also accounts for why many practices might be able to inflect as practising, despite their apparently unrelated content and traditions, varying styles and preoccupations. Underlying the external differences-between, on the level of representation, there is a more profound cultivation of a context in which we might – I use the next verbs cautiously – suspect, intimate, 'access' the subtending moving that is differentiation,[33] or that what our lives and selves *contract* (or form themselves from) are squalls of intensities.

In a sense, the content of shikantaza is both nothing and everything. It is, in this way, resolutely *non*-discerning. This 'non' is not a negating prefix here. Shikantaza arguably pertains to a register prior to quality as such, or rather *is* that register wherein quality per se finds its genesis. ('The negation no longer expresses anything negative', DR 155.) It cannot then be accounted for via any list of qualities, and the usual activities of judgement and oppositional logic are extraneous to it. As mentioned, the student of shikantaza can find this infuriating. I do not say this lightly, or at the student's expense. It can often be painful, unmooring and disturbing. For me, this casts some light on the notably vehement vocabulary in Deleuze's prose in chapter III of *Difference and Repetition*. He writes of the 'violence of that which forces thought' (DR 177) (and indeed uses the term 'violence' no less than sixteen times in that chapter); he employs the term 'shock' (DR 168) and speaks of what 'perplexes' the soul (DR 176) and of 'rigorous struggle' (DR 167). Repeated reading of this chapter can tend to bring this tone strongly into focus, and one wonders about Deleuze's own frustration or impatience (with voluntary, good-natured thought? with representation's shackles?) and simply whether his urge was to nudge any residual complacency from the

[33] For more on Deleuze's distinction between 'differentiation' and 'differenciation', see DR 258; and Lundy, 'Tracking the Triple Form of Difference'.

reader, to drive home how strange, almost horrifying – sublime, too – this dip below the surface of representation's rule can be.

A student of shikantaza, a serious one, can find themselves in the indiscernible atmosphere that flickers within Dogen's rather inviting and reassuring 'gate of ease and joy', and the practice's intrinsic operations, which are at the very least uneasy, if not almost alien, and wholly of another register. As a student of mine once astutely noted, in a yoga class that involved shikantaza practice at the start, it is the ease and joy specifically that constitute the uneasy encounters of 'just sitting'. Ease and joy render nonsensical our usual modes of striving and means-to-ends thinking. They set wobbling the very operations that affirm our self, as a certain kind of apparently 'enduring' self.

It is never clear with shikantaza what standards would indicate improvement, or what might indicate a student's adequacy. Given that most of our actions are invested in forms of improvement-as-motivation (for undertaking or persevering in action), shikantaza can appear intentionally or perversely confounding. It isn't. However, with its emphasis on verb-ness and on that-which-constitutes-category, rather than on measurable standards, approbated feeling sets, recommended thoughts – in other words, much of the content of moral law – it bears scant relation to the bulk of that with which we are typically preoccupied.

Returning to the centrality of structure for practising's criteria – or *the fact of form's operating* – in the fourth chapter of *Difference and Repetition*, Deleuze states unambiguously: 'The reality of the virtual is structure' (DR 260). The notion of the virtual is a complex aspect of Deleuzian scholarship, and we do not have space here to enter into its discussion in an exhaustive way. We can say that Deleuze is clear that the virtual is thoroughly *real* (DR 260).[34] Shortly after this quote, using the work of art as an example, he elaborates:

> When it is claimed that works of art are immersed in a virtuality, what is being invoked is not some confused determination but the completely determined structure formed by its genetic differential elements, its 'vir-

[34] Lundy offers a helpful summary of the difference between the virtual and the possible in his article 'Tracking the Triple Form of Difference', p. 181: 'the virtual does not need to be realised, since it is already real. Instead, the virtual becomes *actualised*. The virtual cannot proceed by eliminating the possibilities before it, for the virtual and the actual do not 'resemble' one another as was the case with the possible and the real – the actual that is actualised is not simply the same shape as the virtual it was, with actuality added to it. The process of actualisation is rather one of *differenciation*, whereby a virtual unity diverges along different lines. Difference, as opposed to the resemblance of identities, is thus primary in the process of actualisation.'

tual' or 'embryonic' elements. The elements, varieties of relations and sin-gular points coexist in the work or the object, in the virtual part of the work or object, *without it being possible to designate a point of view privileged over others, a centre which would unify the other centres.* (DR 260, emphasis added)

The virtual will be a register, arguably, in which it is not possible to desig-nate one point of view over others, or any privileged centre. This recalls that peculiar stance that I am tentatively framing with the term 'non-discerning', and which I'd claim operates for the duration of the shikantaza practice, in principle. Deleuze's depiction of what constitutes the virtual involves a sub-traction of the usual mechanisms that tend towards a privileging of a point of view, an operation also necessary for the articulation – or actualisation – of selves. To practise non-discerning, a certain beyond-of-perspective might arise (echoing the 'beyond' of Dogen's translation). For the duration of the practising, a centre is not prioritised (and if a prioritising arises, then that is not prioritised, and so on). In the process of this strange action, accom-plished initially by a subject, the latter begins to undo or thin out the very stuff or mechanisms of its own subjectivity.

This clearly calls to mind the Buddhist principle of *anatta* – non-self.[35] If the bounded self is partly constituted through repeated actions of adopt-ing a 'position on' and 'attitude in relation to' the world, and via habitual activities, then there is some weight to claiming an alignment between what shikantaza's field of operation rehearses and Deleuze's virtual. In shikantaza, then, the usual activity of a separate self-*ing* is suspended, muted and diluted for a period of time.[36] With content thus de-emphasised, structure itself serves as sole content, and there can emerge a kind of temporarily dispersed point of view. Abstaining from any assertion of the unique perspective of a global self, shikantaza serves as theatre for, and as-if accessing, the vir-tual register as explored by Deleuze. (And as Lundy emphasises: the virtual doesn't do anything.[37]) Shikantaza, then, might also offer one avenue for investigating this register further, and experientially.[38]

[35] Also on this question, see the article by Carlisle, 'Becoming and Un-becoming'.

[36] 'For a period of time' here seeks to emphasise that, for most practitioners, this is not a sustained state but rather a useful or revealing mode. *Anatta* can have problematic repercussions if misread and when muddled with modes of conservative gender, racial, ability or sexual politics and socialisations.

[37] Lundy, 'Tracking the Triple Form of Difference', p. 183.

[38] This reflects what is sometimes termed a 'practice-led' research, that reflects aspects of the investigations of this book. It echoes Ravaisson's assertion, at first rather strange-seeming, that habit is a method – *Of Habit*, p. 59.

If practising is that unusual (but not rare) mode of doing or way of approaching activity, which has, as a consequence, an undoing of the doer or the 'personality' as well as a dispersing of point of view, it also recalls Deleuze's framing of the virtual as the plane of the problematic proper. It is on this plane that Ideas feature, generating their cases of actualisation, solutions and the shadows of the problems – the so-called negative (DR 259–60). The plane itself is structural and generative. It is not constituted by negativities or oppositions, and analogies and resemblance make no sense there; rather it operates as the site of the genesis of all of them.[39] This, as Roffe emphasises, is where Deleuze both engages and moves beyond Kant. Where Ideas in Kant are primarily regulative, in Deleuze's differential and genetic ontology they are constitutive (WGD 195) – that is to say: *creative*.

It is important, in an arguably post-liberal moment, to make clear for the case of shikantaza that this making transparent of the processes out of which *selves* arise is not particularly a cavalier exercise. The practitioner does her research for the periods of sitting, and then returns to a world in which there most definitely are various kinds of fixed and more fluid subjectivities, and one which – for the most part – believes in the latter's logical priority. The practitioner, then, is someone who is aware of the stickiness of the habits of 'selfing', as well as the gravity of dismantling 'selves'. The practitioner may be someone who, due to their intensive research, has more reverence for how selves come to be, rather than a more adolescent-like urge to cast off selfness in a reckless way. Torture, as an example of concerted labour to dismantle another's selfhood, bears no relation to enlightenment. Deconstruction, as discussed, is of a different order to destruction or disavowal.

Practising, then, can be spotted when a set of structured and benign actions operate intransitively – they have as their secret intention, which is their technique, only the carrying-out of these actions. In life, mostly our actions are framed as *for*-something. Normal behaviours start to tilt towards practising when the activity as sheer verb begins to eclipse the reputed benefits or outcomes of the material practice.

A layer of the intentionality of practising, and of criterion 1, pertains to the acquisition in the first place of the form that will constitute the practice. Practising may happen with respect to a form or a practice, which often appears as a habit, that we have either intentionally *acquired* (say, fencing), or inadvertently *contracted* (say, a tendency to clean the house thoroughly, perhaps learned from family).

[39] See Lundy, 'Tracking the Triple Form of Difference', p. 177.

Shikantaza, stipulated as 'exemplary form', could be expressed as *doing nothing on purpose*. This renders it minimally different from doing nothing incidentally, or 'not doing enough' (which in most cases is a cultural fiction). This difference, furthermore, only *makes a difference* in terms of the framing itself (in this case, the posture, etc.).

It will be the fact that practices have a consistent form, and not the particular form of any practice, that will matter in terms of practising. This formal aspect will make feasible the inflecting of the practices of golf, gardening, cooking, ceramics, and so on, as practising and therefore at once non-precluding of transformation and, at once, stabilising.

What Dogen and his lineage seemed to notice and to emphasise was the importance of the attitude brought to practising (in order to inflect it *as* practising). Zen is notorious for this seemingly counter-intuitive aspect, whereby it is crucial that one *not* aim for what *might* unfold. Any (particular) thing that unfolds is irrelevant to the practising aspect of the practice, and we will learn more about this in criterion 3.

The structural requirement of the first criterion – a shape for doing – is that which, at the level of recognition, remains somewhat consistent, enabling the practice (and its practising) to be identified, from the outside, as happening over time. The form will become that-which-will-be-repeated in the second criterion, and this will be the first of the instances of repetition that constitutes practising.[40]

The Second Criterion: Intentional Repetition

We recognise a golfer, because they repeatedly play games of golf and work on various details of its craft. We recognise a swimmer because they swim more regularly than on the odd occasion. We recognise a scholar because they tend to put aside time to read books, and to read them again. Within the register of representation, the consistency and repeated nature of a person's engagement with an activity or practice tends to mark that person as a 'doer' of that thing.

As with the first criterion, there is nothing so unusual about having a skill or an identifiable activity, and then – second criterion – repeating it intentionally. In the case of shikantaza, the relation of the first to the second moment of practising is clear. Someone who 'does zazen' is someone who has decided on, and who is attempting to adhere to, a schedule of sitting – daily,

[40] As we'll see, there is a subsequent repetition, and it will bring us to Deleuze's provocative formulation that the future coincides with 'that which is repeated' – DR 117.

every second day, a longer session once a week, and so on. Said from the other side, a practice can't tilt into practising unless it gets intentionally repeated. This is why a practice that overtakes a person compulsively or routinely won't coincide with practising per se – although it may finally open out to that. It will, mostly, just be a routine with a lot of tenacity, which isn't necessarily undesirable or unpleasant but may be both. We will discuss this more in later chapters.

Repeated behaviours, intentionality, compulsion and routine all point towards a need to examine the notion of habit, which we will do in the next chapter and specifically in relation to Ravaisson's writing on this question and that of his more recent readers. Suffice to say here, shikantaza could be framed, after Ravaisson, as intentionally cultivating the habit of doing nothing, with the result of making visible, or sensible, or perceptible, the subtending mechanisms that mark habit in its quotidian guises. This, I'd argue, will also make shikantaza – as strange kind of intentionally contracted habit – a site or method of ontological investigation. Through the observation of habit's operations and 'what' it does, we tend also to come across or intercept the *hows* of Being itself, of other beings, of our selves at various registers of arising and disappearing. Shikantaza, then, might have one aim and one only: to research indirectly, but also concretely and strategically, the operations constituting Being and Becoming.

Repetition is crucial, even in its first instance as the second criterion (before the fourth criterion takes it up a notch again), because practising – as we'll see – depends on the set of structured, consistent actions being of a kind that can be repeated, and each time 'closer to itself'. This is the miracle, as Deleuze will phrase it, of repetition for itself (DR 3). In the first instance of repetition, we set repetition going – normal repetition (not miraculous yet) and necessary; we get the laboratory of usual repetition going intentionally, so we can start to observe and know intimately these hidden operations that *condemn us to change* (DR 2). This at once distinguishes practising from habit, as well as accounting for the latter's inclusion in practising, which reinflects its operation by accompanying it closely. In practising, habit (and its repetitions) will become other to itself, insofar as that which habit 'makes present' and represents will drop away as content, so as to reveal habit's temporal mechanisms or a sheer dynamism. In a helpful passage in *Difference and Repetition*'s 'Introduction', Deleuze clarifies the order of these repetitions that are native to habit and to practising, respectively:

> One could try to assimilate these two repetitions by saying that the difference between the first and the second is only a matter of change in the

content of the concept, or of the figure being articulated differently, but this would be to fail to recognise the respective order of each repetition. For in the dynamic order there is no representative concept, nor any figure represented in a pre-existing space. There is an Idea, and a pure dynamism which creates a corresponding space. (DR 23)

As we'll see as we proceed, and reflected in the above quote, practising has the peculiar spin-off of being constitutive of, or a genesis for, what can affectively feel like space. Furthermore, contrary to any common-sense notion or expectation with regard to habit and its repetitions, what we learn is that practising's potential to unleash something new, to leave behind established patterns, and to unsettle and recast the status quo, is not in spite of, but rather intimately bound up with the miraculous operations of a certain other repetition, one that inhabits normal repetition or the bare repetition of the Same. Deleuze, at various points, considers bare and *clothed* repetitions (DR 19–22), noting the healing power of the latter.

In chapter II of *Difference and Repetition*, he explains – in terms of difference and repetition – the movement of habit: 'Habit *draws* something new from repetition – namely, difference. [. . .] In essence, habit is contraction' (DR 94, emphasis original). The contraction of which he speaks here is that of the discontinuous 'instants' (or *intensities*) that only knit together to form a 'present' when collected (or 'contracted') in what can be deemed the first *passive synthesis of time*. I find it helpful, myself, to read 'synthesis' here in the explicit sense of bringing elements or cases together in order to constitute something else, something new, and not always something that would appear transparently to be derived from its parts. The 'present' then is that which is stitched from discontinuity; it is continuity – in fact – drawn from a 'take' or perspective on discontinuity, a 'take' or holding-together that Deleuze will tell us occurs *in the mind* but is not done *by the mind* – hence its passivity as a synthesis.

Deleuze will explain that this synthesis produces what we experience as the 'living present', and that, as mode of temporality, it pertains to the habits that we *are*. He writes that '[i]t is simultaneously through contraction that we are habits, but through contemplation that we contract' (DR 95). Instantaneous 'moments', which cannot in themselves repeat, come to constitute repetition (which will turn out to be the very *difference* that is *drawn* from them) within the imagination of a contemplating subject. This 'subject' is not to be simplistically conflated with a discrete human entity, in any way. In the space of the 'imagination', one case can be retained 'as the other appears' (DR 90–1), effectively synthesising 'something' out of that

which was too discontinuous to be a thing or things (as Roffe notes, that upon which contraction operates will be sheer intensities – WGD 221). 'The imagination,' Deleuze clarifies, 'is defined here as a contractile power: like a sensitive plate' (DR 90).

To return to our consideration of shikantaza, as exemplary example of practice and one which sits liminally on the threshold of practising itself, we note that Deleuze is using expressions to name a kind of operation-without-operator. He coaxes our thinking towards the idea of pure operation, whereby 'we' (or any kind of selves) are instantiated. *Through contemplation we contract into the habits that we are*; as condition for the possibility of any genitive mode, this contemplation cannot be *ours* per se. Perhaps it can be clarifying to understand this contemplation as a 'coming into view', as a 'being-gathered' into a perspective – or the possibility of perspective itself.

The use of the term 'contemplation' begs the question of whether Deleuze intends any kind of 'spiritual' or devotional timbre to his examples. His quoting of Samuel Butler (below) might suggest he isn't expressly avoiding such an association. One wonders whether he allows this flavour into his examples due to the fact that, irrespective of religious overtones and their entanglement with moral law, there endures a mode which might be invited by devotional practices which doesn't preclude closer encounters with these very operations that constitute the self.

In any case, the practising with which the present book is concerned distinguishes itself from lay understandings both of routine and of compulsion, through its intentional mobilising of habit which renders the latter no longer merely habit. One way to frame the strategies of practising is that they involve the acquisition (and arguably the sustained intention of continually acquiring more thoroughly the habit anew), rather than the pursuit of the material benefits, of the habit itself. The *goals* of habitually acquired behaviours, in other words (a good golf swing, health, a thriving vegetable patch, staying on the surfboard elegantly, and so on), tend, in a daily register, to obscure the means which habit itself, as mode, puts to work.

Instead of habit finding us, like a virus that we unknowingly contract (the gait of our parents, our subculture's turns of phrase, the ability to drive while drinking a coffee), in practising we tend to find and contract the habit on purpose, thereby complicating its usual logic. Routine and compulsion correspond more to habit's regular guises, and the directions in which it tends to express itself if left to run wild – that is, either towards something deadening, or towards something that compels and drives us (often over-valued in the current moment). We are constituted, then, in the mode of the living present, by a cocktail of habitual routines and compulsions. Practising might

be a way to speak about those moments whereby we would be somewhat less constituted by these operations. This 'less' means that our 'selves' are unstitched a little; our 'weave' becomes more open, and hence other modes and possibilities can slip in.

To summarise the second criterion of practising:

- The intentional repetition of an acquired set of behaviours (the practice or the content of the habit) which is then consistently enough performed, and regularly, over an extended period of time.

As we can now see, the first two criteria together coincide with practising's habitual moment. For the purposes of practising, however, this habitual shape and regularity of repetition is inflected via a less usual intentionality in a way that exceeds, or departs from, habit's simple mode. This renders habit strange (or more explicit) to itself.

In the next section, we meet the final two criteria: *relaxation* and *repeating repetition*. These serve to ramify the reinflection of habit initiated in the first two and to raise their mechanisms to another power. To get there, we will return briefly to the exemplary practice of shikantaza and explore how it operates as more-and-less than habit, and how this opens us onto the final two criteria.

Less and More than Habit

... that which is hard is never hard without also being soft, since it is inseparable from a becoming or a relation which includes the opposite within it [. . .] The sign or point of departure *for that which forces thought is thus the coexistence of contraries*, the coexistence of more and less in an unlimited qualitative becoming.

Deleuze, *Difference and Repetition*, p. 178 (emphasis added)

In the mode we are calling 'practising', the particular habit-as-practice – having been acquired and continually acquired – is then able to be repeated. This repetition is done in such a way that *difference in identity* is not-pursued: that is, we try to repeat the habit without excess or alteration. We try to abstain from using the practice to 'better ourselves' through the repetition. That is, as well as other agendas which may dominate, insist or fade out at times, we also purposely do not attempt to mobilise the habit to effect innovation or variation. Shikantaza is amenable to this approach, since it promises nothing much. You are just sitting there.

We try to repeat the habit's shape very precisely (which has nothing to do with 'perfectly' – an outside measure, reliant upon representation). We whittle away any extraneous content and effort, any striving or other more quotidian ways of approaching doing (doing a thing *for* something else). *It gets ordinary.* This whittling down works to reveal – more and more explicitly – a bare structure and the verb. The latter is then left to work, exposed almost, and subtracted from that which normally accompanies a verb in the usual orders of temporality and regimes of identity. Normal verbs come with a subject (who performs the action) and a specified temporal mode, which determines the way the verb will be conjugated. This all ensures that it is pinned down in space and time or chronotopically (except for the infinitive and participial forms, about which Deleuze has written extensively[41]). What repeats in the case of practising – and in shikantaza most obviously – is arguably sheer verb. To put it in Deleuzian terms: it involves almost retro-accessing something closer to the virtual register, that which has not yet differenciated into the actual, and then 'dwelling' there.

A certain newness cannot arrive in the living present for the precise reason that the version of 'future' native to habit's register does not, as we'll see in the coming chapters, involve radical openness – or Dogen's 'dropping away'. It pertains rather only to prediction or anticipation, sketched from the template of what already exists. The living present of habit is the wrong mode of time in which to try to access the future. Hence, we must 'try' otherwise and differently. My practising would have to involve the intentionality of repeating – strangely – my current, available tendency, my current thinking, my current patterns (clumsy but also beautiful enough) *exactly as they are.* I would need to repeat them as themselves, in order to open to an order in which to actively forget them.

There is much within Zen literature that confirms this kind of counter-intuitive approach to action: exhortation to 'become oneself'; the frog as figure who never *doesn't coincide* with its own nature and thusness, which itself implies a kind of steadiness in non-coinciding;[42] the practice of being exactly in one's place (the 'middle'), in order to bypass the inertia of the living present, which carries us along through harrowing changeless change. Such pedagogical manoeuvres may have become stale as a result of

[41] For example, see chapter III of *Difference and Repetition*, p. 194; and Deleuze, *The Logic of Sense*, more generally.

[42] See also the (perhaps) most famous poem in Japan, Basho's haiku: 'the old pond – / a frog jumps in, / sound of water' (Robert Hass, trans). Available at www.bopsecrets.org/gateway/passages/basho-frog.htm (last accessed 10 February 2021).

New Age or corporate bludgeoning, but there is ontological nous among the poetics. In 'just sitting', relieved of all aims and templates for subjectivity, the repetitive mechanisms that constitute the self-as-representation in each instant are left to chug along, rendered more transparent thanks to the de-emphasis on content that shikantaza involves.

Towards the end of *Difference and Repetition*, in his notoriously brilliant and difficult chapter that discusses the virtual, 'Ideas and the Synthesis of Difference', Deleuze writes: 'it is thought that must explore the virtual down to the ground of its repetitions' (DR 273).

How would anyone do this, and what kind of 'thought' is suitable for the task? Dogen's beyond-thinking? And why this imperative to explore it? Without second-guessing Deleuze, what comes to mind is the (political) urgency of finding opportunities to affirm that there is something other than a certain kind of change – to find the quiet centre, without annihilation, the wormhole – along with a companion desire to build our stabilities on something other than regimes of identity (which always exclude, even as they purport to determine 'inclusion'). Would that be, then, on regimes of praxis? To broaden, thicken or multiply the kinds of change to which we have access? To staunch or thin out our depleting addictions for changes that are mere alterations in the register of the stultifying Same – another streaming service, a different luggage solution, another combination of sugar and trans fats, another sexual identity or partner, a 'new' political allegiance . . . and so on)? We can seem doomed to shunting through usual 'difference' in the register of representation and its generalities. Note, the shunting in and of itself isn't necessarily awful – it is the stuff of a normal, probably often good-enough, life – however it becomes insidious when it remains as the only kind of movement available; when it becomes compulsory and/or totalising, or when we place a faith in it that is not ontologically justified. *I will just have eaten a modification of that other burger; I won't via this act become a new person.*

Thus, shortly after the passage quoted above, we read the following:

> Repetition is everywhere [. . .] in the Idea to begin with, and it runs through the varieties of relations and the distribution of singular points. It also determines the reproductions of space and time, as it does the reprises of consciousness [. . .] Repetition is never explained by the form of identity in the concept, nor by the similar in representation. (DR 273)

To my reading, what these two quotations confirm is that repetition for Deleuze has ontological significance as *operation* (it 'determines the reproductions of space and time'). If practising is a mode of action that doesn't

preclude breaks[43] in the chains of continuous change, in the fabric of the status quo, and additionally if it has a stabilising effect on our relation to the latter, I see it – by necessity – as operating at another, less ontic, register. If the virtual, for Deleuze, is real, but not actual, and it is in tandem with this register that actuality is 'generated' (to put it simply for now), then practising is the doorway to the unrepresentable but very real mechanisms that subtend our seeming identities and worlds. If we are habits, then it may be that via habit, but one of a strange kind, we may reverse engineer that through which our global and larval selves are made – not so as to destroy ourselves in a tantrum, but to manoeuvre more delicately within the register of appearance. This is another way of putting Ravaisson's suggestion that habit (or a nuanced mode of it that warrants disambiguation) reveals something crucial about how being is.

Shikantaza, in this way, helps us to think practising per se, since it works as a more transparent and exemplary kind of laboratory for observing the criteria of practising at work and unadorned, or with less distracting content and 'products'. In 'just sitting', as more and less than a usual habit, there is an explicit structural requirement – a minimal 'doing' – that is a sheer scaffolding with almost no content at all. This scaffolding, then, is of the kind that admits of repetition (of its designated intervals of time), and indeed reinflects as practising when it is then – after being intentionally acquired or in some instances simply 'contracted' – repeated intentionally. This habitual couple of structure and repetition are, then, as if 'raised to another power' via the final two criteria, whose content is even less material again than that of the first two. They take us towards a more precise accounting for the strangeness of what practising both cultivates and unleashes.

The Third Criterion: Relaxation

In lived life, arrays of sets of behaviours (i.e. practices) that would be ripe for inflecting as practising can tend to unfold mostly within the orders of compulsion or routine. However, at other moments, these same forms and repetitions can stray into alignment with the criteria of practising's mode. In these moments, which resist tight curation to a large degree, an aptitude for interrupting usual orders and moral law (DR 8) is strong. It is for this reason that practising also includes those very moments in which practising itself is not quite operating. The later criteria – 3 and 4 – are so slippery that it is

[43] On this notion of the break, or for yogic purposes the *kumbhaka* of pranayama practice, see Pont, 'That Tender Discipline'.

more a case of passing through them, as regions of probability, almost, than of being able to maintain them unwaveringly. Becoming steady in them, indeed, is the hallmark of established practising.

Believing that they must immediately operate steadily, many would-be practitioners are discouraged from playing in practising's field, or they judge themselves or their efforts by criteria that are foreign to practising. After decades of almost-practising, a kind of stability *in* practising, of a consistency within the criteria (as opposed to just showing up and doing the action, which constitutes practising's habitual half), becomes feasible.

In the case of shikantaza, the Zen practitioner must form a clear, if strange, intention: to engage with the set of behaviours (see list above) and repeatedly, and to decide in advance that she will do this, and this despite the fact that the behaviour explicitly produces *no outcome at all*. That is, it is utterly divorced from *poiesis*, or making (in the moment of 'doing' it). The 'in advance' might be seconds or minutes before beginning, although more common with established practitioners would be an intention formulated with a very long-term view. (It calls to mind what philosopher Alain Badiou has termed 'fidelity', which marks his account of a truth procedure. I will not explore this now, but for readers of Badiou, it may assist with thinking the flavour of this kind of intentionality, one that forgoes reliance on transcendent registers.[44])

We saw that the operation of intention in both the first and second criteria, the very same intention at work in shikantaza, marks the point where practising distinguishes itself (minimally) from habit, by enacting habit's typical mechanisms *on purpose*. The two – habit and practising – part ways due to the intense accompanying that the latter enacts on the former. It is an accompanying that takes place by inflecting intention in a precise way. The third criterion, then, extends the role of the application of intention. Where the first criterion involves the intention to repeat the structured behaviour or discrete practice, the third involves the further intention of *reducing effort to a minimum, to the apt amount, without collapsing*. We give this criterion the shorthand of 'relaxation'.

A helpful and more general definition of relaxation is: expending only the force necessary for a given action, no more or less. In order to practise relaxation, as principle of action, there is necessarily a continual process of trial and error, since sensing the precise amount of effort usually involves falling short or overshooting the mark. In shikantaza, the principle of relaxation,

[44] For a summary, see Meillassoux, 'History and Event in Alain Badiou', or Badiou, *Logics of Worlds*, p. 69ff.

as principle of movement, is operating within the very definition of the practice itself. 'Just sitting', as someone once clarified for me, is a *physical* practice, insofar as it involves reducing effort and extraneous activity to a minimum, in order that everything except 'just sitting' falls away. The qualifying term of shikantaza expressly references the third criterion: *just*. If there were any goal at all, it could only be to sit simply, without extras, without attempting to add to, or to collapse, the practice itself.

An interesting question – that reverses the approach – is why would we *ever* do anything more than was necessary for the actions we undertake in a life? It is common to label humans as lazy; however, if this term carried any weight (which I don't think it does in its common-sense uses[45]), wouldn't it make sense that we would conserve (or withhold) effort at every opportunity? Wouldn't our entrenched laziness motivate us, as humans, to work out ways to do less? This does not seem to be the norm, and even less so in a neoliberal moment. Instead, constant and extravagant activity marks most of what we do and *how* we do it, counter-balanced with phases of collapse, sometimes called burn-out, sometimes conspicuous leisure.[46] The reason that shikantaza can be unsettling for a beginner is that it asks her to do very little, almost nothing. It offers the most explicit opportunity for nuanced laziness. From this invitation, many run screaming.

This is, of course, not the whole story. Exerting imprecise amounts of (often excess) effort is also, in fact, *habitual*. At the same time, habit's mechanism can (though not always) entail the reduction of effort, as a kind of organic effect – tracked by Ravaisson and others – tending towards more and more automatic capacity for the action. The effort in habitual effort can be deemed *natural*: the imprecise amount that comes without noticing. Noticing is a crucial aspect of relaxation, and effort then functions otherwise. This *noticing*, as we'll see too, is itself an effort. In the yogic texts and commentaries, it is sometimes framed as the effort required to reduce or release the habitual or 'natural' effort. For an activity to inflect as practising, this third criterion will be operating. It consists of the intention to observe and thereby to invite the possibility of extraneous effort falling away, of noticing effort and our relation to it.[47] Relaxation, too, operates *asymptoti-*

[45] On the questions of laziness, see Pont, in Attiwill et al., *Practising with Deleuze*, pp. 31–3.

[46] On this question, Han has a number of interesting things to say: Han, *Müdigkeitsgesellschaft Burnoutgesellschaft Hochzeit*.

[47] I'm also grateful to colleague Dr Rose Woodcock, whose work on *just*-noticing, stopping short of noticing-*that*, brings up experientially the moment before the impulse, the 'natural effort' of naming, kicks in.

cally. We approach minimal effort; we are on the lookout for excess effort of energy expended in – for example – disappointment, self-judgement, opinionating, the firming of resolve (*I'll do it better next time* . . .). All of these may well be unnecessary. We go looking.

In this way, relaxation as criterion is strange and often frustrating, although it offers us a kind of unusual pleasantness when taken up sincerely, but also not too earnestly. By this, I mean that it also involves the inevitability of failing and invites that we practise our relaxation also in relation to that. What relaxing entails, from experience, is easier with humour.

We practise relaxation to the letter, which means at every level, which means no additional, particularised content, including assessments of better or worse. This takes us back to the non-discernment raised before. The activity of assessing failure and success of any stipulated content is itself extraneous to practising. This means that we decide to practise, and to work with the criterion of relaxation, but we do so without investment in whether we succeed or fail at this aspect. The question is always: *a little more or a little less effort, or differently?*, and not: *did I do well or badly in relation to this effort question?* This can seem a very awkward way to formulate an intention. As such, however, it folds itself on itself, rather than moving forward in a line. In Chapter 4 we will look closely at its mechanism along with instances of it in various practices, so as finally to see how it dovetails with the final criterion: repeating repetition.

The Fourth Criterion: Repeating Repetition

Shikantaza has been, so far, our barometer, our exemplary set of behaviours, for exploring the notion of practising more tangibly and for clarifying the criteria that are consistently operating when practising obtains. The criteria – in most examples of lived practices which inflect as practising – operate under the surface and are only surreptitiously at play. Shikantaza, however, in the nakedness of its minimalism, facilitates the coming out of solution of the criteria, and – as I've argued – supports a thinking of practising itself.

In the case of shikantaza, the fourth criterion – which is a difficult one to articulate and to understand – operates insofar as the practitioner whose behaviour is 'just sitting' repeats that behaviour. The sitting, as we mentioned at the start of this chapter, is intransitive, and not *for* or in-the-service-of anything. There is no content to hone or cultivate; the only thing cultivated is the scaffold for *any* (and every) content. Since there is no *excluding* in shikantaza, and almost no terms by which one could assess success and failure, more or less, to exclude anything would be the very excess

that the criterion of relaxation encourages us to drop. The practitioner attends to the context (the body's posture), the sheer verb of sitting, and remains unbusy with anything that might arise as a content of the practice. Since it is usually the content of the stipulated practice that the practitioner in criterion 2 repeats, the repeating of the fourth criterion is subtly *other*. It is the fact of the repeating *repeating* itself. It is where the repetition applies: not to the content (shikantaza has little to speak of anyway) but rather to the *fact of repetition*. What repeats is sheer form, or what endures (repeats) is only that which is able to transform (differ). Repetition doubles itself or cancels itself. I will leave this for discussions in Chapter 5, where we will find – via Deleuze in *Difference and Repetition* – that this mechanism is by no means innocent and has far-reaching consequences for a broader query concerning what practising does and its enmeshment with so-called ontological registers, with time and its movements.

Summary

Practising, possible in relation to a wide range of practices, involves four distinct but ramifying and embedded criteria. The capacity of practising as mode of action to court difference in itself (or transformation outside of the inertias of normal change) as well as a certain register of stability can be accounted for via the combined operating of these four criteria. All of these criteria are at play in *Difference and Repetition*, in terms of difference and repetition as ontological operations, and arguably with regard to Deleuze's own practice: that of thinking and the conditions under which it inflects into the mode of *practising*. This, Deleuze will consider as thought proper. The gravity and power (*puissance*) of what thought can unleash is of the order, more broadly speaking, of what practising in various other modalities entails and how it interrupts and invites generativity and radical newness. As he writes:

> Something in the world forces us to think. This something is an object not of recognition but of a fundamental *encounter*. [. . .] It may be grasped in a range of affective tones: wonder, love, hatred, suffering. In whichever tone, its primary characteristic is that it can only be sensed. In this sense it is opposed to recognition. (DR 176, emphasis original)

Practising is at once *the art of staging encounters* (transformation), and thereby of *cultivating an ability to withstand them and their strangeness* (stability). It can come in as many guises as there are varied, discrete practices. Donning a guise, by taking up a behaviour, is no guarantee that one's staging is 'sound',

nor that the encounter will happen. One can only – via practising – issue a canny, but patient, invitation to the future. Practising isn't accompanied by any single known feeling which would characterise it (its 'range of affective tones') but it does tend to involve, for very precise and ontological reasons tied up with the operations of difference and repetition, four deceptively simple, but astounding criteria.

Via a close reading of the minimal practice of shikantaza from the Soto tradition – 'just sitting' – these criteria, I've argued, reveal themselves as follows: *establishing a set of benign behaviours or 'a practice' | intentional repetition of these behaviours or actions | relaxation | repeating repetition.*

In the next chapter, I take up the first one of these, exploring it alongside Ravaisson's resonant work on the 'method of habit'. We'll look closely at what Deleuze has to say about structure, habit, time and difference, and the latter particularly in relation to his work, in chapter I of *Difference and Repetition*, 'Difference in Itself'.

2

Habit's Time: Between Routine and Compulsion

That a bare and naked *liberum arbitrium* [free will] is a chimera is best seen by the difficulty, the long, long continuous effort, which is necessary merely to get rid of a habit, even if one ever so earnestly has made a resolution.

Kierkegaard, *Journals and Papers* II 1260 (1849)[1]

Here is a simple proposition about practising in relation to habit:

Practising would be a *methodology* whereby a being – whose very continuity within change relies on the mechanisms of habit – might employ these same mechanisms intentionally in order to temper the relentlessness of habit's operations but without sacrificing its accompanying stability.

Like Being, habit can and, perhaps, must be tenacious. Kierkegaard's noting of how hard it is to lose a habit, once acquired, is salient.

Elizabeth Grosz has responded to the nineteenth-century work of Félix Ravaisson by noting that habit 'produces the possibility of stability in a universe in which change is fundamental'.[2] If we didn't have the mechanisms constituted by habit, we would struggle to have any self at all; the capacity to adapt and persevere would elude 'us'; and a sense of a 'present' would be impossible. In its tenacity, however, habit has the tendency to become sedimented. In responding to change, and incorporating those changes, a being can fall foul of that same capacity for adaptation and continuity when habit veers, via its intrinsic logics, towards stuckness, rigidity and pathologies of various kinds.

[1] I am grateful to the work of Clare Carlisle for introducing me to this quote in her 2010 paper, 'Between Freedom and Necessity', p. 123.
[2] Grosz, 'Habit Today', p. 219.

What kind of approach would be capable of tempering such a force, without stemming the latter's potential for grace and stability? It would be an approach, I'd argue, that *knew* habit and, from within that intimacy, experimented with subtracting and adding *nothing* – a methodology, that is, wherein 'life' would modify its relation to its own conditions.

In this chapter, I will argue that practising constitutes this methodology. It introduces a minimal change into habit's logic (itself a way of responding to change) and, without forgoing habit's offerings, mobilises the very operations of habit itself.

By making of habit an intention, practising offers us – as habitual beings composed of 'thousands of habits' (DR 100) – a way to invite a certain kind of change, to *change the way in which we respond to change*, to our exile in its register.

This amounts to making thinkable, and then sayable – as Deleuze has done – another kind of change or that register where *difference is generative*, not adjectival. The conventional thinking of difference – the one that philosophy has tended to recognise while ignoring difference with its own concept – usually aligns with a reshuffling on the register of the Same. Practising, however, although working with differences, also involves that 'difference' which is not dependent on prior identities, the one Deleuze dubbed 'difference in itself' (DR 36ff.).

Practising would be that which courts the radically new (about which we'll say more shortly), and creativity as such, in a context that is steady (and steadied enough by practising) to withstand the process of transformation, or the arrival of the unexpected. Practising intercepts the ways in which habit's usual mechanisms can end up expressing themselves – for example, as dulled routine, gruelling compulsion, the reinforcing 'loops' of sickness. Instead, it opens a pathway for the practitioner to subtract themselves from these modes, modes from which joy is often precluded and harm can result.

Practising, I'd argue, constitutes the systematic way that a being can extricate itself from the habits of habit, or at least render an entanglement with the latter (and *as* it) more nuanced, neither because habit is undesirable as such, nor because it coincides with that which 'reduces the human to the order of the mechanical' (this, as Grosz notes, was primarily the attitude taken by a lineage of thinkers stretching from Descartes, through Kant, to Sartre[3]). Instead, we might wish to temper habit, because not all of the spin-offs and lived repercussions of its logics welcome desire or are desirable.

[3] Grosz, 'Habit Today', p. 219.

Habit locks movement (taken in its broadest sense) into worn trajectories, that it constructs and modifies in real time, even as it renders us capable of navigating more easily those trajectories.

Practising, then, names *that which reliably intervenes* in the inertias of 'bad' habits and, like habit, is a methodology. 'Bad' here needn't pique any moral register; instead it stands in for 'sedimented', 'impoverishing', 'no longer generative', a life with less expression, or when expansiveness atrophies. Or, even too much cheerfulness, insistent 'functionality' – there are many faces to ossification. Such cul-de-sacs within the order of habit(-as-methodology) amount to what, in a more vernacular sense, we know to label our habits. Losing bad habits, once our being has 'contracted' them – as many of us have learned through experience – is always less straightforward than it seems on paper. Why is it so hard to stop doing a simple, particular thing? – as Kierkegaard so elegantly asks. The easy answer is, after Ravaisson, that we *are* that thing that we are trying to stop or drop. Habits, in a very rigorous sense, *have us*, and not the other way around.

To elide habit's tenacity, practising sets it to work as a kind of ontological score, played in a skilful way, in order to moderate habit's intractability and extremes. It gives us the tools to slip from the outline of, to elide, the *self itself* that habit incessantly sketches. Arguably recalling Derrida's supplement[4] – which in its operation must be dually read as both adding a fullness and also compensating for a lack – practising adds an excess to habit, which it wasn't lacking and didn't need, while also compensating for habit's uneasy repercussions (habit's 'lack'). Practising, then, is neither necessary nor natural. It pertains to a strange excess of adding nothing, which as a result works subtractively.

Already this launches us into the logics of habit, which perhaps do not align with common sense but are consistent enough and able to be derived, nonetheless. In what follows, we will explore Ravaisson's framing of habit, along with others in this lineage such as Grosz and Deleuze himself. Ravaisson's approach to habit offers useful ways to understand habit's relation to practising, and also the way this relation is bound up with Deleuze's disambiguation of difference. Writing about Ravaisson, in his famous essay 'La vie et l'œuvre de Ravaisson', Bergson hints also towards the practising in which his famous subject engaged:

confirming a law that we hold for general, to know that really viable ideas in philosophy are those which have firstly been lived by their author –

[4] Derrida, *Of Grammatology*, p. 141.

lived, that is to say applied by him, every day, to a work that he loves, and modelled by him, over time, to this particular technique.[5]

Some General Remarks about Habit

Something about habit, which one can observe in everyday life, is that active, goal-based intentionality – usual intentionality – along with what gets called the 'will', are (mostly) appropriate tools for the purposeful establishing of habits. If we want to contract the habit of making our bed every day, then the application of what many consider their will won't (necessarily) undermine this aim. For some people, this active application works very nicely. There is an enormous amount of popular literature already available, and being published as I write, that works in this 'ontic' register of habit, suggesting smarter and better, more efficient kinds of habit, which anyone can apparently acquire if they set their mind to it. Trying, then, does not preclude habit formation in any strict sense. Due to this, we can say that habits can be both unintentionally contracted – such as the tic in an eye – or wilfully acquired – such as the ability to do thirty minutes of piano scales before breakfast.

This said, we can set this alongside the losing of habits, and what might tend to facilitate or fail to facilitate it. How do we drop or shed habits when they no longer serve us, when we no longer want them? When it comes to unravelling or sloughing off unintentionally (or even once intentionally) contracted habits, so-called wilfulness and effort can prove to be bafflingly ineffectual. Wilful efforts to stop doing the habit prove often to be, in fact, counter-productive, with the behaviour becoming more entrenched as we work to lose it. We can include among 'habit' here the full gamut of so-called psychological as well as behavioural tendencies and abilities.

The practitioner, in this regard, can be considered someone skilled at, or curious about experimenting with, *the technologies available for the losing of habits*. To do this, they engage delicately with what we might risk calling the 'will' – since what we understand it to be appears conspicuously in the vicinity of the deadlock – and put to work something other than common sense in a laboratory of structured repetition.

Therefore, unlike habit, practising is not the *pharmakon*, as explored by Derrida in 'Plato's Pharmacy' (1981). The *pharmakon*, according to Derrida's reading, is a substance/entity that demonstrates the unusual tendency of being at once able to heal and to poison. By deconstructing Plato's *Phaedrus*

[5] Bergson, *La pensée et le mouvant – essais et conférences*, pp. 303–4.

dialogue, Derrida persuades his reader that writing displays this dual quality. Writing, in this way, is at once useful for recording information, for extending externally the capacity for memory, but also, at the same time, is the likely cause of the diminishing of memory itself. Important for thinking the *pharmakon*, as structure or movement, is not to resolve it one way or the other, as is our knee-jerk impulse. As with much of Derrida's reading practice, the point is to see what happens when one remains in this impasse. (For his part, we see, Derrida in many ways was, like Deleuze, a writer who raises the practice of thinking-reading to the register of practising, giving us hints in action as to how this happens.)

Habit, on the other hand, does demonstrate some tendencies of the *pharmakon*: it has the capacity to lead us into what Ravaisson calls 'grace', while at the same time, via the same mechanisms, it can found tiresome, and even fatal, pathologies. This is reiterated by Catherine Malabou, who contributes the preface to the 2008 edition of Ravaisson's essay 'Of Habit'. She writes that 'all along' the habit to which the book is pointing is of the order of the *pharmakon*, and that '[f]or Ravaisson, also, it is one and the same force that engenders good and bad habits'[6] – in other words, habit has no definite valence, in terms of good and bad; its mechanisms can lead both in so-called destructive and constructive directions. (Note here also that habit is a force, emphasising its distinction from any particular set of behaviours. At stake is habit as operation, which can then animate examples of habits in various forms.)

Practising, in this way, constitutes a means for riding that same force with a precise deftness, as well as being itself a method of inquiry into habit's secret mechanisms (that is, those which bear on time, the self, continuity, and so on). By neither refusing habit, nor collapsing entirely into its logics, practising tempers habit while also wandering among the closer operations of being and becoming.

As we turn now to Ravaisson's conception of habit, we will see that his thesis can be read – to a large degree – in parallel with the first two criteria, as discussed in Chapter 1. This can assist in discerning and articulating that which distinguishes habit from practising.

Ravaisson's Habit

Ravaisson's essay 'Of Habit' from 1838 (2008) can be seen to continue a tradition that finds its roots in Aristotle's inflection of habit. For the former, habit is aligned with the very way of Being that is proper to a being that

[6] Malabou, in Ravaisson, *Of Habit*, p. xix.

endures in a world of change. *Habit constitutes the mode in which beings come to persist in their Being.*

Ravaisson was not the first or last in this line or inquiry, and Deleuze himself can be placed within it. 'Of Habit', however, is particularly noteworthy both for its 'crystalline clarity and rigour' (as Malabou phrases it – OH vii), as well as for the profound implications of its argument.

In the lineage of which Ravaisson is a part, habit is not read as the disease of automatism (although in discrete *instances*, it might express itself like this), nor as a simple thing one has (*a* habit) to be arranged along the lines of good or bad based on its content (smoking, walking in the mornings, washing up after meals, prayer and so on). Rather, with Ravaisson, who both extends and modifies the work of his predecessors, habit (we read in the opening line), '*in the widest sense, is a general and permanent way of being,* the *state of an existence* considered either as the unity of its elements or as the succession of its different phases' (OH 25, emphasis added). In fact, what we perceive as distinct habits in our daily lives are only the more obvious, explicit expressions, more contained examples, of a profound and ubiquitous mechanism that enables us, as organic cases, to exist and to continue at all. *Being*, after Ravaisson, seems enmeshed at more subtending levels in the very same mechanisms that appear more blatantly to us as stable or sedimented patterns of behaviour. It remains a startling thesis.

To cite to Deleuze on the same question:

This is no mystical or barbarous hypothesis. On the contrary, habit here manifests *its full generality*: it concerns not only the sensory-motor habits that we have (psychologically), but also, before these, *the primary habits that we are*; the thousands of passive syntheses of which we are organically composed. (DR 95, emphasis added)

Deleuze here appears to echo Ravaisson's hypothesis and then to read it further, into the closest organic mechanisms of which 'we' are composed. By 'passive syntheses', we can understand the minute, hidden processes whereby life within us perseveres as itself, as our*selves*, without our conscious or wilful participation – oxygen is transported in the blood, our hair and nails grow using proteins from our food, our synapses enact choreographies that we do not direct. In Deleuze's words, 'Every organism, in all its receptive and perceptual elements, but also in its viscera, is a sum of contractions, of retentions and expectations' (DR 93).

'Synthesis', here, can be read straightforwardly as a *bringing together that makes*. At every level a cobbling, combining, retaining of things – also

called a *contracting* – is constantly happening and from this we are constituted as bigger selves, the composite selves with which we typically identify. To evoke this, Deleuze offers us the evocative expression: 'larval subjects'. Accounting for the implications of the passive syntheses, he writes:

> The passive self is not defined simply by receptivity – that is, by means of the capacity to experience sensations – but by virtue of the contractile contemplation which constitutes the organism itself before it constitutes the sensations [. . .] Selves are larval subjects; the world of passive syntheses constitutes the system of the self, under conditions yet to be determined, but it is a system of a dissolved self. (DR 100)

Deleuze is at pains to stress that this pertains to a precise register, and that this 'contraction' or 'retention' is not to be confused with receptivity. The operation of contraction, or passively synthesising, happens logically prior to receptivity, as we typically understand it. We do not contract because we are receptive; rather, our capacity for receptivity is founded on deeper contractions and passive syntheses before they give rise to receptivity's complexity.

In this section of *Difference and Repetition*, Deleuze does not mention Ravaisson but writes from and extends a long and established conversation, which acknowledges the relevance of habit (as a movement, or force, or *way*) for a constitutive (rather than limiting) register, to which Ravaisson is a crucial contributor. Habit in this lineage is an unfolding that accounts for how beings come to be and to endure.

If we read Ravaisson and Deleuze in parallel, something further becomes clear. Ravaisson insists that habit is a stability that results from a change. We read:

> what we especially intend by the word 'habit', which is the subject of this study, is not simply acquired habit, but habit that is contracted, owing to a change, with respect to the very change that gave birth to it. (OH 25)

From the start, then, Ravaisson stresses habit as mechanism. Thanks to habit, a being persists in a unified way, in its being, with this ongoing unity in constant relation to changes, and the integration of such changes, via the mechanisms of habit. In this way, continuity includes modifications, takes them up, and continues – habitually – but as a slightly different version of itself. Grosz summarises it thus:

Habits are the ways in which living beings accommodate more of their environments than the constitution of instinct generally permits: habits are how environments impact and transform the forms of life they accommodate and are themselves impacted and transformed by these forms of life.[7]

Ravaisson's framing of habit, within the broader tradition in which he writes, and which Deleuze and Grosz extend and complicate, offers a glimpse into how to think the interrelation between successions of phases and changing conditions, and the ways in which they constitute the life of an enduring organic entity – a non-static but consistent-enough self.

The terms on which we think continuity-within-change are important. How do we distinguish real change at a certain register (that is, an entirely new relation to that-which-continues), from the constant changing and adjustments *within* a register, those out of which any life's continuity is woven? Continuity, as Deleuze teaches us, is only synthesised difference. So, it becomes a matter of having access to a thought of different, *other* differences – a difference that is different *in kind*. This is Deleuze's focus is chapter I of *Difference and Repetition*.

Let's take an example that might seem to be about an entrenched Sameness and see exactly that from which this Sameness is woven. Each day that a person washes their hands compulsively is, in fact, a different day from the previous one. The Sameness marking the compulsive repetition itself is also, and truly, a matter of enormous numbers of instances of slightly differing behaviour. Approached rigorously, the hands are washed differently each time. However, at another register, this behaviour which is made up of truly different instances – that is, small differences-between – also remains consistent within the world of which it is a part. A unity or recognisability emerges from the instances of incremental differing. The person does, despite the differences, really have a persistent and (it seems) compulsive habit.

The habit is itself the contraction of the discrete instances of hand washing and allows that very washing to endure as a consistent behavioural schema, and a consistent feature, to echo Ravaisson, of *that being's way* in the world. It is the relentlessness of this small differing – not so much the repetition, which we'll look at more rigorously shortly – which in its continuity amounts to a compulsive habit that a person may find debilitating, as well as difficult or 'impossible' to shift.

[7] Grosz, 'Habit Today', p. 219.

The question would not be how the hand washing could differ from itself, because this very differing is the stuff of the very continuity that constitutes the trouble. What is needed is a method to coax the behaviour to drop away altogether, which means subtractively, for it no longer to feature *as a feature* of that being's continuity, of its *being-as-continuity* (in regard to this constitutive behaviour).

This normal mode of difference, by which we get quite distracted, and which is marked by its continuous differing, is the stuff of our habitual presents: stringing intensities together, contracting them into a stretch of seeming 'permanence', making a self within this mode of time. This idea also touches on Deleuze's work on repetition (from chapter II of *Difference and Repetition*), at which we will look in due course.

Returning to Ravaisson, a theory of habit gives us a way to think rigorously the relation of change to apparent permanence or 'persevering': 'Habit is thus a disposition relative to change, which is engendered in a being by the continuity or the repetition of this very same change' (OH 25). This reading of habit hints at that which makes identity possible, given that identity – continuity of a case – does not preclude change, but rather digests and uses it as the grist for the ongoing production of a self through time. As Ravaisson says, '[s]ubstance, at once inside and outside time, is found within me, as the measure of change and permanence alike, as the figure of identity' (OH 41).

Extending the implications of habit's relation to continuity and existence, Deleuze, in the following passage, turns to Samuel Butler, writing how the latter has shown that:

> there is no continuity apart from that of habit, and that we have no other continuities apart from those of our thousands of component habits, which form within us so many superstitious and contemplative selves, so many claimants and satisfactions: 'for even the corn in the fields grows upon a superstitious basis as to its own existence, and only turns the earth and moisture into wheat through the conceit of its own ability to do so, without which faith it were powerless . . .' [. . .] *What organism is not made of elements and cases of repetition, of contemplated and contracted water, nitrogen, carbon, chlorides and sulphates, thereby intertwining all the habits of which it is composed?* (DR 95–6, emphasis added)

Again, it is clear that we are dealing with a constructive and generative view of habit, pursued by the lineage of which Ravaisson and Butler, along with Bergson – their differences notwithstanding – can be deemed to be part. To

repeat Grosz: 'Habit is [. . .] not [. . .] that which reduces the human to the order of the mechanical.'[8] In this tradition of thought, habit might not only take the shape of that which can shackle us – although it also can – rather, in a very general sense, it constitutes the way that animals and humans, and even plants, free themselves from the effort required to carry out the basic, essential functions of their being, and which affords them the means to continue as a case. Habit, in other words, continues all the way down and is also – for humans especially – the mechanism by which existence becomes more sedimented and secure, allowing beings to move beyond mere survival, that which, in Ravaisson's account, is otherwise typically secured by instinct.

Habit, as Grosz notes, 'is a creative capacity'.[9] I will argue, as we proceed, that when habit is then raised further to the power of practising, this same 'creative' capacity (in a broad sense)[10] is at once ramified and tempered, with at times astonishing, even sublime, implications.

The habits that a human might contract – the habit of rising before noon, the habit of regularly preparing food that one might enjoy eating, the habit of expecting other humans to be honest and reliable (or expecting their malice and capriciousness) – function to reduce the effort required to 'get through the day'. If lungs have a 'habit' of breathing, and the heart a 'habit' of pumping, then these more explicit habits similarly enhance our capacity to be, and with less preoccupation. Habit, then, surely does offer at once the means for an entity to continue as a case, as well as a kind of economy of action and of effort: that is, the 'space' to experiment within continuity.

In their 'Editors' Commentary', Carlisle and Sinclair paraphrase Ravaisson:

> The law of habit can be regarded as grace, as a gift given to the subject, insofar as it facilitates action in a way that escapes and relieves the will, reducing effort and fatigue and easing discomfort. (OH 101)

[8] Grosz, 'Habit Today', p. 219.

[9] Ibid.

[10] Grosz explores the creativity that habit makes possible, and I wouldn't entirely disagree with her designation, although I tend to use the term with a different inflection in the current book. To my mind, the contributions that habit can make to creativity pertain to its ability to stabilise one part of our context and experience, in order to leave more space for other things to happen, serendipitously or by curated accident. Without structures in a life, mostly – as we see for ourselves – we don't tend to become more creative, but rather end up burdened by a kind of dishevelled preoccupation with tedious, pragmatic detail. Without the habit of turning the stove off, we deal for days with the fallout from a minor house fire, rather than writing our novel. At this level, undoubtedly, habit is crucial for creative space to open, and to remain steady enough to be generative.

Here, they reiterate Ravaisson's own emphasis on habit's graciousness. Without habit (and its sibling capacity, instinct), the subject would be crippled by the details of existence that would demand constant attending. We – as well as plants and animals – would drown in a squall of minute actions required to remain alive. In the case of those 'lower' on the organic hierarchy (Ravaisson's framing), the first order of relief from this attention to detail is provided by instinct, but the difference between the latter and habit, 'is merely one of degree' (OH 59). Habit, in the 'higher' orders, although never 'attaining, the reliability, necessity and perfect spontaneity of instinct' (OH 57), operates akin to the latter, freeing the will from having to exert fresh effort every time.[11] As Grosz reads Ravaisson, the relation between the instinct and habit proper is such that, in habit's case, there is the added possibility of innovation. Habit, she writes, 'is as close to instinct as possible, but with the possibility of invention, newness, transformation and learning'.[12] Here, Grosz arguably gestures towards that which the current work disambiguates by deeming it 'practising'. Explicit details from Grosz about what this extended inflection of habit entails are not the emphasis of her work in this instance. Either way, to point towards the more gracious part of habit's spectrum (Ravaisson, Grosz) or, as I am attempting here, to clarify precise criteria that operate in this part 'of its spectrum', and to specify the 'moment' when habit tips into something quite other – these are complementary efforts. We need to know how habit works, what it constitutes and makes possible, as well as reading into its less typical peripheries, where – I suggest – we can begin to speak of something else entirely. Habit and practising, in a day-to-day sense, can appear almost inextricable – except that the register at which practising operates is, rigorously, really not at all that of habit. This has to do with temporal modes, along with Deleuze's scholarship on time. Chapter 3 will speak more to this. In any case, that which 'makes the difference' between them is – to speak at once poetically and technically – strictly *Nothing*. Hence it is understandable that one might attempt to speak and think them as a being of the same kind.

[11] *Fresh effort every time* could be a helpful way to recall the very methodology of intentionality that practising *reintroduces* back into habit (which, one notes, usually *diminishes* with the result of a nigh elimination of this very effort). This is the strategy that practising deploys precisely in order to *defy* the logic of habit's more troubling or deadening tendencies.

[12] Grosz, 'Habit Today', p. 223.

The Double Law of Habit

A further 'crystalline' observation, which Ravaisson articulates for his reader, and which also features, although inflected slightly differently, in the work of his predecessors Bichat and Maine de Biran[13] (OH 10–11), is the 'double law of habit'. In this section, I will firstly describe the law itself after Ravaisson, and then two interesting consequences of its logics that he explores. The first pertains to how the law impacts on sensation as distinguished from perception; the second involves something he terms 'spontaneity'.

Describing the double law, in one of several renderings of it in the essay, Ravaisson writes:

> The continuity or the repetition of passion [sensation] weakens it; the continuity or repetition of action exalts and strengthens it. Prolonged or repeated sensation diminishes gradually and eventually fades away. Prolonged or repeated movement becomes gradually easier, quicker and more assured. (OH 49)

Instances where this dual law might be operating abound in everyday contexts. It would be a 'law' for habit since both of its aspects, according to Ravaisson, are in play in the case of habitual repetitions.

Let's take an example that would seem to confirm Ravaisson's approach. When we embark for the first time on difficult movement or activity – hiking, for example – we have a combination of discomfort (at the level of sensation) and clumsiness or struggle (at the level of action). In other words, bits of our body feel new sensations, some of which are uncomfortable (aching thighs and breathlessness, perhaps) and our ability to move is often laboured and marked by unease or lack of coordination (inconsistent walking rhythm, clumsy manoeuvrings of our pack). The double law of habit simply points out that, if we repeat the behaviour of hiking, two things – seemingly going in opposite directions – will happen. First, we will begin to feel less and less strongly the sensations associated with the activity – that is, they will fade – and, at the same time, our ease of movement in the activity will increase. Decreasing sensations are accompanied by increasing ease in action.

[13] See also: Sinclair, 'Ravaisson and the Force of Habit': 'Ravaisson's formulation of what he terms the "double law" is drawn almost word for word from *The Influence of Habit on the Faculty of Thinking*, and yet his explanation of this law differs markedly from those presented by Biran' – p. 69.

Of course, one assumes within this a kind of feedback loop at work – since ease of movement tends to provoke fewer sensations of struggle (*one stops moving poorly*), and the fading of sensations, which seemed at first an obstacle to continuing (*awkward feelings stop accompanying the activity*), makes movement itself more fluid. It is, according to this law, *repetition* (being so constitutive of habit) that makes action easier and diminishes sensation. William James, in his chapter on habit in *Psychology* (1893), speaking of habits in an ontic sense, phrases it thus: 'Habits depend on sensations not attended to.'[14] And in the same chapter: 'habit diminishes the conscious attention with which our acts are performed'.[15]

This is a good story, but it isn't yet the whole story. Ravaisson recalls his reader to the further distinction that this law has tended to mobilise among his predecessors, which is the acceptance that *sensation* is to be distinguished from *perception*. The former pertains to a so-called passive mode, whereas the latter involves the application of will, judgement and intelligence, and is therefore deemed 'active'. His famous example involves distinguishing the connoisseur of spirits from the mere alcoholic (OH 49). For the latter, sensation (in this case the pleasurable taste, but perhaps also the pains of the hangover) will diminish the more he or she drinks; whereas for the former, the application of the understanding and of effort to the sensation – attending to its nuances, let's say – will turn the passive sensation into a perception, into an action. This then evades the loss of pleasure, and instead enhances its possibility. This active-sensing, called perception, becomes a new kind of action in itself, and promises to become as fluent and skilful – according to the double law – as repeated action can be. 'Perception, which is linked to movement,' Ravaisson explains, 'similarly becomes clearer, swifter, and more certain' (OH 49).

Hence, to summarise Ravaisson, on this sub-aspect of the double law:

- *Passive* sensations are reduced and dulled as a result of repetition.
- *Active* perceptions become clearer and more fluid with repetition.

That is to say, the sensation experienced by the organism in relation to what it undergoes passively is diminished by repetition; the efficaciousness and ease of activity and active modes are ramified by repetition. And, as a logical extension: Whereas we might have assumed an easy distinction between feeling and doing, the distinction of the double law is extended to 'within feeling' itself, insofar as we will

[14] James, *Psychology*, p. 141.
[15] Ibid. p. 139.

*be said to 'feel actively' (through the addition of understanding and intelligence) to
a point where the same law that was applied to activity can be equally applied to
active-feeling, called perception.*[16]

We see Ravaisson's contention (cited above) playing out in a practice
like yoga asana, for example. Postures, within yoga, arguably constitute a
scaffolding or laboratory in which movements are executed with honed
intention, a cultivation of curiosity, and not simply for themselves as sets
of ostensibly 'good' or 'healthy' behaviours (that is, for external results).
They are, therefore, explicitly mobilised in order to refine and research – via
their various 'forms' – *perception* itself, both to generate and discover it. A
common instruction in yoga teaching, which reflects quite transparently
Ravaisson's model, is: *observe the sensations* (in the palms, in the soles of the
feet, with regard to the verticality of the spine, and so on). It is precisely
by applying observation to sensation that, in Ravaisson's vocabulary, they
become perceptions, that is, *kinds of actions.*

In her chapter on dance in light of Nietzsche and Deleuze's take on
moving and kinds of agencies, Rothfield writes the following:

> there is [. . .] place for experience within dance. Both Deleuze and
> Nietzsche allow for the rhythmic formation and active utilisation of reac-
> tion (qua experience). Deleuze writes of the normal, healthy role of reac-
> tions, which slow or hinder action, but which are ultimately put to work
> in the name of activity [. . .] These cases represent the 'quick and precise'
> adjustments of the master who turns reaction into action [who *acts* their
> reactions].[17]

In line with Ravaisson's logic, rather than being diminished, the feelings
associated with moving become crisper (or more 'literate' if you like) when
their passivity is *acted*. What a new practitioner might experience as mere
sensation – foggy and imprecise – is, via acted engagement with the sen-
sation, over time, and by dint of repetition, rendered *perception*, a kind of
intelligence. What is interesting for our purposes is the register at which
this *being-active* occurs. In Ravaisson (as with Rothfield's Deleuze), we
shift our register for acting to a subtended level; we become active in a

[16] Compare this to Bergson in *Matter and Memory*, where he discusses how a perception
poses a question to the will (about what motor response is suitable to each situation):
'it is also diminished whenever a stable habit has been formed, because this time the
ready-made response renders the question unnecessary.' *Matter and Memory*, p. 45.

[17] Attiwill et al. *Practising with Deleuze*, pp. 137–8.

realm – sensation – where passivity is assumed to be the norm. At the same time, on the more gross level, we appear to inhabit a kind of non-doing, or doing-less. The doing-less at this more obvious level assists in leaving 'space' for attention or effort (of a new kind) to happen in other layers of the behaviour.

Ravaisson's dual law, in this way, continues to reflect habit's role in enabling a being to persist through change, maintaining a stable identity by dint of the integration of changes marking its environment and passage through it.

Finally, there is a second aspect to how the double law plays out and which further draws out its logics. The latter seem, when followed to their ends, to produce the opposite mode in each of its two poles. What he calls 'spontaneity' operates like this: if movement emerges out of an action on the part of a subject, but through repetition becomes easier, more fluid, and ultimately less and less taxing on consciousness, it strangely begins to resemble less and less the active mode that initially typified it. When taken to its furthest pole, an active behaviour will become – via this double law – *as if quite passive* (fluid, effortless, unthinking). What began as a clear, intended action, then, upon the establishing of a habit, tends subsequently towards something more automatic and less driven by intention. Ravaisson raises the question: Can this behaviour then be considered to coincide with passivity, as if returning the once active subject to 'nature'?

He offers his reader the notion of 'spontaneity' to account for this curious drift:

> continuity or repetition dulls sensibility, whereas it excites the power of movement. But it weakens the one and excites the other *in the same way, by one and the same cause*: the development of an *unreflective spontaneity*, which breaks into passivity and the organism, and increasingly establishes itself there, beyond, beneath the region of will, personality and consciousness. (OH 53, emphasis added)

The dual law of habit reveals at its deeper levels a new kind of activity, one that operates within passivity and activity alike, and combines the two in its designation. 'Unreflective spontaneity' encapsulates the duality it unifies. It is a kind of spontaneity that does not arise through the will. One could state it thus: that an inner impulse or tendency is found even deep within passivity, and that an unreflectiveness is found at the heart of mastered activity. Where 'spontaneity' for Ravaisson pertains to initiating movement or action, here, in the closest detail of habit's mechanism, we see that this

ability to initiate does not stem from a so-called conscious willing, as one might expect, (although 'will' might constitute its *form* in some cases). It rises instead out of an *unreflective* mechanism, and somehow as a result of habit's very nature. Equally, at the heart of nature, which is usually deemed passivity proper, a kind of initiating tendency, which Ravaisson will call desire (and at other points *love*), comes into focus. He writes:

> It is not the will – or at least it is not reflective will – that works out and devises in advance the very production of movement; for this can only arise from the depths of instinct and desire, where the idea of nature becomes being and substance. [. . .] Will constitutes only *the form of the action*; the unreflective freedom of Love constitutes all its substance. (OH 71, emphasis added)

Ravaisson here follows the logic of the movement of unreflective spontaneity through to its consequences, where it can be translated into what he names 'Love'. If habitual creatures stayed close to their desire, if they read it to the letter, repeating movements until these became grace and minimal effort, attending to pleasurable sensation with perceptiveness – allowing, for example, the limbs' own implorings to seek out their longings, and with discomfort fading in the grace of repetition – an atmosphere that resembles 'Love' might well predominate. (In this way too, following Ravaisson's reading, one glimpses the mechanism which might account for joy at the heart of practising.)

In Ravaisson's admirable account, however, habit would seem to work its way almost inevitably towards its culmination in love and desire, grace and freedom. Read generously, he would seem to be pointing towards the tipping-over of habit into what I am deeming practising. To query how practising works is to ask about how and when this mechanism does tip in that direction, and under what conditions. This is because we also know that habit – left alone and to its precise devices – can easily tip in another direction.

Habit may evolve, without contradicting its own mechanisms, at the same time towards less benign atmospheres and spin-offs. As habits, as beings-in-continuity, we are also constituted by habits that will finally destroy us, which are far from freeing and gracious. In the next section, I will consider some practical reasons for this. However, before this, let's acknowledge that Ravaisson and Grosz paint a picture of habit that leaves it open to closer articulation via an account of practising. Habit, as they detail its operations, for it to become practising, would be affirmed, extended and

also subtractively modified in precise ways. This, however, is not a direction that habit will reliably take. It may at times open onto this register. Thus, agreeing with the implications intimated by Ravaisson and Grosz's accounts, I would reiterate that practising, like habit-sometimes, is entangled with an ontological desire,[18] can inhabit atmospheres of 'love', and does court a 'grace' accompanied by intensive joy.

Complications in the Double or General Law of Habit

In their 'Editors' Commentary', Carlisle and Sinclair paraphrase Ravaisson's 'general law' in the following way:

> the 'general law' of habit relat[es] both to spontaneity and receptivity: changes that come to a being from the outside alter it less and less in their repetition; *changes that a being initiates* tend to reproduce themselves with increasing facility. (OH 84, emphasis added)

The distinction here relies on *the source of the change to which the organism responds*. If the change is one that 'comes from outside', the mechanisms of habit make it such that, with repetition, the organism is impacted less and less. If the change is auto-initiated, then with repetition, the related movement or activity becomes more and more fluid and effortless. Habit, we recall, is a 'disposition relative to change' (OH 25).

In Ravaisson's own words, the law reads like this:

> The general effect of the continuity and repetition of change that the living being receives from something other than itself is that, if the change does not destroy it, it is always less and less altered by that change. Conversely, the more the living being has repeated or prolonged a change *that it has originated*, the more it produces the change and seems to tend to reproduce it. [. . .] Receptivity diminishes and spontaneity increases. (OH 31, emphasis added)

[18] Sinclair writes: 'On Ravaisson's account, desire inhabits the body as being inhabits beings. There is a difference, as Martin Heidegger will emphasize in revitalizing the Aristotelian tradition of ontology in the twentieth century, between beings and being, between that which exists and its existence, just as here there is a difference between the body and the obscure activity or tendencies that animate it. Yet this difference is no ordinary difference between two things; and it is not a difference that can be accounted for as a relation of succession between a cause and an effect, or as the relation of a condition to what it conditions.' See 'Ravaisson and the Force of Habit', pp. 80–1.

Changes from the outside – upon repetition – are something to which to the organism becomes increasingly immune, and changes from inside – when repeated – become more and more its own (OH 31).

Some pages later, however, Ravaisson refers again to this 'double law' and makes the following statement: 'Impressions lose their force the more frequently they are produced. They become more and more slight, affecting the physical constitution of the organs less and less' (OH 37).

This is a slightly different statement to the earlier one since it doesn't specify the source of the change. Unless we are to assume that impressions are always generated externally, we can read Ravaisson to the letter to mean *any* impressions. What, then, of impressions that are generated from the experience of the movement itself? We can assume that Ravaisson did not intend including these with his choice of words,[19] but to read him deconstructively opens up something curious.

What I am referring to, specifically in this case, would be self-inflicted injury – when movements are produced by the organism (internally) and create impressions, namely sensations, that do not fade upon repetition. This recalls atmospheres of benign compulsion, as well as the less benign movements of self-harm – in other words, repetitions that potentially reduce the range of behavioural options available to a being. Repetition of action, here, and *not* productive of more ease.

At this point, I'm reminded of James Williams's take on Deleuze's aim in *Difference and Repetition* and other works. Williams introduces the phrase 'repeating well' which arguably un-demonises repetition, while still acknowledging that there might be more and less constructive ways in which things repeat for us.[20] Repetition, then, is not the problem, but rather it's how (if at all) we repeat and at what register the repetition is happening that matters.

I will give an example now, using yoga asana practice, but we could just as easily apply what follows here to other movement practices: rowing, hiking, dance, gardening, even. In Book II of the *Yoga Sutras of Patanjali*, which sets out the Raja tradition of yoga, we meet its eightfold or Ashtanga[21] path for practice. Eight steps are outlined.[22] This section of the larger work, depending on the translation, is also named: 'On Practice'. The first step on this path is rendered in English as *restraint* (yama); some practitioners also understand its content as 'the Outer Directives' – the way we orient ourselves

[19] In the French original, the term is also 'impressions' – Ravaisson, OH 36.

[20] Williams, *Gilles Deleuze's* Difference and Repetition, p. 52.

[21] Not to be conflated with the yoga style taught by Sri Pattabhi Jois.

[22] See Aranya, *Yoga Philosophy of Patanjali*, Book II, Sutra 29ff.

towards others and in the world. And of all the yamas (restraints), the first to be mentioned is non-injury, or non-harming, *ahimsa*, which is also deemed the foundation for all the other restraints. We read in Vyasa's commentary, quoted and then extended by Aranya in his book: 'Of these Ahimsa is to abstain from injuring any beings at any time and in any manner. Truth and other forms of restraints and observances are based on the spirit of non-injury.'[23]

In yoga teaching, and in a personal practice, what tends to happen is that, after finding these yamas all very well, one is far more interested in moving onto the third step on the eightfold path, namely, asana (postures). Asana is more explicit; something seems to be happening. However, despite 'skipping over' the yamas, one inevitably circles back to them in grappling with poses themselves – to recall Deleuze, one is *forced to think* ahimsa due to tangible, lived shocks, that is: the impasses of injury. In endeavouring to learn, do, achieve postures, one meets the urge to harm oneself on the way to the imagined, objective aim. Ahimsa becomes foundational for a sustainable yoga practice because without commitment to it (in all its impossibility[24]), the body wears the costs of the practitioner's striving and, with time, the costliness voices itself with more and more vehemence. Ahimsa, of course, must also be applied to oneself, as a being among beings. Of course, movement practitioners can be injured by external factors – a teacher forcing an adjustment on the body, a badly placed rock for the hiker or runner, an equipment malfunction for the rower, and so on – however, quite often, the injuring is self-inflicted. The body (and the 'intention' that animates it) is involved in harming itself, through forcing, or habitual lack of attention, or other misplaced efforts. In what follows, it can help to distinguish this self-injuring from pains that would happen 'to' us through accident or malice.

So, according to Ravaisson, a lived experience of habitual movement will reveal that the 'dual law' would apply straightforwardly in most cases of non-injurious movement. For example, if I begin to learn running, and if I have a good trainer, I will be encouraged to endure the new feelings of the experience, which may make me breathless, or create strong sensations of muscle exertion. Often athletes and practitioners refer to these as *discomfort*, and they are to be distinguished from injury, since they in fact do not cause it. If I can persevere with this acquired habit over time and with no serious

[23] Ibid. p. 208.

[24] It is impossible to live and not to harm; the commentators all acknowledge this. See ibid. p. 209.

injury, then Ravaisson's law will apply. I will indeed attain both a greater ease of movement, while at the same time the feelings that I found at first uncomfortable, will fade. I will become immune to them.

Diminished sensations, greater ease: the double law

The more difficult thing for movement practitioners in real time is the heavy and delicate question of injury, as mentioned. It can be one reason that people desist from acquiring movement habits that they might want to acquire. They get miniaturely injured; they don't know to name what has happened as such; and the natural and, arguably, sensible result is that they simply don't want, don't feel the inclination, to do the behaviour again. (The body has inbuilt aversions to damage, perceived or actual; this understanding can recast – at various registers – our common-sense notions regarding laziness.)

There is indeed something of habit's press that operates over the course of the establishment of a movement practice. When we encounter the body's limits and its unfamiliarity with the movement or activity, we have two options. We can repeat the movement within a benign zone, where we stay back from the hard limit of what the muscles and the bones can do, or we can insist on touching this limit, with more or less measuredness, to see where it is. In the case of the latter, we stray closer to the realm of injury and we begin to gamble with the body. We may be lucky and reap benefits in the form of quick advances, leaps in facility and so on. The other possibility is that we step too far (which can be objectively not far at all, but still) past the body's limit and find ourselves injured. Such setbacks tend to have an exponential character, insofar as a relatively small step beyond capacity, basically into a no-go zone, can amount to an injury whose recovery time far exceeds what would have been otherwise necessary to traverse the 'growing edge' of capability without the forcing.[25]

[25] The zone where injury becomes more likely, probable and then inevitable, differs for every organism, but it exists. In the case of habits of the obvious 'physical' body, this encounter with injury is challenging to avoid since we may not know where the limit is, and a degree of 'testing the waters' is necessary – and thus risky. One can speculate that habits of the so-called intellect, or psychology – acquired habits of mind, if you like – present analogous risks and testings. It is simply that, in the case of the latter, we have less explicit barometers and vocabularies of harm. Sinclair argues that Ravaisson differs further from his predecessors in that his approach to habit undermines assumed distinctions between mind and body, going via the concept of 'desire'. According to Sinclair, '[f]or Ravaisson, desire is not a property of the mind as opposed to the body

When one performs a movement (self-initiated) which then results in injury (damage to, or destruction of, one of the body's sub-organisms), repetition of that movement, which re-involves the site of injury, will not at all bring greater facility and ease. Instead, it can tend to provoke ongoing pain, restriction and weakness. In an almost Spinozist turn, one could also speculate whether the injury or pain itself becomes the entity – at this other register – which gains the greater 'ease', a kind of parasitic larval self within the meta-organism. The tendency for the very pathway that ramifies the injury to be more consistently followed is borne out in habitual movement. This might constitute a case of 'bad' habits that we would then wonder how to drop. How to intervene in the process of becoming-pain?[26]

We can also read along with Ravaisson in this regard, who hints towards something close to this in his statement: 'If the change does not destroy it, it is always less and less altered by that change' (OH 31). Perhaps one way to understand injury is that something has been destroyed, or at least damaged, at a closer register than that of the bigger organism. In this case, Ravaisson's logic holds.

If I injure my wrist, then 'I' am not destroyed, but perhaps something deep within my wrist, which I cannot perceive or access, has arguably been destroyed for a time. Injury signals a need to desist from repetition of that particular movement until the injury (the pain) has subsided and the body has done the work of repair. In movement fields, there is often anecdotal talk of different kinds of pain, or a distinction made between discomfort and pain.[27] The query is about trying to distinguish discomfort that we may not relish, that triggers reluctance, but which *is* adaptive, from pain that is the marker of injury with its array of pain sensations that will take hold, rather than fade, with repetition.

A nuanced understanding of how to respond to strong sensation in the habits we purposefully acquire fosters the longevity of those same habits. In other words, learning to discern between 'pain' and 'discomfort' is crucial. Furthermore, a growing capacity to abstain intentionally from repetition in the case of injurious pain is a sign of a practitioner's deepening craft in relation to a behaviour.

but is rather to be thought [. . .] as *the prior ground of any possible opposition between the two'*. See 'Ravaisson and the Force of Habit', p. 73 (emphasis added), and then 76ff.

[26] For fascinating and current pain studies which reflect this emphasis, see Butler and Moseley, *Explain Pain.*

[27] I'm grateful, for this and other points in this section, for comments by my colleague, Geoff Boucher, who is also a seasoned movement practitioner.

For practitioners, who want to engage in intentional repetition of their chosen activity, this is an ongoing query, akin to research. For some reason, there is also often a strong urge to mobilise determination in the face of injury, despite on another level the body's generating of a natural fear and reluctance to repeat that problematic movement. This example of injury either adds a necessary qualification to Ravaisson's law, or it requires us to apply it with greater nuance. Another way to remain within his logic is to again shift our register of emphasis: when a part of the body is damaged, the site learns the action of inflammation. It is actively inflaming the area initially to protect and heal it. Unfortunately, at the meta-level, this learning is also an action that gets stronger each time it is acted – that is, each time the cause of the pain is reconjured. This can involve, as healing practitioners know, finding new non-triggering skeletal arrangements or non-associated pathways into the position.

Ravaisson's double law of habit claims that sensations imposed by outside factors and passively undergone affect the organism less and less or diminish in its experience. *And*: activity that the organism initiates itself becomes proper to it and tends to repeat with greater ease.

To which of these scenarios, finally, does injury correspond?

If injury can itself be an internal action of the organism, or the sub-area of the organism, it doesn't in a general way produce overall ease for the organism, so the second limb of the law (above) doesn't apply. Only non-injurious activity undertaken by the organism will tend towards facility and grace in the repetition of the habit. On the other hand, if injury is a feeling or sensation imposed on, say, my wrist from outside itself, by my 'brain' or another register of my organism, then Ravaisson's law equally does not neatly fit this case, either. The sensation – if repeatedly imposed, and repeatedly experienced in a passive way (that is, not allowed to develop into perception) – won't reliably tend to fade, not really. Very poor (rather than just a bit average) working postures, let's say by way of example, are a kind of self-imposed injury over time. The body is weakened and/or damaged by a certain usage of the musculoskeletal system. If very distorted posture persists, at a level that is de facto injurious, the discomfort that results can also tend to become louder with time. Sensations won't always diminish, is my point.

To conclude this aside, in the case of injurious sensation, in my experience repetition will tend to entrench it rather than lead to a 'getting used to'. We get used to discomfort, since it doesn't trigger thresholds where inflammation kicks in. Pain itself, however, arguably becomes the 'movement' that gains in fluency, establishing itself on a repetitive basis, as a

tenacious habit on its own terms, a 'way of being' for that body or part of that body. Losing the pain habit, as chronic pain sufferers know, can require some delicate manoeuvring to lessen the pathways of pain that have gained their own fluency.

To remain within the terms of Ravaisson's law, which I am confident is insightful, we need to read 'movement' in a broad way and to the letter. 'Injuring' itself can end up a kind of habit, at a macro and micro level. Dysfunctional movement, as a subset of this, can itself gain in fluency, becoming easier and easier each time is it repeated. If we do not read habit in a narrow sense, but widely as ontological disposition and way of being, we find again less inconsistency in Ravaisson's take.

Whatever is repeated – to the letter and inclusively – becomes more fluent when it is acted. If it is a painful execution of a lifting movement, then *painful-lifting-movement* will become established and increasingly easier to execute. This is where habit parts company with any wishful thinking, and dovetails, with frightening precision, with operations that indiscriminately make the world, including both its grace and its pathologies.

I now turn to the question of whether and how practising resembles habit's mechanisms. With the help of Deleuze, I'll argue that practising's first two criteria run parallel to, without coinciding with, habit. For practising to be possible requires us, in any case, to contract some ilk of habit or 'behaviour with consistency over time'. In light of the above discussion and for practising's purposes, due to the way it uses repetition, it is also helpful if the habit can be – at a certain register – benign.[28]

[28] 'Benign' here might be shorthand for Nietzsche's test, which echoes aspects of Spinoza's ethology. Deleuze explains: 'It is what Nietzsche also said with his story of the Eternal return, he said: it is not difficult to know if something is good or not, this question is not very complicated; it is not an affair of morals. He said make the following test, which would only be in your head: do you see yourselves doing it an infinite number of times. It is a good criterion. You see, it is the criterion of the mode of existence. Whatever I do, whatever I say, could I make of it a mode of existence? If I couldn't, it is ugly, it is evil, it is bad. If I can, then yes! You see that everything changes, it is not morality. In what sense? I say to the alcoholic, for example, I say to him: you like to drink? You want to drink? Good, very well. If you drink, drink in such a way that with each time you drink, you would be ready to drink, redrink, redrink an infinite number of times. Of course, at your own rhythm. It is not necessary to rush: at your own rhythm! At that moment there, at least, you agree with yourself. So people are much less shitty to you when they agree with themselves.' 'On Spinoza' (small edits mine), n.p. Translator anonymous. Available at https://deleuzelectures.blogspot.com. au/2007/02/on-spinoza.html (last accessed 10 February 2021).

Practising Habit

> Between the general operation of laws, however, there always remains the
> play of singularities. [. . .] and beneath the generalities of habit in moral
> life we rediscover singular processes of learning.
>
> Gilles Deleuze, *Difference and Repetition*, p. 28

Practitioners, undoubtedly, are often people who appear from the outside to
have 'good' habits, and to be good at acquiring or contracting habits. The
committed gardener, the quiet and experienced cook, the consistent flautist,
the practising philosopher, the flower arranger, all by way of example seem
to engage regularly and with clear intent in behaviours that could be deemed
productive, and even morally 'good'. That these behaviours display a regu-
larity and, often, an acquired ease, would seem to align them with Ravaisson
and others' positive conception of habit.

There tends, however, to be an absence of 'habituated' atmospheres to
the 'doings' of practitioners. They are fluid and easeful, hardly recalling the
drabness of routines or the earnest urgency of compulsion. Furthermore, the
moral goodness (or otherwise) of the practitioner's 'habit' is not what desig-
nates their engagement as practitioners.

Are practitioners striving to adhere to moral law – on the grounds that
they seem to have the 'habit of acquiring habits' – or are there more rigorous
and less obvious ways to frame what they're up to? Perhaps they are invested
in something quite aside from replicating the categories of the 'good', but it
can be difficult to say exactly of what their investment does consist.

Intention, precisely inflected, is the point at which practising diverges
from habit. Perhaps, better said again, cycles of habit merging with, and
diverging from practising, with subterranean shifts, describe its reality in
everyday, lived guises. Sometimes practitioners are 'just doing their habits';
sometimes – and it can feel like 'grace' – they are straying into the register of
practising. Practising, furthermore, is also the cultivation of the conditions
which *enable that straying*.

Practising performs very similar manoeuvres to habit while remaining de
jure distinct from it. Another way to frame this is that, while habit's *time* also
features in practising, there is another mode of temporality that operates in
practising which is entirely absent from habit. We acquire, in any case, some
kind of practice (or habit that we can intentionally repeat) which consti-
tutes the form or behavioural scaffolding for our practising.

While smoking tobacco, for example, constitutes something commonly
viewed as a 'bad' habit (for health, for longevity), it could also foreseeably

be inflected in such a way so as to render it a feasible basis for practising. Its ritualistic use throughout history might attest to this inflection of the behaviour of smoking. If a person simply found themselves compulsively smoking (as the physically addictive qualities of nicotine encourage), then this makes it harder for the activity to be used in practising, since intention's role in the compulsion is too diluted. (The relation of habit to addiction is a longer conversation. Grosz makes the following salient statement: 'Either one has just the right number of needs that habit addresses, or a pathological excess.'[29])

On this point, Ravaisson alerts us to a further repercussion of the logics of the double law. His reading allows for a clear account of the mechanisms of addiction, which turn out to be none other than those of usual and non-pathological habit. Substance use, to continue our example, is a certain kind of repetitive activity that calls forth sensations in the body and we know that this repetition – in the case of sensation-as-passive – will result in a diminution of the vividness of the sensation over time. Ravaisson employs the term 'need' to name this effect of repetition. He explains that in the case of sensation's tendency to fade upon repetition, an anticipation of the impression – an imploring for it (OH 51) – is awoken in the body which begins to long for the lost sensation, which it would like to continue or keep constant. This is not necessarily pathological at its core, but it's not hard to appreciate how it could become so. It is a kind of *inertia in feeling*.[30] As habitual beings (being constituted via the operations of habit), we seek a continuation of the status quo, at the level of our organism, of our constitutive mechanisms. Alterations to this 'feeling' are met with the urge to return to the more familiar state (even if it were, technically, detrimental); Ravaisson calls this 'need'. His famous example is rocking a baby to sleep, and the disturbance that a withdrawal of the source of sensation will cause: 'Whenever a sensation is not painful, to the degree that it is prolonged or repeated – to the degree, consequently, that it fades away – it becomes more and more of a *need*' (OH 51, emphasis added).

Returning to Malabou's observation, we can see that, indeed, habit is the *pharmakon*. Entangled intimately with its very mechanism, neither positive or negative in itself, and simply the concatenation of a small set of 'laws', habit can at once produce a kind of constructive inertia, whereby a non-harmful behaviour is able to gain momentum and establish itself in a

[29] Grosz, 'Habit Today', p. 220.
[30] And practising in this way can be understood as a training in/for intensity, that results in a fitness for intensity, or an ability to transition with less and less effort.

person's life (say, surfing daily or flossing teeth or drinking sufficient water); or these identical mechanisms can produce crippling and fatal addictions, and both of these inflections with an equal indifference, reliability and tenacity. Habit adheres to its basic operations and unfolds the consequences of the latter with the same stamina and insistence that mark existence itself.

Habit, then, is a mechanism, in other words: a *way*, as Ravaisson astutely identifies. It is thanks to its movements that we are able to establish ourselves as cases at all – but, as such, habit is accompanied by all of its consequences, both the so-called constructive and the more debilitating or joyless. In this sense, it is arguably a robust *pharmakon*, containing the prescription both for life, and equally for disease, and subsequently death. Decay might be the mortal habit par excellence, a tendency that comes to establish itself, to gain momentum, at the heart of every living organism. We read, towards the end of Ravaisson's essay:

> The same principle and the same analogies reveal the secret of the abnormal and parasitic life that develops within regular life, which has its periods, its course, its own birth and death; is it an idea or a being which constitutes illness, or is it not rather at one and the same time an idea and a being, a concrete and substantial idea beyond consciousness? (OH 63 and 65)

Ravaisson is at pains here to emphasise both directions of habit, as well as its broader principle, which he will go on, famously, to link to virtue, the good, and to love's reach right into the heart of nature, across all levels of its hierarchy. In some ways, he is trying to account for how goodness arises within the organism at all, and the presence of that same mechanism throughout nature. This arguably unsettles, in an entirely contemporary way, any exclusive human claim to it. As a moral thesis it is not unconvincing; for my purposes, however, the emphasis of his argument is not mine.

If we return to this chapter's subtitle, 'Between Routine and Compulsion', we can say that practising occupies an unusual position in relation to habitual modes. The latter – in addition to producing constructive ways of being and living with less effort – may also eddy into dulled and stultifying routines, as well as wind themselves into the frenzies of compulsion and addiction. In both of these cases, routine and compulsion, habit's mechanism is the same. It plays out indifferently its various strains, all of them native to its disposition.

Recalling Malabou's reading, Ravaisson enacts a kind of deconstruction of habit and the 'goodness' it might enable by showing that contamination

is built into habit's system – and that this means one can't stifle the difficult aspects of habit's working without also smothering what links it to grace and virtue. This capacity to develop great tenacity in constructive behaviours, a kind of vitality in the organism, is the same one that renders a stable being vulnerable to fatal addiction, certain chronic diseases, or infuriating psychological knots. In terms of habit's verve, if we remain solely within its mechanism, we do not exactly get to pick and choose.

Practising constitutes the means by which one might be able to 'pick and choose' – a means for navigating habit's disposition skilfully (or Williams might say 'well'). It is the mode that enacts – via habit's own mechanisms – a research into habit itself, which means an ontological investigation and one which opens a beyond-of-habit.

Practising intervenes as little as it can, so as not to trigger habit's trip wires, which are ramified by any resistance to them. Practising puts to work the laws and shape of habit itself, and under certain very precise conditions. It would seem to *repeat 'to the letter' habit's mechanism without carrying forward its content*. But I jump ahead.

It is worth stating clearly that routine and compulsion, from the point of view of practising (not necessarily from the point of view of society, our own prejudices and preferences, or even notions of psychological wellness and so on) are to be viewed neither positively nor negatively. This would be to take a moral stance on them and their contents, which falls outside of the preoccupations relevant in practising. Compulsion is, on the whole, a negatively inflected term in common parlance; routine may be inflected either way. In both cases, for the purposes of practising, neither constitutes any stable pole of a spectrum along which we would slide depending on our poor or meritorious behaviour. Understood another way, which we'll meet in the following chapter, routine and compulsions enact, or fall into line with, certain modes of *time*. Practising, too, as we'll emphasise, being a very delicate constellation, is often likely to stray operationally back into routine or wind itself into compulsion at certain phases. Purity of mode is not the focus or frame here, nor is it achievable in a lived sense.

Both routine and compulsion involve repetition of a certain kind, as does practising. The latter obtains, however, when the repetition slips into another, more elusive, mode – namely this strange Deleuzian offering of 'miraculous repetition'. In order to court this other level of repetition in practising (criterion 4), we may well fumble around quite a bit in routine, or (depending on our psyches) have to contend with compulsion's tangles. This should not discourage us. Practising's genius is its ability to *include* these modes *and* to slip their binds, with only the slightest of (non)interventions.

It is the intervention of adding nothing.

We can summarise the equation of habit to practising in the following way:

Acquiring a habit alone does not constitute practising; however, practising does require that there be a form of movement, activity, or behaviour that coincides, in its first instance, with habit's usual operations. In various fields, this activity might be called 'a practice'.

This formulation accounts for the apparent coinciding of practitioners with people who have intentionally acquired habits they deem desirable. Practitioners are also those who – when viewed from the outside – have 'good' (enough) habits. Good habits, as opposed to 'bad ones', tend to be such that they can, to some extent, be pursued via the application of conscious effort. It takes time to establish the habit of swimming four times a week, no matter the weather. A particular effort is required (although the exact mode of this effort is worth our attention). Some people, when observed from the outside, are deemed to have very strong 'wills' or the capacity to keep 'applying themselves'. Something in their make-up seems to lend itself to sticking to the activity they have decided on. These organisms seem able, over time, to exert a directed effort towards performing their chosen behaviour. They establish themselves inside the structure of their specific habit, and for all intents and purposes, via an exercise of what has been, historically, called the will.

At another level, however, we could countenance a different slant on the matter. It may be that 'bad' habits are hard to lose via conscious effort, but also that, despite appearances, we don't really acquire habits by means of the will (or some simplistic notion of it) either. Deleuze, according to Williams, is of the latter opinion:

Deleuze goes on to conclude that habits cannot emerge out of activity but only out of contemplation, where contemplation means active, experimental triggering of events on different levels. Contemplation belongs to the imagination and not to the understanding.[31]

It is neat to say that we intentionally acquire habits for the purpose of practice. And at some level we do, since many practices are also sets of skills that need to be repeated so as to be performed, competently and with

[31] Williams, *Gilles Deleuze's* Difference and Repetition, p. 98.

some fluency. However, Williams's observation does not necessarily counter this but rather supplements it with more nuance. In lived experience even with 'intentionally acquired habits', the process is rarely straightforward, and does not coincide with some simple notion of a 'will setting to work on its goal'. Instead, what we can summarise under the nomination of 'an intentionally acquired habit' is more likely to have proceeded in leaps and starts, accompanied by setbacks and disillusionment, and the enduring sense of lostness that also marks creative engagement. The playfulness intimated by Williams's quote, therefore, is surely also operating. Habit-acquirers play within the constraints of the chosen habitual form, finding ease and pleasure haphazardly and often through luck, or perhaps Ravaisson's 'grace'. This decision to *keep playing* (which includes failing to play at times, reluctance to play, forgetting why one wanted to play in the first place) might be another way to read the shorthand of 'intentional'.

Echoing this, Williams offers again an astute way to think this intentionality in the face of a certain passivity that also marks what we do, depending on the register from which we are 'viewing': 'But your conscious activity has an effect [. . .] not in the sense that you can finally determine [. . .] outcome[s] but in the sense of opening up and closing down different paths.'[32] In order to set up the conditions for a particular practice and for practising per se, an apprentice practitioner will also have to proceed, for quite some time, *as if* acquiring 'a good habit wilfully', by deciding to open up that pathway, and often to shut down others. (Taking up early morning swimming might mean delaying or forgoing a lengthy perusal of the newspaper or news sites before work, for example.) Even if the habit never moves beyond habit, there are many arguments in favour of having 'good habits' (they are stabilising, if not very radical). Only the person herself will be able to say the impact on her life and know whether the habit increased or decreased the intensity of her experiences (to borrow from Williams's framing), or whether it increased her capacity to act (to hark back to Deleuze on Spinoza's account of reason, learning and ethics[33]).

It can also be that – and this becomes a reflection on impoverishment and privilege that may not necessarily, or solely, go via the economic – habits have been acquired during childhood, and without consultation. Children are exposed to the habits of their family or cultural sphere and are often expected to participate in these behaviours. These same habits may have persevered in their adult person and may (or not!) reappear in a fond light.

[32] Ibid. p. 105.
[33] See, for example, Deleuze, *Spinoza*, pp. 55–6.

One thinks of playing a musical instrument, dance training, or in my own case, the simple family habit of going for hour-long walks. Later in my life, not having disliked this walking, I began to take it up more intentionally. From being a family disposition, it became something I could use as a basis for practising. You will, in all likelihood, have examples from your own life.

The first two criteria of practising embrace the general shape of habit (with no resentment) and then supplement it with a simple intentionality, in the first instance. This is to say: the *contraction* that is habit, and normally something passive, is redeployed in practising more actively. One acts the 'reaction' of habit's tenacious inertias.

In the second criterion, we do something that is technically irrelevant, obsolete, nonsensical. Whereas Ravaisson's thesis will tell us that we don't *need* to be so active in the habitual repetition (because habit is this continuity, this perseverance, because it has an inertia all of its own), in practising we behave *as if* this inertia doesn't operate, and we repeat with a purely superfluous intentionality, going against the grain of habit's press, overwriting its law. Ravaisson's description of perception, as active response to sensation, recalls this.

What is interesting about the habits we set out to acquire, perhaps hoping or convinced that they'll bring something desirable to our lives, are ways in which (or if at all) they function in this capacity. In the final section of this chapter, I explore what habit-as-structure does. If intentional habit is the first rung of practising, and if it basically involves introducing a structure that repeats through time, what might its inherent impact be, even without its being raised to the other power of practising?

The Kindness of Structures

> For both [Ravaisson and Bergson], only the structured order, the enforced sameness that habit produces enables the creation of free acts and new knowledges. Habit both reveals our place in the natural order; and also the possibilities that we have for understanding and transforming this natural order, including that part of it that is lodged within ourselves.
>
> Grosz, 'Habit Today', p. 224[34]

A yoga student in one of my classes made an astute comment on how participating in the yoga course over a number of sequential eight-week terms

[34] I am grateful to Elizabeth Grosz for permission to reuse this quote to introduce this chapter section. Personal correspondence, 2 December 2020.

had impacted on her life. Instead of remarking on physical changes and improvements in her health or somatic experience (as she had done on other occasions), this time she stated that doing the practice (showing up to class, without fail in her case) had begun leaking into other areas of her world where she now felt more able to follow through on threads that otherwise might have been left hanging, to operate with more intentionality. To decide. Another student described the regularity of their evening weekly class as the reliable tether around which the rest of the week revolved. Nothing else seemed fixed (she had precarious/casual employment; she was studying, and so on). The class operated as a fixed locus for her not-unusual contemporary life marked by changing rhythms and modes of precarity.[35]

The way time is structured (that is, divided into periods), or the way in which its relentless continuity is interrupted, impacts on humans and presumably other kinds of creatures. The structures and intervals that make up our days, weeks and years contribute to a stability of experience, within which identity can cohere, in relation to time and arguably as a function of it.

Practising, in its guise as intentionally acquired habit – its first two criteria – puts to work this human tendency, and for a kindly outcome. The structures constituted by habit, as repeated behaviour, resemble in their effects that which obligation can contribute to belonging and steadiness – interpersonal obligations, utilitarian ones, voluntary ones, and so on. Unless we live in isolation, all of us are to varying degrees obligated to others, as well as to the pragmatic aspects of staying alive (and experiences of enforced isolation can bring this very structuring into view). These obligations position us in space (where we have to be) and in time (what we have to do now and later). For a large part of our lived experience, we are preoccupied with the content of such obligations (and in many cases, their content may make up the bulk of our complaint).

While it's true that the minutiae of a lived life can be overwhelming, we often bemoan this content (emails, transportation logistics, organising our children, communicating with partners, securing food and attending to our

[35] In my school in central Melbourne, Vijnana Yoga Australia, I have tended to only run terms or courses to which students commit in advance. Only rarely is it possible to participate in a haphazard way (shift workers are the exception, but still we try for advance notice once they have their schedules). There are complex reasons for this approach, but an obvious one is that students also get the benefit of working among a consistent group of peers that does not change from week to week. Scaffolded learning is enabled, but also more predictable atmospheres and a shared habitus requiring fewer words of explanation.

financial position, and so on), and remain blind to what else is going on by dint of the sheer fact of being obligated. The two habitual criteria of practising silently grasp something of this, and set its structure to work, but minus the content. Practising's beginning – as habit, in other words and if nothing else – gives us the benefit of being structured, while relieving us of some of the more overwhelming content that usual obligation, as our most usual experience of structure, normally brings.[36]

Practising, then (or simply the acquisition of practices and the first level of repeating them), involves being structured by something other than the demands of human relationship and practical and economic necessity. The vertigo that people can experience when they are no longer employed, or when their children leave home, or when a primary relationship ends (examples are endless) arguably attests – notwithstanding grief, fear and other emotions – to the role that obligation-as-structure plays in a life. In other words, necessity and involvements with other entities (persons, non-human persons, objects) structure our quotidian worlds. Freedom from this structuring – whatever it would look like – is a common fantasy, but for the average person it would be an ordeal of some magnitude. Arguably, it could qualify as the kind of 'shock' that Deleuze considers an impetus for genuine thought (DR 168). This relation between habit (as stabilising operation) and practising (as something other than merely an increasing stabilisation within change) should not be oversimplified.

Let's say for now that our 'obligations' (as things we may also seek out and amass) structure the otherwise relentlessness of time's unstructured flux. They provide a kind of existential frame for us. Furthermore, what we experience as an aspect of day-to-day 'love' or being-loved can include, among other aspects, also a structural effect, produced by the sheer fact of the other's difference and desires and their pressing into, and therefore shaping of, our worlds, times and selves.

This recalls the fact that structure often appears in the form of an effectively benign constraint or limit but may have expansive or emancipatory side effects. We can note that having bemoaned the demands of a close person, once we find ourselves 'liberated' from them, we can be met by

[36] A mundane and well-explored example in personal relationships is when two people regularly have conflict in order to instigate a temporary pause in their 'togetherness' (that is, a structure of apartness). The latter, which the conflict secures but painfully, is the hidden motor, and a benign one, for the conflict. The apartness could be managed without it if it were organised as a planned structure within their habits of the relationship.

the blankness and vertigo of it no longer mattering (to them) what we do and where we are. In other words, freed from their constraints, we may not always feel 'free'. This genre of freedom, unless supplemented by other efforts and decisions of structuring (such as practices, and practising), does not always increase our agency or contentment.

With these sketches, I seek to present a grounded consideration of the crucial role of the rhythms of structuring (and unstructuring!) of time and activity for what we could dare call everyday happiness. If people who have 'good habits' can sometimes be a bit happier than other people (or at least steadier in their moments of objective struggle or misfortune), what could begin to account for this? Perhaps the 'virtue' of the habit, as 'good habit', is explanation enough. I suspect, however, that although the 'goodness' may not be irrelevant, it isn't the primary mechanism. We also know of 'nasty' or hurtful or destructive habits also providing a structural solace to those who 'have' them. Structure – in whatever form and without so much reference to moral categories – contributes to the stable and creative functioning of humans, and presumably other organisms. We can reiterate Grosz's formulation: 'habit is a fundamentally creative capacity that produces the possibility of stability in a universe in which change is fundamental'.[37]

The moral nature, or otherwise, of the activity in question is not necessarily a pertinent factor in the relief that structure provides (although it may determine certain of the action's consequences). This can be unsettling if we are attached to the idea that only 'good' actions bring 'enjoyable' feelings.[38] In the case of habit's structuring effect, it is more plausibly the structure itself, aside from any particular content, which accounts for the resultant stability. Stability, we could say, is one less reason to feel miserable. Too much structure, or 'only' structure, on the other hand, can foster it.

Nigel Thrift, in his 2008 work *Non-Representational Theory: Space, Politics, Affect*, is canny to point out the link between practice and the possibility of stability. I read his term 'practice' to refer to the structured sets of behaviours explored here, to the movements and actions over time of bodies. We read:

[37] Grosz, 'Habit Today, p. 219.

[38] On this note, Adam Phillips writes of a patient, a young boy of ten, who felt happiest when cutting the feet off live rats. This example can be found in a psychoanalytic essay by Phillips on the pursuit of happiness. However, one can also consider in this example, the latter's insights aside, that it might also have been the structuring effect of this activity (a habit of kinds) that provided the patient with the 'happiness' he described to the analyst. Phillips, *One Way and Another*, p. 323.

[N]ew bodies are continually making an entrance but, if we are looking for something that approximates to a stable feature of a world that is continually in meltdown, that is continually bringing forth new hybrids, then I take the practice to be it. Practices are productive concatenations that have been constructed out of all manner of resources and which provide the basic intelligibility of the world: they are not therefore the properties of actors but of the practices themselves (Schatzki 2002). Actions presuppose practices and not vice versa.[39]

Any behaviour – almost – can qualify as this kind of structuring and may come in more or less explicit shapes. The companionship of one particular person; the promise of reading fantasy novels in the bath after work; cleaning one's teeth after meals; the motion of checking one's emails on a phone. All of these work to structure us *as* habits, as that which habit makes.

In the case of the latter, the rhythm of this email-checking structuring may or may not soothe the organism, and this would primarily have to do with intervals. The technology, nevertheless, still achieves a structuring function since it is the medium for a demand on the user – whether this demand comes from other individuals, groups, or as a feedback element of the system itself, and the press to participate in an online world. That social media allow us to be almost ceaselessly structured by others may go some way to explaining how quickly these have established themselves as a tenacious feature of more recent daily life (aside from the more explicit efforts of software/algorithm designers and data-harvesting interests to activate addictive modes, which has been well-documented[40]).

Rhythm, therefore, is an interesting factor in the case of structure, habits and their stabilising effects. The rhythm at which a habit occurs, and the intervals of its repetitions, will impact on how the habitual structure affects the person who repeats that behaviour. There is often much discussion in various traditions of practice about desirable regularity. I have also heard, from experienced teachers, that working out the rhythm of one's practices is an activity that is in fact part of the practising itself, rather than external to it. Making decisions about when, where, how often and how (in relation to other demands in a life) remains for practitioners a constant question. It

[39] Thrift, *Non-Representational Theory*, p. 8. Thrift's quote references the 2002 work by T. R. Schatzki: *The Site of the Social: A Philosophical Account of the Constitution of Social Life and Change* (University Park: The Pennsylvania University Press).

[40] See, for example, Jaron Lanier's many (internet) talks and books, on this topic. Or Shoshana Zubhoff's work on surveillance capitalism.

is an art to maintain tenacity, to experiment with intensities of rhythm, as well as to allow for a liveable flexibility. Habit's tendency to ripen towards routine or compulsion clarifies why the further nuances of practising matter, since they allow for a greater sensitivity and responsiveness – an intelligence regarding the place of practising, of the practice itself. This involves a continual curiosity about what happens during practising and to the life into which it is integrated.

If a particular structuring activity occurs within a cultural tradition – think of Shabbat in Judaism, of Sunday mass for Catholics, or daily prayers in Islam – it can be far easier, since the social world is organised around the expectation that the practice will be given space. Everybody is having dinner in a clean house on Friday night in Judaism, so it's just easier to do it. For those in secular contexts, this absence of cultural/religious shared practices poses a degree of challenge as to how one can find enabling structures that are not solely motivated by economic imperatives and which will be shared more widely, rather than individually stipulated every time. One is also more vulnerable, arguably, to being organised by trends which, although working to hold one temporally and to serve as shared currency, also – unsurprisingly – require 'disposable' income in order to participate.

The Habits-We-Choose, or Practices

For practising to be possible, we require a set of behaviours, or a *practice*. They may or may not have been intentionally acquired, but they will – once we move to the second criterion – be repeated *intentionally*. This may be an external envelope of repetition, such as tennis at 6 p.m. on Wednesdays weekly, which further encases the repetitions intrinsic to the activity in question (hitting the ball, collecting the balls, walking a little, serving and so on).

There is a suite of reasons why a person might take up (or have already) the behaviours which can become the basis for practising. Here are some possible ways:

- the behaviours are part of our cultural, familial or sacred/spiritual contexts, in which case they tend to be contracted rather than intentionally acquired;
- we decide that a particular behaviour will be beneficial or 'good for us' or it is recommended to us on these grounds, and we take it up initially as a kind of reparatory or 'healthy' habit;
- we are attracted to the context in which the habit tends to be practised (or to the kinds of people who practise it);

- we are aesthetically, or otherwise, drawn to the content of the habit itself or to its paraphernalia;
- after an arbitrary encounter with the particular form or set of activities, we discover a spontaneous flair for its content that is pleasing and draws us back;
- the encounter with the behaviour or activity coincides with a time of shock or disruption in our usual life rhythms (as well as existing practices) and into the gap which has appeared we slot the new behaviours in, and they take root.

Although one might assume that people take up practices as a result of piety or so-called self-discipline, there is a preponderance in the above list of inclination, wish or perhaps Ravaisson's idea of 'desire', 'obscure activity' or 'tendency'. As Sinclair clarifies, on this point, '[f]or Ravaisson, desire is not a property of the mind as opposed to the body, but is rather to be thought, as will become clear, as the prior ground of any possible opposition between the two'.[41]

Desire, in other words, conditions the arising of the binary mind/body itself. If habit, too, is inhabited by this kind of desire, we can entertain that our acquisition of new practices, or our growing investment in already acquired behaviours, may echo the movements of this tendency. We may begin learning bagpipes because we admired their bellow and the skill of the Chinese teenager playing them at a public event; we may begin meditation because, as a friend of mine recounts, there was a very attractive fellow who attended the group; we may find solace in doing an activity that one once shared with grandparents, such as baking or gardening – the examples are many. The idea that one acquires moral habits, within a kind of punitive or corrective atmosphere, is the assumption I'd wish to unsettle here. Benign practices (the ones best suited to practising), along with their intrinsic repetitions, are often also sources of delight, embodied pleasure, comfort or child-like surprise.

We can consider Ravaisson's own account of this obscure tendency, when he writes: 'Hence habit is not an external necessity of constraint, but a necessity of attraction and desire. It is, indeed, a law, a *law of the limbs*, which follows on from the freedom of spirit' (OH 57, emphasis original). A *law of the limbs* is an evocative way to name the inclination, curiosity or 'imploring' (to borrow Ravaisson's term) that might be persistent enough, in us, to prompt our interrupting our many obligations with another that we

[41] Sinclair, 'Ravaisson and the Force of Habit', p. 73.

have concocted intentionally. This must be noted against a salient feature of the background of our sociohistorical moment, where – if you ask around – everybody claims to be busy. It can be a novelty to meet a person who will not use this term in a description of their regular life; indeed the behaviour of describing one's time in this way has become habituated, irrespective of its accuracy. And if one were to inquire with those who aren't claiming to be busy, my hunch is that they will be practitioners of some ilk, who may have cultivated a stance with regard to questions of structure and time, and towards the politics of both.

If constant declarations of busyness don't necessarily bear a straightforward objective relation to a person's density of activity, the declaring itself stands out as a kind of behaviour. It might also be a kind of communication with an imprecise objective. Frequent declarations of busyness may be a response to how it feels to live under the conditions of late global capitalism/neoliberalisation.[42] I've also been coyly told that claiming busyness can be a strategy to ward off envy between peers (where, according to Agnes Heller, envy operates the most vigorously[43]), by making it seem to our similars that we are existing under far more burdens than they. Or, is it a statement in the face of how a certain density of obligation feels? The structuring that this being-obligated brings to a human life is both not insignificant and also consistently at work. Structures support the possibility of steadiness – within identity, temporality and so on – and it is due to the distracting nature of their content that we fail to appreciate the way the structuring itself works.

Humans know, whether explicitly or unreflectively, that structure helps them, or rather that an absence of structure is destabilising. On the other hand, the most ubiquitous form of life structuring available to us – namely, that common cocktail of personal and social (including 'technological') obligations (money-work, parenting, life admin, and so on) – often brings with it a certain flavour of urgency or burden and is unwieldy. We are in a bind. If I untangle myself from more of my personal and social obligations – because they seem exponential, because I feel like a rat on a wheel – then I may be (or do I fear to be?) left in the existential vertigo mentioned earlier. Without explicitly thinking it, I may worry that my 'I' could fare badly if completely deprived of these structures and so I don't risk departing from them (if their bulk, furthermore, is parental obligation, I simply won't be able, and probably don't wish, to). In the absence of other ways to structure

[42] As Simon Springer prefers to call it. See, as example, Springer, 'REPLY: Space, Time, and the Politics of Immanence'.

[43] See Heller, A Theory of Feelings, p. 40.

myself, I'm left with an unsatisfactory constellation: to remain heavily obligated *and* stabilised in the identity this provides, while still enduring the feeling that there seems to be scant space in life for surprise, accident, grace or rest to get in.[44]

In this vein, when people declare their constant and unstoppable busyness, we could wonder whether they are also, in the same gesture, posing a kind of disguised but open question. (Deleuze will elegantly say that 'need expresses the openness of a question before it expresses the non-being or absence of a response' – DR 99.) Baffled somehow by the conundrum of the atmospheres in which we suffer or endure if a little stalely, we are perhaps seeking the terms on which to formulate a serious question regarding obligation's logics.

This is where practising and practices come in.

Intentionally acquired sets of practice-like behaviours are another way to navigate this bind for which the phenomenon of declaring busyness could be a cipher. Practices that we intentionally select and mobilise provide an obligation that we have organised for ourselves; they are both (with any luck) fairly unnecessary within an instrumentalist logic as well as deeply kind. By the latter, I mean that the behaviour has no harming, or injurious effects on the practitioner or others, and therefore is suited to being repeated continuously and over long periods of time.[45]

We are also familiar with those who are also very busy due to all their 'good' habits, which seem to squash all the breathing space out of their life.

[44] Obviously, one could speculate here on the role of defences (in a psychoanalytic sense), but that discussion exceeds the scope of this chapter. That claims of 'being busy' might be a shared cultural habit *and* be a convenient trope to recruit as a defence is not unlikely.

[45] This would be a very practical way of reading what many might consider a moral imperative at the start of the second chapter of the *Yoga Sutras*. Emphasising practical approaches which constitute the path to yoga, the chapter presents the reader with the foundational (ostensibly outer) 'directive' of non-harming (ahimsa). If one practises yoga, one should begin by minimising harming. It is possible also to read this simultaneously as an 'inner' directive insofar as it is relevant to the practitioner's own encounter with the practice itself – that it be non-harming. For yoga to be possible, it requires enormous dedication and years of repetition of forms. If these are not approached in a way that minimises harm, the practitioner will simply not be able to sustain their practice long enough to cultivate yoga's 'goals'. See Sen-Gupta, *Patanjali's Yoga Sutras*, chapter II. In this way, what appears as 'moral' to a casual reader, becomes something closer to an ethics, in Spinozan terms. Non-harming will probably be that which doesn't reduce the practitioner's capacity to act. It reveals itself, therefore, as a strictly practical imperative in line with the spirit of the whole chapter.

Over-scheduling of practical tasks can be a marker of this strategy. For this reason, the idea that a practice is slightly useless or at least innocuous (rather than 'good', 'helpful', 'healing' or 'instrumental') is important.

This accounts for why there can be a double language around activities like yoga, meditation, or other modes that have been lumped onto the 'wellness' bandwagon. Start pottery classes to reduce your stress. Take up horse riding for peace of mind. Practise 'mindfulness' so that you can be more productive at work. These are slippery formulations, and, for our argument, they eschew the generative *uselessness* that certain structuring methods involve in order for practising's repercussions to obtain.

The point is not the content (which is then bound up with the concept of 'benefit') but the simple fact *of a structuring* that comes from inside.

Many people begin exercising because they want to look a certain way, or cure anxiety or insomnia. Research shows that their motivations will tend to shift over time. They will move from being so-called external to internal – from ostensible 'benefits' to 'feelings'. I take this to suggest that an honouring of our basic desires works. We may not need to transcend or to resist desires, as certain formulas might have it, but rather go very far along with them, reading them to the letter. The latter does not imply irresponsible action. The sticking-close is a technique.

To offer an example, before we move to the next section (which deals with the inflection of desire that is reluctance), the Taoist text called 'Understanding Reality', in verse 21 'On the Dragon and Tiger', outlines a resonant methodology (couched in the terms of this tradition):

> in spiritual alchemy there is a method of using the artificial to cultivate the real, using the real to convert the artificial. The method is *to go along with what one desires, gradually guiding desires, making dedicated effort on one level* to lead from disharmony to harmony . . .[46]

Practising and Reluctance

As I was writing this chapter, I found myself noting something too neat about a straightforward alignment of habits and practices. At a simple level, a habit and a practice are somewhat interchangeable, with the latter arguably also describing clusters of habits. Habit, after Ravaisson and Grosz, on the other hand, is the *methodology* of a being, which allows it to integrate the changes it must endure, to be changed by these, but to continue not in spite

[46] Cleary, *The Taoist Classics*, Volume 2, p. 87 (emphasis added).

of, but somehow by dint of, the change integrated. Habit (ontological), to be clear, as opposed to habits (ontic), is a kind of operation. Habits would seem to be what results from this operation; *we* result from it.

If habit produces us as habits, then how do practices work? Are they just the behaviours that turn out to have been what or 'how' we were 'doing' when the secret mechanisms of practising started to roll? To say something about how (if at all) practices might differ from the general category of habits (to which they technically must also belong) could go something like this:

- Practices tend to be very simple, repeatable behaviours (such as walking, sitting, preparing tea, arranging flowers) that can be mobilised via the criteria of practising; but also . . .
- Practices (in order to remain practices) tend to be behaviours within which one discovers layers of complexity and nuance, which make them less available to habit's inertias of routine (arranging flowers suddenly revels itself as not so simple after all, for example).
- Practices don't have to be aggregations of complex sub-behaviours; however, often they are (with this complexity being such that it may go unnoticed by those outside of the practice).
- Whereas habits tend to get themselves contracted and start running (us) behind the scenes, with less and less effort . . .
- Practices can often be spotted as very benign and pleasant activity that we also, for no transparent reason, resist doing.

This last point may be one way of disambiguating, in a lived sense, habits from practices. A common experience of practitioners, at least for a very long while, can be resistance, reluctance in, or simple inability in the face of, beginning the practice in each of its separate instances of repetition. Practices tend to demand effort of us in a precise way. They invite a singular and strange effort. They usually require an ability on our part to interrupt established inertias. For example, I have to learn to close my laptop at a particular time and roll out a yoga mat. This is an interruption/temporal structuring that 'I' instantiate; it is different from letting my family come home and interrupt a day of working by dint of the day's timetable rolling onwards. Practising requires an internal capacity for interruption of inertias, not just letting something else interrupt from the outside and set going, in turn, its own inertia. Practising is not the alternating of various forces of organisation. It's the effort of interrupting such incidental organisations per se.

A straightforward way to spot practices, therefore, might be when one finds a behaviour (which is objectively fun, nice, simple, pleasurable, and

with some intricacies that might invite a little effort) which one (unfathomably) often also doesn't quite want to do, or which one resists doing with startling tenacity, and then manages, and then resists, and so on. When I speak with groups of doctoral students in workshops about time and what happens to it over the course of a candidature, the tendency to resist the behaviours involved in creating the dissertation would suggest that the latter has the capacity to be transformative. Writing up research is not really habitual, and therefore once brought into being (the writing), this creation will also have 'ejected' its 'maker', who will already be someone else.

If habits do have a role in practices, it might be as subsets of behaviour within them. Often the initiation of the meta-practice itself (for a cook, embarking on the afternoon set aside for reattempting bacalao; for the golfer, getting going for a full eighteen holes) is marked by this baffling reluctance, where – on the other hand – the sub-habits of stirring, rinsing, cutting, washing produce, walking, hitting the ball, putting, and so on, can be done with some habitual ease. As hinted above, the reason for this is arguably that the 'I' of our personalities resists what practising risks opening: that is, change aside from change-as-continuity, a threat to the 'I'. At the same time, and after a certain point, the 'limbs' themselves know the movements within the practice and can get a sub-behaviour going and the details of the practice session follow. This said, if the sub-habits become too sleek and unconscious, the behaviour will just be a cluster of habits habiting themselves and might not open onto the strangeness of practising.

We can understand this interlocking, multi-levelled process as habit's ease providing space to open onto other, more obscure aspects of the practice itself. The cooking turns out not to be about cooking as we knew it, but about more and more subterranean layers of the activity, that only appear when a certain ease takes care of the explicit aspects. Without this opening into nuance, the ease would just constitute a switching off, which might be stabilising, but isn't usually transformative.

The un-habiting of that which always threatens to become too effortless is part of what practising requires. We want another time, other temporal possibilities; for this to work ontologically will require a careful navigation and wariness of habit's ease. This tendency towards 'unconscious' doing and ease is, of course, inherent to habit and it will create – as we'll see in the next chapter – our lived present.

Finally, doing or initiating the practice in company, or with a motivator for the behaviour, can either obscure (although not always) or can overcome the reluctance that I would claim is somehow also inherent in practising. Someone can be very good at doing interval training with a coach nearby,

but it will be a whole new phase of their engagement with the activity to be able to manage the same training intensity without the coach's presence. This is where intentionality enters again, and it will be a focus of later chapters.

Summary

This chapter has focused on the habit-resembling first two of the four criteria of practising – namely those in which a structured behaviour or 'practice' (as a kind of habit) is set going via intentional repetition. Ravaisson, a thinker of habit as ontological operation, has with his analysis of habit provided a clear counterpoint for what practising does. His rigorous reading of habit's operations, tendencies, internal laws and their sometimes surprising repercussions assists in a disambiguation of how practising differs from habit per se, as well as providing a close look at the mechanisms that practising so closely accompanies, but from which it remains distinct.

In this chapter, we have explored Ravaisson's theoretical position, as well as taking up the notion of habit and practising in a number of more quotidian guises. In the next chapter, the focus will shift to Deleuze's notion of repetition, its relation to various kinds of temporality, and to difference.

If we remained solely in the realm of 'good habits', various stabilities – I'd argue – would surely result. We would, however, remain marooned in the register of 'moral law' (with all its injustices) and under whose regime things change dependably in order to effectively remain also the same. In other words, with (good) habits, you only get change of the same kind. Habit's regime condemns us to change on terms that are already specified and sedimented in advance. The 'moral law', which secures a certain order of stability, also tends to shut out 'true' repetition (see below), which is the mechanism which accounts for forms of radical innovation or transformation.

Deleuze writes:

> As a result, the moral law, far from giving us true repetition still leaves us in generality. This time, the generality is not that of nature but that of habit as a second nature. It is useless to point to the existence of immoral or bad habits: it is *the form of habit* – or, as Bergson used to say, *the habit of acquiring habits* (the whole of obligation) which is essentially moral and has the form of the good. (DR 5, emphasis added)

Could Deleuze make it any clearer? Habit secures the register of generality, which is fine. It is not, however, miraculous, not surprising, not a shock, an

idea, or anything new. I would conclude this chapter with the assertion that habit is crucial. We do not wish to be rid of it; we would be ridding ourselves of ourselves. However, in the spirit of Deleuze of 1968, we do not wish for it to exhaust all that there is or could be. Habit matters, and its interruption matters too. We need to know how to take a rest from ourselves as habits. This sounds like a simple wish; it is anything but.

Deleuze's quest, in this excerpt, to articulate how a newness, or a de-sedimenting of a sedimented order (in ourselves, as the social fabric, of what it is possible to think, to feel [affect], and so on) is a timeless question. It is one that many of his contemporaries – such as Derrida and Badiou, among others – also took up from various angles.

This book proposes that practising is a mode of action and intervention in which one doesn't have to throw the 'baby' (what we *are*) out with the 'bathwater' (that which has become stale and murky). Practising enables stabilities that are robust enough to withstand the changes of transformations that shift the terms of our situations. Practising's 'habitual' aspects do enable steadiness in the face of the future's opening. This is one face of its strange capacity. In Chapter 3, we will explore the notion of repetition in Deleuze, in the hope of surfacing some convincing (as well as intricate) reasons for why this might be.

3

A Different Difference and Repetition's Three Times

Deleuze's philosophy is then beyond the demands of certainty or even any nostalgia for certainty or approximation to a secure hierarchy of outcomes.

James Williams, *Gilles Deleuze's* Difference and Repetition, p. 32

That practising (and habit) involve repetition of a certain kind, one that we can access within the everyday, is reasonable enough. We can observe its modes in straightforward ways: sub-instances of repetition within meta-episodes of repetition. Via his engagement with predecessors, Deleuze reveals this more transparent mode of repetition, which appears at the surface of habit and practising, to be both interesting and intricate.

This chapter turns to Deleuze's work on certain registers of repetition in *Difference and Repetition* (2004), exploring their operation in relation to two modes – or 'syntheses' – of time. In the first and second passive syntheses of time, we discover how even straightforward repetition, for Deleuze, has a way of ramifying its own mechanisms and producing curious, even 'paradoxical', interdependencies. This will prepare our discussion for the 'other' kind of repetition – repetition for itself – that aligns with the movements of the third synthesis, and also dovetails with the fourth criterion of practising, namely, the self-referentiality of *repeating repetition*.

This 'other' repetition is the focus of the final chapter of this book and will bring together Deleuze's reading of the operations of difference and repetition with the way these manifest and are mobilised in practising.

James Williams offers a useful framing of, and springboard for, thinking repetition in Deleuze following the latter's own explicit comments in this regard. Williams echoes our emphases so far concerning the way in which the acquired habit necessary for practising puts repetition to work

in a precise way: 'repetition is not an objective fact but an act – a form of behaviour *towards that which cannot be repeated*'.[1]

Repetition is an *act*. Williams is almost describing what practising is.

We note the emphasis on repetition as operation, rather than as nominal entity. This corresponds to how an intention to repeat functions both in the initial acquisition of a habit or set of structured behaviours and within the practising for which it constitutes the basic form. We practise because, perhaps, at some level we appreciate (or have glimpsed the fact) that life is made up of discontinuous instants, or intensities operating prior to understanding, and that 'we' ourselves are conjurations, mere effects which only appear as cohering constellations, being incessantly woven from this singularity – *that which cannot be repeated*.

In this face of this singularity, the perennial question arises: 'how to act?' in any particular instance, and more broadly, 'how to live?' Practising, which comes in the form of a constant posing or holding open of questions (or better said, a touching on the register of the problematic), can be our response to that pre-conceptual hunch. An 'answer' is: to practise, where practising is an engagement with questions per se, rather than identifying discrete answers to any particular question or pseudo-question.[2]

In the face of (being) that which cannot be repeated, repetition (as behaviour, approach, method, procedure) becomes what, and *how*, we do.

We do not repeat so as to secure within our experience a standardisation of happenings, or a consistency of feelings or sensations, skills or outcomes. Rather, our (arguably strange) attempt at an impossible repetition – Deleuze's other repetition – serves as the means or attitudinal deftness for encountering, over and over, the fact of *nothing the same*.

We don't repeat because we have resigned ourselves to life's crippling generality. Instead, when we repeat 'on purpose', we subtract ourselves, court a subtraction, from such modes of paralysis and automatism.[3] This can seem

[1] Williams, *Gilles Deleuze's* Difference and Repetition, p. 35 (emphasis added).

[2] See also Deleuze in *Bergsonism*, 'Intuition as Method' chapter, p. 13ff.

[3] This has been something regularly and often explicitly acknowledged by practitioners – for example, within the Oulipo movement the liberating effects of constraint are lauded (with constraint being a kind of structural container set up prior to embarking on the writing). Roubaud, citing Queneau, notes that the 'author who writes his tragedy in accordance with a number of rules that he knows is freer than the poet who writes whatever comes into his head and is the slave of other rules that he doesn't know'. Cited in Andrews, 'Constraint and Convention', p. 225. In Andrews's work, he usefully distinguishes between the notion of constraint and convention – which the above quote, in its dual use of the term 'rule', muddles. If I were pressed to consider

counter-intuitive. We attempt repetition – as methodology, as a species of framing technique – in order to not deflect a glimpse 'beneath' or 'through' the illusion of stability of identity and the implacability of the moral order, as Deleuze might put it.

Williams goes on to note – regarding the semblance which a common-sense reading of repetition might assume – that this kind of semblance is only enough for a 'given purpose'.[4] In other words, we generalise to achieve very practical ends. Semblance in identity is practical and useful up to a point. We have the tendency to whitewash the differences between things, because, for our everyday needs, finding resemblances helps. To see that different objects are similar as chairs may assist us to provide seating for a dinner party. For the purposes of the dinner party, our view pans out, to the register where the differences are eclipsed by general semblance, thereby allowing us to solve a very mundane problem. The assumption, at this register, furthermore, that these objects are interchangeable, one for the other, helps to organise a social gathering.

However, at another register, this assumption of semblance is not rigorous – the five chairs in a row do not amount strictly to the repetition of a case, since each chair is also different in a myriad of details, despite being also generalisable if viewed primarily in terms of its obvious and conventional function. As Williams notes, each chair also has a different past and future to each of its similars.[5] It is this usual or common-sense view of repetition – which only holds at a particular level of generality and semblance – that Deleuze, and then Williams, counter.

Repetition (of a certain ilk) – far from being the mode of the humdrum, or that which we would dream of escaping – proves to be 'rare', 'due to miracle' (DR 3) or a kind of portal to transgression or unsettling of a moral order that relies on assumptions of generality and resemblance in order to function. Deleuze writes: 'Beneath the general operation of laws, however, there always remains the play of singularities' (DR 28).

In the previous chapter, we raised the curious idea of 'being condemned to change', which speaks back to more usual assumptions about change and repetition in conventional experience. Spontaneously, we may tend to subscribe to the notion that we are locked into repetition: repeating

this distinction more, I would venture that the difference between convention and constraint follows the contours of the distinction between habit/practising that has been discussed here.

[4] Williams, *Gilles Deleuze's* Difference and Repetition, p. 35.
[5] Ibid. pp. 42ff.

errors, repeating relationship patterns, genetic and familial repetitions, the repetitions of cycles of anticipation and disappointment, and so on. What Deleuze suggests (as an inheritor also of Freud), is a more complicated and nuanced picture, in which – due to the dominance of the regime of representation – small differences-between tend to mark, and obscure, our experience. This conjures the impression that 'normal' repetition is not only ubiquitous, but is also inescapable. Under this regime, difference in itself and repetition for itself – those intriguing modes proposed by Deleuze – are mostly precluded.

Our enmeshment in a regime where everything has a concept and is represented, where we cannot think outside of concepts and representations, means that we continue to live as if repetition constrains us, and difference eludes us. However, viewed freshly from another angle, the situation may be another way around entirely.

Deleuze's work in *Difference and Repetition* does much to assist and clarify a query into and study of practising. A large part of this contribution consists in his account of the way time is made, or how it synthesises, via the operation that involves *repetition being drawn off from difference in itself, and as the first difference*. To a large extent, this chapter will work towards bringing to light the repercussions of what this means for the reader and for our query. As articulation, it is a startling one and deserves thorough exploration in terms of what it unleashes and enables for thought.

In what follows here we'll draw on the conceptual scaffolding that will assist us in saying 'practising' more rigorously. The first section, below, is titled 'Difference in Itself' and is a discussion of this strange notion and its importance for thinking into repetition in the way Deleuze uses it. The largest section below, titled 'Repetition or Three Ways to Make Time', consists of two parts, handling the first two of three passive *syntheses* or operations of making time, respectively. (This is one of the most theoretical passages of the current book, and it may not be crucial reading for every reader, depending on their interests and focus.) The final section, titled 'Practising and the Paradoxes of the Syntheses in Deleuze', begins to tease out practical aspects of practising in relation to repetition more generally, along with its relation to some aspects of the syntheses. The picture of the syntheses will be filled out in Chapter 4 on relaxation (with more on the second passive synthesis), and in Chapter 5 on repeating repetition (third passive synthesis).

In terms of Deleuze's approach, chapter I of *Difference and Repetition* is dedicated to thinking difference in itself. Chapter II extends this thinking and accounts for the latter's relation to repetition for itself and the synthesis

of time(s). Chapter III then approaches the broader, and somewhat more politicised question of representation, via the provocative notion of the 'dogmatic image of thought'. In the arrangement of Deleuze's volume we can see the enmeshment of these concepts. It is the habit of thinking (rather than the practising of thought) that enacts itself through us, and constitutes 'us', and in a world effectively committed to a dogmatic image of thought, which makes it seem as if repetition is ubiquitous and that difference is only of the kind that qualifies relations between entities that are already constituted. This is Deleuze's challenge: to provide difference with its own concept, rather than its only qualifying existing concepts.

When, however, representation no longer saturates our avenues for thought, when we can think something other alongside its practical but domineering mode, a brush with difference in itself becomes at least almost thinkable, via the miraculous and non-intuitive doorway of repetition for itself. Such encounters are likely to be intensive rather than conceptual or representable (for obvious reasons), although philosophy's task is also to think and say such things. Practising's task is to encounter them.

Due to the fact that practising also bears little relation to the regime of representation (and its investments in certain kinds of outcomes, goals, and material acquisitions and milestones), practising too has been very hard to say. As a result, it has either been framed evasively, sometimes poorly, sometimes cryptically, or has simply not been said at all.

Repetition's role in practising is more likely to be appreciated and accounted for if we can place it in relation to the ontologically revealing notion of difference in itself and the latter's relation to (or exclusion from) the regime of representation.

In some ways, practice constitutes a means for 'accessing' difference in itself – that is, intensive encounters with life – but in ways that are neither haphazard nor despotic. Practitioners, in my view, are those who are committed to interrupting their collusion with a dominant order – via radical newness, creativity-as-such – in a profound way, but who are not cavalier about what this entails.

Like a skilled practitioner's ability to do more with less effort (and, for example, less chance of injury), similarly, practising approaches the wildness of difference in itself with something more than naive hopefulness and blind infatuation. It doesn't, in other words, fetishise destruction, nor cave in to the idea that collateral damage is inevitable (because with sufficient rigour, it may not be). With this in mind, I turn now to the first two mechanisms that make this constellation plausible. The third aspect – representation – will inform the discussion in pertinent ways, and throughout.

Difference in Itself

Williams writes at the start of his chapter called 'Difference': 'The central problem of the "Difference in itself" chapter of *Difference and Repetition* is how to determine difference without defining it in terms of identity and representation.'[6] Much of Deleuze's first chapter in *Difference and Repetition* is concerned with working through the ways in which, throughout its history, philosophy hasn't quite managed to do this. Thus we have Williams's pithy summary of the challenge. Deleuze identifies that our notions about difference always track back to an identity that has to be prior. First, we have identities, and then we find differences in relation to them, or which qualify them in some way, or differences *between*.

Williams lays out the various approaches to difference from this chapter. Aristotle's notion of difference pertains to 'divisions within being: categories, genres and species'.[7] Hegel's notion of difference was 'as the never to be reached end of an expanding process of contradiction and synthesis'.[8] Both of these versions of difference position it as something we identify only after we have assumed stable identities operating (categories, moments in a process). Then, there is Leibniz with whom 'difference must be thought of as infinitely small differences', and then going further back again, Plato, for whom 'difference must be thought of as that which departs from an original'.[9] It becomes obvious that none of these (albeit great) thinkers really took up the problem of difference in itself, and how to think it on terms that were its own. The examples above, in themselves, are all just variations on a theme of difference as a mode of an identity (even a negative one).

This may seem, laid out here, quite obscure; however, a quick survey of our day-to-day lives can attest to an inability (or habitual tendency not) to think difference on its own terms. Functioning as a tenacious bias, as a concrete obstacle for thought, this slant impacts our ability to live intensively, and to see clearly and afresh the regimes of relentless 'change' and continuities born of habit in which we are enmeshed and which constitute the (version of) 'ourselves' to which we tend to subscribe. By identifying mostly with that-which-appears-to-persevere, we also maroon ourselves in this register, which although also stable, tends to be grinding, too.

Deleuze wants to clarify the operation of a more hidden, but also gener-

6 Ibid. p. 60.
7 Ibid. p. 60.
8 Ibid. p. 60.
9 Ibid. p. 60.

ative and no less tenacious, difference. Upon this difference rest identity and the possibility of representation as we know it. By dint of this *other* difference, we have the lines of differenciation that lead to the emergence of discrete and actual entities – those *things* that could indeed, eventually, be different from each other.

This kind of difference is not a nominal entity, or an adjectival mode or qualifier, but rather a kind of operation. If its movement precedes identity ('intensive individuals', or that which is differenciated),[10] then it precedes nouns and things and so on. This less obvious difference – difference with its own concept, its own movement – Deleuze dubs 'difference in itself' (DR 36ff.) and in the opening of chapter V in *Difference and Repetition*, he'll be more explicit again:

> Difference is not diversity. Diversity is given, *but difference is that by which the given is given*, that by which the given is given as diverse. [. . .] It is therefore true that God makes the world by calculating, but his calcula-tions never work out exactly [*juste*], and this inexactitude or injustice in the result, this irreducible inequality, *forms the condition of the world*. (DR 280, emphasis added)

It's easy to imagine that a proliferation of diversity (as a kind of difference-between) would be an approach to seeking creativity. But diversity belongs to the register of the already-represented. It shows itself via differences *within* representation. In this quote, Deleuze is clear that the conditioning of the world, a creation that would be 'divine', goes via this deeper difference, not via diversity. It is the operation of God's wobbly calculations that produces the world as excess, as 'remainder' – something entirely new. Diversity, as result, relies on, is conditioned by, the differentiation that operates 'beneath' representation's cladding, which covers over with extensity and quantity, with the 'forms of actualisation' (DR 235).

As Deleuze teaches us, representation is defined by, and can be spotted in the presence of, 'identity in the concept', 'analogy', 'resemblance' and 'opposition' (DR 174). It is the water in which we swim, and so it is hard to spot, especially within thought, but it can be spotted when we see these kinds of logics at work.[11]

[10] See Roffe, *The Works of Gilles Deleuze – Volume 1*, pp. 242ff.

[11] On this note, it is also interesting and challenging to write about difference and rep-resentation, and to look for and provide examples, or sometimes even illustrations, to assist the reader in relation to one's arguments. One would appear to be left vulnerable

Roffe recalls that Kant himself went some way to noting the covering over of representation's genesis as not so much an aberrant departure from thought's inherent clarity, but native to the operations of thinking itself. This is Kant's *transcendental illusion*, and Roffe notes 'thought misleads itself – and [that] Deleuze is genuinely struck by this intervention' (WGD 188). A shorthand for this is that it is not at all straightforward to avoid buying into representation's register, and therefore also into its apparent inertias. In other words, it's less a question of our personal stupidities, but rather a structural stupidity (as Deleuze delights in naming it) that is inextricable from thought itself. As Roffe notes, 'there is nothing that guarantees that we will manage to think' (WGD 188).

If we consider the so-called transformative or creative aspects of practising, it is not that practising ushers in a difference between you and yourself, that is to say, a slightly amended or improved version, when done consistently over many years, and so on. Instead, practising is the pathway via which a wholly new self comes into being or is invented (one that recasts 'self-ness' altogether). This self bears no relation (at one register) to the self-that-was. It works (to borrow from Badiou who himself borrows from a long line of thought) in a *subtractive* mode.[12] That is to say, this new self can

to the charge that the project itself falls prey to a kind of representational thinking – a 'this equals this' kind of logic, disqualifying, in this very manoeuvre, its own seriousness. The argument of the current work is that practising is an approach to behaviour, to 'living' that displays the logics that we find in Deleuze's work on difference and repetition. Practising already operates as a close encounter with Deleuzian difference and repetition. Practising is not an example illustrating Deleuze's ideas; it is not a metaphor. It is the setting to work, rather, of the operations of difference and repetition in ways that echo Deleuze's provocations and specifications, and this means that we have a lived example, a kind of pre-existing laboratory, that has used, and continues to use, difference and repetition in the ways Deleuze framed them in 1968, but without naming them in Deleuze's manner. This is an observation that arguably ramifies the non-abstract nature of Deleuze's intervention. As well as accounting for how practising intervenes at a level that is not representational, it reveals it as closer to what I'd loosely call 'ontological', the register of the problematic from which creation as change emerges.

12 Badiou explained, in a lecture to students at the Art College Center of Design in Pasedena: 'I name subtraction the affirmative part of negation. For example, the new musical axioms which structure for Schönberg the admissible succession of notes in a musical work, outside the tonal system, are *in no way deducible from the destruction of this system*. They are the affirmative laws of a new framework for the musical activity. They show the possibility of a new coherence for musical discourse. The point that we must understand is that this new coherence *is not new because it achieves the process of disintegration of the system*. The new coherence is new to the extent that, in the

simply not be accounted for rigorously via any kinds of logics of relation reliant on negations or destructions. (Badiou will claim that it exists within the horizon of negation or can be understood as the affirmative part of negation but must be subtly held distinct from it.)

At *one* register, then, the self that practises does, of course, become 'a little bit different' compared to the pre-practising self; however, on another register, this next self, emerging via the behaviours of practising, also rigorously bears a non-relation to this prior self. Simplistic negation or stabs at destruction are the more typical, knee-jerk ways in which we can grasp at change (or intensity of life). However, as one often comes to learn from repeated (clumsy) experience, and whether precisely articulated or not, these methods almost inevitably fold us back into the similar or into increments or degrees of the same. The newness or intensity emerging from practising is not a *reaction to* what was there, to the prior self; it does not grow out of it. Following Badiou, I read it as a kind of indifference to the modes or logics of that which we wish to leave behind. Likewise, the mode that may emerge as a new way (when practising is operating robustly and quietly) often has little memory of its predecessor. (Practising can, in this way, involve a kind of forgetfulness that recalls certain of Nietzsche's remarks on remembering and the unhistorical.[13])

There is a startling scene at the end of *Decay of the Angel* (1971), the final book of Yukio Mishima's *The Sea of Fertility* tetralogy. Honda, the best friend of Kiyoaki, finally embarks on a gruelling pilgrimage to find Kiyoaki's former lover, Satoko. She and Kiyoaki had had a dangerous and doomed love affair years earlier (in the first book, *Spring Snow*). After this harrowing ordeal, which the reader presumes would have marked Satoko's life irrevocably, she retreats to Gesshu nunnery, of which after many years she has become the abbess. In other words, for an extended time she has led the life of a religious

framework that the Schönberg's axioms impose, the musical discourse avoids the laws of tonality, or, more precisely, *becomes indifferent to these laws*. That is why we can say that the musical discourse is subtracted from its tonal legislation. Clearly, this subtraction is in the horizon of negation; but it exists apart from the purely negative part of negation. It exists apart from destruction.' 'Destruction, Negation, Subtraction – on Pier Paolo Pasolini', 6 February 2007 (emphasis added). Available at http://www.lacan.com/badpas.htm (last accessed 11 February 2021).

[13] 'Cheerfulness, the good conscience, the joyful deed, confidence in the future – all of them depend, in the case of the individual as of a nation, on the existence of a line, dividing the bright and discernible from the unilluminable and dark; on one's being just as able to forget at the right time as to remember at the right time; on the possession of powerful instinct for sensing when it is necessary to feel historically and when unhistorically.' In Nietzsche, *Untimely Meditations*, p. 63.

practitioner. After a long journey, Honda secures a brief audience with her, and in a quiet room he tries to raise the memory of his friend, Kiyoaki, and by implication Satoko's relation to him.

In this haunting exchange (haunting because unlike our lives, it is oddly *un*-haunted), Satoko replies that she has no recollection of someone of that name. It is an unexpected turn to the narrative, but utterly convincing. Honda is as if unmoored, since in his own life he is unable to relinquish the memory both of his friend and of the tragic love affair (incidentally, he is also a *voyeur*). Honda's preoccupation with Kiyoaki, a kind of compulsion if you like, has carried the reader through all four of the novels of the tetralogy. Honda's insistence on remembering, on remaining in-relation-to, is the pretext for the whole narrative. It is a habit, in the thrall of which Satoko, the person more directly affected by the events of the original, devastating liaison, has not remained. Presumably, she has moved on to other experiences, registers of intensity, ways of living, possible selves. To recall Williams's formula, *connect with everything; forget everything*: she has connected with (a new) 'everything' and forgotten (the old) 'everything'.[14]

The setting of the convent is then by no means an arbitrary choice for this moment in Mishima's narrative's arc and for its plausibility. It is specifically in a setting that implies intensive practising of a certain kind (meditation, ritual, prayer, work, study) that 'Satoko's' reply (for she also has a different name now) is most convincing. The reader does not suspect ruse on her part and her answer rings out with a strange, poised plainness. She has not, it seems, spent the entirety of her cloistered life within the deadlock of comparison with, longing for, or reaction to, the love affair of her youth; rather she has found a way to access the register – I'd contend – of difference in itself. Put another way, there is almost none of the earlier 'self' remaining, that fiction-in-representation from which she could differ in any usual sense.

Satoko, furthermore and from that moment on, is a powerful, but in some ways, obsolete character for this particular novel. The tetralogy, incidentally, ends soon after. She has stepped outside of the desire-loop that keeps the novel as a story identical to itself, and with the continuities that engross us. We could speculate that she has exceeded the bounds of herself, as subject-of-continuity as we usually understand such a thing. Intriguing certainly and by no means lacking in agency, her velocity dovetails with stillness, as if pure movement; she is more of an intensive field than a dependable character-with-content and set trajectory, as we normally encounter them. There could be another book entirely about her new self,

[14] Williams, *Gilles Deleuze's* Difference and Repetition, p. 5.

but it would bear almost zero relation to the narrative for whose duration Honda has accompanied us.

We can also contrast her with Honda who remains a thick and riveting character, by dint of his preoccupations, desires and flaws, which have propelled him forward in the mode of normal repetition. Practising, we can say, does not make for addictive viewing, although it might make for a life (and for deaths . . .) with an augmented quality and intensity.

The love-tormented Satoko as we knew her, or so the final scene implies, has ceased to exist, and has not been repressed. The scene is infused with a kind of sublime forgetting, or perhaps Badiou's indifference (which is not 'performative' indifference, but real indifference). A new person sits before Honda, who has no tether to that past to which he refers (and to which he has referred repeatedly, as a source of meaning for his life).

The past of this self, furthermore, does not even correspond to the past of that other Satoko. The continuity of this prior entity has come undone and bears no relation to the abbess. It is not that her experience with Kiyoaki was not vivid or important. To the contrary, it was profound. However, such strong experiences often mark their participants with the stamp of habit (which is how a being responds to change), carving a deep groove in relation to that once-was, which makes departure (radical difference) from it less and less accessible.[15] One way to read Mishima's dramatisation is that Satoko has managed to live intensively *and* to move on to other intensities, through – we infer – the technologies of a religious tradition and through the modes of practising. These have permitted an active forgetting via repetition for itself (the details of which we'll discuss in due course).

In this same vein, practising is a means for disrupting, unsettling and de-sedimenting our cosiness within a certain conception of difference. When practising, we can no longer sustain the illusion of difference-*between* as primary or exhaustive of difference's *kinds*. Too many strange things happen over the course of an established 'life' of practising. Presumed orders waver, and causality is other. Let's recall Deleuze's first approach to difference in itself in his chapter of the same name:

[15] In this vein, we can quote Nietzsche again: 'one would have to know exactly how great the *plastic power* [*die plastische Kraft*] of a man, a people, a culture, is: I mean by plastic power the capacity to develop out of oneself in one's own way, to transform and incorporate into oneself what is past and foreign, to heal wounds [. . .] There are people who possess so little of this power that they can perish from a single experience, from a single painful event, often and especially from a single subtle piece of injustice, like a man bleeding to death from a scratch.' Nietzsche, *Untimely Meditations*, p. 62.

> Difference is the state in which one can speak of determination *as such*. The difference 'between' two things is only empirical, and the corresponding determinations are only extrinsic. However, instead of something distinguished from something else, imagine something which distinguishes itself – yet that from which it distinguishes itself does not distinguish itself from it. [. . .] Difference is the state in which determination takes the form of unilateral distinction. (DR 36, emphasis original)

Let's begin with the end of this quote: Deleuze emphasises that the determination (difference in itself) is not the usual kind of reciprocal difference-from. This special form of difference involves a *unilateral* distinction. He grabs for the image of lightning, to try to help his reader with their approach to this difficult-to-think mode of difference *as verb*, difference as operation. Difference here is the very making of distinction – a force and happening.

This determination as such, which I am aligning with the term 'difference in itself', is what makes distinctions, is their very making. Therefore, it logically precedes any discrete entity in relation to which one could then find 'difference' between. Difference at this register in Deleuze is ontological insofar as its concept constitutes a means for rigorous articulation of movements of being and becoming. Difference, as it had previously been thought prior to Deleuze's project, only allowed us to be tourists in the ontic realm – the realm of various *beings* and of diversity – as opposed to being able to navigate the register of 'Being', of conditions of what is and how it becomes, and how existence moves beyond its own terms into newness. Furthermore, if we want to account more precisely for the possibility of human creativity (or as Derrida would prefer, 'invention'[16]), we also need Deleuze's concept of difference in itself.

On the point of difference in itself preceding entities, we read:

> We must show not only how individuating difference [difference in itself] differs in kind from specific difference, but primarily and above all how individuation *properly precedes matter and form, species and parts, and every other element of the constituted individual*. (DR 48, emphasis added)

Difference in itself *makes* (or is the very making-of) the distinctions that allow individuals – with identity, and which can be represented – to enter the register of appearances. Only after that is it possible to speak of specific

[16] See Derrida, *Psyché – Inventions de l'autre*, chapter 1.

differences between things, and rightly so. However, without a thinking of this 'first' difference, we misunderstand the operation of the various levels of difference and more importantly disavow identity's logical dependency, mistaking representation as prior, rather than merely a particular slant on 'things'. Our remaining within such an 'illusion' (as Williams also terms it) has marked effects on how we inhabit our actualities and impacts on the likelihood of encountering newness and real change (and perhaps of noticing real change). Articulation is, in itself, a kind of action and has its effects.

Now, in the moment of writing the current book, following decades in scholarship where thought, theory, students and readers have digested the work of Deleuze, Derrida and others, it can seem less radical to suggest an overturning of this logical, common-sense order (entities, then difference). However, it continues to be radical to really think it consistently and to live the repercussions of those conceptual labours, to allow them to infiltrate praxis, to traverse (and to up-end [bouleverser]) a life.

The following statement from Deleuze makes clear that this upheaval in thinking is no small thing, particularly in the face of philosophy's history and dispositions:

> That identity not be first, that it exist as a principle but as a second principle [. . .] that it *revolve around the Different*: such would be the nature of a Copernican revolution which opens up the possibility of *difference having its own concept*, rather than being maintained under the domination of a concept in general already understood as identical. (DR 50, emphasis added)

Deleuze is explicit: the aim would be to think difference on its own terms. This new thought of difference – difference in itself – does not find and name what is different between existing concepts. It is a concept *in itself*. Arguably, it designates the name of how we can begin to think that which hasn't been imagined yet, the mechanism for change that isn't modification within an existing regime. This novelty doesn't construct itself as a variation on an existing concept or entity. Its differentiation, as movement, is unrepresentable and prior to other concepts.

Here, we can return to the question of practising and the unusual constellation that it enables – namely, courting transformation while also cultivating (or not undermining) stability at certain registers. The unusual nature of difference in itself is echoed in this logic. A practitioner, as someone often engaged in the operations of practising, tends over time to be less and less busy with any particular identity. They do not shore up identity for

themselves via logics that seek difference-between or semblances. Practising tends to dilute reliance on, or recourse to, identity. Practising thins out the habit of identity per se. It could be called the discipline of forgoing, or having a looser relation to, representation's crutches.

At the same time, and perhaps contrary to what might be anticipated, neither is the practitioner particularly 'flimsy' or unstable. It is not so much that their *self* seems precarious or underdeveloped, rather that it is increasingly non-relevant. They are less busy with that activity – self-ing as a kind of doing that must be done, maintained, attended to. In other words, practitioners are not those who have damaged or weak egos, to borrow the language of some lineages in ego psychology. Practising involves a non-relation, or lighter relation, to identity, more than anything – a stepping over or past it, without energy directed at its refusal or negation. (If we distinguish *detachment* from *non*-attachment, the former would therefore not be its mechanism.) Sometimes, too, practising will lead people to grapple significantly with their identity, on the way to unsettling the givenness of identity per se.

'Transformation', on the other hand, is a tricky term about which we can say more later. What would transform? Did Satoko 'transform', in so many words? Perhaps we can say that in the field of practising, *there is* transformation, but locating precisely who or what is transformed remains elusive. The transformation, or its marker, is the dropping out of the 'who' that maintained itself as self within the continuity of the habitual present.

Following some discussion of Nietzsche's eternal return – a concept that I'll explore in subsequent chapters – Deleuze links Nietzsche's Übermensch (Overman) with the notion of transformation: 'the Overman is defined as the superior form of everything that "is". We must discover what Nietzsche means by noble: he borrows the language of energy physics[17] and calls noble that energy which is capable of transforming itself' (DR 51). Deleuze hints at something material but which is not of the order of entities. That which transforms itself in this quote is energy or *borrows the language of energy physics*; 'things' or 'subjects' are de-emphasised. The Overman is a form or an operation. We can note, on this point, that the narrative arc of Mishima's tetralogy includes a poetics of reincarnation – a metaphor for something non-entity-like both enduring and transforming, carried across discrete lifetimes.[18]

[17] As in the noble gases: helium, neon, argon, krypton, xenon, radon.

[18] In a public lecture in Melbourne at the Australian Catholic University (ACU) in 2018, Professor Françoise Dastur mentioned that lay Western understandings of

Perhaps in the case of 'things', or entities within representation, we can at best move them around within sets of existing relations, which may not really constitute newness at all. To find wholly new relations between such things, for energy to transform itself, would be newness of another order. The helps us to understand better James Williams's framing of the question to which Deleuze's thought responds: *how to create without representing.*[19] To which I would add: *how to let fall away without destruction?*

There is a kind of creation that does not proceed via images, representations; it does not erect itself atop existing categories, nor does it destroy, as if to 'make room'.[20] Without some way to say the movement of difference in itself, it remains difficult for thought to think precisely this kind of radical creation or change – a creation that brings into actuality relations and intensities that were previously precluded from representation's order.

Straightforward, common-sense attempts to make change happen, to force creativity (which is something other than working with structural constraints), or to get out of the ruts in which we find ourselves are unlikely to function as we'd imagine or wish. The difference sought may not be accessible via these avenues, allowing – as they do – only a proliferation of differences-between, condemning us further to a particular register. The latter is a register that ensures stability but which, in turn, may be accompanied by a dulling of intensities. It is, of course, the register of habit (and as we'll shortly read, a mode of time). We can ask, perhaps: how could we court this kind of difference in itself if common-sense means of 'making change happen' are unsuitable and ineffectual, but also without foregoing too much stability? Part of the answer is the focus of the next section, along with the other major preoccupation of Deleuze's work: *repetition.*

Repetition or Three Ways to Make Time

Just as Deleuze presents two orders of difference, so too do we find two orders of repetition being explored in his 1968 work – for ease, let's say they are the

rebirth tend to imagine that what goes on and on, rebirthing, is a discrete entity, whereas – she emphasised – it is not the *atman* as permanent entity that is seen to rebirth. Her phrasing recalled me to the fact that it is rebirthing *as a process* that goes on and on. The action or verb itself is what endures and insists. That-which-repeats, as we know also from Deleuze, is not the entity as such. 30 May 2018 (private draft copy).

[19] Williams, *Gilles Deleuze's* Difference and Repetition, p. 47.

[20] See generally Badiou, *Being and Event*; and also 'The Subject of Art', *The Symptom*. Available at http://www.lacan.com/symptom6_articles/badiou.html (last accessed 11 February 2021).

common-sense order of repetition, along with the other less usual, or mirac-
ulous, kind. Chapter II of *Difference and Repetition* embarks on a discussion
of repetition in its various guises, which enables Deleuze to clarify the three
ways that time is made or 'synthesised' (DR 90ff.). Let's turn now to each
of these: the living present; the deep or a priori past; and the pure empty
form of the future. They map to aspects or moments of practising. The latter
would then, arguably, constitute a way into, a skilfulness in the face of, or
a lived commitment to accessing more than the most readily given, that is
habitual, temporality.

(i) First (Passive) Synthesis of Time

Deleuze begins by pointing out, after Hume, that repetition – strictly
speaking – does not reside in the object that repeats (DR 90ff.). It is not,
in other words, a quality of the object. One might casually assume instead,
however, that repetition involves the same thing recurring or reiterating.
If that were so, again, it would depend on something outside the object to
witness the sameness or consistency from instance to instance, and thus one
has the question of where exactly repetition occurs, and what its nature is in
relation to the object.

From the point of view of the repeating thing – such as the tolling of a
bell – there is only each individual and discontinuous instance. In this way,
as Deleuze will emphasise, repetition cannot be *in itself*. For repetition, as it
is generally understood, to emerge, it is necessary that there be this outside
perspective, or a contemplating 'mind' that draws a difference (a new thing)
from the unrelatedness of each *clong, clong, clong,* thereby *ascribing to them a
pattern of repetition.*

In this typical, common-sense notion of repetition, it turns out to occur
in the mind of what Deleuze agrees to call a contemplating subject or 'soul'
(DR 94). Let's imagine this 'soul' or 'subject who contemplates' as a kind of
field, or capacity for retention, one which contracts those unrelated, disap-
pearing instances together, to draw off from them a *difference* which in fact
occurs 'in the mind'. Deleuze will say that this operation – discontinuities
being-contracted together – constitutes a synthesis of time called the living
present (DR 91). The mind, or what Deleuze will call – after Hume – the
imagination (DR 90–1), can be viewed as a sensitive plate that is able
to retain one instance when another comes to replace it. Sensitive plate,
'imagination', 'mind' arguably all offer ways for the thinker to grasp the *oper-
ation* of 'contracting', 'holding', contemplating. The 'mind' or 'imagination'
stands in for a function here, not a prior thing with identity.

Relevant to a consideration of practising and its mechanisms, it is note-worthy that the difference drawn off is not *done by* a contemplating mind, which would imply an activity or a state of agency, commonly understood, but occurs rather *in* the mind-that-contemplates (the operation), with the latter's idea serving as a condition or field in which the contraction of instances can take place. This might recall my earlier speculations on what is happening with the person who-might-once-have-been-Satoko. 'She' seems to have become a multiplicity of perspectives, like a field or context – more aligned with the sheer verb of contemplation, than with the common-sense notion of a discrete subject (as primary) who contemplates (as secondary function). I wonder if she (as character) can be grasped as also a field of con-templation, that is to say, her subjectivity ceases to reflect only usual notions of what a subject is. She becomes multiple, but not disintegrated.

This drawing off of a difference from the contracted series of (in themselves) unrelated instances constitutes the very substance and concealed mechanism of repetition, as we normally understand it. Deleuze clarifies: it is not so much that we *have* the habit of contracting instances together, but instead that this contraction *is* what we are. This kind of repetition, which is bundled up with habit – the habit of contracting discontinuous instances together – is the same operation that makes the first mode of time: the living present.

By calling it a 'synthesis', we can understand Deleuze to be saying that *this operation makes this kind of time* (DR 91). He introduces us to the fantastic notion that time is less *given* than *arising* by dint of a thinkable operation, one which aligns effectively with habit (after Ravaisson and others, as we've seen in Chapter 2).

Without habit's mechanism (as a mechanism subtending more gross examples of habit and involving the exact, same basic operation), we do not have a living present. There are many examples of people – after trauma, for example, or other severe disruptions to habitual continuities – where it is not merely poetic to say that they have lost, or have unpredictable, access to a living present.

The present as we know and live it – as palpable stretch (with the past 'just gone' and the future 'up ahead') – is produced or synthesised out of the very same mechanism which (if we recall the preceding chapter) allows *us* too as cases to cohere and continue. It's another way of saying that time and being rely on the same mechanism – that of contracting 'changes' or teem-ing differences out of which repetition, as first thinkable 'notion' (that is: *a* difference), comes.

Difference and repetition turn out to be crucial in making time and fostering 'our' continuity, in a mode of time called the present. Habit and

its repetitions reveal themselves to be the mechanisms thanks to which a stretch of present – with us as cases within it – can arise and continue to be synthesised.

The First Passive Synthesis determines time in the following way:

> Time is subjective, but in relation to the subjectivity of a passive subject. Passive synthesis or contraction is essentially asymmetrical: it goes from the past to the future *in the present*, thus *from the particular to the general*, thereby imparting direction to the arrow of time. (DR 91, emphasis added)

With the first passive synthesis we are always in its present, just sometimes in a past or a future aspect of that present. This is a crucial factor for practising, since it has as much to do with futurity and a vast kind of pastness as it does with stability in the now of the living present. A core contention of this book is that practising includes our access to the latter (and intentionally cultivates the stability it entails) while also allowing access to other temporal modes.

The first passive synthesis operates at the level of *particularity/generality*. Generality marks the register of difference as we've tended to know it prior to Deleuze's intervention (difference-between). Deleuze discusses throughout *Difference and Repetition* how generality is bound up with the common-sense mode of difference which dominates thought – we are always *generalising* what appears from clusters of particularities that preoccupy us. Via generality and its particulars, we end up with the useable, if always-smeared, categories for life (animals, women, locomotives, political parties, and so on), but not necessarily the more precise means for intensive life.

This pairing of particularity/generality will be used as a counterpoint through *Difference and Repetition* to the other pairing of singularity/ universality. Singularity eludes our habitual mechanisms due to its (non)relationship to representation, and universality as a result tends to dip beneath our means of conceptual capture, apparently unthinkable. Difference-in-itself and repetition-for-itself have to do with this latter pair.

In the habitual present, 'the arrow of time' has a clear direction; it always moves from lived particulars – which then slip into the recent past of the 'just been' – to conjure an anticipated 'future' which we can only generalise. Together these constitute the crucial ingredients of (stability in) the present. To have a present means that my time includes a host of (often) benign enough recent pasts (waking, preparing tea, putting clothes on, which behave as one expects them to; walking to the table, which also

behaves as expected), and these can be projected into an anticipated future mode of this same present (leaving the table, and predicting a general notion of a day ahead with some meals, some tasks, expected encounters with close people, and a day's end including – if one isn't living in a zone of conflict – safe-enough sleep, and so on. As Grosz makes clear, habit's nature is to integrate changes,[21] to make them grist for its mill, and as long as the change is able to be included, habit prevails. One day the clothing is all in the wash basket, or one day I learn the house is to be demolished, and so I will have to organise a new place for the table, etc.). To have a living present with these particulars (with changing particulars that can be integrated mostly), as well as generalities, is both robust as mode *and* not to be assumed. One only has to consider life in war zones, where fewer of these particulars and generalities are certain, or scenarios when the changes become unable to be integrated by the organism, to appreciate that the living present – although 'usual', 'typical', 'habitual' and as Deleuze would say foundational (DR 101) – arguably is not given or not given wholly or reliably, in every conceivable circumstance. To have a living present is also a privilege. At the same time, humans are remarkable at integrating changes which, if considered in advance, would have seemed too much, or beyond integration.

Each of time's modes has to be made and, therefore, can *fail* to be made well, if its conditions are threatened or unavailable. To lose the habitual present entirely would be very serious – however, it is less unusual for it to synthesise, on certain occasions under certain conditions, less *well*. Its consistency can be compromised. What a trauma therapist might be doing with a client/patient, in other words, is to assist them in recovering the possibility of a reliable living present.[22]

The first passive synthesis occurs through contemplation, or contraction – that is, by dint of the mechanism of habit, in the retentive field of the imagination, done by no subject at all. In a poetic passage, we read: 'We do not contemplate ourselves, but we exist only in contemplating – that is to say, in contracting that from which we come. [. . .] To contemplate is to draw something from' (DR 95). What might Deleuze be intimating by the phrasing 'that from which we come'? The obvious reading is simply that we contract unrelated differences, and in this contraction a mode of time is synthesised with us as part of this mode. By extension, though, 'to contemplate' becomes a foundational verb upon which existing depends – the

[21] Grosz, 'Habit Today', p. 219.
[22] My thanks go to Anne-Laure Couineau for discussions from a clinical perspective on this question.

possibility of something contracting into a distinct entity – and this doing is distinguished from any active ('wilful', 'conscious') action. Williams offers this reading, wherein he emphasises both the non-conscious nature of this contemplation, and also that it is not the sole tendency of humans alone:

> [this] contraction of previous instances in later ones, thereby creat[es] an *expectancy*. This contraction is passive in the sense that we do not have to think consciously about it for it to take place. [. . .] It would, therefore, be a mistake to associate expectancy solely with the experience of human subjects. Rather, it is the property of *passively acquiring an unconscious relation to the future*.[23]

Williams's offering of the term 'expectancy', as another rendering of Patton's 'anticipation', supplements the latter helpfully.[24] Together they give a vivid sense of the movement, neither willed nor conscious, of how our habit-of-continuing comes to operate. We *expect* that we will continue as a case; and this expectation conforms to what we know about habit.

Williams emphasises that in the case of the first synthesis, it is not expectancy in relation to any particular event X, but only a generalised sense that things will go on – in other words an expectancy of futureness-in-general.[25]

Some pages later, Williams also clarifies brilliantly an aspect of the first synthesis, which links us neatly back to our broader question of repetition. He writes that Deleuze claims that:

> any interaction with an actual thing is accompanied by the expectation that the thing will maintain some degree of consistency. The expectation depends on a contraction that must be based on repetition – a thing is not sensed *unless it is sensed as repetition*.[26]

Linking back to the discussion above, in relation to losing a sense of a living present, Williams's emphasis on the obviousness of our expectation of consistency and continuity helps to dramatise a feeling of this expectancy that underpins the majority of experience. Other syntheses can be thought in relation to this first one, which 'means that we do not have a complete understanding of the later process without understanding its relation' to the

[23] Williams, *Gilles Deleuze's* Difference and Repetition, p. 94 (emphasis added).
[24] Paul Patton is the translator of *Difference and Repetition* into English.
[25] Williams, *Gilles Deleuze's* Difference and Repetition, p. 94.
[26] Ibid. p. 96 (emphasis added).

first synthesis,[27] even though – which will be the curious thing about time – the first synthesis will turn out to be not quite logically prior. It's more that we need to think it first, in order to retroactively access another mode of time: the deep past.

Before we move to a discussion of this second synthesis, also passive, it is worth considering the active mode that erects itself on the foundation of the first passive synthesis. Due to the workings of generality and its particulars, a further synthesis occurs which is responsible for the arising of representational orders of understanding and memory.

As Deleuze teaches us, the first passive synthesis constitutes a stretch of living present, in which the past is an immediate one 'of retention' and the future an immediate one of 'anticipation' (DR 92). 'Resting on' this first synthesis, we discover a more 'active' synthesis, and one that's easier to intuit from lived experience. This active mode of the first synthesis is marked by a change in inflection between the kind of 'past' and the kind of 'future' that operates and pertains to the function of representation introduced above.

Deleuze explains:

on the basis of the qualitative impression in the imagination [first passive synthesis], memory reconstitutes the *particular* cases as distinct, conserving them in its own 'temporal space'. The past is then no longer the immediate past of retention but the reflective past of *representation*, of reflected and *reproduced particularity*. Correlatively, the future also ceases to be the immediate future of anticipation in order to become the reflective future of prediction, the *reflected generality* of the understanding. (DR 92, emphasis added)

There is a pleasing symmetry to the thought explored in the above quote, and it will become clear as we tease out Deleuze's explanation. First, the capacity of memory works on the immediate past of retention, takes up its many particularities, and preserves them. Arguably, this repeats to some extent the operation of the first passive synthesis, which is done again, and it becomes active. This more active synthesis constitutes memory, the retaining-again of particularities, synthesising the particulars of a past of representation. (This speaks to considerations of the long-established (re) constructive nature of memory.) Furthermore, except under unusual circumstances, what we call memory seems effectively to have always already worked on the immediately retained past (which we can't quite access,

[27] Ibid. p. 95.

Table 1

	First passive synthesis (sub-representative)	First active synthesis (representative)
'Past' aspect	Immediately retained particulars of the just-been	Represented particulars of memory
'Future' aspect	General anticipation (of continuing as a case)	Represented generalised prediction and its understanding

since it is sub-representational – DR 106). This working-on constitutes a *representation* of the immediate past.

Furthermore, in terms of the future aspect of this more active synthesis, we see that the activity of understanding (the re-anticipation of the anticipated future) constitutes a future of *prediction*. Prediction, here, is shown to be general. We have vague (read: imprecise) notions of what's up ahead for us in our lives. That which is anticipated in the living present is worked on and from this is produced generalised predictions. This future, therefore, accords well with our capacity for both fantasy and pessimism, in that it is neither especially detailed nor clear. An appreciation of the essentially general nature of this mode of time, which – together with the passive aspect of the synthesis – predominates in our quotidian experience, arguably accounts for particular tendencies in relation to fantasy and pessimism. When a further operation of active contraction is worked on the passive synthesis of retained past/anticipated up-ahead, we end up with representations constituted by the detailed *particularity of memory* and the *generalisations of predicted understanding*. The latter are, of course, conjurations synthesised via the operations of repetition, that is, via the same operations involved in foundational habit, repeated at another level. Where the passive syntheses are sub-representational, the active syntheses constitute representation as we live it, and are mostly all we can access. We sift the particulars of our memory and we joust with the predicted generalities that seem to be so obviously and 'naturally' up ahead for us.

Table 1 shows this shift from the first passive, to the first active, synthesis.

Turning now to the question of practising and its relation to time(s), in the various fields of meditation practice, there can be an emphasis placed on the so-called present, and a vocabulary in teaching along the lines of *being present*. It is perhaps interesting to speculate that this emphasis arguably implies some relation to the first synthesis. The aim, perhaps, in these vocabularies, of this focus on the present might be explained by viewing it as part

of a set of experimental instructions, for prising oneself away from the active synthesis (or pausing just 'before' its mechanisms kick in). The active synthesis's reliance on memory and understanding, which together produce the past of *representation* and a future of *prediction*, could be something that meditation is either curious to peek behind or (more plausibly) keen to encounter viscerally, in terms of the structural inaccessibility of the mode which subtends it. The pedagogical thrust of such instruction is perhaps to encourage the practitioner, through the experiential aporia (impasse) of the imperative 'Be present!' (that is: *access the first passive synthesis! go on, have a go!*), either to refine their sensing of layers beneath this active one (if at all possible), or to encounter the impossibility of access. Via this 'failure', a coming to terms with our marooned-ness in the register of representation might occur, inviting a kind of deconstruction both of the representations that bind us, and of predictions which are either illusory or frightening. These deconstructions in practice would be less 'understood' than lived experientially.

The disadvantage of this instruction is that it can be misread as a description of what is possible, as something to be attained simplistically, and this – in many cases – can tend to have the unfortunate result of producing in the newer practitioner only a sense of failing at a task, and the sense that it is somehow morally desirable to be present. This risks landing the practitioner back in yet another version of a 'moral order', and generalised laws. In other words, to read a curiosity about present-ness (and therefore time more vastly) as the descriptive name for an outcome misses the playfulness that the instruction could provoke.

Play around with the present! might be another way to achieve this, especially if the idea of play evokes the way that practising arguably always involves research into time's mechanism.[28] The next chapter explores the role of relaxation, as the third of the four criteria. If 'be present' is shorthand for 'find your way back to what lies beneath all your representations and predictions' – namely the first *passive* synthesis – then to do this would have to involve relaxing the activity, or at least dominance, of both a certain memory and the understanding, since these, as Deleuze clarifies, are by definition active modes. Finally, then, the obvious problem with 'Be present!', when it is not encountered in a pedagogical context that supports its operation as a scaffold for experimentation, is that it just provokes again

[28] When I've had the chance to speak with very serious meditators – those who have been mediating for thirty years or more and for several hours per day – this is what they report: direct encounters with the layers of passive syntheses that go on beneath active memory and understanding.

the doer in us. We may be stimulated by it to respond to its 'order' with a compliant (re)action. In this way, it can exile us within the active synthesis more, and if it were the passive syntheses of the present that we wanted to access – by definition *passively* – then it may obstruct the atmospheres conducive to that slip to a rarely accessible register. It's a delicate undertaking. Another way to read the instruction 'Be present!' would have it intend and exhort a more intensive engagement with sensation. This, as Deleuze discusses in chapter III of *Difference and Repetition*, can launch us on the path to thought itself.[29] Furthermore, as Deleuze cites the Nietzsche from *Untimely Meditations*: 'Thinking actively is "acting in a non-present fashion, therefore against time and even on time, in favour (I hope) of a time to come".'[30] To act (up)on time as what constitutes thinking: this would return us to the work of practising – whether this be via philosophy or other guises of behaviour that act (up)on time.

Thus, the (living) present, whether in its passive or active inflection, is not the only way time synthesises. *Practising is interesting for the very reason that it invites encounters with all the syntheses of time*. Practising begins, as we've seen, via the portal of habit and its shapes but, once up and running and accompanying habit but with uncommon intentions, it drifts into other temporalities, acting on time in untimely ways. The second passive synthesis is one of these.

(ii) Second Passive Synthesis of Time

Parvati said to Siva: 'Please explain. Pleasure leaves no memory . . . Yet Kama, Desire, is also called Smara, Memory. Indeed, it's as if that were his real name. Or at least that's the name I always use for him.'

Roberto Calasso, *Ka*, p. 110

In this quote from Calasso's *Ka*, Parvati wonders about the relation between the way pleasure leaves no memory and how the latter can (at once) take the same name as desire. This is very relevant in practising, since the latter is primarily about pleasure – or following the lines where desire runs paral-

[29] 'It is true that on the path which leads to that which is to be thought, all begins with sensibility. Between the intensive and thought, it is always by means of an intensity that thought comes to us. The privilege of *sensibility as origin* appears in the fact that, in an encounter, what forces sensation and that which can only be sensed are one and the same thing, whereas in other cases the two instances are distinct.' (DR 182, emphasis added)

[30] Deleuze, *Nietzsche and Philosophy*, p. 107.

lel to a plainness without irritation – and which is difficult to 'remember' since it doesn't quite happen at the register of what can be represented). At the same time, desire – Parvati notes – is sometimes called memory. This observation is astute and arguably very Deleuzian. It brings us to the second passive synthesis, that of a kind of memory – the deep past – which bears a strong relation to atmospheres that we might deem erotic, atmospheres that are often precluded from habitual time(s).

We can begin by saying that if the first passive synthesis is a mode of time in which the past and future are *dimensions of the present*, then for the second synthesis the present and future will be *dimensions of the past*. All three syntheses, incidentally, have this basic structural pattern in common. (The third synthesis, then, has the past and the present as *dimensions of the future*.)

This second synthesis is thus called, but its 'secondness' is not a simple matter (Deleuze also refers to it as 'primary'.[31]) Its secondness is perhaps more in reference to an order in which it's easiest to think through and about temporality. I see it as logically second, if not really chronologically second (since chronology as reference wobbles if we are working in the weave of temporality itself).

In other words, if there is an entry point for grasping time and how it is 'made', the first passive synthesis can be a manageable way in. With this synthesis, one can work from some factors seemingly 'given' in the world. We see Bergson begin with it, in *Matter and Memory* (1896),[32] and Deleuze in his own account. Going from 'first principles' (difference, repetition), an accessible account of one mode of time can be derived tracking a process involving the contraction of instants which creates the stretch of the living present. Once made available to thought, via this set of initial and tangible enough axioms, there are logical fallouts from this living present and its mechanisms. Only after thinking the living present, along with habit and contraction, are we in a position to approach the more subtle and paradox- ical ideas from which we can build a picture – albeit still an evasive and difficult one – of the mode of time that logically precedes or grounds the possibility of a living present for Deleuze, including 'presents' that pass and an account of the direction of the arrow of time.

In *Difference and Repetition* – while clearly attributing the possibility of appreciating the second passive synthesis to Bergson's detailed efforts in *Matter and Memory* – Deleuze does not rehearse for his reader all of the arguments of this seminal text for his audience, having explored Bergson's

[31] Deleuze, *Bergsonism*, p. 53.
[32] Bergson, *Matter and Memory*. Hereafter referred to as MM.

work in the 1966 volume, *Bergsonism*. (The latter appeared two years prior to *Difference and Repetition*.) For the present reader, perhaps less familiar with Bergson, it may be helpful to revisit some of his offerings which concern a particular understanding of matter, and which have repercussions for our conception of memory. Indeed, they result in two kinds of the latter.

Bergson's lengthy argument in chapter 1 of *Matter and Memory* culminates in an account of matter (or reality) that bears on memory (or we might say 'contraction') for its comprehension. That which habit (as *bodily* habit of action, for Bergson) contracts, that which we then gather together subjectively in duration, would be matter. Matter, then, is retroactively derived. It is *that on which memory operates*: a multiplicity. He uses the term 'vibrations' (MM 70), where after our readings of Deleuze we might read instants,[33] elements or cases: 'What organism is not made of elements and cases of repetition . . .' (DR 96). At the end of Bergson's chapter dedicated to providing an account of 'what our body means and does' and of matter, we read:

> The qualitative heterogeneity of our successive perceptions of the universe results from the fact that each, in itself, extends over a certain depth of duration, and that *memory condenses in each an enormous multiplicity of vibrations* which appear to us all at once, although they are successive. If we were only to divide, ideally, this undivided depth of time, to distinguish in it the necessary multiplicity of moments, in a word to *eliminate all memory, we should pass thereby from perception to matter, from the subject to the object*. (MM 70, emphasis added)

In order to isolate what matter might be, it is necessary to acknowledge how memory is inherent in what we know as perception, and then to subtract the former. What remains logically, once the operation of memory and its 'condensation' is withdrawn, is what could be known as matter, the object.

Bergson then goes on to explain that there must be, then, two types of memory. In a moving passage, where the distinction begins to take form, he writes:

> To call up the past in the form of an image, we must be able to *withdraw ourselves from the action of the moment*, we must have *the power to value the useless*, we must have the will to dream. Man alone is capable of such an effort. But even in him the past to which he returns is fugitive, ever on the point of escaping him, as though his backward turning memory were

[33] For example: Deleuze, *Bergsonism*, p. 51.

thwarted *by the other, more natural, memory*, of which the forward move-
ment bears him on to action and to life. (MM 82–3, emphasis added)

The 'natural' kind of memory, that which is bound up with bodily habits,
'bears [us] on to action and to life'. This first memory is able to condense
matter's instantaneous and successive vibrations into something 'all at
once', as an 'undivided length of time' – into *durée*, duration, a presently
lived time.[34] This memory does not arise, for Bergson, due to 'images in the
brain', or if so, only if 'image' in this sense is understood as resulting from
pathways of action, of reactivity, of filtering and response – the discernment,
in other words, of our 'consciousness'. Here we have the role of bodily habit,
and as Grosz has emphasised in her reading of Bergson's take on habit, the
capacity of the organism to integrate change. Echoing discussions in the
previous chapter here, we read Bergson's own words:

> Yet our whole life is passed among a limited number of objects, which
> pass more or less often before our eyes: each of them, as it is perceived,
> provokes on our part movements, at least nascent, *whereby we adapt our-
> selves to it*. These movements, as they recur, contrive a mechanism for
> themselves, grow into a habit, and determine in us attitudes which auto-
> matically follow our perception of things. This, as we have said, is the
> main office of our nervous system. The afferent nerves bring to the brain
> a disturbance, which, after having intelligently chosen its path, transmits
> itself to motor mechanisms created by repetition. Thus is ensured the
> appropriate reaction, the correspondence to environment – *adaptation*, in
> a word – which is *the general aim of life*. (MM 84, emphasis added)

So again, habit ensures our ability to adapt, which is the *general* aim of
life – the organism 'contrives a mechanism'. Such a habit might be, as in
Bergson's more palpable example, learning a lesson by heart. This memory
does not involve a kind of storage of 'images as files' cerebrally, but rather –
at this first level for Bergson – is an action (coinciding in this regard perhaps
with Deleuze's active synthesis of memory) at the level of bodily response.
Our first memory, for Bergson, is constituted by our *action(s) in response* to

[34] Deleuze echoes this in his own way in *Difference and Repetition*: 'each disturbance or
excitation, is logically independent of the other, *mens momentanea*. However, quite
apart from any memory or distinct calculation, we contract these into an internal
qualitative impression with this living present or *passive synthesis*, which is duration'
(p. 92, emphasis original).

encountering the world. This register of memory in Bergson is an action, not an archive.

On the role of repetition for this 'habitual' memory, he writes:

> Repetition, therefore, in no sense effects the conversion of [habitual memory] into [that which is incapable of being repeated: recollection]; its office is merely to utilize more and more the movements by which the first was continued, in order to organize them together and, by setting up a mechanism, to create a bodily habit. (MM 83–4)

All of this is familiar enough, given the ways of subtended habit and the active synthesis of memory that is erected upon it. What is new, though, and which brings us to Deleuze's second synthesis, involves this other kind of memory, and for Deleuze, other kind of time. He writes: 'If *Matter and Memory* is a great book, it is perhaps because Bergson profoundly explored the domain of this transcendental synthesis of a pure past and discovered all of its constitutive paradoxes' (DR 103).

The paradoxes are not insignificant. Jones provides an elegant synopsis of their consequences, in his account of 'involuntary memory' in Bergson. He writes:

> involuntary memory does not refer to a 'no longer present' moment but a pure past (in a sense all the iterations of a possible experience) that serves as a transcendental precondition for time's passage, and thus constitutes the very *being* of the past itself. This past does not follow the present that it supposedly was but coexists with it, insisting as an ontological reservoir that allows presents moments to pass without itself passing, subsisting as the coexistence of all moments.[35]

Bergson himself also offers a poetic account of spontaneous recollection (also called involuntary memory) and of the pure past associated with it. Note that the first line, from the perspective of practising, is crucial:

> *And a living being which did nothing but live would need no more than this.* But, simultaneously with this process of perception and adaptation which ends in the record of the past in the form of motor habits, consciousness, as we have seen, retains the image of the situations through which it has successively travelled, and lays them side by side in the order in which they

[35] Jones, 'Marcel Proust', p. 106 (emphasis original).

took place. Of what use are these memory-images? Preserved in memory, reproduced in consciousness, do they not distort the practical character of life, mingling dream with reality? They would, no doubt, if our actual consciousness, a consciousness which reflects the exact adaptation of our nervous system to the present situation, did not *set aside all those among the past images which cannot be coordinated with the present perception* and are unable to form with it a *useful* combination. At most, certain confused recollections, unrelated to the present circumstances, may overflow the usefully associated images, making around these a less illuminated fringe which fades away into an immense zone of obscurity. (MM 84–5, first two emphases added)

That which Bergson calls consciousness 'sets aside' or excludes those memory-images 'which cannot be coordinated with the present' and are not 'useful'. While consciousness here is aligned with habitual 'memory', there is another zone of obscurity – a hazier periphery – where the less 'useful' memory-images come to reside. Bergson reminds us that '[s]pontaneous recollection is perfect from the outset; time can add nothing to its image without disfiguring it; it retains in memory its place and date' (MM 83). This memory is essentially incapable of being repeated (in any usual way).

Linking very clearly the two orders of memory, Bergson explains:

No doubt they are dream-images; no doubt they usually *appear and disappear independently of our will: and this is why, when we really wish to know a thing, we are obliged to learn it by heart*, that is to say, to substitute for the spontaneous image a motor mechanism which can serve in its stead. But there is a certain effort *sui generis* which permits us to retain the image itself, for a limited time, within the field of our consciousness; thanks to this faculty, we have no need to await at the hands of chance the accidental repetition of the same situations in order to organize into a habit concomitant movements; we make use of the fugitive image to construct a stable mechanism which takes its place. (MM 85, emphasis added)

Spontaneous recollection falls outside of our field of access unless we integrate it via habit's repeated movements into a 'stable mechanism' which enables willed access. For a writer, this might be the writing of a poem to capture a fleeting episode, and the subsequent forming and rereading of that poem, laying it down in accessible memory. Or, to take Bergson's example of learning the poetry of others: the first time we read a work (and being without unusual capacities such as 'mental photography'), it will not remain

accessible to conscious recall. This initial reading (retaining its date and place) will insist in the archive of our past, unrepeatable in itself, but fully intact and perfect, and only to (re)appear (if ever) by chance or some inhibition of the mechanisms of usual consciousness. To access the content of the poem *reliably*, we would need to construct a bodily mechanism, through which we could call it back to mind using learnt, habitual behaviours. As Bergson writes: 'The [learned memory], conquered by effort, remains dependent upon our will; the [recollection memory], entirely spontaneous, is as capricious in reproducing as it is faithful in preserving' (MM 88)

A crucial role of recollection, according to Deleuze early in *Bergsonism*, is how – along with affection and contraction memory – it also gives the body duration, making it more than just an instantaneous, mathematical point. Recollection can take advantage of the *écart* (the interval) between the excitation (received movement) in the brain and the executed movement (response) of the brain.[36] Into this interval, recollections may interpolate themselves – *changing nothing*, however. On this, Deleuze writes: 'the recollections of memory [. . .] link the instants to each other and interpolate the past in the present'.[37]

Thus we find ourselves before an important Bergsonian difference-in-kind. Recollection memory is to be distinguished *in kind* from contraction memory. Our *experience*, however, is always a mix of these different kinds. Within contraction memory – in the interval – recollection memory intervenes, and this lived mixing obscures their difference in kind, the obscured conditions of our experience.

Bergson's register of recollection – involving his famous metaphor of the cone – is a second kind of memory, easily overlooked due to its being mixed up with perception and finally appearing to merge with it. Relevant for practising, as we'll see in the next chapter, is that where the mind situates itself in relation to the levels of this vast 'cone' of the pure, archival[38] past involves 'the degree of tension which [it] adopts' (MM 105) which connects us to the role of relaxation as criterion for practising. We read Bergson himself:

In other words, personal recollections, exactly localized, the series of which represents the course of our past existence, make up, all together, the *last and largest enclosure of our memory*. Essentially fugitive, they

[36] Deleuze, *Bergsonism*, p. 24.
[37] Ibid. p. 25.
[38] Williams, *Gilles Deleuze's* Difference and Repetition, p. 101.

become materialized only by chance, either when an accidentally precise determination of our bodily-attitude attracts them, or when *the very indetermination of that attitude leaves a clear field to the caprices of their manifestation.* (MM 106, emphasis added)

The 'indetermination of attitude' is arguably another way to speak about relaxation – in a lived and practical sense. For any simple experience of recollection's own atmosphere to rise above the noisier demands of the present and its perceptions, we tend to need conditions in which practical demands and the body's forward-facing preoccupations (*which action next in response to which stimulus?*) are lessened. These demands, of the adapting/surviving organism in the present, prompt the mechanism of contraction-memory, and usually tend to obscure or override recollection's less mixed modes.

Within practising of many kinds, a certain relaxation of ends-oriented behaviour can – indeed must – occur, with the result that recollections from undated moments in the past may 'rise up' or 'float through' the body – like smoke rings or billows of textured ambiance. These are absolutely familiar but strange, and in the case of relaxed mental/physical states, appear arbitrary or random (Bergson might say 'capricious'), as if an inimitable quality of the bodily posture had released them. Sometimes they are not able to be located temporally or linked to any specific past episode or passage; sometimes we speculate on a lived origin. In either case, they feel or are known to us, somehow. Writing in relation to Proust and Deleuze, Jones will describe them in terms of being *essences*:

Unlike voluntary recollections, involuntary memories do not directly evoke (or mirror) what actually came before – a previous moment stored as an image within the empirical mind – but instead an essence that bridges two disparate moments in experiential time, an essence that links them both virtually and thematically but which was never experienced in itself *because it constituted a temporality that was never actually 'present' either now or previously.*[39]

The pure past is a strange register that does not bear a straightforward relationship of before and after with any living present, or even with voluntary memory. Its atmospheres arise by very dint of their arising not being of practical use. It's as if the involuntary rememberer is brushed by the foundation of time, by the element in which habitual time moves. Familiar,

[39] Jones, 'Marcel Proust', p. 106 (emphasis original).

yet unlocatable, known yet from no lived place, according to Jones after Deleuze. One glimpses here the reason for Deleuze's description of them as always erotic – they serve no instrumental aim.

For Bergson, *attention* is one name for the attitude of the mind when it 'gives up the pursuit of the useful effect of a present perception' and is often reliant on 'an inhibition of movement, an arresting action' (MM 101). Practising involves placing structures around the behaviour, seeking out contexts, as well as trialling recommended attitudes (of traditions or fields), which resemble closely Bergson's notion here. In current popular literatures, but also in scholarly texts from various spiritual traditions, one sees this frequent reference to an 'attention' of a kind that recalls what Bergson describes. The inhibiting of the strong, habitual tendency to pursue the useful effect of a perception requires a particular training. Practising is one name for this training, although it is not limited to it.

We read in *Matter and Memory*:

Suppose for a moment that attention, as we have already suggested, implies a *backward movement of the mind* which thus gives up the pursuit of the useful effect of a present perception: there will indeed be, first, *an inhibition of movement, an arresting action*. (MM 101, emphasis added)

In this emphasis on the arresting of action, we recall the 'passivity' of Deleuze's second synthesis and of Bergson's second kind of memory.

Consciousness (following a certain definition, and as we normally live it) could be seen as a kind of doing, already within the register of representation, part of an active synthesis. With its gaze trained on usefulness in any given situation, for Bergson it can be understood as constituted by the finding of responses – in action, bodily attitude – to the demands of its current moment. The 'material [r]epetition', Deleuze writes, subtending representation 'comes undone', as its elements are projected 'into a space of conservation and calculation' (DR 106). He distinguishes two kinds of sub-representative repetition, each pertaining to the two different kinds of passive synthesis, respectively: material and spiritual. Regarding the latter, he explains:

Spiritual repetition unfolds in the being of the [pure] past, whereas representation concerns and reaches only those presents which result from active synthesis, thereby subordinating all repetition to the identity of the present present in reflection, or to the resemblance of the former present in reproduction.

The passive syntheses are obviously sub-representative. (DR 106)

We may suspect, then, that the passive syntheses hold the keys to loosening the binds of representation's shackles. In *Understanding Bergson, Understanding Modernism* (2013), Dowd explains the link between Bergson and Deleuze on this point:

> Deleuze [. . .] emphasized the force of the concepts created by Bergson, notably the image, thereby cementing his legacy as the philosopher who caused philosophy to cast a critical light on one of its most enduring prejudices, namely in the shoring up of an image of thought grounded in representation.[40]

My argument in this chapter is that practising is a methodology whereby it becomes possible both to 'move' between registers of time, rather than only within the habitual present, and to encounter – in whatever fleeting way – the sub-representative syntheses and their ontological operations. Practising refines one's encounter with, and living of, the present (as habitual mode), but it also renders more accessible the less usual temporal climes of the pure past – as explored by Bergson and then Deleuze – as well as a future register. (The latter is arguably even more unusual than the first two; it is explored in the final chapter of this book.)

That the second mode of time, the pure past, tends to escape both our usual experience and quotidian tendencies is attested to by Deleuze when he writes:

> The entire past is conserved in itself, but how can we save it for ourselves, how can we penetrate that in-itself without reducing it to the former present that it was, or to the present present in relation to which it is past? How can we save it for *ourselves*? [. . .] it seems that the response has long been known: reminiscence. (DR 106–7, emphasis original)

The risk with our relation to the past is that in accessing it, we can easily flip it into being just another mode of the present (see above), rather than leaving it in-itself and visiting it 'there', on its own terms. There is an unambiguous sense that we must approach this past as the 'otherness'-that-it-is – calling to mind Byung-Chul Han's writings on Eros, where the erotic other remains also-unknowable, and not able to be consumed in a series of

[40] Ardoin, Gontarski and Mattison, *Understanding Bergson, Understanding Modernism*, p. 317.

Sameness.[41] So, we encounter this time on its own strange terms, so as not to risk collapsing it into habitual modes that will – in being coerced, subjected to representation's manoeuvres – have finally nothing to offer of that very specific atmosphere. It's as if, like rings of smoke, one cannot grab or grasp it without dispersing its shape.

Practising bears on an ability to slip into the mode of reminiscence. This has to do with the way it combines aspects of habit's mechanism and reinflects them, as well as its emphasis on relaxation, which we will explore in the next chapter.

That many people have experienced glimpses or windows of reminiscence is clear. What is less clear, in the absence of a language around practising, is how one would intentionally enable this atmosphere, invite and cultivate it. Holidays, weekends, nature, the dreamy time between sleep and waking: all these are certainly helpful for many in fostering the constellations of factors that invite the stealth entry into this other mode of time. Due to practising's combination of structure with intentionality and attention involving relaxation of action (also Bergson's means to displace the dominant present), it is the name of the mode which reliably cultivates the likelihood of 'accessing' this pure past, of a brush with its capricious recollections and erotic reminiscences.[42] Rather than going via remembering, the logic of this temporality comes to us otherwise: from '*within* Forgetting, as though immemorial' (DR 107). We need to 'forget' our usual modes of action and pragmatic response; and this forgetting requires a training, a staying-with a (socially, politically, economically) counter-intuitive mode of being. Otherwise stated, it is an art, with artists of all kinds tending to cultivate a knack for its ways and moods.

On this point, Jones summarises:

> Genuine thinking only occurs when we are compelled to forgo our reliance upon mental clichés. The involuntary encounter with something external to thought provides this impetus, inducing a vertiginous movement that draws from each faculty something specifically novel and unique to itself but which also resists its automatic subordination within a synthetic act of voluntary mental reflection.[43]

What follows here, in the section immediately below, involves a closer reading of the paradoxes, as noted by Deleuze. Readers with a less technical

[41] See generally Han, *The Agony of Eros*.
[42] See DR 107 for Deleuze's account of why this pure past has an erotic atmosphere.
[43] Jones, 'Marcel Proust', p. 116.

interest (in the Deleuzian temporal syntheses) are invited to read ahead to the fourth chapter, on relaxation.

Practising and the Paradoxes of the Syntheses in Deleuze

The relationship between the living present and a Bergsonian pure past, as mobilised by Deleuze, has much to offer a more precise account of practising. The present, as habitual mode, as a temporality constituted via the very movements of habit itself (contraction of particulars, the integration of changes into a lived continuity), aligns with how practising begins, or with the basis off which it works. Practising, like habit, also begins with a set of structured (recognisable) behaviours, but it is then repeated with (or supplemented by) an excessive or superfluous intention. Habit, as that movement which contracts instances of change into a smoother mechanism, marked by both a just-gone past and an anticipatory up-ahead, parts way with practising in the latter's aspect of superfluous, counter-intuitive intentionality.

Practising includes the almost habitual, but reinflects it. Temporally speaking, practising also involves the mode of the living present, but does not stop there. This might account for the strange imperative that can be found in many forms of esoteric practising: namely, the instruction to 'be present'. This suggestion, as already argued, is experimental, insofar as it wants the practitioner to add intentionality to something that is – by necessity – already happening. In most cases, one is always already in the living present. It is the dominant, that is *habitual*, mode of time to which we have access. The instruction 'Be present!' plays exactly into the habit/practising distinction, due to its being a suggestion pertaining to intention. *Intend to be present. Intend to do exactly what you cannot help but be doing.* (It is not hard to detect a Nietzschean genius in this, in its affirmative manoeuvre. See Chapter 5.) Students may erroneously believe that they aren't present, and that the instruction is asking them to attend to an omission, to be present when they have been 'absent', but the pedagogy here is more nuanced. Of course, one might be drifting within various modes of the living present: the immediate past, or the anticipated future,[44] but Deleuze's second and third syntheses are different to these inflections of the habitual present, and

[44] My experience in teaching yoga and meditation is that the 'future' in which students commonly worry they 'spend too much time' is simply the anticipatory mode of the living/habitual present. It is not any kind of genuine futurity and, in fact, can preclude this same futurity very effectively. That is: the tendency gets exactly what 'it' wants: not to be interrupted as habitual self.

not as easily accessed. They constitute other *nappes*, layers or planes, to use Bergson's term.

How thought might 'get access' to the second and third syntheses is something for which we turn to Deleuze. Practitioners, as I see it, work in modes that by definition allow or court access to these further syntheses, but without necessarily having rigorous means to articulate how.

Here below, we will think along with Deleuze and Bergson with regard to the paradoxes of time. They are, of themselves, interesting for thought. For practising, on the other hand, being able to *approach* thinking them – even a little – casts useful, more precise, light on its methodology.

Deleuze formulates the following questions as to why we would look for another synthesis of time, beyond the living present: *How can we account for time's passing? (there is nothing in the mechanism that would cause any one 'present' to pass); and in what medium would such 'passing' occur anyway?* (see DR 100).

This refers us to the first paradox of the present: *it constitutes time while passing in the time constituted* (DR 100). In thinking time via these syntheses, it tends to be that one approaches them via the 'first' passive one. Deleuze will confirm that this synthesis is indeed originary (it originates time), but not that it is original, or foundational. It is the soil, but not the ground. Williams too emphasises this crucial difference: 'Despite its status as an originary process, the present in the first synthesis of time is not eternal, it passes and it passes in a very particular way.'[45] Whereas, we read that the past 'is the *element* in which each former present is focused upon in particular and as a particular' (DR 101, emphasis added).

Now, the first synthesis, as well as having a passive aspect, also has an active one, and within the living present there is a remembering happening. There is a representing of the just-gone present, with this former-present represented *as part of*, or alongside the present-present, and within the element Deleuze and Bergson consider the past (that which is constituted via the second passive synthesis). Bergson's account of this next paradox is lucid, and we read:

> we may say that this present consists, in large measure, in the immediate past. [. . .] Your perception, however instantaneous, consists then in an incalculable multitude of remembered elements; in truth, every perception is already memory. *Practically, we perceive only the past,* the pure present being the invisible progress of the past gnawing into the future. (MM 150, emphasis original)

[45] Williams, *Gilles Deleuze's Philosophy of Time*, p. 52.

Table 2

Habit	acts our past experiences in relation to a future that it constantly anticipates, and does not call up the pure past, since the latter cannot be represented. Corresponds to (the mechanisms of) Deleuze's first passive synthesis.
The body	is the hyphen, or connecting link, a special kind of material image for Bergson, since 'it is not only externally perceived, but also effectively experienced from within'.* It is the 'place of passage' for memory more generally, for presents that are quickly becoming past, for the present as 'what is being made' (MM 149–50).
Pure past	is 'preserved in shadow' since not relevant to actions undertaken by the consciousness; as Al-Saji notes below, it cannot be represented, as such. Can be depicted as the famous 'cone of memory', where the point of the cone is the body and whatever is relevant for consciousness in terms of actions to be made. It contains the past in its entirety. Deleuze will say: 'far from being a dimension of time, [the pure past] is the synthesis of all time of which the present and the future are only dimensions. We cannot say that it was. It no longer exists, it does not exist, but it insists [. . .] it *is*' (DR 103).

* Al-Saji, 'The Memory of Another Past', p. 219 (paraphrasing Bergson).

But along with the represented-right-now-alongside-the-'present-present' aspect of memory, there is a darker, unconscious region of the past, not apparently useful to consciousness (the latter being preoccupied with self-securing, pragmatic actions).

Al-Saji writes this about it, and I cite her at length:

> Individual memories can only be extricated from a plane of the past by actualization (just as we discern particular objects by selecting the sides and relations that interest us and by putting the background in abeyance). But as an interconnected and infinitely detailed whole, *pure memory remains unconscious; it cannot be represented as such.* And this applies as much to the memory of the present as to any plane in the cone. [. . .] the memories of Bergson's famous cone lie outside consciousness. The cone may constitute a huge ontological memory, as Deleuze says, but it is also a kind of forgetting.[46]

We find ourselves with the structure shown in Table 2, for ease of overview.

[46] Al-Saji, 'The Memory of Another Past', p. 216 (emphasis added).

When we are 'in' the living present, we are at the same time almost always also representing the immediate past, or the former present. The present that we experience is then effectively an experience of representing (and thus we see the labour involved in Deleuze's project to displace the representational bias in thought itself). That which we think of as the present passing is, more accurately, the movement of representation in the living present. Alongside this, something also unfolds:

> The present present is treated [. . .] as that which reflects itself at the same time as it forms the memory of the former present. Active synthesis, therefore, has two [. . .] aspects: reproduction [representation of the former present] and reflection [of the present present's activity of reproducing]. (DR 102)

Deleuze goes on to explain that 'the active synthesis of memory may be regarded as the principle of representation under this double aspect [. . .] and constitutes [time] as the *embedding* of presents themselves' (DR 102, emphasis original). It is then in relation to the question that this then implies – '*Embedded where or in what medium*' – to which the second passive synthesis offers an answer.

This embedding of presents has several further and related implications:

- If the present-present and the represented former-present embed themselves, then they also exist *contemporaneously*; and
- Each present is therefore always already *past*, and therefore can be said to have a past aspect, according to Williams.[47]

In this regard, a paradoxicality operates, bundled up with this dual aspect, which produces via its strange structure an 'infinite proliferation', a 'constant augmentation of dimensions' (DR 102).

Bergson's exploration of time's paradoxes is praised by Deleuze (DR 103), and I lay out below the first three, with supporting commentary.

First Paradox: *the contemporaneity of the past with the present that it was*, which provides a reason for why the present passes (DR 103). Each particular present-present and former-present exist at the same time, not sequentially, due to the interaction of representation and the latter's representation of its representativity. Al-Saji describes it like this:

47 Williams, *Gilles Deleuze's* Difference and Repetition, p. 102.

If a present had to await the arrival of a new present in order to be constituted as past, then it would continue to wait, and us with it in a perpetual and frozen presence. Nothing can impose movement or transformation upon this present, which has no *internal* reason or means for passing. According to Deleuze, the only way for the present to pass is if it passes while it is present – if the past is given along with itself as present and is internally implicated in it.[48]

From this initial paradox, another follows on, ramifying and complicating it further.

Second Paradox: *the paradox of coexistence*. Deleuze explains that: 'If each past is contemporaneous with the present that it was, then all of the past coexists with the new present in relation to which it is now past' (DR 103). The contemporaneity of the first paradox has no stopping point, with the logical outcome of this being *coexistence*. 'It' ricochets through, like crystal formation, but instantaneously. Deleuze writes:

> The past and the present *do not denote two successive moments*, but two elements which coexist: one is the present, which does not cease to pass, and the other is the past, which does not cease to be but through which all presents pass.[49]

Third Paradox: *the paradox of pre-existence* completes the initial triad, toppling logically out of the first two. Deleuze puts it like this: 'each past is contemporaneous with the present that it was, the whole past coexists with the present in relation to which it is past, but *the pure element of the past in general pre-exists the passing present*' (DR 104, emphasis added). We might live empirically in the living present of the first synthesis (with its passive and active modes), but all the while there is also an '*ever-increasing coexistence of levels of the past within [the second] passive synthesis*' (DR 105, emphasis original).

From the triad above, we find ourselves facing the 'fourth' paradox, which corresponds to Bergson's famous cone, and what it implies about the second synthesis, the pure past.

Al-Saji writes of it:

> If the whole of the past coexists with every present, but also preexists the present in general, then *the past is not dependent on the present for its*

[48] Al-Saji, 'The Memory of Another Past', pp. 209–10.

[49] Deleuze, *Bergsonism*, p. 59 (emphasis added). (I'm grateful to Al-Saji's article for prompting my return to this quote.)

existence. Rather, the past 'preserves itself in itself' (*'se conserve en soi'*) [(*Bergsonism*, 59)]. In this sense, it is not only with the present that the past coexists, but first and foremost with itself in a state of pure and dynamic virtuality.[50]

This is what Bergson seeks to convey with his image of the cone. At the pointed end (the bottom of the image), we have the present (our body), as active synthesis. This is the sum whole of our memories (and arguably not just ours alone[51]), our 'past' concentrated into the fine tip. At this point, the contraction-that-we-are is at its most intense. Further up, however, there is another entire repetition of 'our' past, but this time slightly more relaxed (hence the wider width of the cone diagram). As we move progressively towards the widest end of the cone, we find more and more repetitions, but at greater degrees of relaxation. This coexistence in various levels, or degrees of tension, relates to a further paradox (the penultimate one), the one Deleuze calls, in *Bergsonism*, *le paradoxe du saut* [leap], along with which he mentions Kierkegaard, as the philosopher of the 'leap'.[52]

Bergson says this about these levels in the cone:

The same psychical life, therefore, must be supposed to be repeated an endless number of times on the different storeys of memory, and the *same act of the mind may be performed at varying heights.* In the effort of attention, the mind is always concerned in its entirety, but it simplifies or complicates itself *according to the level on which it chooses to go to work.* Usually it is the present perception which determines the direction of our mind; but, according to the *degree of tension which our mind adopts* and the height at which it takes its stand, the perception develops a greater or smaller number of images. (MM 105, emphasis added)

The final paradox (or arguably Bergson's earliest) which he articulates in *Matter and Memory* is the Paradox of Being.[53] This is the dualism – a strict difference in kind, and in principle – between pure perception and pure memory, or between the present and the past. (See also above and MM 66–7.)

Delimited by the movement of these paradoxes, the whole of the past encompasses a spectrum between most contracted and most relaxed (present

[50] Al-Saji, The Memory of Another Past', p. 211 (first emphasis added).
[51] See ibid. generally.
[52] Deleuze, *Bergsonism*, p. 61.
[53] Ibid.

consciousness and matter, respectively). Each level represents the whole of our past, repeated therefore, with only various degrees of contraction and relaxation distinguishing their planes. We 'leap' (or, as a practitioner, I might use the term 'transition') from one degree of contraction/relaxation to another – and this constitutes temporal and ontological shifting. One can think of it as a temporal nimbleness.

The pure past, then, constitutes this second way in which time makes itself, and which involves repetition. We now begin to see a pattern: namely, that every synthesis involves repetition. *That which is synthesised* from the flux of discontinuous instants or intensities in contraction (holding them together, drawing them together – imagine loose stitches in a piece of fabric, being 'pulled together') *is repetition*, as a structure drawn off via contemplation.

The living present involves a contraction of discontinuous instants in order to draw off from them 'repetition' – that is, the initial difference, that 'difference' which is an emergence of continuity and structure where 'before-hand' there was none. Out of sheer discontinuity or inconsistency,[54] passive contemplation draws off (via its capacity for retention) the *first difference, which is repetition*.

Through its lens (as the soil, underneath which we can find the ground), the second passive synthesis involves contraction and relaxation in order to constitute repetitions at every level of the pure past. If all of time is also always already there (or that out of which what we call time synthesises), then it is by dint of the passive 'movements' of contraction/contemplation and relaxation/contemplation that this mode of time constitutes itself, thanks to the differences – between the levels, so to speak – and which again are drawn off in the modes of various repetitions.

So, there must be the first difference; the 'content' of that first difference *is* only repetition. Sheer repetition – drawn off in differenciation. It is like the difference between Picture 1 and Picture 2, where the window is open in Picture 2. Repetition is this open window, in the difference between the two pictures – one of which is No Time, and the other, Time. The appearance of repetition is the first indication we have that *something differs from something else* (and there are no 'things' yet, in this picture). Repetition is the sign that there has been this first difference – this first difference, a sheer organisation of difference in itself, (a difference between *no*-thing, prior to any identity). The shape in which difference in itself comes to appear *is* as repetition before it is a repetition *of* anything, the sheer fact of repeating.

This we then call repetition for itself. It is not a repeating of anything;

[54] Perhaps a more apt term, borrowing from Badiou.

it is rather the most basic form of structure drawn off from a register of no structure. Repetition is the first *Something* that we get from *Nothing*. It is pure structure, or operation. This is why Deleuze can say (rather bafflingly if one comes at it cold) that *difference in itself is repetition for itself*: 'Repetition thus appears as difference without a concept, repetition which escapes indefinitely continued conceptual difference' (DR 15).

All this is quite marvellous for establishing a way to think, and perhaps to say, the how-ness of the register of temporal continuity in being, which constitutes time (at the same time), and then the element in which this continuity unfolds, which after Deleuze and Bergson is able to be thought like a cone – a huge region of pure pastness, whose ways and structures we can divine if we take the implications of the logic of the first passive synthesis right to their ends.

Finally, before we approach the final synthesis, which is even stranger, we can note about the second passive synthesis, just like the first passive one, that it is entirely unrepresentable. Deleuze names them both 'sub-representative' (DR 106). This fact also makes it very difficult even to hold the pure past – as a notion – within thought (in reading this you may already have 'forgotten' even those parts of the above discussion that did make sense!). This may be because our usual thought mostly relies on the shapes of representation in order to do its work. That it be sub-representative means that, just like in the case of the first passive synthesis, it is only under very unusual, very seldomly arising, circumstances, or when certain conditions are in place, that any kind of 'access' is feasible. We could say, more poetically, that we have to listen for it closely and in ways that subtract our usual filters from the scenario. Practising constitutes this kind of unusual listening.

Al-Saji echoes this intuition that comes from, and constitutes the methodology of, practising, when she writes:

> Intuition is a way of listening and becoming attuned to the past. It is not simply to jump to the plane of the past at which I am 'at home', but to other planes that present unfamiliar distributions and perspectives and that are recounted in other voices.[55]

'Miraculous' or impossible might be strong words to use, but I use them here with consideration, and Williams gestures in the same direction. He writes that:

[55] Al-Saji, 'The Memory of Another Past', p. 227.

the questions [about how to access the pure past] are much more devastating since they pick up on the possibility that, in principle, there can be no way of acting on this account and that, therefore, the deduction of the pure past is an empty exercise, a mere metaphysical diversion.[56]

Perhaps our difficulty in accessing the pure past, the ground in which our living present moves, can account for a certain atmosphere of longing or lostness – the question of nostalgia and its timbre – that can mark any life, and which perhaps should be known better rather than disavowed.[57] There is, it seems, something we struggle to touch, that remains by its nature out of reach, and which we mourn, almost as if mourning for home. It isn't, however, back-in-the-day, or 'at the pure origin'; it rather accompanies us silently and by definition outside of our perceptual (although not Deleuze's conceptual) grasp. Haunting. Or like a shadow, as commentators note.[58]

Deleuze, despite Williams's concern, does not leave us entirely empty handed. He will name the way we access this pure past *reminiscence* (DR 107). We can note that it is not really an active mode. It is not a normal kind of 'activity' as we'd usually understand this word. Rather, it is also liminal, a little like the contemplation that marks the first passive synthesis. The unsurprising example that Deleuze offers, in order to give his reader a flavour of this pure past and a falling into it, is Proust's work on time: *À la recherche du temps perdu* (*In Search of Lost Time*, 1913–27). Williams notes, in this regard, that Deleuze's 'preliminary indications' about how we could engage with this pure past involve somehow 'the relation between forgetting and reminiscence that relates us to the pure past as something that must be recreated'.[59] Proust's work would constitute such a recreation, but practising – this book argues – and therefore Proust's writing-as-practising, is also a means whereby we move within this register, to a certain degree, drinking in its atmosphere, and this whether we go on to compose novels about it or not.

We can ponder the suggestion that forgetting – like an action that one can only accidentally do – aligns with certain cultivated intentions that are native to practising.

James Williams notes that Deleuze admits that he cannot, with only the first two passive syntheses, give a rigorous account for why the sensual trigger in Proust – the *madeleine* cake, as a sign from the past – should work to

[56] Williams, *Gilles Deleuze's* Difference and Repetition, p. 105.
[57] Much of Derrida's oeuvre assists us in this tender exercise.
[58] Al-Saji, 'The Memory of Another Past', pp. 212 and 218.
[59] Williams, *Gilles Deleuze's* Difference and Repetition, pp. 105–6.

throw its eater back into the pure past. He notes that 'a third synthesis must be discussed to arrive at this explanation'.[60] This third synthesis will be the focus of Chapter 5 and will dovetail with discussion of the fourth and final criterion. However, emphasising the role of sensation in the second passive synthesis, Roffe clarifies that '[i]nvoluntary memory is how the past is lived in-itself – it is lived as *an encounter with a problem in sensation*' (WGD 226, emphasis original).

Let's return to the quote from Williams on Deleuzian repetition, in the early pages of this chapter, which notes that to repeat is a way of behaving in the face of that which cannot be repeated, something singular and unique. Another way to think this is that repetition is a way to respond to the question of 'how, from here?' that arises in grand and minor guises in the unrecognisability and unknownness of any life, sensed and full of uncategorisable sensations. Our life only seems like a general thing full of interchangeable particulars; however, when peeled of its illusions of identity and resemblance, it's more precise to say that each moment is singular, and we have never met it before. When faced with problems – as Deleuze defines them: that which have no ready solution in the scheme of existing 'things' – the only behaviour with which one can move forward is – quite strangely – to *repeat*.

Repetition in the second synthesis might also, according to Deleuze's line of argument, account for certain operations at the heart of the erotic. He writes of a hypernesia, linked to erotic repetition that involves a 'never-seen' immersed in the 'already-seen' of the pure past. We read: 'We do not know *when* or *where* we have seen it, in accordance with the objective nature of the problematic; and ultimately, it is only the strange which is familiar and only difference which is repeated' (DR 134, emphasis original). When only the strange is familiar, we might think that relaxation is the least likely atmosphere to emerge; however, as we move to Chapter 4, we will explore the intricacies of this notion, as a crucial criterion for practising.

How would we slip registers from the implacable continuities of the living present into the other modes of time that can augment and run parallel with that same present to evade and thin out the latter's more tenacious tendencies?

In the face of problems, proliferating desires, the small details of the day-to-day, the practitioner is she who can acknowledge and withstand not-knowing and spot her own de- or il-lusions regarding fixity. Then, via relaxation, she enacts the (ontologically intelligent, temporally artful)

[60] Ibid. p. 106.

behaviour of repeating in a certain way, one which coincides with the operation that Deleuze attributes to repetition for itself and, via this action, abstains from precluding the little deaths that are themselves precisely little creations.[61]

[61] It was only after composing this that I noticed that Williams uses a similar formulation, and I quote appreciatively: '*You are already gone – in so many little deaths [. . .] for you to enjoy*' (ibid. p. 217, italics original).

4

Relaxation: That Unnatural Effort

As we've seen, the first two criteria of practising can be viewed to some extent in parallel with the mechanism of habit. However, where usual modes of habit are often contracted passively and run themselves with increasingly less intentionality, the 'habits' of practising *may* be intentionally acquired and *must* be intentionally repeated. The focus of the current chapter is the moment when these are reinflected via what can be called 'relaxation'. It is the third criterion, and its role in practising is very precise.

The first criterion states that we need an (intentionally) acquired structured behaviour – a kind of 'habit' – as the basic scaffolding for our potential practising. We've seen that this could be surfing, knitting, gardening, circus arts or throwing pots. The second criterion then states that we need to repeat this structural component *intentionally*. This involves our deciding to practise – when, as well as how often. This aspect of practising, in other words, involves a delicate engagement with what might loosely be called 'whim'. We don't do the *when* and *how often* of practising by feeling but we also can't override entirely what we wish or 'feel like' in order to practise sustainably. Practitioners dance between these modes of 'just doing the practice' and experimenting with desiring the practising.

Practising, we note then, can take a process or movement (potentially a usual-enough benign habit) that may either be *passively* 'contracted', or something learned as a craft, and re-enact it intentionally, making of its contraction and repetition a particular kind of effort (and a decision) – first and second criteria. Next, the third criterion – in the moment when we might imagine 'wilfulness' to come to the doer's aid – there is a mobilising of a modified approach to effort that I will discuss shortly.

The very precise relation to effort that is native to practising can be called *relaxation*. We are not passive *about* practising; and we are relaxed *in* practising. In this chapter, I attempt a close thinking and articulation of

the mechanism whereby a 'good' or benign intentional habit might become something else entirely. Relaxation can be read as pertaining both to:

- the way of doing or approach that cultivates relaxation;
- a quality or atmosphere that results from consistency in this approach.

Relaxation is a kind of hinge in this constellation of practising. It is the pathway whereby a benign habit that has been acquired and repeated intentionally can shift into another atmosphere or be raised to another power. (Recall watching the extreme skating movie, where an activity you had until then viewed as a pastime of urban kids in Los Angeles was reinflected, via the latter's dedication and startling 'effortlessness', and raised to the power of practising. You leave the film feeling – for a brief window – as if your life would really *mean* something had you devoted yourself to extreme skating. However, what has been missed in this moment of awe is that it was the *fact of dedication* in the shape of skating-as-practising that has been so moving and impressive. This same dedication, of course, could be applied in rhythmic gymnastics, or to lithography, to making pastry, and so on.)

From the outside, the shift may be imperceptible. It may seem to an onlooker that the practitioner is simply very skilled, or an 'expert'. It is not uncommon, too, to hear people speak of the way of moving done by practitioners as 'seemingly effortless'. Usually, what's implied is that *there must still be lots of effort*, but it doesn't *look* like it. Practising's logics imply instead: *there looks like there's minimal effort because the practitioner has worked with changing their relation to effort*. The practitioner continues, as always, to write poetry, to compose music, to arrange flowers, and so on; however, their activity somehow has entered another register. They may know this at some level but may not know how to speak precisely about the shift, or the conditions for it.

Without the nuanced constellation we are calling 'relaxation', our 'good' habits – no matter how virtuous, or efficient, or admirable, or healthy – remain mere, and often excellent, habits. One way to speak of this involves thinking it in terms of a delicate teetering between routine and compulsion. Recalling our discussions in Chapter 2, this is more easily said than done. The 'good' habit, as it pertains to practising, will only be raised to this other power via the third criterion when there is an established and consistent operational indifference to the more ubiquitous rhythms and logics of routine and compulsion.[1]

[1] There may a place for considering my word 'compulsion' in relation to the, at once, broader and more precise Lacanian notion of *jouissance*. There isn't room here to do

When we run because we can't seem to stop running, or when we pray like an automaton, without attention to how we pray, or when we clean the house obsessively, practising in itself will not obtain. We might, however, get fitter, stave off for a time panic or guilt, calm our thoughts, have a clean house. If the activities don't reinflect towards practising, the normal effects of those actions will, naturally, stand; the benefits of structuring time that they afford will obtain.

We can use this logic, regarding compulsion, to think further into addiction. Addiction arguably involves a substance working as a strict structuring influence to prevent unbearable existential vertigo inevitable in any life that's poor in structure.[2] Addiction, as addicts will candidly tell you, is a relationship – even the primary relationship, for that person. What we might deem the external, practical hallmarks of 'love' – such as, but not limited to, anticipated time spent with others, networks of care, safe-enough primary relationships, reciprocal social obligations and so on – involve these kinds of structures, which not all people have reliably and consistently encountered.

For the purposes of structure, addiction functions as a workable supplement. This framing allows us to speculate about why some substances are physically addictive and others are addictive in a 'psychological' sense (the body doesn't technically 'need' them). In the case where the body itself shows a dependency, then the strictness of the structuring influence is held more firmly in place by the so-called chemical 'need'. However, in the case of the substance having a hold psychologically, I would contend that it literally does *hold*. In a costly, but effective way, it holds a life, and time itself, in place.

When behavioural habits, on the other hand, shift mode and become practising, this reinflection can be accounted for due to the particular inflection of effort involved in relaxation – criterion 3.

If our intentionally acquired habits are able to walk the knife's edge between routine and compulsion/addiction, and therefore somehow to remain intentional habits, they are likely not only to have a strongly stabilising effect but also to render the doing available to being inflected as practising. It is in the third and fourth criteria that we see the stranger aspects

this query justice, and others are more qualified than I am to do that work. Lacan, however, in exploration of what constitutes *jouissance* may account better for why compulsion is problematic, and why it has little to do with desire, as such.

[2] I am emphasising a structuring effect in cases of addiction in this reading, rather than an emphasis on the numbing effects of substances or behaviours. Both readings hold, but arguably at different layers of the addiction's impact.

of practising in operation. These pertain to the ways and atmospheres firstly opened up by relaxation – the erotics of Deleuze's reminiscence, sensibility, a certain letting-in of sensuous, even nostalgic, climes – followed by the steady courting of futurity, for which relaxation-as-strategy is a crucial condition.

Clarifying 'Relaxation'

'Relaxation' is a term often on high rotation and a staple of various vocabularies, ranging from corporate-speak, to advertising, to the New Age. It would seem that there is a persistent speculation that relaxing might be a desirable thing, that we desire it, or at least approve of it, in principle. However, akin to the ambivalence around 'being busy' – that we seek structure, but not necessarily all the terms on which we find ourselves structured – our relation to the prospect and notion of relaxation can be fraught.

Relaxation, we seem to admit, would be nice, but surely if we relaxed more, we would achieve less. We are only competent, skilled and successful, so the argument continues, due to constant tension, due to constantly straining towards our limits. It is *excess* that propels us forward in our tasks. *Isn't it?*

Over the course of this chapter, it is hoped that this view of relaxation and its relationship to efficacy might be somewhat complicated and its logics unsettled. Relaxation, like many things, can be understood as a matter of timing. It is always a question of *when*. And then, more importantly: *how* to know *when*.

A simple way some practitioners explain relaxation (for example in Tai Chi) is to define it as *a way of doing that results in the appropriate amount of effort for the activity in question being used – no more and no less*. This definition includes our two aspects of relaxation listed above. Relaxation is a 'way of doing', and its effect is that a very precise amount of effort, neither falling short nor exceeding the demands of the activity in question, is expended.

Concentrating on the result of a process of relaxing makes relaxation seem somewhat simpler than it is. The idea of precise effort is quite appealing. It sounds minimal, lean, clever, economically efficient. However, this emphasis on the outcome – minimal usage – evades the *how* of this outcome, the intricate and interesting operations involved in directing oneself towards relaxation.

For practitioners working closely with the contours of their chosen practices, *to relax* is a compelling and demanding undertaking, a frame for constant experimentation, one which in fact has its own modes of precision and, as we'll see, of effort.

We will speak more about this kind of 'effortless effort' shortly, with refer-ence to some helpful commentaries on the *Yoga Sutras* of Patanjali.

Let's also note that the degree of effort, in each instance, which consti-tutes relaxation is always in flux. From moment to moment a relaxed doing of a particular task will look different; it will be changing as the contours of the task itself shift. What amounts to a relaxed way of driving an auto-matic car is different to the relaxed way of transferring boxes into a removals truck. A relaxed checking of email looks different to a relaxed playing of a final match at a Grand Slam. In fact, relaxation evades easy categories of quantity, with the amount of effort for car driving and tennis playing being incommensurable. If it is not notions of number and quantity that give us access to the *how* of relaxing, then what is it?

(For this reason, the emphasis on the outcome of relaxing tends to be a gaudy distraction from the practising of it. We can keep this in mind as we proceed with some slightly gaudy examples. The relaxed state of a virtuoso is a very seductive image, but this is of no help to practitioners, who need to work at the coal face of relax*ing*. Any striving for relaxation would be, obvi-ously, a problematic scenario. Things have to proceed otherwise, and with perhaps an ignoring of images of relaxation.)

Just like our discussion of 'Be present!' in the last chapter, the impera-tive *Relax!* (as silly as it clearly is) also remains a somewhat ubiquitous, if perverse, refrain. It's also – as the reader would know – an infuriating com-mand to be on the end of. As mentioned with the example of being present, relaxation is similarly a way of doing that resists being commanded. This is because it isn't brought about through any provocation of the 'doer' aspect of the practitioner. Hence being told *Relax!* is unlikely to have the desired effect, and on top of that tends to arrive as an indirect judgement (that we resist, resent and so on).

This is not to say that any instruction that pertains to relaxation is doomed to fail. It depends very much on the delivery and also the insight of either the practitioner themselves, or the person who might be teaching them in a tradition, for example. In dance, or yoga, in pistol shooting and so on, a method of training in relaxation might go via the detour of an instruction pertaining to noticing tension. Notice *that* the area around your tailbone has narrowed. Notice *that* your right shoulder is lifting. Noticing, or the liminal action of observation, is less incendiary than a direct instruction to relax.

When noticing only, we are absolved from the demand to make a change to what is happening. It isn't a meddling, and thus can be a form of curiosity rather than an amending. Judgement here is problematic not because it is

unkind or unpleasant (although it is both), but because it is *extra*. It simply incites more doing – or more resistance (another kind of energy-intensive doing).

Noticing renders the body more likely to move into relaxation of its own accord, or at least doesn't hinder this possible drift.[3] We can't command this. The use of noticing or observation, in practice, tends to lead to the discovery that when attention goes to a place, and does not impose action on that place, the place itself drops any excess effort, and moves towards a minimal doing. There is a toggle, in other words, between *how little* imposing happens, and *how much* relaxation emerges. In other words, the excess in the first instance is operating *anyway* due to previously imposed and imprecise notions of doing on the body, and which have remained 'in' the body. Another way to say this is that the body is caught in the *habit* of actions of response to these earlier impositions, and increasingly can do little else.[4]

'Tension' might be another term for instances of misuse of the instrument, and of enduring misunderstanding of its function, traces that have accreted – of meddling, subtle harms, criticisms and so on. All practitioners, in this regard, remain for a long time enmeshed in the difficult process of finding and then working with these traces. If there is humility in serious practitioners, it's arguably because one never leapfrogs this process.

(A colleague, Dr Chris McCaw, asked me about children, in relation to this question, since they don't appear to need to learn to relax at all. We considered the fact that for some lucky children, at least, and for a window of time, the criticisms and resulting 'negative' self-consciousness that accrete in bodies as they interact with the world over time, and which generate the very tensions and silent 'natural' efforts that mark bodies that are not relaxing, have not yet accumulated so much. There is less to 'notice', less to 'undo', since the body has not learned the patterns of over-reactivity that

[3] In yoga alignment training, one uses the suggestion of noticing the relation between the back skull and the lower back (sacrum bone). One is encouraged in meditation, also, to attend, gently but consistently, to this relation. Simply attending to/noticing it is often enough for the posture to 'correct itself' without any imposition from the practitioner as meta-influence. In a room full of people sitting with eyes closed, as the teacher, I can make this suggestion and watch a whole room of spines self-adjust.

[4] In dance training that I was lucky enough to do with contemporary dancer, choreographer and traditional Chinese medicine practitioner Louisa Duckett, she would use the technique of posing an open question to the body. One asks, mentally, *How wide is the tailbone? How broad does the forehead feel? How long is the back of the neck?* These gentle questions often conjured those exact qualities in those places – width, breadth, length – without any direct instruction, forgoing any imperative verb at all.

rise up to compensate for being observed as 'lacking' or 'falling short' of any norm, cultural, familial, etc.)

There is an early scene in the documentary about Andy Goldsworthy, called *Rivers and Tides* (dir. Thomas Riedelsheimer, 2001), where Goldsworthy has gone to a beach, very early, in order to make a sculpture of stone pieces before the tide comes in to flood his workspace. We are with him there, under evident time pressure, and seeing shots of his hands freezing in the cold weather as he places each stone precisely. About one third of the way into the work, something teeters, and we see him try to hold the structure together, only to watch its clear form crumble into a random pile of rocks. There is a flicker of dismay – much more restrained than the viewer's own painful disbelief – before he turns to begin again. The day is advancing, and so is the tide. The sculpture is again going well, its conical base slowly taking shape. It's clearly exhausting, painstaking work.

At some point, we see him place a piece, in a way that can't be distinguished from any other placement, and at once the whole structure exhales, loosens. He calls, perhaps to Riedelsheimer himself, director and DOP (director of photography), to help him. The two place a heavy, large piece on the entire thing, as if to support it temporarily. Goldsworthy looks for other pieces, and they make an attempt, while the viewer manages their own mounting dread, having become as invested in the sculpture's success as Goldsworthy himself presumably is. Moments later, the whole thing is again nothing but a pile of rocks. The viewer wants to pack up and go. It's pointless, more than thankless. But we see Goldsworthy get his breath back, and then he says something to this effect: *You think you've understood the stone, but then you learn that you haven't yet understood the stone.*

This example raises the interesting question of which body is relaxing when relaxing is being practised. Perhaps the notion of discrete bodies is reframed, at the same time as an appreciation is gained (as we see with Goldsworthy) for the ways certain 'bodies' move, their behaviours, their *habits* (what allows them to continue in their being, as Ravaisson might term it). I want to use the word 'nature' here, as in 'quality' or 'character'. The 'nature' of the bodies – the stone, the paint, the human limbs and spine, the ocean – would be, in this way, what would remain to be discovered and a new relation *invented*.

For practising, I'd emphasise, this has to involve respecting the integrity of all bodies involved, since a destruction constitutes no invention. There may be a falling away – of misconceptions, excesses, and so on. This kind of undoing is more akin to a de*con*structing, rather than a destructing. The 'con' shows that it is done 'together'. Relaxation pertains to a practis-

ing of relationship – clarifying a relationship to stone, to wool, to space, to the lower back, or to whatever. This new relationship may involve a becoming-more-simple, since practising is also about losing. In this sense, we also *lose* our relation to something that didn't work, and less effort is required. Via loss, a new body also comes into being, a never-before-encountered body.

Relaxation, not surprisingly, has a long association with mastery. One thinks of images of tea ceremonies in Japan, or long-distance runners, or the smooth gestures of an haute couture seamstress. The master, as I read it, is someone whose body seems to know viscerally *just how much* effort this task requires. And they know the bodies with which they are in intensive relation – matcha and hot water, the road and weather, fabric and thread. Our question remains 'how?'.

We are familiar, in other words, with how relaxation looks, due to our frequent exposure to images of mastery in media and wider culture. These are often put forward as examples of an unattainable virtuosity, for most; something linked to inherent talent or gruelling dedication. Masters, we might note, may often be practitioners. Mastery, on the other hand, as label, tends to be applied from outside. Those practising may be less preoccupied with such titles (if not always immune to their seductiveness). Their so-called mastery, I'd argue, is established via emphases other than those of category and nomination.

We will explore now the role played by effort in thinking precisely relaxation as criterion for practising.

Effort

If relaxation, as a perceived effortlessness, is admired, why then do so many of us in our everyday modes seem inadvertently to expend imprecise amounts of energy or effort, and often too much, on the task that we must, or wish to, complete? What has the 'master' understood that the lay person hasn't? Is relaxation merely a question of familiarity with the activity? Or is it a matter of how we envisage the point of the activity in question, of how we understand action per se?

It may have to do with something else, what we will call the *effort of relaxing*. We will examine it shortly, after a description of mastery as relaxation.

Some years ago, I attended a tennis match in which Roger Federer was playing. What particularly enthralled me, as a long-time body-practitioner (and not an established fan of tennis), was simply that, as I watched him play, I saw that he had mastered relaxation, and the opportunity to watch this for over an hour was a rare joy. What Federer, or the body we identify as

Federer, knew or had integrated in its very fibres was the practical fact that, when playing at such a level, not a shred of extra effort could be wasted.

He would return the ball to his opponent, and in the interim – because I kept watching him – he would completely relax – his arm, his shoulder – keeping the racquet loose. He stood each time clearly on his feet, in a way (one speculates) that would tax the entire physical structure the least. From this seemingly complete relaxation, he would then meet the next ball expertly and with the requisite amount of force. This shot would also – according to the definition above – count as relaxation. It was the *relaxed* way to return a ball travelling at 170 kph. There was seemingly a very precise amount of effort being expended in each case – that of waiting and that of hitting, respectively – and in a refined proportion to each act.

His 'competitive' edge, I concluded as I watched, was therefore in part due to a discerning non-doing. His mastery consisted in knowing when and then *how* to do *nothing at all*, to find those windows of *barely anything*, so that when the time came, when the racquet needed to meet the ball, there was a reserve of capacity, ideally, just the right amount – no excess, and nothing lacking – that would meet the demands of the task, which in tennis is to better one's opponent.

On that day, incidentally, he was playing someone much younger, and perhaps a body technically capable of greater quantities of sheer physical force. What was clear was that this fact was still no match for Federer's *discerning use* of force. Over time, fatigue and then imprecision marked the game of his less experienced opponent. Federer won the match. At the time I also wondered how much he concentrated on winning (the idea of it) and how much he was doing something else that was even more conducive to winning.

Needless to say, at the most accomplished levels of sport, we see a kind of dovetailing of practising and the player's ability to win. Due to the context in which we encounter players and their exploits, this competitive aspect can tend to eclipse what else might be happening. In order to have reached that level, I'd contend, brute competitiveness has had to be supplemented (even surpassed) by something more ineffable and harder to say. The art, arguably, becomes resisting a preoccupation with winning or losing, in order to inhabit a register where relaxation, as the way of 'mastery', is more consistently accessible.

What mostly passes for competitiveness in daily life probably bears little to no relation to practising, as I inflect it here. Similarly, practising need have no relation with competition or mastery in an explicit way. At some point, however, the contents filling out our mundane competitiveness *can*

be turned towards practising and shift their nature; and equally, practising doesn't need competition in order to get started, or to be very serious. Finally, competitiveness and practising may be able to coexist, but I suspect the practitioner in this case is able to inhabit a kind of dual attitude or intentionality, perhaps at times sliding more towards usual competitiveness, at other times noting the atmosphere that opens (and sometimes the resultant, accompanying expertise) when their intention is turned and attuned differently.

Much of what constitutes practising looks very ordinary. Zen, or its Chinese predecessor, Ch'an, is replete with emphases on ordinariness. One could read this as a cultural slant, which may not be inaccurate, but it is also, arguably, a strategy for instructing practitioners.

In Zen, for example, due to the external uninterestingness of its structured behaviour (just sitting still), the emphasis on ordinariness can be helpful to a newer practitioner who is wondering about what's meant to happen. It can reassure them that not much will appear to happen for quite a while – 'notmuch' being the point! – and that this shouldn't be a source of concern. As Zen communities and teachers resist, or don't, the insistent press to provide answers regarding their activities in terms of outcomes and purposes, it can be difficult to abstain from listing the 'benefits' of practising, or the 'improvements' promised by engaging in sitting. It is always difficult – and a book like the current one, arguably, flirts with the same danger, at least in terms of how it can be read and taken up. The fact that there *are* incidental benefits to practising, and that these can motivate a beginner, does not undermine the fact that practising per se is subtracted from those kinds of logics and that an insistence and constant reminder of this is rigorous and crucial, if practising is to remain distinct from 'good' habits.

Mastery, then, may emerge as an incidental (and somewhat irrelevant) effect of practising well and over long periods. A practitioner is someone who might indeed be very good or even expert in the externally assessed aspects of what they do, but this slant on the activity fades out as their priority or focus.[5] This relates to what happens to categories of identity when practising

[5] For example, any identification on my part with an idea of being expert in yoga is irrelevant and distracting. More worryingly, it risks genuinely undermining something deep and crucial in the practising (as I hope this book will make clear). There are some practical benefits of being taken seriously in one's field (it can get me out of certain conventional obligations/rhythms that eat into practising time, for example). Otherwise, ramifying any image or self-notion is a slippery slope towards mis-emphasis in relation to the criteria that rely on sub-representational mechanisms to be set going and to be sustained.

is happening, and also to the impact that repetition for itself has on the one who sets that repeating going. We'll look at this more in Chapter 5.

To reiterate, relaxation is the bridging criterion – a kind of hinge – whereby a good-enough habit, acquired and intentionally repeated, might shift to another register, where it is rendered available to, or ripe for, the movement of Deleuze's repetition for itself. In other words, relaxation is a prerequisite for 'practising in itself', preparing the field in question for the less controllable aspects of the latter. These, we must acknowledge, are not predictable *results of actions of any 'subject'*. This is why we use the term 'court' in relation to its transformational aspects. To say 'court' is simply less presumptuous, suggesting only a structured approach that invites an unreliable to-come.

Relaxation and Intention

Intention makes a reappearance within this question of relaxation. In criteria 1 and 2, the intentionality operates with regard to activity. The practitioner can acquire the habit actively, with intention. It is a straightforward approach to activity – one that subverts or undoes the usual workings of habit as mostly passive or auto-contracted.

In the case of criterion 3, however, the intention is reversed once more and equally non-intuitively. We embark here on an engagement with the issue of effort that consists in a falling away of effort which nevertheless doesn't compromise the form of the acquired activity. In other words, we relax *and* will not become 'sloppy'.

Philosopher Alasdair MacIntyre has a helpful take on an aspect of what he calls 'practices', emphasising that they are determined in communities and via tradition. The form is not something rigid, and may develop, and indeed should evolve, via debate and discussion within the tradition. For MacIntyre, insightfully, however, the form is not something that an individual dreams up for herself.[6] Swimming breaststroke so that it remains breaststroke, and not a creative form of floundering in water, is not arbitrary, and the tradition of its movement has involved a refining of what 'breaststroke' means. The same goes for MacIntyre's example of chess.

[6] See MacIntyre, *After Virtue*, p. 187. The notion of practice in MacIntyre does not align fully with my definition in this book. However, I echo his spirit of rigour in delimiting the term for the purposes of his focused exploration – citing him: 'I shall be using the word "practice" in a specially defined way which does not completely agree with current ordinary usage, including my own previous use of that word.'

Similarly, yoga asana (postures) are determined by a long tradition, and doing asana means adhering to certain conventions of movement and attitude (ahimsa, strictly meaning non-wounding, for example, the posture remaining stable and pleasant,[7] and so on). Otherwise, one is not doing asana but rather something else, perhaps something outside of a tradition.

The account of practising in the current book places less explicit emphasis on tradition per se, but I would acknowledge the soundness of what MacIntyre points out, and the usefulness of its approach for speaking clearly about what the 'structural requirement' or habit-to-be-repeated involves. It is not that inventing a certain ritual of eating or hopping or dancing erratically could not eventually constitute defined practices. Indeed the *tapasvins* of India did in fact invent quite wild and bizarre physical ordeals for themselves, such as standing on one leg for twelve years, and other challenges. These acts constituted the form of their chosen practice, and their commitment raised an arbitrary activity to the level of a recognisable form (the fact that we can cite examples today is evidence of this status).

It is more a question, however, of the structural requirement having a kind of fixity through time that is not a personal matter of preference and inclination. The point here is that what is relaxed is not the form. The practitioner is relaxed *within* the form. They seek the most 'stable and pleasant' relationship with the form.

Ideally, too, the form would be non-wounding – to oneself and others. One obvious and pragmatic reason for this is so that the practice can be performed sustainably over long periods. Practising, we recall, requires that it be possible to repeat the structure over time. Without such repetition, the activity will not fulfil the criteria of practising. If the practice injures us too much, or injures our inclination to do the activity, our disposition or overall capacity for doing the activity will wither or evaporate. In such cases practising is compromised, ceases permanently, or peters out. Traditions often involve cautionary approaches, gleaned via the experience of long-term practitioners of that tradition, as to how to go about its structured activities sustainably. Films and books abound where the relationship (when not perverse) between student and teacher in the narrative arc attests to the teaching of these more sustainable ways.

Injury, in other words, is to be avoided as a principle, and therefore an alertness to injury and exploration of ways to avoid it while still engaging seriously in the practice's form becomes a requirement of the training in relaxation. This is partly because relaxation is not assisted by pain, and

[7] As written in Sen-Gupta's *Patanjali's Yoga Sutras*, Sutras II.30 and II.46 respectively.

injuries are usually painful and often distracting. Injury can also indicate that appropriate relaxation was not happening in the execution of a particular aspect of the activity. Think of a violinist who must learn what is causing the pain in their shoulder in order to continue with hours of practising per day. (By contrast, but in the same way, too much 'relaxation' of the wrong parts of the body – that is inappropriate *lack* of effort or integrity – can equally lead to injury, as is the case with certain uses of stretching prior to anaerobic movement, which undermine the tone and integrity required in the muscles, tendons and ligaments.[8])

Commentators in yoga have suggested that one way to understand pain is as a form of restlessness or over-stimulation – *rajas* (if we translate this term in the usual way) – that is, not being relaxed. The example relates to seated meditation; however, we can extend its concept further to include how chronic pain itself may operate as a kind of heightened reactivity in the pathways, continually triggering despite the site of injury being technically 'healed'.[9]

Furthermore, harmful or exaggerated modes of performing activities – which can lead to injury and pain – can also be due either to careless modification of functional forms for activity (that have not sufficiently evolved and so remain imprecise), or to persistence of inadequate forms that could be innovated but haven't been. Think of the way ballet has evolved, accompanied by increasingly refined physical practices that make the dancer stronger, more integrated, and safer. The trick is always to work out what is not working, and this close research goes to the heart of methodologies aligned with practising.

[8] My thanks go to physiotherapist Maria Chau, for conversations on this question.

[9] We read: 'Normal activity is that which the senses are habituated to perform. When through such action, inertness disappears, the feeling that arises is pleasure. Unless perception is developed and activity remains subdued, pleasurable sensation does not arise. Pleasure and pain, sentience and activity are comparative states. Feeling of bodily comfort means the feeling arising out of the normal working of the system, *while uneasiness arises from over-stimulation through external causes*. When mental action in the shape of desire is normal it gives pleasure but when it is too much it causes pain. Again, when on getting a wished-for object desire is satisfied (*i.e.* overaction of the mind ceases), pleasure is derived. In stupor, *i.e.* in a state in which there is no sensation of pleasure or pain, there is very little activity and sentience is indistinct. In comparison with that, there is more sentience in pleasure. Therefore, quieter sentient state (Sattva) is inseparable from pleasure while active state or Rajas is associated with pain – mental or physical. When Sattva is overcome by Rajas, pain is felt' (Aranya, *Yoga Philosophy of Patanjali*, p. 157, emphasis added). Note that Aranya defines, interestingly (and in a more nuanced way than typical translations of these terms), *Rajas* as 'mutation' and *Tamas* as 'retention'.

In general, imprecision in form risks injury for the practitioner and is not desirable, but of course in order to evolve, a modality must often pass through imprecision. Accompanying this, however, is the fact that the more precise and subtle the practitioner, the less that incidence of harm marks the modus operandi, and very astute practitioners may find ways to innovate very carefully, thereby avoiding whimsical modifications while still in virtuosic ways assisting their tradition to evolve and become new.

This ability to transform without resorting to harm translates to a kind of atmosphere around deft practitioners and may be felt as an unusual absence. One could attribute this to an operation reminiscent of the yogic notion of *sattva* – a dynamic mode of responsiveness (called by Aranya 'sentience') that forgoes mutation *and* retention/over-holding (*rajas* and *tamas*).

It can seem a mode that is hard to place or odd within our everyday cultures of doing that more often than not simply amplify and insist upon, when met with obstacles, doing more (of the same), rather than seeking nuanced and serious ways to innovate without damage. This intimates the relevance of creative responses and why Deleuze's contribution is useful, with its precise thinking of intensity and what constitutes it. More, in other words in a Deleuzian frame, cannot simply translate to more-intense. This muddies registers. In fact, more apparently happening in the register of representation often only amounts to a reduction in intensity at the levels where change and newness will be really generated.

Before practising begins to sound like paradise, we must emphasise that it is also and always an inevitable ad hoc engagement with these moments of impasse. One cannot avoid them, and every practising trajectory will intersect them. Each time, for example, that I injure myself in yoga (which has become more infrequent over time), I embark on a long and often frustrating, but also finally revealing, process of understanding better the area that I've hurt. Like *knowing the stone*, I learn that I was using or relating to that place unwisely. The learning, naturally, is quite slow.

In practising, we stage an encounter with our most gauche ways of moving forward. We also encounter – repeatedly – how much non-relaxed approaches fail. Or if they appear to succeed in the short term, they flounder and cause setbacks in the longer term.

In practising, in other words, there is no way around problems. In line with Deleuze's writing on problems, we learn that it is not a matter of finding a packaged solution, but rather of inventing a way to live with the problem better, refining our ways of moving, in all senses of this word. This subtle distinction between finding a discrete 'answer' and adapting one's way of living, moving and engaging is the crux of what practising entails.

Mastery, then, would be the very superficial face of the accumulation of many years of not-quite-practising, but also practising, and continuing to try, and to try differently and elsewise, within the 'container' of a structured behaviour.

Practising, we could say, is the laboratory, or indeed Deleuzian theatre, where we get to have an intensive relationship with non-practising – the mode which for most of us constitutes our way of being, habitually. We proceed in a lost fashion, abandoning or forgetting the *hows* of before, or of our pasts, and risking a future in which the *how* is reinvented, and without our staying in any way the same. 'We' are not preserved in this future.

Relaxation, then, functions as a kind of obscure password, a code of sorts, the meaning of which we continue – obstinately, good-naturedly – to not-understand. Relaxation is the open secret of practising. It seems far too simple to be implicated in what practising would seem to promise. It is, and is not, simple. To approach it means to work somewhat aside from our usual intuitions. We take up its invitation on occasion, only to abandon it again, when usual logics insist that it couldn't possibly work, that what's surely needed is an inflated quantity of doing.

The Effort of Relaxing

> And would not immediate knowledge show that these difficulties, contradictions and problems are mainly the result of the symbolic diagrams which cover it up, diagrams which have for us become reality itself, and beyond which only *an intense and unusual effort can succeed in penetrating?*[10]
> Bergson, *Matter and Memory*, p. 187 (emphasis added)

Why is it that in our spontaneous modes we can tend to find ourselves using more effort than is necessary, or too little, resulting in a fatiguing haphazardness? Why are we reluctant to, or wary of, experimenting with less or different effort? To what might an experiment – a tenacious and rigorous one – in how much effort to use, moment by moment, lead? We could note that the slur of laziness has not lost its bite for many; and that busyness, functioning differently within various milieus and classes, can nevertheless lend a reliable aura of work ethic 'virtue' and guarantees of approbation.

[10] At face value, what Bergson champions here could appear to be about *more* of the effort that we know and use spontaneously, but I would suggest that we read him to the letter, specifically noting the term 'unusual'. To relax is, arguably, the most unusual effort, and to shift into its mode can feel 'intense', indeed.

The Indian writer Vachaspati Mishra articulates the question at a more mechanistic and astute level. What he observes is that striking a pleasant balance between too much and too little effort *itself* constitutes an effort – of a different kind and non-'natural'. Using too much effort, in other words, involves using the effort that we are accustomed to making. Wasting effort therefore functions as being *less* effort.

In his commentary, Mishra writes the following, which we can read as applying to all practising:

> A natural effort sustaining the body is not the cause of this kind of posture which is to be taught as an aid to yoga [practice]. For if [it were natural] preaching it would be purposeless in that it could be naturally perfected. Therefore *this natural effort does not accomplish this* kind of posture which is to be taught.[11]

Mishra makes it clear: if there is an effort involved in 'perfecting' yoga asana, it is not a natural effort. The effort that we can find ourselves making spontaneously is not the kind of effort that practising, which involves relaxation, requires. There is another effort, then, which involves by-passing or abstaining from the natural effort.

The practitioner is someone who enacts a different kind of effort. It is the effort of forgetting the usual way of natural effort. We exert ourselves differently in letting natural exertion fall away. This might sound slightly maddening, but it goes some way towards accounting for why this ideal of relaxation is no easy thing to enact in real time.

What we mostly do, in our regular lives, is to let natural effort run willy-nilly. Too much, too little. In various parts of our organism. Exerting effort in this way somehow requires (while still being costly) less of us than noticing the amount of effort or attention, and then beginning to see how much of it could be undone, dropped or lost. Interestingly, abandoning all forms of effort, what we might associate with being 'sloppy' or 'switched-off', or what my teacher terms 'collapsing', turns out also to be costly in a different way.

Thus, relaxation is itself an effort, but of another kind. It subtracts itself from the usual binary of over-effort/collapse, a binary in which many of us live our quotidian lives: working, collapsing, working more or simply harder, frightened by the collapse but nevertheless immediately grooming the conditions for it to occur again.

[11] Mishra, *The Yoga System of Patanjali*, p. 192 (emphasis added).

'Sloppiness' or 'collapsing', then, involves undertaking any activity – irrespective of its reputation for being a 'lazy' one or an 'active' one – with an inappropriate amount of effort that would be conducive for that activity, and which errs towards too little. In other words, lying on the couch might be done quite elegantly and deftly, and running about town on errands and making phone calls at the same time might be done quite sloppily.

The paradoxical effect of sloppiness – in all cases, irrespective of type of activity – is that it is tiring. Moving sloppily, sitting sloppily, walking sloppily are all very energy-expensive ways of moving through the world. It matches the same kind of expenditure of energy that overdoing involves. Both involve insufficient relaxation, and both are costly.

This is why relaxation – which requires a particular register of effort, at the level of paying attention and noticing – in effect preserves energy, and taxes the systems involved the least possible.

Another related effect of this is what I call the 'snowball effect of fatigue' or of low energy. When one over- or under-uses effort – that is, follows blindly the natural effort of one's tendency – then either way one ends up tired. The effect of this fatigue can go in two directions. We might rail against fatigue by switching into an adrenaline mode, which is a disaster for the future energy reserves, or we might start to become very unstructured, due to our flagging energy levels.

The snowball effect names how in order to preserve energy, we need a certain minimal amount, and in the absence of that minimal amount, our expenditure 'snowballs'. The minimal amount is that precise amount required for by-passing or letting drop the natural effort, that is, it requires the effort of noticing. This is the *non-natural* effort that we can learn to exert through a practice of relaxation, where a minimal initial outlay is required in order to approach the more ideal amount with consistency.

When we find ourselves exhausted (whether it appears as a falling-apart, or as surges of adrenaline) then what tends to happen is that we start to squander what small amounts we have. We start to stumble in our movements; we start to lose things, make mistakes. We find that instead of just attending to inconveniences, we are now creating them. This is a very predictable process, and perhaps it is a strong motivation for considering seriously this idea of another kind of effort, which has nothing to do with our natural or spontaneous efforts.

The metaphor of the snowball effect always touches me because we find ourselves in it very frequently. It is akin to the way poverty can complicate itself from within, and indeed can be deemed a kind of poverty of our energetic practices. When a person finds himself or herself close to having no

money, or dwindling security (their 'energy'), despite what logic tells us, they are less likely to make good decisions about any remaining funds. Instead, it's almost as if financial 'exhaustion' renders poor decisions about spending more likely, that a person will make grand gestures, suddenly running up debts, or take questionable risks, and so on. It is the stuff of many novels and life histories. It is also a mechanism of not-quite-enough and not a reflection on a person's intelligence or sanity (which counters moral judgements that can attach themselves to poverty). Rather, as Mishra tracks, it is a function of something mechanistic and structurally predictable. In those moments, we – as organisms – are embroiled in a very specific energetic trajectory with its own inertia. (I will speak more about the idea of effort and inertia in the final section of this chapter.)

Just like with the way we do our tasks, and illustrated in the money analogy, it is a strange and elusive kind of effort that we need to think, perhaps say and hone, in order to move towards ways of effort and doing that squander our energy less, either in modes of too little or too much, which – as we've seen – circulate within a recognisable logic.

In this way, when I read Ravaisson, I can agree with him up to a certain point, but my experience tells me that most of our habits – if left to run with what Mishra calls 'natural' effort – don't tend towards the grace and love about which Ravaisson seems so confident. The shape of habit, its mechanism, doesn't preclude this direction and, rather, there is something very precise that is required for repeating patterns of structured behaviour to access this other level – of grace, virtue, love, ease.

It is possible that if a person, or any organism (who's to say?), has an accidental experience of ease in a movement, then they may wake a curiosity as to how to cultivate this other quality in acting. They may or may not name the pathway they discover for this 'relaxation' (and there could be many names for it); but if left to run, without a strategy of 'noticing' (or Ravaisson's 'perception'), without a certain effort of the refined intelligence of the body, habits (as we normally understand them) can tend more often towards compulsive or automated rhythms.

Over the course of a life, for example, we don't tend spontaneously to move towards more effortless posture, for example. We begin as toddlers with a quiet, simple spine, open hips and a body that we listen to, rather than impose upon. As we grow older, the usual direction for habitual daily movement is seldom towards ease and greater fluidity. Some might counter this by claiming that the body is, anyway, 'naturally' deteriorating. However, it is possible that the causality of this perceived 'deteriorating' is other than we assume. The body does age, but perhaps the discomfort that gets called

age is partially linked to the dwindling fluidity and ease that accompanies a repeated structured behaviour that has not gone via an experiment in or curiosity for relaxation.

On the question of effort (and the subject's knowing of himself [sic]), Ravaisson writes: 'it is in the consciousness of effort that personality, in its highest manifestation as voluntary activity, becomes manifest to itself' (OH 43), and then later: 'Effort is in a sense the site of equilibrium where action and passion [. . .] come into relation' (OH 43).

This notion of 'effort' as a place of relation, as well as Ravaisson's emphasis on the pleasure involved in repeated movement without pain, suggests to me that Ravaisson was attempting to name something like Mishra's non-natural effort. This could account for how, in Ravaisson's conception, habits may move towards something sweeter and finer, the grace of which he speaks.[12]

The curious thing about organisms, but notably human ones, is that we regularly don't move towards pleasure and ease, and away from strong and uneasy sensations. There have been many explorations of why this is, both clinically and theoretically. We won't pursue the question here. Noticing its fact, however – that is, noticing our tendency to not follow ease in each case – might be its own kind of doorway that allows something else to happen. It is this something else that, arguably, aligns with Ravaisson's vision at the end of his brilliant essay.

Sensing[13]

To experiment with relaxation can seem, to the novice practitioner, a nice notion *and* a horrifying prospect. A student of mine once joked insightfully about how *awful* relaxing felt. Unlike our untested fantasies about what relaxation is – beaches, unstructured time, a lack of obligation, TV, *doing whatever you want* – relaxation as an approach in practising involves a difficult and lengthy apprenticeship.

[12] Bergson, writing about Ravaisson, recalls a quote form da Vinci: 'la beauté . . . est de la grâce fixée' (Beauty is grace, set in place / fixed – translation mine). Bergson, *La pensée et le mouvant*, p. 306.

[13] Discussions throughout this chapter generally benefited enormously from conversations with author and yoga practitioner Orit Sen-Gupta. This section in particular, however, draws very strongly on her practice-led research in the field of movement over her forty-year personal, daily practice. I use her term here – 'sensing' – which comes out of practice, without any relationship to Deleuzian vocabulary. Its alignment with the latter, however, is to be noted.

If relaxation for our purposes means delivering a (more) precise amount of effort required for the activity in question, the means for assessing and honing this dynamic, suited amount is both obvious and extremely confronting, involving also, as it does, an inevitable and repeated missing of the mark as we refine our approach.

Any 'assessment' of how much could also only proceed through one avenue: that of sensing. Sensing, I suggest, is how the body *thinks*. Given the infinitude of variable factors pertaining at any one time to the movement or activity at hand, the so-called brain (the one we deem to be exiled in the skull) will be a poor barometer for this assessment. The sensing or embodied thinking that is needed for this process happens much faster and much closer to the sites in question.

Conditions are constantly changing and the body and whatever the latter is in relation with are differently placed in space each time. The forces with which one is interacting are not stable enough to pass in real time via a representational conceptualisation, although they may go on to be inevitably digested and rendered iterable and storable via conceptualisation – that is, at those same registers of memory/representation and understanding/representation that we discussed in the previous chapter.

On the question of sensing and encounters, Deleuze curiously writes something surprisingly resonant with the practising-derived position above. As cited earlier, but more extensively here, we read:

> Something in the world forces us to think. This something is an object not of recognition but of a fundamental *encounter*. [. . .] It may be grasped in range of affective tones: wonder, love, hatred, suffering. In whichever tone, **its primary characteristic is that it can only be sensed**. In this sense it is opposed to recognition. In recognition, the sensible is not at all that which can only be sensed, but that which bears directly on the senses in an object which can be recalled, imagined or contrived [. . .] The object of encounter, on the other hand, really gives rise to sensibility with regard to a given sense. It is not an *aistheton* but an *aistheteon*. It is not a quality but a sign. It is not a sensible thing but the being *of* the sensible. (DR 176, italics original, bold added)

Deleuze here makes an important distinction between the 'sensible' (which pertains to various objects that can be represented) and the being of the sensible, 'that which can only be sensed'. The latter, which is what the practitioner is staging encounters with, is that which gives rise to what we understand the sensible to be. It is its genesis. For this reason, shortly after,

Deleuze states: 'It is therefore in a certain sense the imperceptible [*insensible*]. It is imperceptible precisely from the point of view of recognition' (DR 176).

It is via sensing – after the fact perhaps re-presented in the shape of concepts, techniques, manuals, instructions, anecdotes, ideokinesis and so on – that a practitioner takes up the problem of how to behave in relation to that which is singular, to that, for Deleuze, which cannot be repeated. If we want practising to give us access to that which stands outside of repetitions of the Same, then we must behave in a way suited to that intention, or longing. We must find a way to engage singularly, and this means that any staging or deployment in terms of regular difference won't help.

Without having engaged with Deleuze's oeuvre necessarily, practitioners often speak of sensing in order to describe what they are doing – their methodology – when they peer below the horizon of the representable contents of their various modalities. Deleuze goes on to say that 'that which can only be sensed' 'moves the soul, "perplexes" it – in other words forces it to pose a problem' (DR 176).

Practising, then, is very hard to represent back to oneself after the fact. One struggles to re-member it, to put it together using existing components of recognition and category. This is what also makes attempts at practising apt to slide towards the thrilling or the boring. If we think it should *feel like* something, then we will topple out of practising's delimited mode.

When it is happening, it is in a strange space *between* thrilling and boring, since the happening of practising – sensing – has little to do with existing qualities. Deleuze calls what it encounters a sign. Practising occupies a kind of space apart from these two recognisable atmospheres. If it becomes too thrilling, it risks becoming fuel for compulsion; if it errs towards drabness, white-washed to tedious minutiae, then it wanders in the realms of routine. On this point, Deleuze also has something to say: 'The sign or point of departure for that which forces thought is thus the *coexistence of more and less* in an unlimited qualitative becoming' (DR 178, emphasis added).

This might be another name for relaxation's neither-more-nor-less, reframed as actually *at once more and less*. Thrilling and ordinary. Relaxation, then, as the reader may be coming to see, is a name for a tolerance or stamina for a no-man's-land, an 'at once' that escapes recognition's mechanisms. It is thus a strange, non-natural effort of staying put,[14] there where we resist

[14] Interestingly, the language of the *Yoga Sutras* flags this very fact. Where one might struggle to unpack Sutra I.13: 'Practi[sing] is the effort of becoming stable there' (Sen-Gupta, *Patanjali's Yoga Sutras*, p. 29), reading it in conjunction with Deleuze

insisting that things be recognisable; where it is precisely recognition that is not in play.

What is repeated precisely in practice and as practising, and that which accounts for the relaxation it cannot forgo, is the *sheer fact* of sensing,[15] the only way we can encounter intensities. This is how one would gauge the effort required (where more and less will prove to be exact) and come – asymptotically – to approach a relaxed doing that does not compromise form. 'Gauge', even, is not precise enough, since anything that implies assessment, quantifying and so on, collapses us back into the terms of a represented register.

Practising slips beneath this register – which we don't need to disavow, but rather see for its own character – conjuring both a softness and swiftness that is peculiar to a methodology of sensing, and aligning with an intelligent, tenacious relaxation.

There is something at once dignified and vulnerable in this process. To practise a steady and constant sensing is to change profoundly one's relation both to one's environment (it is no longer generalised) and to dogmas of thinking (one perceives them as illusory, or at least not the whole story, without needing to react against them in gestures that would only energise their logics). In the next section, we'll explore the kinds of contexts in which practising tends to happen more readily – namely, those conducive to the hinge or threshold that is relaxation.

Relaxation subtracts our action – although still conforming to form – from a certain mode of repetition of content. In sensing, content becomes something else entirely, and therefore is unable to be tracked, replicated or represented back to the doer by the usual means. Sensing, in this way, dissolves rather than ramifies contents. Sen-Gupta, for example, speaks of what is normally deemed the 'body' becoming sheer bounded space, held by something ineffable and in a clear region, with an edge that is precise, but not hard. She compares it to the effect of sketching lightly with charcoal, when the line is more grey than black.[16] It recalls Deleuze's insistence that within the climes of the Dionysian, the logical pairing is the *distinct* (with the) *obscure*, and not the Apollonian clear-distinct (DR 350). Practising inhabits the former, as conversations with long-term practitioners intimate.

allows it to pique a less obvious meaning. We might read it: Staying put, in that register that is sensing, prior to what it produces, namely the sensible, *is* practising.

[15] Again, my deep gratitude goes to Sen-Gupta for her clarification and testing of this, and her willingness to share her insight.

[16] Personal communication, 11 September 2015.

The unrecognisable body of practising remains distinct and obscure, slipping below the searchlight of the register of representation. Its contents are not to be known in advance.

As we'll see in the final chapter, this dropping-away of, or de-emphasis on content, which has marked the criteria of practising from the start, will take on a crucial operational function when we reach repetition for itself and that latter's entanglement with the something we can call the 'eternal return' for shorthand.

In the next section, we'll consider contexts in which relaxation becomes more possible, and how practitioners set up circumstances in which they can experiment with its risks.

Containers for Relaxation and Conducive Environments

What we've explored above may cast some light on why practising is often enacted in unusual or specialised environments. When beginning to experiment with relaxing, people may seek out suitable spaces, and (perhaps especially) reliable or experienced people who might assist the process or offer instruction.

The word 'cloister' also comes to mind, meaning an enclosure, but also a structure of protection, a separation between worlds. Relaxation is such that it can benefit from being experimented with (especially in the period of its early discovery) in environments that are less demanding and hostile than our day-to-day. Working, thus, in this protected way, also has the advantage that it is less likely that quotidian mishaps will stimulate a defensive or protective overdoing, or a fatiguing 'sloppiness', heavily invested in resisting unconsciously. Both of these, as we've read, squander 'energy' or capacity.

Furthermore, a body committed to sensing and to approaching 'in action' what relaxation might look and feel like is more vulnerable, and therefore might do better to feel safer than usual contexts allow. That's not to say that a body practising a structural requirement is also not already more stable, and increasingly robust – a kind of fierce body. It is more vulnerable because it is beginning a simultaneous experiment with the porosity and fluidity of self; it is fiercer due to its not being an entity in defence against other registers of being/becoming.

Sensing, as part of what relaxation makes space for and of what it requires, will not reinforce identity. It does not represent, and therefore fails to ramify activities and their so-called outcomes at that register, one of which might be called 'personality'. On the other hand, in becoming attuned to sensing,

a body will also perceive the world, both its wounding and delighting fluctuations, keenly. Adhering to its intentional behaviour and the latter's repetition, it finds itself within the register of appearance, but on a footing other than a rigid notion of self. This is the unusual constellation accompanying practising, that of a functioning 'self' but on altered terms, accompanied by increasing robustness and steadiness. In order for this constellation to be well 'held', specialised environments are sometimes advisable and generative.

Relaxation arguably then prefers a container in two ways. It may demand an external container – a physical place for practising it – where the usual demands of life are set aside for a short (or longer) while. This might be the garden, or the practising room, the studio, or the monastery. (Once established, the practitioner may then be able to practise anywhere, such as Federer in front of a stadium of fans.)

Then, relaxation demands an internal container, which is nothing other than the chosen form of criterion 1. The necessity of this form cannot be overstated. It is irrelevant, to some extent, *what* it is. One could say that ideally there is a deep affinity to it, some even call it – coyly – a 'calling', in that old sense of *vocational*. It is helpful that the budding practitioner likes well enough the form chosen, since it will be long years of apparently just doing that form, with little sign of things getting more interesting. Sometimes forms are also beneficial in other, more practical ways. Someone with asthma, for example, takes up swimming as a sport, but then extends it into the realm of practising. It isn't *un*helpful that a moist environment is healing for most asthmatics.

Among my circle of practitioner peers, people speak of the motivations for practising. It is acknowledged that it doesn't quite matter what brings you to it, but that without a curiosity going beyond a 'wanting to cope better in the world as it is' attitude, practising seldom establishes itself with much vigour.

We do develop good habits because we want to improve our lives in a pragmatic sense. We may come to understand that structuring isn't optional, waking up to the fact that if we don't want to be solely structured by economic exigencies and the capricious demands of others, then we'll need to structure ourselves (hopefully without losing our interpersonal responsiveness).

After we deal with certain burdens of personal, inherited torsions in the self and its relation to the world, we may have a niggling interest in something else. This might be an array of sensibilities that welcome temporalities other than a utilitarian present – the sensuousness, for example, of an insisting, vast past. This might also be the future, and the intrinsic deaths that constitute its portals – the themes of the next chapter.

If there is something extra – an excess – that most of us add to our doings, then this excess, strictly unnecessary for the fulfilment of the empty form of doing, is what throws up the mirage of self in the wake of our chosen activities. Put another way, this excess is the verb uprooted from the infinitive form and conjugated, which thereby adds ourselves (as agent) and time as determination.

This very excess anchors the movement/doing, its effects and ourselves in the register of representation, within the living present. In the final section of this chapter, we are going to explore the question of rest, and its relation to relaxation, as we've framed it here. Rest is an oddly contentious, sometimes inflammatory topic, one that has a strong relation to the *how* of relaxation.

Relaxation and Rest

The question of one's relationship to resting, as well as the more pragmatic question of how to do it, the forms it can take in a life, often raise their heads when practitioners begin to get more serious about their practising. Rest, pertinent too to the sustainability of practising, bears a curious relation to relaxation, one that echoes certain movements in the latter's logics.

In the life of an organism, rest – although clearly necessary – can be a fraught, or at least complicated, prospect or mode for many. We can invest it with ambivalences, use it as a cipher for our dissatisfactions, bemoan its scarcity, or refuse it. A friend of mine speaks of the traces of ordeal left in him from years of being harshly woken in his childhood. It was a mounting horror of never being-allowed-be, in resting. He still manages those traces, creatively, but it's a work, nonetheless. Resting's dearth (the lack of opportunity to do or *have* it) – haunted by its flipside, busyness – is either a not uncommon topic of phatic exchange or conspicuously absent.

We know how to complain/boast about exhaustion and over-commitment, but do we know how to say and think resting? Perhaps, it is more risqué than we know, almost unseemly, a too private subject to bring up. Resting, we could speculate, might be an almost illicit aspect of intimacy. If sex-with-climax becomes intimacy's work-like, accountable face, just another task, what might rest contribute to our equations of togetherness? Orgasm, if leaning towards a measure of achievement (in some paradigms), might reflect that generalised press within representation for something recognisable to take place. Resting's contours are more obscure.

Rest, in our coyness about or reluctance to explore it, may have become something taboo. I'd venture to suggest that rest, as opposed to what can be des-

ignated as legible sexual conduct/outcome, is one of our most erotic modes. It's curiously often the mode out of which desire, if it has quietened, stirs again.[17]

Holding open this possible inherent relation between resting and the erotic, we can turn to Deleuze, perhaps with more insight, when he writes:

> [Eros] is the companion, the fiancé, of Mnemosyne. Where does he get this power? Why is the exploration of the pure past erotic? Why is it that Eros holds the secret of questions and answers, and the secret of an insistence in all our existence? (DR 107)

We do not need to answer Deleuze's questions here (which lead his discussion towards the third synthesis, the focus of our next chapter). Rather, we can note that drifting in the cone of Bergson's past involves precisely *relaxation*: appropriate degrees of tension and de-contraction, in order to situate oneself at various levels in this realm of insistence. When we rest, when we relax – playing with levels of tension and non-tension – we coincide with the operations that mark this synthesis, a synthesis which, according to Deleuze, is by its very nature erotic.

Harking back to our discussion of the vulnerability of a body learning relaxation-as-mode, the body at rest is similarly exposed. In rest, we encounter ourselves as an organism among others – dependent on phases of recovery, as well as action and accomplishment. If our status and sense of worth are reliant on 'doings', then rest turns into an unmentionable thing; it must happen – if only as dead-to-the-world sleep – but it is concealed, both how and how much it happens.

Claiming a commitment to rest may, until recently, have meshed uneasily with public personas, social roles, cherished and broadcasted identities.

Rest, for our purposes here, is something that supports the work of practising. Essential, fecund, whimsical, precise in its mechanisms, erotic, vulnerable, it arguably subtends the operations of criteria 1 and 2, insofar as we need at the very least sufficient rest so as to establish the 'good' habit which our practising will inhabit. Even in everyday language, rest is rarely conflated with 'laziness'. We rest, I'd argue, intentionally, intelligently. We decide to put the world's immediate concerns aside, because other concerns matter too.[18]

[17] In the last decade there has been a surge of popular interest in sleeping and resting. Examples of widely sold books include Arianna Huffington's *The Sleep Revolution* (2016); and Matthew Walker's *Why We Sleep* (2017).

[18] Recent interest in fasting (from food), which has often been an inherent aspect of many religious and ascetic traditions – done at certain specified times of the calendar

In its relation to the third criterion, rest then becomes even more inter-esting. Perhaps when resting, we can stray into the mode of the second pas-sive synthesis, into reminiscence. We can begin to thicken our experience of time, complicating the living present with brume off the ocean of the pure past. In resting, we are porous to the fact that time isn't a single mode, and that reality doesn't solely consist of representation. Freud's genius stud-ies at the start of the last century – into a register of human life called the Unconscious – derived from his paying attention to dreams, which – let's note – happen to us primarily when we are asleep.

Furthermore, we need rest because without sufficient energy, the attuned attention involved in relaxation (criterion 3) will be inhibited. Sensing is a very delicate business, and adrenaline – which dominates when a body's 'credit card' is overdrawn – tends to be a noisy, overly mutable condition (*rajas*). Full of adrenaline, one might suspend the delicacy of rigour in favour of amplitude. Adrenaline is flashy, arguably addictive, but an atmosphere (for most, and on the whole) in which it's nigh impossible to do the intricate work of unstitching the seams of representation's fabric.

Most of us, unless trained, or mentored, or perhaps only after long years of trial and error, can find ourselves without both techniques for resting, as well as a clear understanding of why we'd do it. Many people treat rest as if it's something to resist, as if giving in to its need is a kind of resignation, or even a weakness (which is absurd, despite being often culturally instilled), rather than an astute strategy.

Just like the snowball effect discussed earlier, a small amount of discerning rest saves the body from shutdown (sometimes called 'burnout'), which often is lengthier, more costly, and disruptive to activities and projects. In recent years, I've become more able to take short rests during the day (when cir-cumstances allow). Knowing that I can decide to rest reduces certain kinds of underlying anxiety – about limits, exhaustion, discomfort and so on – from which many of us suffer in contexts where to rest discerningly is not an acknowledged option. The resting might be for only ten minutes – lying on grass somewhere, doing nothing, or on the floor at work (if workplaces have spaces). While writing for long stints, I've learned to stop and do a supported

– coincides with a realisation that our organs might also need a rest from the work of processing what gets 'put in' or 'through' them. Rhythms of eating are also vulnerable to habit's inertias. Constant eating, in societies of affluence, rather than being kind or generous to the body, is often also enormously exhausting, resulting in complicated contemporary health conditions. The resting emphasis in fasting is far less perverse and mean-spirited, I'd argue, than the 'deprivation' attitude that has accompanied dieting practices framed in terms of calorific reduction.

yoga pose for five minutes or so. Examples are numerous; effects are encour-aging. These small interventions resolve most fatigue, allowing for (often) several more hours of focused activity without strain. My sense is that the fact that we rarely do this (when it is objectively possible, intelligent and so on) has much to do with cultural norms and behavioural conventions. It is part of convention to fetch a coffee, or to eat sugar in the afternoon, and it is not a convention (in many countries) to rest.

We are speaking here, however, about the most obvious face here – the common-sense notion – of resting, and this is not the sole emphasis. Like effort, we can think about rest as something we do too little or too much of (mostly the former), but it's not really a question of inhabiting the 'correct' or 'more moral' pole of this binary. That would be to apprehend resting as a kind of 'good habit' (which it might be, as in my example above) that we can acquire (and we surely can).

At the level of rest and practising, the question becomes far more inter-esting. Let's propose that resting is to the *when* of doing, what relaxation is to its *how*.

I'd like to propose an inflected definition of the two terms as follows. It is an inflection that highlights their parallel operations at two related registers:

Relaxation: the capacity of an organism to transition between modes of more and less effort in the performance of its practice or structured behav-iour; and/or the state an organism is in when this capacity operates most reliably.

Resting: the capacity of an organism to transition between activity and an 'absence' of activity (between doing and non-doing) in its life more gen-erally; it tends to emerge alongside relaxation, becoming more established within practising.

In other words, relaxation is to practising what resting is to life.

Relaxation speaks to how we go about the various movements involved in our chosen, structured behaviour. We pick up the glass in a relaxed manner, which involves a dynamic sensing in each moment, in relation to the glass, the context, my arm strength, and so on. Relaxation, as we tried to clarify, is about how we transition between intensities of effort within a discrete activity: for example, our ability to transition between the hand-beating of egg whites, and the folding of them into the chocolate mixture. A relaxed practitioner is able to make these transitions – from appropriate effort to next appropriate effort – with fewer clunks and misfires.

Likewise, a practitioner's relationship to resting involves the question of knowing when to engage in their chosen practising mode and other activities in general, and where this fits in a life. The meta-rhythms of rest's problematic, as opposed to the subtending, dynamic efforts within a session of practising – relaxation's problematic – run parallel to each other, when we embark on practising for the long haul.

Something of the deftness of relaxation in practising, then, comes to be played out at the broader levels of our lives via the sibling lens of resting. Resting becomes that which, in turn, supports the possibility of each episode of practising – its feasibility in real time, if you like.

To be a practitioner, in my personal experience, is to find oneself having very non-negotiable, non-ambiguous encounters – as problems – with the questions of when to practise, how often, how, in the place of what, and so on.

Does one get up and leave a lover in the bed, alone? Does one go to bed earlier, but see certain friends far less? Does one modify one's diet to support the 'doings' of the practice more, or remain easy-going in relation to food, as a crucial and generous aspect of social conventions and communities? Does one forgo sleep for time practising, or does one sleep enough and reduce the time available for other aspects of being a conventional person, or limit practising?

The answers to these questions are not always quantitatively straightforward. Time changes when you practise. This must also be taken into account.

Resting, it could be said, involves one's ability to integrate relaxation's genius into a real, contingent, unpredictable, shared life. This is also a life with stages and moments, with phases of householder commitment, or years of solitary research, some years for retirement (for those lucky enough), twenty-something explorations, and so on.

These questions and how we integrate practising remain pressing as we navigate the stickier details raised by our commitments to 'doings' that by definition won't be acknowledged or countable within the register of representation, the one in which a dominant part of our experience unfolds.

Resting, then, pertains to our ability to navigate various inertias implicit in living. This inertia is nothing other than our tendency to persist in whatever we are doing, a fallout of our being entities that are generated by habit's mechanism. Resting is shorthand for the field of our experiments in transitioning smoothly between our explicit doings and other non-doings, between practising, working, laughing, sleeping, hurrying, waiting, creating and sobbing. Put another way, resting pertains to our knack not only of fall-

ing asleep, but also of waking up. It saves us from being marooned in any particular mode. Just as relaxation has little to do with collapsing, resting bears a non-relation with crashing from one moment in our life into another.

In relaxation, we subtract our action from so-called routine and compulsion, and in taking up the invitation of resting and the integration it cultivates, we arguably become more attuned to the threshold between our discrete episodes of practising, and the 'rest' of our lives. Practising, if it is not already obvious, need not set itself up in opposition to a lived life.

Structuring Rest

Rest, then, as an aspect important for the third criterion of relaxation, is in fact not an easy thing to experiment with in a life. The reason for this might partially be practical and returns us to the question of structure. Without structuring, intentional and consistent rest can elude all but the most attuned. And the latter, in 'gaining' their experience, will furthermore have predictably struggled with, and have had some breakthroughs regarding, resting in terms of how to access it reliably through structure. In other words, relying on chance to enable adequate periods of resting is unlikely to result in adequate rest.

Windows for rest function as periods of non-structure within structure that are crucial, but which in turn need a container in order to be feasible. We spoke above of the containers for relaxation, and similarly, resting is almost impossible without certain structural props. As one becomes more expert at resting, however, the 'props' can become more minimal.

A good way to illustrate the structural aspect of realistic resting is to give the example – from within a number of practising traditions – of retreats. Retreats are periods of time, usually stretching over several days, up to many months, and in unusual cases years and decades, where people withdraw from quotidian life and its obligations, in order to adhere to a different kind of contrived schedule.

A schedule is a way to structure time. I'd dare say that there is no retreat that does not use a consistent schedule that is repeated across its decided duration. The duration of a retreat is also typically, although not in all cases, decided in advance. The retreats that the average person will encounter in the current historical moment are mostly for a set number of days or weeks. During a lay retreat, needless to say, one is also economically non-productive.

A retreat may have any number of various 'contents', which will be determined by the particular tradition within which they are taking place.

If we look past these 'contents' what we see is that – if the retreat is insightfully organised – it is structured with a rhythm that involves content alternating with unstructured, content-less time. Often called 'free time' on the schedule, these periods where nothing is scheduled become opportunities for resting; and resting is far more likely to happen in them (than in normal life) due to what happens around them, the structural scaffolding holding their emptiness or spaciousness in place, and bearably.

As beginners at resting in its usual sense, we can't handle very much of it – especially not lucid stretches of it. We can handle sleeping (as a form of rest), if we actually get to sleep, but resting in a lucid fashion strikes most people – and justifiably – as marginally horrifying. On a retreat, on the other hand, there thankfully appears to be a lot of 'things' one has to do. One has to get up at 6.15 a.m., drink some tea, and then be in the practice room at 6.45 a.m., for example. Then one has to do a three-hour practice consisting of various things (probably some well-disguised resting), and then one gets to eat. After the eating, however, there might be 45 minutes where nothing is scheduled. For newcomers to retreats, they may experience this gap as a kind of waiting, which won't be very pleasant, or they might – which is more usual – decide in advance all the things they can 'fit in' to that gap (bush walks, stretching, making phone calls home, reading that self-help book, checking work emails when nobody's looking, and so on).

All of this might also be very restorative, and in certain cases necessary (leaving 'life' and its obligations behind is no easy feat). At some point in one's retreat trajectory, however, sometimes accidentally, one forgets to do something in this 'free time' window, and finds oneself lying about on the grass, snoozing on a veranda somewhere, or wandering around (but not bushwalking) aimlessly. One has a very good book in one's hand but finds that it doesn't get opened. Instead, one does nothing. One isn't even practising . . .

Because the schedule reliably starts up after that 45-minute gap, the resting doesn't become vertiginous and too much. It's a little taste of and can serve to extend one's capacity for doing very little. Also important for the resting, *as resting*, on the other hand, is that it not be endless. The rhythm of the retreat schedule, in its alternating of activity and non-activity, is also a practical training and preparation for a life rhythm that also wouldn't be either all frantic doing, or overwhelming slumps of lethargy and temporal vertigo.

Retreats, then, predictably train the practitioner in transitioning between states of doing more, doing less and doing differently. When the bell rings, signalling a return to the practice room, the participant doesn't ask whether

she feels like it, she just goes and practises. The fact that the retreat struc-
ture (and the teacher/organiser) stands behind this structure helps here too.
There is also the comfort of knowing that one will only practise for another
couple of hours, and then again, there'll be food and more aimless time, with
an end point, and so on.

This is a very 'human' solace, the thought of which we shouldn't underes-
timate. The thought of endless anything, in this way, is exhausting. A clem-
ent rhythm, as well as something supporting us to hold to it, is immensely
comforting, and conducive to creativity and joy.

The most resonant literary example of just what I've been talking about
is Thomas Mann's *Der Zauberberg* (*The Magic Mountain*, 1924). Any reader
who'd like a visceral experience of a retreat without going on one might find
interesting the very particular atmosphere that pervades most obviously the
first half of Mann's masterpiece.

Hans Castorp heads to visit his cousin Joachim, who despite appearances
really does have a serious case of tuberculosis, at the luxurious alpine sana-
torium at Davos, in Switzerland. Castorp famously intends to stay for only
three weeks. Ominously, those he first meets there respond somewhat con-
descendingly to his assertions in this regard, their responses implying that he
is mysteriously likely to stay for much longer.

What we see in the early parts of the novel are very much the clear
structures of life at the sanatorium: repeated meals, small walks, doctors'
appointments, more meals (which themselves are internally structured –
with innumerable courses!) and, most crucially, extended sessions of *Liegekur*
(the lying-down or resting cure) to which the patients at the sanatorium are
committed. The passage where Castorp purchases for himself a camel hair
rug for this 'activity' is quite memorable.

As the novel progresses, it becomes clear how the regular schedule, its
boring lack of variation, in fact has a profound influence on one's experi-
ence of time. Castorp, incidentally, stays for seven years. It is a complex,
and unforgettable, novel, but one of its contributions – for this reader, at
least – was that it managed in representation to convey some of the stranger
atmospheres that emerge when schedule is implemented in a particular
way. Resting, in other words, might also be for 'wellness'; however – via its
relation to relaxation, and relaxation's relation to criterion 4 – it also gives
access to a register we might call the existential, or more rigorously, the onto-
logical. The novel, of course, also tracks the seductions of a rhythmic life
that sequesters itself away from the world's contingencies and interrogates
this theme via its narrative denouement. At the same time, Davos becomes
a kind of microcosm for the world's own rhythms of struggle, grandeur and

decay, its retreat finally also being a context where such exigencies are distilled and played out anyway.

People in the know go on retreats because they know that the fantasy of the restful holiday is usually just that. Holidays are something else. They are a change of scenery, a chance to see the world, to spend time with loved ones – peacefully or in conflict – to eat, to pursue a hobby, and so on. Holidays, as we know, are only sometimes, and often accidentally, restful. This is the cruelty of media that promote their fantasy, but also almost ensure in the same sleight of hand that their reality will fail to deliver the windows of aimlessness in which longed-for transformations might be glimpsed.

Retreats are an example of a very old technology that knows how to intervene in a certain mode of time and also to give people access to forms of rest that can have radical potential. This potential has something to do with what *contents* a retreat involves, but even more to do with the structures in which the latter are delivered. Rest and windows-of-less are very powerful, and when we are rested, we can forget to remember certain versions of ourselves. To access deep rest means to evade for a short while the seamless fictions we are, to see around and through their ruse.

This is more difficult without setting to work an understanding of structure and rhythm. In order for the unstructured to operate and to appear, it must – strangely enough – be structured.

Spacious Nothingness

If we return to Derrida's idea of the *pharmakon* that we encountered in earlier chapters, we can ask ourselves if unstructured time is not also some kind of *pharmakon*. Its status as *pharmakon* would go a long way to explaining why we struggle with it so much, and why we have a justifiably ambivalent relation with it. If rest is a name we can give to *structured* unstructured time, a mode that would not poison our life, then unstructured time not held somehow, in a container becomes indeed for many a little toxic.

The current book is not a context in which any psychological claims can be rigorously made. I would be very curious, however, for someone more suitably equipped to explore whether the poisonous face of unstructured time might have anything to do with what commonly appears under the vague, or at least nowadays ubiquitous, nomination 'anxiety'. I pose it simply as a question, while also knowing that structuring tasks is commonly used by people recovering from histories of anxiety.

We must, in other words, acquire the means to take safely our draughts of nothingness. Those who abstain perhaps do so with some hunch as to its

dangers. At the same time, a life without such draughts also risks another kind of horror. Life without the *pharmakon* of unstructured time is a life that – to borrow from Derrida – wakes the 'necessity of the worst'.[19] This is our dilemma. We have to risk nothingness without drowning in it, or risk perishing slowly but surely, in a dry, predictable place. One is terrifying, the other grinding.

Understanding that structure-as-strategy goes some way to making the wilder aspects of unstructured time available to us as resting is part of that which practising facilitates.

For the purposes of practising, I'd contend that resting is not to be under-estimated, and also that, if engaged with intentionally, it becomes something that can be elegantly sufficient. By this I mean, it satisfies *enoughness*. We neither deprive ourselves of rest in a reactive fashion, nor do we fall into a bottomless pit of lethargy; just like relaxation, we practise enoughness, which approaches more and more a simplicity that is neither cavalier nor conservative.

To rest elegantly, therefore, works to sidestep the likelihood of collapse. Just as relaxation has very little to do with the 'sloppiness' that comes with not enough effort (and its accompanying costliness), rest is a delicate business worthy of consideration. Any cavalier, even macho, approach to resting (its avoidance or disavowal), achieves little more than posturing and, without doubt, risks hindering our potentials for practising. In the next chapter, the discussion returns to Deleuze in order to explore the workings of criterion 4 – *repeating repetition*.

[19] Derrida, *Specters of Marx*, p. 34.

5

Repeating Repetition: Practising with the Future

Under what other conditions does difference develop this in-itself as a 'differenciator', and gather the different outside of any possible representation?
Gilles Deleuze, *Difference and Repetition*, p. 143

PART I: Revisiting the First Three Criteria and First Two Syntheses

In the third chapter of Deleuze and Guattari's work *What is Philosophy?* (1994), the one entitled 'Conceptual Personae', the authors introduce the curious notion of taste, as being the 'philosophical faculty of coadaptation'.[1] Taste here for them appears as a faculty that 'regulates the creation of concepts'[2] and does so with no reference to measurement.

According to Deleuze and Guattari, taste operates *prior to* consistency's modulation of three aspects: the concept-to-come; the plane out of which it will arise; and the conceptual personae that will 'carry out the movements that describe the [creator's] plane'.[3] Taste is the faculty constituting a 'rule of correspondence'[4] between the three instances before they are technically available to articulation, and without their being in any way commensurable.

I've raised this notion of 'taste' in Deleuze's work because I think it provides a way into and an atmospheric hint for the central issue of this chapter, where we'll discuss the final criterion of practising: *repeating repetition*.

[1] Deleuze and Guattari, *What is Philosophy?*, p. 77.
[2] Ibid.
[3] Ibid. p. 63.
[4] Ibid. p. 77.

Practising, as has been argued, involves times. One of these times is the arriving or enabling of a particular inflection of 'the new', or of the future, where several auxiliary criteria crucially operate. This 'new', however, is not the 'new' of variation, or the 'new and improved'. It is not incremental change (although, from the perspective of the actual it may appear this way after the fact). It is not 'novelty', if we read this word as an inflection of 'modification' (there are of course other ways to read 'novelty' – for example, in Badiou[5]– and these correspond more to our discussion here).

The 'new' that might be courted by practising's mode, and which, over the course of this book, has sometimes been referred to as 'transformation',[6] is one that is strange, barely recognisable – how could it be? – since not operating in any obvious relation to existing regimes, by definition illegible from within the dominant one. It passes through, across and despite ('trans-') existing structures, with no regard for their topographies and *without reacting to them*.

Its relation to existing forms is to put them to use otherwise, or differently, through a particular mobilising of repetition's operation. It does not engage with form out of subservience to (nor reaction against) it, but due to an understanding that form and repetition constitute together a very precise gateway to temporal mobility, and to futurity as part of this, by manoeuvring the mechanisms that constitute how being becomes. Deleuze's Nietzsche might call it re-acting.

So, there is a 'taste' that operates, which inclines towards a kind of 'newness' that we neither like, nor of which we could ever, on existing 'grounds', approve. Deleuze and Guattari will use the word 'love' – the love of the well-made concept – to describe their version of it.[7]

What is made in practising may also be 'concepts' (if one practises philosophy), or it may be affects and percepts (if one works in the realms of art). It may be ways of being together in the world (in the case of political/ social practices), and so on. What is made, then, will be the kind of newness that may emerge when the four criteria of practising are operating. In what follows here, we will investigate the fourth, and most startling, of these: repeating repetition. But before that, let's revisit the first three criteria

[5] See Meditation Twenty, for example, 'The Intervention . . .' in *Being and Event*.

[6] See Deleuze's use of this word in *Nietzsche and Philosophy*: 'This is why Dionysus is himself *transformed* in multiple affirmations, rather than being dissolved in original being or reabsorbing multiplicity into primeval depths. He affirms the pains of *growth* rather than reproducing the sufferings of individuation' (p. 13, emphasis original).

[7] Deleuze and Guattari, *What is Philosophy?*, p. 77.

cumulatively, so as to appreciate where and how the fourth one raises them to another power, and produces a constellation of a very different order.

Recapping the First Three Criteria – and Emphasising Relaxation

In order to assemble the constellation of criteria that constitute practising, as we've explored it, we begin with a set of behaviours which can be mobilised as the form of the practice. This (usually but not necessarily an intentionally acquired) form, whose shape may look a lot like that of 'habits' we recognise in the world, satisfies the first criterion, which states that practising begins with a bounded behavioural form, without the form undergoing too many or frequent modifications.

The difference that practising courts is not one of modification, and hence modifying the form of practice constantly or in an erratic way can tend to dilute its mechanisms and their cumulative power. This approach to practising, however, can be, for newer practitioners, less appealing. It is also something, which, I've argued, might be a distinction between most forms of practising and the creative arts, specifically, where one might develop new methodologies in conjunction with new works.[8] This development is hardly, however, erratic, and constitutes the most mature aspect of the practice of artists.

The perception, furthermore, that perhaps a lack of modification is boring mistakes the register on which the labour of practising courts the new. Intentionally trying to modify the arrangement of the pieces in the register of the actual, seeking recognisable novelty is not the way in which newness, or a temporal, subtending shift, obtains. Most of us have personal experience with this kind of futility, and without a scaffolding for thinking it, the failure of this mode of intervention can be baffling, frustrating or drift into compulsion, where repetition is then pursued furiously but without the requisite 'ontological' nuance and, therefore, without effecting an intervention.

The form of the first criterion flows into the second criterion, which requires that this initial form or behaviour be such that it can be intentionally repeated. The intentionality in the second criterion isn't optional. The repetition must enter a mode that begins to subtract it from habit's ambit (in other words, it involves acting one's reactions). Together, however, when analysed with reference to existing scholarship on habits (such as

[8] On this point, of modification, or 'invention of the form itself', see generally Pont, 'Practising Poetry'.

Ravaisson's and more recently Grosz's), the first two criteria run parallel with a subset of what has tended to constitute 'habit' as methodology. Habit, too, involves an identifiable set of behaviours that repeats.

For a practice to have a workable basis, both a behavioural form and the repetition of that form, occurring intentionally (that is to say, in various modes of intentionality), is required. As explained in earlier chapters, if we were to stop here, what we would ostensibly have would amount to something resembling a garden-variety 'good habit'[9].

Good habits, as part of a moral order, constitute an initial engagement with structuring, with 'deciding', and with attempting to make small incisions into the 'flow' of time as it is produced in any given historical moment. Regarding habit, in general, and its social effects, William James only has approving but slightly ominous things to say about it. I quote him at length:

> Habit is thus the enormous fly-wheel of society, *its most precious conservative agent*. It alone is what keeps us all within the bounds of ordinance and saves the children of fortune from the envious uprisings of the poor. It alone prevents the hardest and most repulsive walks of life from being deserted by those brought up to tread therein. It keeps the fisherman and the deck-hand at sea through the winter; it holds the miner in his darkness, and nails the countryman to his log-cabin and his lonely farm through all the months of snow; it protects us from invasion by the natives of the desert and the frozen zone. It dooms us all to fight out the battle of life upon the lines of our nurture and early choice, and to make the best of a pursuit that disagrees, because there is no other for which we are fitted, and it is too late to begin again. It keeps different social strata from mixing.[10]

If we needed any convincing regarding the link between habit, politics and practising, James's summary here may well do the job. He lays out, without flinching, habit's role for the conservation of the sociopolitical status quo.

Habit, if we follow his argument here, is therefore unlikely to contribute to our radical inhabiting of the world, and rather will assist us to stomach it, in its current form, without seeking to reinvent it.

[9] At the time of writing there was a consistent amount of interest on the Internet in daily habits and routines of artists. A website that regularly features articles of this kind is www.brainpickings.org/ by Maria Popova. This widespread curiosity arguably suspects the importance of structures and repeated rhythms to creativity.

[10] James, *Psychology*, p. 143 (emphasis added).

A structuring behaviour, ramified via repetition, does however constitute that aspect of practising that has a stabilising effect. However, *that which would become stable* in practising (as opposed to via habit) is rendered less decidable, as practising moves into its third and fourth moments or criteria.

As we saw in the previous chapter, the hinge that constitutes the moment when an established 'good habit' begins to tip into the very other mode that is practising, begins with criterion three – relaxation. It may indeed be a relaxing at the level of being-a-recognisable-self that is at play in this criterion. Or a relaxing that relaxes reactivity, per se.

At this point, we can note, for a reader of Deleuze's original text on this matter, that Deleuze distinguishes between orders of 'repetitions' using two divisions that can appear at least confusing at first encounter, if not inconsistent. First, he elaborates two dual orders of repetition – bare and clothed; repetition-of-the-same and repetition-for-itself. Much of the 'Introduction' to *Difference and Repetition* (DR 1ff.) is dedicated to exploring these and related distinctions.

Later however, in the chapter called 'Repetition for Itself' (DR 114), we see him listing 'three repetitions', a move which can appear confusing to a reader less familiar with this work, given the division into two that is in play in other sections. As it turns out, the further series of 'repetitions', as I read it, corresponds to the three passive syntheses, of which the third would surpass both the 'bare' and 'clothed' versions of the first two syntheses, the living present and pure past. This structure is reflected in the way the three syntheses are treated in the current volume – the third chapter here on Deleuze's Repetitions, namely, the first two syntheses, as example of two repetitions through which practising moves – and now the current chapter, which will unpack the third of these syntheses, or the third 'repetition', which dovetails with the 'miraculous' order of repetition.

A simpler way to articulate Deleuze's approach is to say that he distinguishes two forms of repetition proper; but in order to situate their manner of operating, he explores three modes in which repetition produces or synthesises time – namely as habit (living present), then as memory (pure past), and finally as repetition for itself (which 'makes' the future, or rather frees time from its subordination to the habitual present and the involuntary past, what Roffe calls the 'half-awake, half-dreaming life of habit and memory' – WGD 231).

Let's link this to habit, then, and how it can be folded into the conditions for practising. Deleuze explicitly mentions habit and how to work with it in *Nietzsche and Philosophy*, stating:

[Culture] is always a matter of giving man habits, of making him *obey laws*, of training him. Training man means forming him in such a way that he can *act his reactive forces*. The activity of culture is, in principle, exercised on reactive forces, it gives them habits and *imposes models* on them in order to make them suitable for being acted.[11]

If we substitute the terms *structured behaviour* for 'obey laws' and *making habit intentional* for the 'acting of reactive forces', and finally the *habits that we acquire* for 'impose[d] models', we begin to see an emerging picture of practising's alignment (or at least its first two criteria) with a certain timbre of Nietzsche's idea of 'training'.

To return to the third criterion of practising, constituted by relaxation (of our reactions), it is deemed crucial for the transition through and beyond the first two instances of repetition (habit and voluntary or represented memory), via involuntary memory (repetition at the various levels of Bergson's cone, or archive of the past – Second Passive Synthesis), and towards the third repetition (which would generate a future that is nothing other than the empty form of time).

It cannot be overstated that relaxation – what I'm deeming the hinge in practising and which operates in relation to Deleuze's notion of reminiscence – is (from the perspective of the breadth of practising and its training in temporal nimbleness) crucial in this transitioning among times that does not preclude sheer futurity. The difficulty involved in thinking (and therefore of acknowledging-with-the-aim-of-enacting) the falling away of superfluous effort, of doing-less and of taking exertion as close to the x-axis as possible without coinciding with it, especially in this historical moment, should not be underestimated.[12] It cuts against the grain of late capitalism's insistence on infinite growth (or on proliferating projects of damage or destruction, which via their stimulation of reparatory activities – hyperbolic and reactive doings – also constitute 'growth' within the model's terms). Relaxation ushers in stranger temporalities.

Relaxation is the elusive link that stitches 'good habits' – with which the strategic and affluent classes have long been preoccupied – to an altogether

[11] Deleuze, *Nietzsche and Philosophy*, pp. 133–4 (emphasis added).

[12] Roffe notes this, in his chapter on *Difference and Repetition* in *The Works of Gilles Deleuze – Volume I*, p. 227, when he remarks: 'rare is the person who takes tea with their cake and finds themselves in the presence of an "all powerful joy"', but this rare quality is indeed exactly what the practitioner is cultivating via the principle of relaxation-as-methodology.

other order, which would not satisfy itself with making-do, or simply exploiting, or manoeuvring within, existing conditions. Relaxation is the responsive condition of the body of Nietzsche's dancer.

It doesn't make the 'I' feel better (as wellness discourses would have it). Instead, when allowed to unfold thoroughly, relaxation will initiate a losing sight of the known or recognisable 'I' and in this gracious gap – which upsets the system's veneer of completeness or necessity – unleashes accidents, anomalies and monsters, as Deleuze might say, from the register that subtends the actual.

Relaxation, one could also venture, depends also on a kind of 'taste'. To relax involves pursuing a non-inventoried flavour. One suspects it would rarely be the spontaneous preference of a resentful and ramified 'self'. It is this that constitutes the difficulty and unlikelihood of the gathering together of the first two criteria, the subsequent inflection of them via the third, and finally the strangest mechanism of all: the fourth criterion of repeating repetition (and *only* repetition). Acting reactions, without an eye on their outcomes.

Relaxation, then, as proclivity, as an atmosphere that could come to be sought out, by an 'I', but without that 'I' being ramified in the process, involves a precarious sensibility (which may account for why there have been few, if any, contemporary ontological accounts of practising). To practise relaxation, as the third criterion, is utterly non-intuitive, non-'natural' (if by natural we intend that which would be routinely triggered by an entanglement in Deleuze's shackled order of representation).

To relax constitutes a form of efficacious resistance (which is closer to re-acting, in Deleuze's Nietzsche), but one that *does this utterly without resisting* as mode. Practising might also be understood as the process upon which one embarks, which then passes by (at various moments, only to be lost sight of again) the insight that reactive resistance – *resistful* resistance – is less effective than it appears or than everyday assumptions and impulses would promise.

A practitioner turns to relaxation often as a last resort, or even as an accident of sorts, lulled by the rhythms of the first two criteria, when resistance-as-activity has proven itself (*repeatedly*) fruitless. Relaxation, we could say, is a form of experimentation of the purest order. In *What is Philosophy?* on the question of experimentation, we read: 'There is no creation without experimentation',[13] and then shortly after: 'Seeing, seeing what happens, has always had a more essential importance than demonstrations,

13 Deleuze and Guattari, *What is Philosophy?*, p. 127.

even in pure mathematics'.[14] Helpful for our purposes, Deleuze and Guattari drop in 'even in pure mathematics'. It may be that the present reader is treating this term 'relaxation' (which I'm linking here to 'seeing what happens', to experimentation), deployed in the context of a discussion on practising, as relevant only for certain *kinds* of practices. *Yes, it's believable that a dancer would have to engage with relaxation, and yes, probably painters have to relax if they want the 'juices to flow' and for brushstrokes to work well,* and so on.

However, emphasising 'even in pure mathematics' should bring home the fact that this playful experimentation, attributed to creativity as such, is not only relevant in this circumscribed way, but rather is central to endeavours of any modality that would operate as practising – that is, as an approach that courts both stability (a robustness within the present) and transformation (a capacity and willingness to lose that present, as well as the 'self' the latter produces). Stability, then, can be understood as pertaining to a context *which can withstand the newness that may arrive.* Or, the trained body or mind, which is not an end in itself, but only a moment in a series of concatenating transformations.

This rearticulation of what we've covered so far in the preceding chapters is in the service of bringing our thinking up to a point where we can approach the complexities and strangeness of the fourth criterion. What we saw in Chapter 3 of this book was that Deleuze offers an account of three repetitions, whose respective movements produce three different syntheses of time: the living present (as habit), the pure past (as vast, insisting 'memory') and in the third passive synthesis, the empty form of the future, which will be explored below. As we've explained, practising involves all three kinds of repetition, and therefore involves an encounter with three modes of time. In the next section, we will revisit these syntheses again, since they help to make sense of the third and final one, which is crucial to practising's fourth and strangest criterion.

Deleuze's Passive Syntheses, or Making Time

If we follow Deleuze, we can say that there are only two basic components that make (out of sheer difference) time's synthesis in its various modes possible: *structure and repetition.* And perhaps more precisely: *structure as repetition.*

In the first passive synthesis, it is repetition *as this first structure* that is 'drawn off' from a sea of unrelated instances or intensities (difference in

14 Ibid. p. 128.

itself). Via this contraction, the living present is produced. As Roffe phrases it: 'It gathers together the vectors of change into stable and self-stabilising contractile formations' (WGD 226).

In the second passive synthesis, the *ground* of time (as opposed to the first synthesis, the 'soil'), as Deleuze calls it, is constituted via another instance of repetition – at various degrees of contraction (and relaxation). It is not that the second synthesis comes *after* the first, but rather that on the basis of *clarifying* the first, we can retroactively derive (the paradoxical operations of) the register of pure memory, the insisting mode of time, since when approached rigorously, it must be there in order to make the living present *pass*.

The pattern becomes conspicuous here. Time, that which we call time, is none other than ramifying relations between repetition's structuring, which in turn unleash immense complexities, and are themselves generated out of nothing more substantial than difference in itself, which is the very definition of substance-less-ness (or of 'substance' depending on which tradition one is in). Of course, we don't *lose* substantiality as we know it – my teapot stays safely put on the solid table, and I do not leap through walls. (Contractile formations have a strong inertia.) However, we do come to appreciate the thickness of things and its *how* more closely and with greater ontological precision. We also know, then, to manoeuvre within it differently, if we want substance and its tenacities, as well as change and its intensities, to impact us otherwise.

We also see, in the cases of the first and second passive syntheses, the importance of *contraction* (also called 'contemplation'), as movement, as operation, since thanks to that 'qualitative impression in the imagination' (DR 92) difference in itself becomes repetition (as 'first' structure) *in* the mind-which-contemplates. Contraction will feature again as crucial in the second passive synthesis, where the 'levels' of the pure past differ purely on the basis of differences in relaxation and contraction. The difference of more-or-less-contracted (as operation) effectively synthesises the various 'depths' of Bergson's cone. The 'thickness' of the realm of the pure past, in other words, is solely the result of further operations of contraction (and relaxation, as a mode of contraction), raised to another power, complicated, ramified.

The argument of this book is that practising accompanies, or indeed enacts, the very ontological movements that Deleuze articulates. *Practising learns time*, so to speak, by setting up a laboratory that deploys the very moves of this interaction between structure and repetition; it 'imitates' or 'stages' those basic operations which constitute the registers of becoming. It is not a metaphor for them; it is their dramatisation, as such.

Deleuze's project for practitioners gives some clue as to why practising seems at times able to constitute a way 'back through' these ramifications and their production of the stability of worlds, and the synthesising of time itself. It is this constellation, articulated thanks to Deleuze's ontological couplet, which practising has always known to set to work – sometimes artfully, sometimes haphazardly. It does this specifically via the shape of the final 'repetition'.

It is not strange to inhabit habit. In fact, we are habit, as Deleuze will make clear (DR 95). Habit only becomes strange when we reorient ourselves to it non-intuitively. Similarly, reminiscence, as Deleuze describes the mode belonging to the second passive synthesis, is also not necessarily so strange, although it is certainly rarer, less humdrum. Many of us fall by accident into atmospheres that would remind us that the living present is not the sole way in which time makes itself. In other words, sometimes, accidentally, we flirt with relaxation at various levels. In this spirit, Deleuze asks, in *Difference and Repetition*:

> The entire past is conserved in itself, but how can we save it for ourselves, how can we penetrate that in-itself without reducing it to the former present that it was, or to the present present in relation to which it is past? How can we save it *for ourselves*? (DR 107, emphasis original)

His own repetition (in the prose) is curious here, too. One senses longing at play. Reminiscence can be a thick and luring atmosphere, a mode that makes life far richer than when it simply shunts 'past' in the mode of the living present. It can feel like the source of 'meaning'. Deleuze's answer to this question of *how?* is Proust.

Without disagreeing, I'd prefer to avoid leaning on a proper name and say instead that practising (a mode that Proust had realised at a new intensity, perhaps) is how we might stray more intentionally into the mode of the second synthesis, to drink from its atmosphere.

Indeed, a strong aspect of sitting or shikantaza, when it is permitted to happen in a free-style manner, are the instances of, or drifts into, reminiscence. The latter can be distinguished from worry (about the past), or the first synthesis's mere retention of its particularities, or the active mode of voluntary remembering (when those particularities flip into being generalities from or generalisations of one's own or personal 'past'). The strange thing about reminiscence (as a mode included in practising) is that it tends to be astonishingly vivid. Using Proust as an apt illustration, Deleuze writes:

[T]his designates a passive synthesis, an involuntary memory which *differs in kind from any active synthesis associated with voluntary memory*. Combray reappears, not as it was or as it could be, but in a splendor which was never lived, like a pure past . . . (DR 107, emphasis added)

We can't try to remember in order to awaken the doze of reminiscence; in fact, we absolutely mustn't try. In some ways Deleuze is very quiet about any way (apart from being Proust himself) whereby we might access reminiscence. We can read about it, represented in literature, but this is something else. 'For ourselves' – to use Deleuze's words – we have no roadmap. Usual effort, we know, precludes it in advance, and so we would be referred to the strange mechanisms known to the modalities of practising in order to 'save' the pure past. As Deleuze makes clear, where the active syntheses of memory (and understanding) usually overcome forgetting in order to access what active memory remembers, reminiscence will take place *'within* Forgetting' (DR 107, emphasis original).[15]

Forgetting as a (non-)doing already gestures in the non-intuitive directions that, as we have seen, belong to practising and its four criteria, and most markedly, its third one. We forget, in rare moments, to either over- or under-do our movements and relaxation obtains. We also need, as Deleuze's Nietzsche emphasises, to be able 'to be done with' things, with memory traces, and this is the capacity of forgetting, which gives onto less reactive doings.[16]

If the first two criteria of practising – which arguably mimic the synthetic arising of the living present – can be thanked for practising's ability to produce an ontological (or even existential) stability in practitioners, then – I would contend – it is to the third criterion that we can attribute the profound shift in perspective on the part of the practitioner that practising facilitates, one which rehearses a certain loosening-of-habituated-self required for the fourth criterion.

[15] For a very interesting discussion of 'a certain extraordinary hardening of the present' (which could look like a mode of reminiscence but which isn't), see Deleuze's reference to alcoholism and the danger of being trapped between two times, or living two times at once (but 'not at all in the Proustian manner') in the twenty-second series of *The Logic of Sense*, 'Porcelain and Volcano', p. 179. We read: 'the alcoholic does not live at all in the imperfect or the future; the alcoholic has only a past perfect (*passé composé*)' – in other words, they combine the softness of the past participle with the hardness of the present auxiliary. It is an 'imaginary past', explains Deleuze: *I have done, I have seen* . . . to finally become: *I have drunk* (p. 180).

[16] See Deleuze, *Nietzsche and Philosophy*, p. 115.

If reminiscence or reverie occurs *within* forgetting, then it requires a departure from active modes (memory and understanding). Relaxation may be another word that aligns with this mechanism. Furthermore, that which would-be-relaxed in the third criterion has something to do with subjectivity, with the work that ensures the continuity of the 'I'.[17] When drifting in the vastness of the pure past, the narrowness that marks a specific point of view, which accompanies crucially the constitution of ordinary subjectivity, operates with less tenacity. The past which one would 'access' in reminiscence is not a personal past, but the whole of the past. This might be one way to grasp Deleuze's rather mystical claim about this 'immemorial' mode:

> Here again, the relation between passing presents does not account for the pure past which, with their assistance, takes advantage of their passing in order to reappear *underneath representation*: beyond the lover and beyond the mother, coexistent with the one and contemporary with the other, lies the never-lived reality of the Virgin. (DR 107, emphasis added)

The way in which I would approach this passage is to take up the emphasis that what unfolds in this synthesis is 'underneath representation' (which is reliant on active modes, in Deleuze's broader account) and to entertain the possibility that the second synthesis here, in its passivity, is also radically non-personal, and therefore subtracted from any specific (or particular) point of view. Al-Saji, in her work on Bergson in relation to this synthesis, reinforces this:

> Virtual memory is thus not univocal. Rather, consciousness through its attention to life attempts to establish univocity. It does so by eliding *the multiplicity of pure memory* and by allowing only those memory-images into the present that actualize the plane of the past to which I jump most readily (i.e., those memories that are recounted in 'my' voice). Just as memories are attributed by being recollected, 'my' voice is defined and

[17] On this note, we recall Douglas Hofstadter in his work *I am a Strange Loop*: 'there is a flip side to all this, a second key ingredient that makes the loop in a human brain qualify as "strange", makes an "I" come seemingly out of nowhere. This flipside is, ironically, an *inability* [. . .] to peer below the level of our symbols. It is our inability to see, feel, or sense in any way the constant, frenetic churning and roiling of micro-stuff, all the unfelt bubbling and boiling that underlies our thinking' (p. 204, emphasis original). Of course, the point of the current work is to dispute that we cannot 'sense' it, but to do this we will have to have gone via a long detour into practising and how it works.

actualized by coming into the present where it accords with my actions and interests; traces of virtuality, of other voices, hence go unheard.[18]

If the represented subject is an illusion thrown up by the workings of generality, via contraction's magical synthesising, then the pure past is a field of forgetting, since there would no longer be any subject 'there' (or 'operating') who could remember in usual ways. (This is also why the regime of opinion is of no interest to the practitioner, nor to the transformation that practising courts.)

The second synthesis, then, constitutes a 'time' subtracted from the 'personal' and its point of view. It is a field of vast perspective, and for this reason, an untrained subject – that is, a subject that is left to the automation of its own constant production and reinforcement – may struggle to access it, except in an ad hoc fashion.

A literary (or writing) practice, as Proust clearly demonstrates it, would be one way for a subject to slip the bonds of its own insistence, and tarry within forgetting, in the sprawling fields of the pure, non-personal past. Being 'underneath' representation, or subtending it, the documenting of this register, however, might constitute a second moment of that same practising, where the activity and effort of representing returns, along with the author/agent.

Arguably, to shift between forgetting and articulating that which surfaces 'within forgetting' constitutes the work of a very nimble practitioner, since the two modes, although adjacent, are also distinct. We could speculate that Proust knew something of relaxing and perhaps of resting. (His novel does open with a passage about falling asleep.) It is this balance between passivity and activity, as a balancing act that navigates between the different modes of temporal synthesis, that marks practising when the four criteria operate robustly.

How does what I'm calling here a (depersonalised) subtraction of point of view that operates via reminiscence-within-forgetting, impact on the ontological stability guaranteed by the first and second passive syntheses? For Deleuze, the first synthesis of the living present and the second synthesis of the pure past operate side by side to constitute the soil and the ground of time, respectively. When practising engages with these two syntheses, via the first three criteria (to simplify it somewhat), then a stability arises that emulates the movements of ontological stability, but, since intentionally deployed, constitutes a less usual kind of stability.

[18] Al-Saji, 'The Memory of Another Past', pp. 227–8 (emphasis added).

Habit mobilised is different from habit accidentally contracted (re-acted, cf. reacted), and similarly, the turning back of the subject's own intention (however we entertain this concept and the operations that produce its 'effect') on the operation that enables the apparent source of that intentionality alters the nature of the subject thus produced. Furthermore, whereas the second synthesis provides a ground for the living present, normally in practising the relaxation that can allow entry to reminiscent modes passes via a loosening of any dominant perspective, in favour of a dispersed point of view, which isn't one at all. Thus dispersed, as if drifting through the various levels of Bergson's cone, via relaxation in practising, the practitioner is less identified with the self produced in/as the present, which is the cone's tip. 'What is useful' no longer holds sway over 'what is sensed' – recalling Bergson – and hence reminiscence surfaces all number of marvellously 'useless' but ontologically satisfying atmospheres.

Bergson summarises the advantage afforded by a de-emphasis on utility that normally skews what he calls our knowledge, rendering it 'relative', advising us:

> to seek experience at its source, or rather above that decisive *turn* where, taking a bias in the direction of our utility, it becomes properly *human* experience. The impotence of speculative reason as Kant has demonstrated it, is perhaps at bottom only the impotence of an intellect enslaved to certain necessities of bodily life and concerned with a matter which man has had to disorganize for the satisfaction of his wants. Our knowledge of things would thus no longer be relative to the fundamental structure of our mind, but only to its superficial and acquired habits, to the contingent form which it derives from our bodily functions and from our lower needs. The relativity of knowledge may not, then, be definitive. By *unmaking that which these needs have made*, we may [. . .] recover contact with the real. (MM 184–5, last emphasis added)

In this startling passage, Bergson clarifies that it is precisely an emphasis on usefulness (which marks the living present) that obscures from us the 'ways' of other registers, and which renders our knowledge of things 'relative'. Practising, as we'll see, also understands how essential it is to approach its doing with a strange intention of not-putting-to-use, of doing 'for no good reason' and definitely not to acquire recognition. This is not some kind of mystical turn, but rather takes us straight back to Bergson's argument and sets it into play.

Table 3

	First passive synthesis	Second passive synthesis	Third passive synthesis
Time synthesised	Living present	Pure past	Pure empty future
Usual mode	Habit	Passive / involuntary memory	Eternal return
Operates via	Contraction	Relaxation	Active forgetting; repetition for itself
Mode in practising	Intentional habit / structured behaviour repeated	Relaxation subtraction of 'goal', of behaviour, as content	Repeating repetition (content and agent expelled)
Corresponding criterion	1 + 2	3	4
Generates	'First' content ('repetition' as first 'difference') = structure; first mode of time	Field of former present / element in which time passes	Interruption / discontinuity / little death
Ontologically accompanied by	Stability / inertia	Polyphony; dispersed point of view; sensuousness	Contingency
In practising, courts	Stability of context	Encounters within the archive of the (impersonal) past / reminiscence	Transformation / newness / futurity

Table 3 summarises the discussion.

If the first two passive syntheses constitute that which would generate both the things-that-repeat and the broader field in which those things repeat, constituting a continuity of content and context, accompanied by the necessary degree of impersonality, then it will be the third synthesis that provides an ontological counterpoint to them, operating as the mechanism by which change itself can be interrupted, and where discontinuity and emptiness/spacing 'reappear'.

In the third passive synthesis, that which remains open, that which can't be secured in advance would be therefore both any *content* of the future – since, as true futurity, it doesn't exist, isn't pre-ordained – and the identity of the subject/agent. This is one way to understand why Deleuze speaks of the *pure* and *empty* form of time (DR 111). The context is pure, and what it contains is undetermined, 'empty', unknowable in advance. What is most curious about this synthesis is that it is the mode that holds the possibility for

change open, but as an ontological or temporal form it is crucially *unchanging*. Deleuze puts it like this: 'Time is the most radical form of change, but the form of change does not change' (DR 111).

Given the role of structure and repetition in the first two syntheses, an obvious question pertaining to the final passive synthesis would also address the role of both structure and repetition in this synthesis that 'makes the future' and whose structure is pure, empty and unchanging. Deleuze will explain, going via the literary example of Hamlet, the northern prince, that the latter's statement about 'time being out of joint' pertains to the third synthesis in particular, with Hamlet serving as a clarifying dramatisation of it. Nothing within his habitual repertoire or even personal memory prepares him for the shock of his situation.

Out of 'joint' (*cardo*), says Deleuze, refers to time no longer being subordinated to 'those properly cardinal points through which pass the periodic movements which it measures' (DR 111). It becomes a pure *order* of time ('ordinal') – that is to say, sheer structure, with no movement, and no content.

If the first two syntheses involve that which guarantees stability and its medium, then the third passive synthesis involves no movement at all, and strangely is thereby the guarantee for the future's radical openness. The latter constitutes the counterpoint to stability-as-continuous-change, being instead the empty break that has a radically unchanging form, and which lets newness in.

Were one searching for an image, it would be possible to speculate to what degree the third synthesis is profoundly *still*, and then to wonder about its relation to stillness in practising. In other words, what would *stillness's repeating* look like? How would one practise a repetition of movement's absence?[19]

Let us now, in Part II of this chapter, explore the third synthesis, as Deleuze has clarified it and extended it, in the lineage of Nietzsche. Here we will further explore its relation to practising theoretically, as well as what it means for lived practising.

[19] In Richard Powers' 2018 novel *The Overstory*, the reader meets, in the opening lines, a voice attributed to a pine tree: 'Every piece of earth needs a new way to grip it. There are more ways to branch than any cedar pencil will ever find. *A thing can travel everywhere, just by holding still*' (p. 3, emphasis added).

PART II: The Final Criterion

The Third Passive Synthesis of Time in Deleuze

As we've seen, it is by drawing off repetition's structure from difference in itself that the first synthesis *makes* time. One of the effects of practising is its peculiar engaging with temporality per se. Most of us have surrendered to the 'reality' that time is not a medium in which we can somehow 'manoeuvre' with any degree of intention. Perhaps we represent it to ourselves (in our faculty of understanding) as either something in whose midst we sit, or which slips through our fingers like sand, or which hurtles towards us inexorably.

Given that the mechanism for the first synthesis of time is the very same as that which allows us to appear and continue as a case, it is no surprise that we may feel tangled up and beholden to time. It comes and goes, it drags or flattens us; it is increasingly 'scarce', or accelerated, with its mood, one assumes, not up for negotiation. One is, in other words, subjected to time rather than being in a nuanced relation with 'it' and its conditions.

In other words, time appears stubbornly resistant to any direct effort to constrain, to slow, to grow, or to save it. Time as source of frustration – especially its scarcity and onward march, as well as (curiously) its dragging – dominates much quotidian complaint and musing.

Repetition, as we've explored, is crucial for both of the first two passive syntheses. In the first, repetition is what is drawn off to constitute (the way we experience being in) the (living) present. By encountering things (including our so-called selves) repetitively, they attain consistency and hence have a kind of presence. We have, as Williams says, an expectancy as to their continuation.

In the second passive synthesis, the whole of the past keeps repeating – independently of us, as agents and subjects – at different degrees of contraction and relaxation. We do not repeat it; it repeats *itself*. It is passive and sub-representative. It is mostly not ours (hence Deleuze's sincere query as to how to 'save it for ourselves' – DR 107). The mechanism of repetition is common to both ways in which these times are made, and us along with them.

In the first instance, this will be our very being and its duration; in the second, the medium in which this being would be grounded, and the field in relation to which a subject would exist, namely at the apex of the cone. Bergson, with whom Deleuze is clearly in conceptual dialogue, will argue fairly convincingly that this *is* the body.[20]

[20] We read: 'we may speak of the body as an ever advancing boundary between the future

It will come as no surprise that the third synthesis of time, then, also involves an inflection of repetition, and possibly in the strangest way thus far. In this synthesis, time is viewed from the point of view of the future, where the past and the present are mere dimensions of it. This completes the pattern established with the other syntheses (see DR 117).

The repetition belonging to this synthesis is of a special or elusive kind. (Recall that Deleuze mentioned that true repetition is miraculous, rare, and its possibility only speculative – DR 3.) Having distinguished perseveration (or something's persevering) from repetition (DR 2), he elaborates:

> If repetition can be found, even in nature, it is the name of a power which affirms itself against the law, which works underneath laws, perhaps superior to laws. If repetition exists, it expresses at once a singularity opposed to the general, a universality opposed to the particular, a distinctive opposed to the ordinary, an instantaneity opposed to variation and *an eternity opposed to permanence*. (DR 3, emphasis added)

It seems that we are talking about slightly different inflections of repetition, but ones that are obviously close enough to merit Deleuze's bringing them together. Where repetition in the first two syntheses is the form in which the 'first' structure arrives, as if skimmed off or drawn from difference-in-itself, in the above passage – which comes from the 'Introduction' to *Difference and Repetition* – we see a grander vision of repetition, but one not divorced from these other modes.

Here repetition is associated with 'transgression', with slipping from the strictures of moral and natural law. It was as if repetition, whose promise of structure constitutes the ramifying stability binding together and making both being and time, is also the thread to pull, the thread which holds the secret to their coming undone, or at least loosening. If law provides life with necessary stability, with its training in 'functionality', then this same structuring can get caught in its own nefarious loops, and is therefore the very same indifferent mechanism whereby, when left to run on, life's own processes harden to become intractable, stuck – not so lively.

When laws operate without interruption, without the airy erupting from time to time of sheer difference in itself, it could *appear* (from the perspective of these same laws) that newness were structurally precluded, with only

and the past, as a pointed end, which our past is continually driving forward into our future. [. . .] my body [. . .] replaced in the flux of time, always situated at the very point where my past expires in a deed' (MM 78).

proliferating orders of resemblance, analogy, opposition and identity being possible. (In other words: if one reads life exclusively from the sheer vantage point of representation's order – notwithstanding its serious traction and consequences – it tends to signal bad news for most.)

This is the flip in the logical sequence, or an illusion of kinds, where all that which difference in itself has generated – identity, structures and so on – come to *appear* as if they were logically prior, and then to erase their tracks. A quote from Deleuze speaks to this displacement: 'the path [. . .] trace[d] is invisible and becomes visible only in reverse, to the extent that it is travelled over and *covered by the phenomena it induces within the system*' (DR 146, emphasis added). This is a version of the transcendental illusion. Laws, due to the fact that they must generalise in order to function, automatically dampen the possibility of singularities appearing, of encounters with intensity, and of newness, of gaps in the sentence we call continuity that allow for a little death, a little transformative stillness, to get in.

To diffuse the simplistic impulse to resist law, a move which reliably binds the resister back more closely to law's structures – gives her a barely modified role on the same stage – another, rare form of repetition constitutes how we would court another ilk of change. Counter-intuitively, by repeating repetition as decision, intentionally, we invite a register in which the new is not shut out, because – quite simply – repetition for itself *constitutes* the 'first' newness.

If the first synthesis establishes *what is*, and the second synthesis establishes *what always was* – the ground within which the *what is passes* and at whose most contracted point stability obtains – then the third synthesis is the mode in which *what will be* is made. It is the synthesis peculiar to repetition for itself, or the one in which we reverse-engineer time's formation. Deleuze's use of the term 'vice-diction' (DR 241), which he takes from Leibniz, recalls the way we read into repetition in practising. In relation to its character, he writes: 'The procedures of vice-diction cannot, therefore, be expressed in terms of representation, even infinite, as we saw with Leibniz, they thereby lose their principle power, that of affirming divergence or decentring' (DR 241). There exist procedures (plural) for vice-diction; and the repetitions of practising, we'll argue as we proceed, constitute a strand of them. Or to say it differently, practising is a context in which vice-diction is more likely to obtain than in other contexts.

One way to read the term 'decentring' in Deleuze's quote is in terms of the movement in both practising and the third synthesis, that expels the self and any identity. As mentioned as early as Chapter 1 of this book, there is a strategy in practising to abstain from getting stuck in any particular point of

view. Practising, at the same time, attends to singularity in conjunction with a decentring which invites the universal.

The repetition of this third mode of making time pertains to newness per se. Deleuze writes the following remark, which at first glance can seem counter-intuitive: 'We produce something new only on condition that we repeat [. . .] what is produced, the absolutely new itself, is in turn *nothing but repetition*' (DR 113, emphasis added). It is a matter – to some extent – of rethinking how we understand newness and what it could be. Newness would not be the introduction, via coercion, of a difference-between, one that would depend on the assumption of an originary Sameness or identity. It is not the 'New!' or 'Latest Version' of an interminable Now with which we're familiar in the register of representation, in our habitual temporalities.

Such a 'difference', cobbled from coercion, constitutes nothing new but is rather the mode of incremental variations on staying-the-same and per-severing as a being through time that marks life in its habitual mode, in its *resentful* mode. This mode of repetition rides on habit, and is itself the habit of Being, rather than the modus operandi of Becoming (see DR 156). In other words, the right kind of death – gap in continuity – is quite hard to come by. Destruction, murder, forcing, coercion – ways that we see being mistakenly implemented to get some 'death' out of life – will tend to fail.[21] They misunderstand subtraction; they misunderstand death's relation to life; they misunderstand, I would claim, at what register we can put our inten-tionality to work.

Deleuze writes in the 'Preface': 'We propose to think difference in itself independently of the forms of representation which reduce it to the Same, and the relation of different to different independently of those forms *which make them pass through the negative*' (DR xvii–iii, emphasis added). In this quote, we are reminded of Deleuze's investments in writing *Difference and Repetition*, and of its profoundly affirmative underpinnings. The problem, in other words, with the kind of difference (and methods for change) in which we normally deal is that they inevitably have recourse, even if veiled, to the negative within representation, to generalisations of comparison and analogy and to the interminability of resemblance, and finally to gross acts of destruction, that disappoint and dismay.

In its place, Deleuze proposes a different way to think newness, and does

[21] In *Nietzsche and Philosophy*, Deleuze offers a very nuanced account of the role of destruction in relation to reactive tendencies which does not, at base, conflict with my account here, but which I will not explore in this particular forum. See pp. 84–7.

this via a thinking of repetition, via the articulation of the repetition of the third synthesis.[22]

As opposed to the passivity with which the 'mind' draws off the difference of repetition (via the same mechanism as habit) from a pure discontinuity or sheer intensities, this third repetition pertains to acting. It will be, as we'll see, however, a very strange version of it. In Deleuze's 'Introduction' we read:

> It is rather a matter of acting, of making repetition as such a novelty; that is, a freedom and a task of freedom. In the case of Nietzsche: liberate the will from everything which binds it *by making repetition the very object of willing*. No doubt it is repetition which already binds, but if we die of repetition we are also saved and healed by it – healed, above all, by *the other* repetition. (DR 6, emphasis added)

Yes, we die from some repetitions, and we are saved by the *other* kind. We also note here two things: the thought of Nietzsche (which is aligned with 'acting', 'willing' and 'freedom') and also the 'other repetition'. Let's begin with the 'other repetition', and we'll find ourselves in conversation with Nietzsche's contribution to thinking this.

This 'other repetition', according to the passage above, is that one which constitutes the operation proper to the third synthesis of time, and which – I'd contend – aligns with the fourth criterion of practising.

Note: the first two chapters of *Difference and Repetition* can be confusing for the unsuspecting reader, since Deleuze seems to proliferate a number of schemas of 'repetitions'. In some ways, the book is a catalogue of all the guises in which repetition operates, offering initially an analysis of its role in the passive syntheses. For example, Deleuze distinguishes between 'bare' and 'clothed' repetition in his section exploring the relation between the second passive synthesis and the first. Bare or material repetition, in this case, would be that which, in the first synthesis, is drawn off – horizontal, actual, material (DR 106) – whereas the repetition that he calls 'spiritual' – or clothed,

[22] The Deleuze of *Difference and Repetition* might not necessarily agree with my critiques of destruction, since terms such as 'destruction', 'violence' and 'cruelty' litter his prose in this work. I put this partially down to a stylistic tendency in the philosophical prose of his time; it features in other works of his generation. Ann V. Murphy's thorough work, *Violence and the Philosophical Imaginary*, tracks this tendency in the language of philosophy more generally. As opposed to his style in the prose, my reading of him (and of what he contributes) is such that I contend that the destructive mode is, in fact, superfluous to the operations outlined.

vertical and virtual – subtends the repetition that is at play among the various levels of the pure past of passive memory (DR 106). I quote him at length, in this passage, to elaborate:

> The [material] is a repetition of successive independent elements or instants; the [spiritual] is a repetition of the Whole on diverse coexisting levels [. . .] the two repetitions stand in very different relations to 'difference' itself. Difference is *drawn from* one in so far as the elements or instants are contracted within a living present. It is *included in* the other in so far as the Whole includes the difference between its levels. One is bare, the other clothed; one is repetition of parts, the other of the whole; one involves succession, the other coexistence; one is actual, the other virtual; one is horizontal, the other vertical. The present is always contracted difference, but in one case it contracts indifferent instants; in the other case, by passing to the limit, it contracts a differential level of the whole which *is itself a matter of relaxation and contraction.* (DR 106, emphases added)

Some pages later, however, he goes on to speak of the 'three repetitions' often associated with the movement of eternal return: the before, the present and the future; or the intracyclical, the cyclic and a special third one (see DR 114ff.). These divisions – into two and three, respectively – can be confusing on initial readings of *Difference and Repetition*. We attempt to clarify their workings here.

Perhaps an instructive place to start is with Deleuze's very clear exposition of *repetition as the category of the future*. With one eye on the relation of this notion to practising and its moments, we read:

> A philosophy of repetition must pass through all these 'stages', condemned to repeat repetition itself. However, by traversing these stages it ensures its programme of making repetition the category of the future: making use of the repetition of habit and that of memory, but making use of them *as stages and leaving them in its wake*; struggling on the one hand against Habitus, on the other against Mnemosyne; *refusing the content of a repetition* which is more or less able to 'draw off' difference; refusing the form of a repetition which includes difference, but in order once again to subordinate it to the Same and the Similar (Mnemosyne) [. . .] but making [repetition] the thought and the production of the 'absolutely different'; making it so *that repetition is, for itself, difference in itself.* (DR 117–18, emphases added)

Like a philosophy of repetition, in practising as an encounter with repetition itself *as* difference in itself, we go via the two stages of habit, and relaxation/reminiscence, respectively, in order to court something far wilder, something beyond and in excess of representation's reach. It is this last moment that pertains so precisely to the mechanism of the fourth criterion. We see then – thanks to Deleuze's exploration of all of repetition's guises and as the basic ontological mechanism – why the act of repeating in practising is both stabilising and context/condition-producing, but also finally and strangely, the key to transformation (Deleuze calls it *metamorphosis* – DR 115): the production of the new, of the work, and independent of any agent, without any foreknown identity, whatsoever.

Thus, we understand Deleuze in saying that we must 'make something new of repetition itself' (DR 6). Mostly, and most naturally, confined to the registers of repetition in relation to Habitus, and then of the Same and Similar in memory, he is arguing that we can also countenance in thought that which I'd argue is accessed in practising: namely, repetition for itself (the healing, saving, free repetition). As one reads in the depths of chapter II of *Difference and Repetition*, Deleuze must turn to examples from art, philology and literary history to reach towards some manner of illustration for his contentions.

Recall Deleuze's strange remark, that *to repeat is to behave in a certain manner* (DR 1). It seems, I'd argue, that this behaviour consists in a manoeuvre that takes something, which happens passively or habitually, and makes it 'the very object of willing' (DR 6). It doesn't occur to us, if we rely on a quotidian logic, that the way to change our relation to change, to that which seems inevitable, is *to act this inevitability out* and willingly. This constitutes the crux of accessing the 'other repetition'.

If we repeat intentionally, if we make repetition (which on the level of representation appears to be what we seemingly can't get away from) that which we *seek out and affirm* and re-enact, then repetition is profoundly transformed or, rather, its more radical nature is revealed. This has an impact on the future. In other words, this repetition *is the future*.[23]

In a number of detailed pages (DR 107–11), Deleuze prepares his reader for the notion of – and for the rhythm that leads to – the eternal return of Nietzsche, where repetition will show its miraculous mechanism. He

[23] This conjures the idea of assuming the inevitability of one's death and making of its inevitability an action. To not to be 'too weary even to die' – *Nietzsche and Philosophy*, p. 151. It has more to do with inhabiting the fact of death's necessity *as if we chose it*. This is the switch that shifts us from doomed repetition to affirmative repetition.

does this by noting the role of time, and its absence, in the thought of Kant and Descartes, respectively. This involves the role of 'the determinable' in Kant, an internal kind of difference, that radically supplements the schema of Descartes. Kant's introduction of time into the *cogito* of the latter, as that which *fractures the 'I'* (whether of God or of rational psychology), has ramifications for the self, for theology, and for the passive self, who turns out to have a synthesising passivity prior to any receptivity.[24] Then, via a critique of the mythic as it operates in relation to Mnemosyne (or pure memory), Deleuze notes that Kant effectively discovers a difference-without-concept (but abandons his 'initiative'), and that it will be Hölderlin who will make something very interesting out of it. He will, no less, discover the 'emptiness of pure time' (DR 110). As Roffe writes: it 'will constitute a rift or ungrounding proper to the structure of Being' (WGD 228).

The times of Habitus and Memory are both, even if not obviously, subordinated to representation, although each differently. Deleuze's discussion finds its way to Hamlet's declaration that *time is out of joint*. Deleuze explains this strange utterance of the northern prince:

> time out of joint means demented time or time outside the curve which gave it a god, liberated from its overly simple circular figure, freed from the events which made up its *content*, its relation to movement overturned; in short, time presenting itself as an *empty and pure form*. (DR 111, emphasis added)

How can we read this, not only as philosophers, but also as practitioners – those in the very laboratory of practising? What does this work of Deleuze tell us and encourage in relation to practising's experiments? We can immediately see two crucial aspects. This third form of time recalls the operations of practising insofar as it is time in a mode *without content*. What matters here, for this out-of-joint time, is at first *pure structure*, pure form, and then finally to drop away, into formlessness (as we read in a quote above). Content is de-emphasised – still operating, but incidental. The time of the third synthesis has left the train track of representation, and the transcendental illusion that gives rise to identity as logically prior, to become time's expression as pure form – which is by definition *empty*. Let's recall:

[24] See Roffe, *The Works of Gilles Deleuze – Volume I*, pp. 227ff., where Kant's position is clarified for an unfamiliar reader.

Practising, as a very strange way of behaving, involves an action of repetition which mobilises a form, in which content features but is increasingly eclipsed, to set going the empty form itself in a willed repetition.

Practising has never needed Deleuze in order to do this. It has been doing this very thing, in a multitude of guises and modalities, for a good long while. However, Deleuze provides a scaffolding for saying rigorously what is going on, to allow my effort here at distilling that series of operations precisely, and to know what is important in practising. Practitioners of all kinds – who have left identity behind – are travellers in the future.

The repetition of the for-itself, the repetition of Nietzsche's eternal return, invites the repetition of a register beyond content, that is, of the register of difference-in-itself (DR 153). When we repeat in this strange way – a very delicate and evasive constellation – the future is no longer (as it normally is) precluded from appearing; pure difference would be the only content for this future, with the key to its lock a behaviour of repeating emptiness in a willed or 'acted' way.

We'll now revisit this famous conceptual structure from Nietzsche – the eternal return – which Deleuze takes very far, using it for the dramatic basis for his account of the third synthesis of time.

The Thought of Eternal Return and the Affirmation of Practising

You should understand that zazen *is not meditation or contemplation*; it is not about quieting the mind, focusing the mind or studying the mind; *it is not mindfulness or mindlessness*. If you want to really understand zazen, then know that zazen is not about sitting or lying down. Zazen is zazen.

John Daido Loori, *The Art of Just Sitting*, p. 128 (emphasis added)

An initial curiosity might be – for the non-practitioner – why Nietzsche's formulation, subsequently rearticulated by Deleuze, would find an echo in the context of practising. Nietzsche's provocation, if you like, is a strange one. What the demon whispers amounts to an invitation to affirm everything that has gone before in a life, and to be willing to repeat it, indeed *to will its repetition actively and without reluctance*. If we, in normal modes of time, come to see the emergence of ostensibly repeating patterns of events, experiences, desires and choices, then at first glance it would seem reasonable to respond to this observation by plotting how to escape or amend such patterns, how one could resist them, override them. (Deleuze says that Socrates,

for Nietzsche, in this way 'posits life as something which should be judged, justified and redeemed by the idea'.[25])

Nietzsche's suggestion, in other words, appears at the surface as fairly non-sensical, or even perverse. Furthermore, it might seem unbearable, for most of us, to countenance that one's so-called mistakes and entire trajectory thus far might not just possibly, but rather probably, or even inevitably, repeat. Recall what Deleuze writes about destiny, earlier in chapter II of *Difference and Repetition*:

> however strong the incoherence or possible opposition between successive presents, we have the impression that each of them plays out 'the same life' [. . .] This is what we call destiny. [. . .] We say of successive presents which express a destiny that they always play out the same thing, the same story, but at different levels: here more or less relaxed, there more or less contracted. This is why destiny accords so badly with determinism but so well with freedom: freedom lies in choosing the levels. (DR 105)

We don't choose the *content*, it seems; we choose, via contraction and relaxation, the *levels*, and it is at this ontological register that we have access to 'choice' and 'freedom'.

So, what intelligent path is open to us?

Nietzsche's invention, or arguably his rearticulation of a truth of sorts, is to propose a non-natural, non-intuitive way to behave in the face of this fact (that life and our existence within it repeats with small variations, or more precisely that this very variation *is* our life and being). Instead of evasion, squeamishness, refusal or a wishful position, Nietzsche's provocation – the eternal return, as I understand it – works with ontological and temporal deftness.

Faced with the fact of an ostensibly inevitable repeating, the behaviour that marks the Übermensch (or Overperson[26]) involves total affirmation and active willing of this inevitability. *To will the inevitable* and to make it the object of decision is the genius of the eternal return. If friction and

[25] Deleuze, *Nietzsche and Philosophy*, p. 14.

[26] The term is often translated as 'Overman' (for ease of pronunciation, perhaps), but the word is not initially referring solely to male beings (although it is a masculine word), in the German. The *Wahrig Wörterbuch* 2000 edition opens its definition with: 'the highest developed living being, person' (*das höchstentwickelte Lebewesen; Person*), p. 865.

resistance keep the world turning, then willing *that which is 'unavoidable'* – this strangest of manoeuvres – brings everything eerily to a standstill. In this moment of stasis, or infinite speed (one can't be sure, since there would be no points of representation against which to measure either), 'continuity' with the past and 'inhabiting' of the present is interrupted. We move from the cardinal to the strictly ordinal (DR 111). The third synthesis is a static synthesis: (as quoted earlier) 'time is the most radical form of change, but the form of change does not change' (DR 111).

There is only future, empty and pure, in which *anything* can happen. This radical openness of content constitutes the conditions for the new. The future – thanks to the act of willing of repetition (which flings out the very subject who 'wills') – no longer precludes newness, and is open for something other (*so* very other) than a repetition of the Same. As sheer repetition, without content, or with every content indiscriminately affirmed as mechanism of selection, it is deprived of its seed of inertia. On this point, Roffe writes:

> because the eternal return is the empty form of time, all that it 'selects' or affirms is what differs. Why? Because the self-identical does not subsist over time. [. . .] the future, being empty, has no 'room' for identity. All that it could possibly affirm is what can undergo transformation. (WGD 229)

How do we see this operating in practising – in the seemingly dull, daily repetitions of forms that we have intentionally contracted with some inkling that they may open to future, without knowing exactly how or why?

When we practise, in whatever modality, we become extremely familiar with the content, and we subtract our decision to repeat from any connection to gain or final goal that the behaviour might produce or attain (since this approach is extremely suited to habit's order). Eventually, in other words, we don't do music scales in order to improve – rather we play because *that is what we do*. An emphasis on gain, improvement and so on, will cut across practising's mechanisms, even though it may affect what it aims for, namely improvement while remaining within the same register. *Sure, you got better, but only within the same present; you are still the same 'you', or same enough.*[27] In other words, emphasis on improvement will not produce transformation; it will not change the rules of the game.

[27] As acknowledged elsewhere, I am grateful for James Williams's stylistic precedent, in philosophical writing, of inserting italicised 'performances' of how concepts being discussed might play out in familiar language and applied thinking. I borrow this technique from him.

When operating with all four criteria (not just the first two), we mobilise the sheer form of scales for a more radical ontological experiment – affirming *all* of chance.[28] And, while we do become familiar, our practising is not to let the repetition of the structured behaviour slide into routine, nor to allow it to be carried off as compulsion – common tendencies intrinsic to the habitual mode.

We continue to repeat intentionally, remaining at the cusp of habit's production, which incidentally coincides with how (the illusion of) 'self' is produced. In the case of practising, however, this production is accompanied explicitly – not with any doing as such, but with the non-natural effort of reducing doing to a minimum:

- In the first two criteria, we contract a benign habit, which we then intentionally repeat (at regular intervals and often with a sub-repetition making up the content of what is repeated). Intentionality operates here as an operational modification of the passivity which marks habit as ontological mode. Practising, in other words, intervenes in the usual passive/active constellation, choosing via tension and relaxation *the level at which we repeat.*

- With the third criterion, in relaxation (at the very moment at which we might – were we *not* practising – actively seek to accomplish something), we subtract ourselves from the typical applications of passivity/activity, and effort operates asymptotically, as neither more nor less, in the doing. Relaxation enacts, too, a withdrawal from the active syntheses, a choreographed retreat from the usual inertias of doing, which can accompany and smother the 'other' repetition. We may drift, during this 'moment', into the climes of Mnemosyne but, as Deleuze emphasises, we do not stop there.

- If relaxation's mode saturates the doing, de-emphasising the identity of the practitioner, and if nevertheless, from the decision to repeat, *an act* arises from the conditions of a wholly strange constellation – fracturing the 'I' in time, which will be ejected from the equation altogether – then the third synthesis, via the fourth criterion, obtains:

 As for the third time in which the future appears, this signifies that the event and the act possess a secret coherence which *excludes that of the self*; that they turn back against the self which has become their equal and smash it to pieces, as though the bearer of the new

[28] See Deleuze, *Nietzsche and Philosophy*, pp. 26ff.

world were carried away and dispersed by the shock of the multiplicity to which it gives birth: what the self has become equal to is the inequal in itself. (DR 112, emphasis added)

Both the content of the modality of practising (bee-keeping, prayer, yoga asana, rock climbing, soccer-juggling, and so on), as well as the agent of the structured behaviour previously established (the practitioner, as habit of saying 'I'), will become incidental, with the operation of repeating the fact of structure alone – repeating repetition itself – constituting the very production of the future of the third synthesis.

It is with the fourth criterion that we come as close as practically feasible to courting newness. It cannot be coerced, and it will not be made to come, but it will involve an act. The behaviours that constitute practising are a deft setting to conjure the conditions required in order not-to-preclude the future, as such. In our everyday modes, we explicitly and effectively, through our habitual toggle of effort and passivity, exclude newness by default. (And, of course, we also need our stable continuities; we can't be 'dying' all the time.) Without practising – by whatever name – newness rarely arrives into the conditions that constitute our living present.

Practising is a training, then, in behaving as if one were not colluding with the transcendental illusion of identity and of substance as logically prior; it is a training at being able to do that, and at the same time to be able to return to operating inside the illusion. From within a register wherein identity's self-evidentness is presumed, practising sets to work another logic. It mobilises a perspicacity informed by the point of view of a register inaccessible to experience, or rather to experience as an habitual subject, who would be able to actively remember it for themselves, in any active synthesis.

This may be why we can never remember (or have the feeling of explaining well or 'fully') why we practise. Often people attend classes in things, or keep strong relations with teachers in traditions, or read voraciously in their area of practice, because they are trying to maintain contact with an atmosphere that is seldom obvious in the sphere of normal 'doings'.[29] They cannot always say, and sometimes don't themselves know, why they continue to come to class, go on hikes, to retreats, and so on.

[29] On the other hand, I also tell my students, who want to embark on independent practising, that the logic of the everyday – habit's logic – will rarely lead them to or into the stranger logics of practising. One just has to be discerning (about the teacher, the tradition, etc.) and then, once assessed (as benign and intricate enough), decide to act, to begin. It often won't 'make sense', since practising isn't good for anything, in any commonsensical way.

Without a philosophical account of practising's mechanisms, practitioners can be tempted to lean on less rigorous explanations as to 'why practise?'. These commonly refer to notions of improvement, bettering, repair or redemption (of the subject). We will see below that this creates a kind of knot for practising, since these reasons are, at a very subtle register, *not at all* what it is going on if practising aligns with the four criteria proposed here. On the other hand, these reasons, despite their lack of rigour per se and their reliance on a sometimes insipid vocabulary, may still function well enough to get a person dipping their toes into what can become consistent practising.

Deleuze's labour in *Difference and Repetition* and elsewhere provides, as I've tried to show here, the conceptual scaffolding to think with precision the strangeness of practising's ways and attitudes.

Practising, its ways sometimes esoteric, and which have repeated across millennia and in vastly different geographical locations, bears witness to the fact that these sets of behaviour conform, in the best instances, to the shapes that court transformation without destroying every stability. Often, however, budding practitioners falter at the stage of relaxation, or in the face of the seeming absurdity of repeating repetition for itself (rather than for something, a goal, an improvement.[30])

The hunch as to why proceed into the modes required by the third and fourth criteria need not, in the world of lived practising, be articulated well, or at all, or with any kind of conceptual rigour (although this is not to say that this hasn't been done by great philosophers in those traditions, of which Dogen, from Chapter 1, would be a solid example). For the keen practitioner, there is often a kind of trust (some would call it faith) in the traditions of practising.[31]

Precise insight, after the practitioner has been practising 'intensely and over a long period' (as the *Yoga Sutras* word it) and still without having a vocabulary for saying it, may come later, if at all. What practising itself brings is not a theoretical understanding (and we can read the latter in line with Deleuze as being part of that active synthesis built on the first passive one). Many Zen texts, in correctly emphasising this point, can – however

[30] In peer reviews of my chapters and articles in various journals or collections, reviewers often display the most indignation and scepticism with regard to this notion of subtracting 'striving'.

[31] And this 'faith' when erroneously attached to teachers themselves, as discrete and fallible beings, is highly problematic, as too many examples have shown. The faith is more reliably placed in practising's *mechanisms* and particular logics, which are clear, do not require subjugation of any kind, and operate in relation to ethical principles.

regrettably – be read as inviting a kind of anti-intellectualism. This can per-petuate a false binary and a resentment of thought/thinking more broadly which is imprecise and not interesting.

Practising, as we live it, courts transformation and stability in ways that are obvious in the experience of the practitioner. We do not have to venture far into both anecdotal and scholarly accounts to get a sense of this shared experience.

If we consider practising's relation to the faculty of the understanding, as well as its reliance on a register that makes *no sense* from the point of view of our day-to-day worlds and their surface mechanisms, it constitutes a doing that does not conform to good or common sense. Neither does it reject them, however. The relation, as we've noted, is rather subtractive.

The Fourth Criterion in Practising

Let's consider the following formulation of the third synthesis:

> In the third synthesis, the present is no more than an actor, an author, an agent destined to be effaced; while the past is no more than a condi-tion operating by default. The synthesis of time here constitutes a future which affirms at once both the unconditioned character of the product in relation to the conditions of its production, and the independence of the work in relation to its author or actor. *In all three syntheses, present, past and future are revealed as Repetition*, but in very different modes. The pres-ent is the repeater, the past is repetition itself, but *the future is that which is repeated*. The future [. . .] is the Royal Repetition. (DR 117, emphasis added)

If we were to take up this quotation and redeploy it as a set of instructions for sidling up to the future, then how could we understand what to do in relation to the third synthesis? This is the conundrum to which practising, perhaps through trial and error, has for a long time known the answer – if we can consider a way of proceeding an 'answer'.

To the riddle 'the future is that which is repeated', practising responds by setting up an intentional habit (in the present-as-repeater), relaxing in the 'doing' of it (allowing the past its repetition), and as a result enacting a strange behaviour which consists in simply repeating repetition itself, by allowing both the content (the 'what' of the practising mode), and espe-cially *the goal* of that activity, to fade to a cultivated minimality. Without emphasis on the habitual aspect of the doing, the agent too fades as doer – or

in Deleuze's poetics: is flung out, smashed to pieces. (I don't concur with Deleuze's language here since, often, serious practising goes via a strange and unsettling thread of *pleasantness*. This is far harder and more confronting for most of us than the bravado of 'smashing' etc.)

What is arguably left operating is the sheer fact of empty structure repeating – which dovetails with the 'movement' (or rather stasis) of the third synthesis. It is for this reason that, to a large extent, it is not particularly relevant what mode of practising is selected (that is, which good-enough habit). It is the integrity of enacting the criteria of practising in itself from within that chosen mode that turns out to be more crucial as to whether practising will court transformation without undermining a certain stability, one which has no relation to the subject's identity. There is stability, in other words, but the subject will not be that which becomes stable.

This issue of stability, and how it is insistent in practising, is perhaps the trickiest one to explicate, requiring a taking up of the four criteria as a cluster in order to be persuasive. Deleuze's third synthesis would seem – especially considering the prose in which it is delivered – to evoke anything but steadiness or stability. Descriptions of the agent being expelled, of the drama of Hamlet, conjure rather stormier images, the eternal return resembling a tornado that comes to rip us into the future, as a trauma or disaster. Perhaps, however, we can say that there are two aspects to the atmosphere that we've thus far designated with the shorthand of 'stability'.

We've already explored the fact that the first two criteria contribute quite straightforwardly to the contours of what would operate very successfully as a 'good habit'. With the first two criteria, we learn structure and how to surf the flux of time with intentionality. A template is laid across the roiling of difference in itself, its ceaseless intensities, in a way slightly other than that which passive contemplation, and the activities of memory and understanding, afford. We contract, we contemplate, but we *as if* accompany the former's passivity. It is a not-quite-activeness that is neither a passive nor active synthesis exactly.

So, if we establish in our daily lives the regularity of a good, benign habit ripe for practising, then we are temporally 'held' in a certain way. We are beginning to engage with time differently. It is not yet practising, but it belongs to the bundle that many practitioners know comes along with practising. In other words, we can't leap over this step. This is the less glamorous aspect of practising. It is the bit with no innovation; it's the aspect in which practitioners get read as 'very pious or disciplined people'. However, as we know, it has more to do with the hunch that any use of variation here would be misplaced, derailing practising's further possibilities. For example, doing a

version of meditation practice and constantly changing mantra, or changing one's approach to the 'thoughts', or looking for more enthralling teachers, and so on, as if seeking gratification within variation, is a sure sign that practising isn't on the way, or is getting put off till later.

So, practising will stabilise us *in time*, in terms of the first two criteria. We will face, almost through re-enacting their dramas, the first two passive syntheses with a little more visceral insight, coming to perceive them accurately by dint of a kind of shadowing of their mechanisms. But this can't be the whole story of why practising is steadying.

I would argue, although not exhaustively here, that, also in the third and fourth criteria, a stabilising is at work. Deleuze mentions, as we noted above, that the third synthesis is a *static* synthesis. Time is what guarantees change but is itself unchanging. It is a pure and empty unchanging form. Where our exile in the first two passive syntheses appears to condemn us to change – to the swill of changing minutiae – the third synthesis involves time of a wholly other order.

Williams will emphasise that it shifts from being cardinal (like a clock's hands passing through the cardinal point of the twelve) to being ordinal, a sheer order. He notes that '[Deleuze] claims that such time is empty, that is, empty of the contents given to it by cardinal points'.[32] Time, then, is no longer subordinated to movement which measures it. The practitioner knows from experience that in rare moments – since the fourth criterion is not something one corrals but rather nudges, falls into, *forgets to avoid* – practising coincides with a mode that is profoundly static, or still, or weightier than stone. The flux of minutiae no longer howls and there is a kind of vastness. It *is* empty. And what this 'it' is, is difficult to say.

In such a way, the times made by the first and second syntheses prevail but are reinflected somehow by this last synthesis – time then as pure form, still and ordered, indifferent to the subject, where this subject's human-ness is irrelevant. As Williams writes: 'The third synthesis of time is not based on human experience. It is rather a speculative claim about time based on the disruptive appearance of the new. [. . .] This third synthesis is a cut and an ordering.'[33] And shortly after: '*the caesura is an event* and has a depth to it. [. . .] it divides time such that a drama is required to encompass this division'.[34] There are several points here. The human is not central in the cut that is staged in the third synthesis. Furthermore, according to Deleuze (and

[32] Williams, *Gilles Deleuze's Philosophy of Time*, p. 89.
[33] Ibid. p. 90.
[34] Ibid. p. 91 (emphasis added).

as Williams emphasises), a drama is required. What could this mean? I would argue, concurring but also extending this point, that this contingent drama – acting in the face of that which cannot be contracted, nor cushioned by memory – is the one that practising stages *intentionally* (apprehending, as it does, the limits of where intentionality can operate).

Practising as theatre for metamorphosis. Or, after Deleuze's Nietzsche, affirming all of chance. In any case, what else can be done?

Yes, the uncurated course of a life might present serendipitous/shocking/overwhelming, arbitrary circumstances that correspond to the operations of the third synthesis, and the examples of Hamlet and Oedipus assist in showing what such events might entail and how they move. Practising, however, is the systematic courting, rigorously informed (either by tradition's work, or a flair of thought), of that same constellation, one which takes into account all of the details of the three syntheses. This stands, I'd argue, regardless of whether practitioners can say it clearly or not. One practises precisely to withstand that which cannot be repeated.

In this sense, and before we move on to focus on the question of 'affirmation', I would tentatively suggest that within the realm of practising the above claim is not 'speculative', as Williams (referring to its philosophical weight) states. For practitioners, the third synthesis of time is encountered, usually without a vocabulary for its operation, but tangibly and with some consistency (if one can speak of consistency at all at this register).

Affirmation versus the 'Reparatory'

In terms of how practising affirms, it works due to the absolute necessity that the practitioner abstain from any attempt to 'improve', to 'gain', to effect any kind of modification. This echoes the non-resentful position of Nietzsche's Übermensch, who accepts and wills (affirms) the totality of what has been; she does not quibble about little details that *she would prefer to have been otherwise*. There is no eternal return if one tries to 'fix up' this or that, tries to select resentfully (ruefully, wishfully and so on), or via the measures of good or common sense.[35]

[35] One could also argue that affirming one's actions opens pathways to sincere apology, to apology *with traction*, and to the likelihood that past cruelties, hurtful reactivities and so on are able to be left behind for good. The idea that affirming what one has done would bed down continuities of shoddiness, meanness and exploitation, for example, arguably confuses the registers of where this mechanism operates. Affirming does not equate to 'celebrating' but rather to seeing 'with wide eyes' (as the expression in yoga goes) what has happened, without ornamentation or shirking. There is no pride, no

The eternal return is a total affirmation (and must be in order for it to operate ontologically; the 'must be' is not morally derived). In a similar way, practising, in this final criterion, deploys the living present and its constraints and limitations as content/agent upon the ground of the second synthesis as condition, and it abstains from activating the future modes of either of those. The 'future' of the living present is constituted, after all, only by anticipation, which the understanding's activity then turns into prediction. In this mode of active synthesis and via the understanding, since already within representation, it cannot invite in real futurity, since the latter is not of the order of representation. Similarly, the 'future' aspect of the pure past is only an a priori level of contraction or relaxation. It is an always-was. This is the faux-future of which we dream, as if backwards, in nostalgia.

Regarding the kind of newness that Deleuze is speaking about, Williams puts it this way:

> The new present must therefore be new in a very radical manner, that is, it must be completely undetermined, yet determinable. This [partly] explains [. . .] why Deleuze appeals to a pure and empty form of time: a time that renders the new present determinable yet undetermined.[36]

In practising, in the fourth criterion, we mobilise the delicate conditions that effectively issue an invitation to the new – both content and agent will prove irrelevant. This is why we can call it, without being sensational, a kind of death. It is *as* frightening as a death since we, as subjective agents, will not be preserved in the process it entails. This death would not be at the level of material destruction – rather it is a 'death' insofar as that which we think of as *our* continuity will not be guaranteed. We also must not be too weary to die.

Structure repeated so as to constitute a repetition that repeats nothing but itself (as repetition) satisfies the equation that enacts or stages Deleuze's third synthesis. By remaining undiverted by the lure of modified content, or improved agent (the self-improving subject, as if making amends at a subterranean register), the mechanism that matters remains central. The mode of repeating has to be one that repeats the present's content, and enacts the agent as they *are*, and as they *have always been*. (This goes a long way to fur-

complacent entitlement to one's actions. Rather, affirming here is plain and, if fully taken on, may leave a space for an empty, unknown future.

[36] Williams, *Gilles Deleuze's Philosophy of Time*, p. 86.

nishing support for approaches, such as 'radical acceptance', used in various modes of psychotherapy, and which are clinically efficacious.)

This whole constellation – which forbids the urge towards modification (a represented, an already recognised) in favour of an *act* – is logically infuriating or evasive, since the subject is socialised, trained, indeed formed through these same mechanisms which would propagate the continuity of the 'self' (that contraction of intensities, of difference) through habitual modes of perseveration as representation in the living present.

It also frustrates those in the sway of equally prevalent modes that valorise a mythical past, fantasise the integrity of originary states, or seek solace in utopic constructions, situated either 'forwards' or 'back' in time (it matters little). We do go via these climes; however, to stay in them too long – as Thomas Mann dramatises in *Zauberberg* – is not enough and can become sickly. The future that comes via the third synthesis is not one that can be guaranteed in advance to be incrementally 'better'. It is, rather, the opening onto sheer contingency, a newness that elides prediction or anticipation of any kind.

This raises the dilemma faced in situations where encouragements that might seem to be at hand when speaking about practising or discussing why one practises – even if accurate at a certain level: *you* will *destress if you meditate* – turn out to be impediments to its fuller operations. The same encouragements are misleading since they emphasise a content rather than the stranger mechanisms of pure repetition and structure, which finally, themselves too, also must fall away.

It can also be a case of the content of the 'ambition' eventually being 'attained' or dealt with. When one finally understands how 'stress' works, and learns tricks to manage it, for example, then perhaps one can cease being so interested in it, so busy with anecdotes about it, and then the initial 'good habit' is left available as a structured behaviour to be raised to this other power. Managing one's habitual life *well enough* does often seem to be a prerequisite for organising a life with space for practising (and one can see how a sociopolitical context that doesn't wholly sabotage this possibility in very real ways is also crucial and to be protected or fought for).

Practising, therefore, in this moment of its unfolding, does return us to the question of desire. There is a Zen quote that speaks about our desires not being too big, but rather being too paltry. It recommends, rather, that we inflate our desires, taking them to their limit. In other words, when we seek little betterments, scrabbling after an advantage here or there, we are doomed to remain in the register of representation. Our desires will by definition be modest if they are already inventoried in the register of what

has been represented thus far. The pieces will move around, and this might amuse us (and then inevitably dismay or devastate us), but there will be no transformation as such, no radical, incommensurable newness.

If it is the latter for which we long, for which we are 'curiouser and curiouser', then desire needs to take a very different tack from a kind of negotiation within Sameness, or an imploring for different versions of what already is (this would be the error of envy, although it is always a good indicator of where want lies). The fourth criterion brings us face to face with this aspect, since it is very difficult for practising to move into this final operation if there is any investment at all in getting something recognisable out of the practice.

Practitioners, then, are usually no longer at a stage in their lives where they are seeking certain tangible benefits from the other criteria of practising. In other words, doing meditation in order to 'destress' means that the so-called good habit of meditation will bring a lot of benefits, probably, but that emphasis won't help with practising as I've theorised it in this volume. This would be the thrust of the quote from Loori at the start of this section, which speaks to this in the specific case of zazen: 'zazen is not meditation or contemplation; it is not about quieting the mind, focusing the mind or studying the mind; it is not mindfulness or mindlessness'.[37] One can only assume that in this kind of text, written for practitioners, the author is trying to clarify something about practising that constantly goes awry or gets covered over: namely, the idea that it must be *for* something (already known, or finite), and the attempt of newer practitioners to corral it into usefulness.

It must be further emphasised for the rigour of practising's own logics, that *neither* mode will be inventoried 'better' or 'worse'; we are not preoccupied with the moral order. One can, however, distinguish various modes of putting-to-use from practising per se. And, as readers of Derrida, we know that practising must always already be contaminated by its adjacent modes. Practising, at the very least, is often likely not to comply with our imagined (represented) plans for it; however, it may coincide – at another level – with the unspoken magnitude of our longing. This would be that which has no shape and no existing representations that could lend it form in advance.

Conclusion

We can now less cryptically say that practising, via the fourth criterion, approaches the art of repeating pure difference, through a repeating of repe-

[37] Daido Loori, *The Art of Just Sitting*, p. 128.

tition. Mobilising a non-intuitive intention, it constitutes the set of diverse ways that invite or court difference in itself (the register of genesis proper), by putting to work the strangeness of repetition for itself. In this operation, practising shows itself, through its long lineages of refined technologies and less usual intentionalities (for example, re-acting our reactions), to be the field in which an open secret is activated, the well-established constellation that lets the future in.

As Deleuze will ominously note: 'the production of something new entails a dramatic repetition which excludes even the hero' (DR 115). When we engage in practising, the pronouns-that-we-are are unlikely to emerge intact. Practising would be the strange doing of an identity or entity, that has abandoned investment in the preservation of the current version of itself. To recall the language of Deleuze's Nietzsche, it would be the activity of an entity who at once can 'be done with things' (who is not drowning in, or over-activated by, memory traces), and who has the more active kind of memory: they are able both to *promise* and to remember the future.[38]

Williams paraphrases Deleuze, writing: 'the multiplicity of the self, the many selves underlying the subject of an action, is itself broken and remade in the third synthesis of time'.[39] Our selves are remade; the subject that we are, oftentimes both our worst burden and most defended 'treasure', is left behind, forgotten despite itself. Practising stages an encounter with this remaking, and while not destroying the subject at the register of representation, it opens its fabric up at the levels of its constitutive selves. It loosens the weave that binds us to a certain site and to choreographies in this register; and this is strangely steadying, like an exhalation, as if we find a way to relax within the enduring constraints of continuity.

This repetition for itself, furthermore, makes almost cumulative use – in practising – of the other forms of repetition. Access to repetition for itself goes via repetition more generally. Practising, then, across its three aspects, puts to use repetition, thereby also enacting a kind of delicate meddling in the operations that constitute the ways in which time is synthesised. All of this contributes to what we've named above the paradoxical dual repercussion of practising: a co-arising of steadiness and nimbleness, a weave of Being and Becoming, namely non-destructive transformation or rupture that both intervenes in the future, and *is* future, as pure, undetermined form.

[38] Deleuze, *Nietzsche and Philosophy*, p. 134.
[39] Williams, *Gilles Deleuze's Philosophy of Time*, p. 94.

Towards the end of the 'Repetition for Itself' chapter, Deleuze explains Nietzsche's eternal return's relation to the future, in a way that rehearses what is at stake, and the how of what happens, in practising:

> The eternal return has no other sense but this: the absence of any assignable origin – in other words, the assignation of difference as the origin, which then relates different to different in order to make it (or them) return as such. (DR 153)

What this means for a practitioner is vast, since the eternal return articulates that if we have no fixed origin, if we indeed *come* from nothing (from no ultimate identity, subjected to no negativity, relative to no analogy, nor arranged within resemblance), then we also – necessarily – can be anything, *everything*. No longer creatures of necessity, as Deleuze emphasises, but of chance – *all* of it – with this 'all' being the only necessity.[40] This is the affirmation, whose strategy practising has always had a knack and a hunch for mobilising, in order to slip the register of representation, and its constitutive illusions (which also, at another register, prevail, modify, advance).

We do not, on the other hand, get to manoeuvre ourselves-as-such through the vastness of this affirmation. As Deleuze will clarify, no subject can really sustain that intensity, but rather it is at the register of larval selves that this total metamorphosis can take place (DR 145). This may account for why practitioners may not perceive the transformations to their habitual I's that obtain from sustained and serious practising. If they practise seriously, indeed, they may find it none of their business.

Within the weaves, however, which make them up, there will have been world-shattering transformations, which rumble up through the constellation of 'selves' to find shape and to reverberate at the grosser register. Practising understands that any destruction within the register of identifiable clumps of larval selves (me, you, this group, that situation) will mostly be pointless, gauche shots in the dark, leading to simple destructions-that-ramify, rather than creations and transformations. This is why, as the quote at the start of this chapter intimates, this interpretation – of *Difference and Repetition* – that unearths sheer difference as 'originary' is not just one manner of speaking among many. Rather, it changes everything. It changes what is able to bubble into representation, just as it *stabilises* the self – as effect and illusion – within an ontological precision. It is the stability that obtains from a *resting* in chaos.

[40] After writing this as draft, in these words, a long time ago, I found the same sentiment in Deleuze, *Nietzsche and Philosophy*, p. 26.

The temporal 'surgery' that practising knows to enact is so fine as to amount to nothing. This *doing* of nothing is the only way to trip the threads of change at a larval or constitutive register, and it is a doing that offers little or no gratification to the subject, as such. For this reason, the latter will always protest its futility. It must do this, also, in order to preserve its own continuity, which is profoundly unmoored, or set adrift in practising. (*What self ever chooses to die or become obsolete?*) With practising, this drifting becomes a kind of travel, and to travel, one must leave home. As a Zen quote says – whose source, regrettably, I don't recall – 'find homelessness and dwell there'.

Conclusion: A Theory of Practising

> . . . art is the opposite of a 'disinterested' operation: it does not heal, calm, sublime or pay off, it does not 'suspend' desire, instinct or will. On the contrary, art is a 'stimulant of the will to power', 'something that excites willing'.
>
> Deleuze, *Nietzsche and Philosophy*, p. 102

In 2017, I saw an exhibition of David Hockney's work at the National Gallery of Victoria, Australia. It consisted partly of works composed on digital devices, other works of video footage (screens arranged as tiles showing monochromatic, kaleidoscopic scenes), and a vast number of painted portraits, each – according to the accompanying information – done mostly over three consecutive days of sitting. There was a tenacity intimated by the repetition of works, by the re-engagement with a particular technique, and evidence of strong intentionality which, aside from any aesthetic response to the works themselves, made a lasting impression.

Afterwards, in the gift shop, printed on some mugs, I encountered a famous quote by Hockney (which ventriloquises the understanding of practitioners everywhere): *You must plan to be spontaneous.* The quote, while not summarising everything one needs to know about practising, does resonate closely with some practical aspects of what's been proposed here. Perhaps the quote can be upcycled for the purposes of this book to read: *If you want to practise, you must plan to be spontaneous.* If you want to make art, if you want to step into another life, if you want to grapple with real problems, if you want to love another entity that is in a process of becoming (mineral, vegetable, or animal), if you want to invent new ways to live . . . you must *plan* that which popular language likes to call and revere as 'spontaneity'.

The planning aspect of this exhortation resonates with criteria 1 and 2 of practising as I've explored them in this book. Possibly maligned by those

who might prefer spontaneity to remain magical or unthought, or who might misunderstand the character of planning as something necessarily constraining, Hockney's recommended stance involves framing time with intention, courting the conditions for that which has no precedent. Planning, as such a frame, does not restrict the future's wide-openness; it does not embed a repetition of the Same, since repetition – as we've seen – is rare, and the Same is the name we have for interminable, ever-being-digested change.

As the nigh-oxymoron of planned spontaneity highlights, when you frame time with intention (by 'planning'), you leave a space open that is not yet mapped by the expectancy (to use Williams's word) and predictable-ness of the living present. To 'plan for spontaneity' is to say yes to not letting ourselves-as-habit, or even as wanderers in the vast archive of the past, shut out the future.

Spontaneity, then, would in this case be a word gesturing towards the realm, towards the atmospheres of intention and of its being raised to that strange second power intrinsic to criteria 3 and 4. Spontaneity, as we know, speaks to *timely*, rather than impulsive, behaviours.[1] To be artfully spontaneous – I'd argue further – bears no relation to being hasty, to being cavalier, to being prone to reactivity.

Certainly, one may need to forgo earnestness in order to ride spontaneity's wave, but that doesn't mean that spontaneity merges into anything like *carelessness*. For spontaneity to have its proper weight, the stakes must be real and high enough. Criterion 3 emphasises relaxation, and as we saw, relaxation has nothing to do with collapsing the body. Relaxation simply involves reinflecting intentionality in ways that appear counter to usual logics. It involves abstaining from the organism's inertias of 'natural effort', in order to access effort that works otherwise. Again, flippancy or indifference is also of a wholly other order than the relaxation of criterion 3.

What marks spontaneity's mode perhaps most strongly is the lightness, the faintness, of the so-called subject who would be its vehicle. In a spontaneous mode, the self is left behind, fades out somewhat. The self is gently forgotten, looked past momentarily, rather than explicitly destroyed. Fading into the background, subjectivity of a certain ilk is eclipsed by the exuberance of spontaneity's surge, which might – to borrow Deleuze's phrasing on the subject of *difference in itself* – involve 'distinguish[ing] itself' from this same subject, without the subject 'distinguish[ing] itself from it' (DR 36). This pertains, as he clarifies, to *determination as such*.

[1] 'The excellence [. . .] of the initiation of movement is in its timeliness', chapter 8, Tzu, *Tao Te Ching*, various translations, working with Legge's.

This understanding of spontaneity, then, might loiter in the vicinity of difference in itself. Yoked to practising, to a thought of practising, it is what we plan for when we want to subtract ourselves from what continuity has planned for us. To slip the logics of inertia, or habit, in other words, requires an intervention in rhythm – a hiccup in the order of things – the ontology of which is only unsettled by a non-intuitive application of intentionality. It is the latter that practising in all its modes has documented and reflected, across history and continents, without explicitly accounting for.

This book has sought to sketch a modest but steady beginning for a coherent theory of practising per se, one that is rigorous and consistent irrespective of the latter's mode. To have a kind of litmus test for practising, or a framework for querying how it could be that an activity shifts into this other register, parallel to habit but of another order, is – I believe – a worthwhile thing.

If we can spot practising and its traits, and appreciate its quiet mechanisms, we can remember to care about it, to tend to the windows in which it can unfold, as well as – if relevant – to explain to ourselves or others why we might be devoting ourselves to strange, apparently pointless behaviours. Saying-practising can help us protect and refine its processes, to care for the contexts that encourage it, and to foster its longevity in a life.

For artists, leaders, lovers, thinkers, revolutionaries and inventors, it matters for us to know what operations are conducive – *ontologically* conducive – to generating via our structured behaviours anything more than incremental modifications of the Same. How, to put it simply, can we work *with but beyond* habit, without being marooned in a register of mere good sense, compliance and complicity with a status quo that might not be wholesome, expansive or, more importantly, just?

To understand practising better also guards against those moments when, having seen through the manoeuvrings of the same, abjuring, at times deploring it, we are tempted by the lure of an imprecise and hasty response – an exaggerated but ineffectual and dangerous response – that wishes to thwart continuity's reign with the fantasy that destruction will be its antidote, its remedy – our collective, overblown escape hatch. On this same question, Deleuze's contemporary, Alain Badiou, has the following to say in his book *The Century*:

> The other path that the [twentieth] century sketched out – the one that attempts to hold onto the passion for the real without falling for the paroxysmal charms of terror – is what I call the subtractive path: to exhibit as a real point, not the destruction of reality, but minimal difference. To

purify reality not in order to annihilate it at its surface, but to subtract it from its apparent unity so as to detect within it the minuscule difference, the vanishing term that constitutes it. What takes place barely differs from the place where it takes place. It is in this 'barely', in this immanent exception, that all the affect lies.[2]

As we develop a taste for practising, we tend to lose the taste for violence (or at least any naive hope that its flamboyance would be any guarantee of efficacy) and for the irresponsible swipes of destruction that in fact prevent death's renewal, meddling with the joyous deaths that are teeming and alive.[3] These are deaths that no one can give us, and which we can only court, by letting the habit of 'I' thin out, or fade into the background, confident that nothing that matters will be undermined by this losing.

The structured repetition aspect of practising (what we might call habit's simulacrum, habit's disguise) is such that it grooms a context in which the practitioner can survive their own little death(s). It cultivates, in other words, a clime (some would call it a container) in which that-which-practises can survive the many endings and silent ruptures that make a life worth living.

To practise dying as the very stuff of an intensive life.

I recall (without recalling where) the many Zen texts and commentaries that stress the urgency of practising in relation to death – *death is coming, there is no time to lose!* – but perhaps, if I could reread them now, I'd perceive within them their exhortation regarding dying itself, our ability *to do it*, or to let it *do* us, to transition between registers, to slip the binds of the inertias that constitute our drearier continuities.

Practising, then, works as an apprenticeship in wriggling differently within the operations that make time. These operations, which Deleuze identifies with so much careful virtuosity in *Difference and Repetition*, help us to think the possibility of this nimbleness, and account for why practising

[2] Badiou, *The Century*, p. 65 (emphasis added). My use of the term 'subtractive' throughout this work is indebted to Badiou's writings on this notion. The above paragraph could be read as a cipher for many discussions that have unfolded here.

[3] For the majority of time I worked on this book, I used the term 'transformation' as a place marker for that which co-arises with steadiness in practising. I remain ambivalent regarding this term. While listening to a paper by Daniela Voss (6 December 2016) I saw that another term for what was in play was 'deaths' or 'dyings', and much more could be written about this. I'm grateful to Voss for this inadvertent assistance. Although her paper did not relate to practising, it has contributed clarity to the vocabulary of this work.

can be so compelling, even if the more typical terms that frame our everyday can't quite put words around it. We don't only practise for common-sense benefits; and practising isn't one diversion, or pastime, among others. It isn't really a way to 'use up' or 'spend' an already-given time, outside of our more concentrated phases of economic or social 'productivity'. Rather, it is this tiny-bit-more room to manoeuvre in time, as time, and with time's elements as (serious) playthings, that makes practising so thrilling, and so linked to risk. Risk, when it is alive, is always the space of an oscillation, a glimmering that inhabits the affirmative place of the *yes . . . and*.

To encounter long term, very serious practitioners can feel ghostly. This isn't due to a dearth of intensity in their vicinity, nor because they are some-how disassociated in any usual way. Tenacious practitioners feel strange to be around. I'd speculate this is because they are dying and being born again at such a velocity that they flicker in and out of a more typical solidity, out of the usual stuckness that marks identity within its local register. They can feel both extremely light but somehow not insubstantial. They rarely leave their middle, their mid-line, with this site being a region that is every region at once. The centre is the portal to everywhere. To emptiness, *shunyata*. As if exemplary of life, they feel both intensively 'there' but also spacious, constituted by a self that is able to drop, forget itself, become lost, with this phenomenon occurring in the field of a dense and empty centre – the con-text that practising makes.

Practising, then, is always a laboratory for an encounter with time and its operations. To practise at all, one must learn the methodology of making a mark, of stipulating a break in the living present's usual insistent flow. To practise requires a twofold decision: first, *that* one practise; second, the times *when* this is to occur. Practising interrupts or counterpoints the living present, without needing to break or destroy it. This accounts for its ongoing relation to habit (as that whose mechanism synthesises this mode of time), as well as its non-participation in habit proper. It does not, in other words, make of habit an enemy, nor does it collude, as mentioned, with habit's good and common sense.[4]

Practising doesn't need, then, to divorce itself from habit's choreogra-phies, but rather to reinflect the latter's various aspects according to the

[4] 'Good sense is based upon a synthesis of time, in particular the one which we have determined as the first synthesis, that of habit. Good sense is good only because it is wedded to the sense of time associated with that synthesis. Testifying to a living present (and to the fatigue of that present), it goes from past to future as though from particular to general' (DR 284).

four criteria set out here: structured behaviour – repeated intentionally – relaxation – repeating repetition. The role of intention in both the second and third criteria is where this reinflection begins to play out. Intentionality, furthermore and obviously, is a temporal matter. To intend something means to foresee a moment in time and to act within that parameter. I can accidentally do some yoga, or write a poem, or walk, but I become a practitioner of those modes when I regularly decide that at 4.30 p.m., I will stop whatever I'm doing and I will leave the house, or that the following morning at 5.45 a.m. I will wake and, after a hot drink, will 'just sit' (practise shikantaza) for an hour.

This is the way a practitioner operates. They apply a principle of structuring to time itself, to time as that which constitutes the principle of structuring par excellence. Time is nothing but structure, and its first structure, as we've learned, is that shape that can be called 'repetition'. Repetition is the shape that difference in itself makes when it is structured. Deleuze calls this contemplated, or contracted – and no matter, the basic operation on the flux of intensities is consistent.

When we practise, we do something of time's work *for* time; we circumvent its mechanism by rendering it, for a moment, irrelevant. We have done what time normally does to synthesise itself. And this curated glitch in the usual order of things produces a space where death's life can get in. In the act of mimicking the very operations that constitute time, 'we' are suspended (or raised to the level of a question) by dint of the fact that those operations – if time forgets to do them, to constitute itself – also make 'us'.

In yoga there is a practice called *kumbhaka*. There can be a kumbhaka (or break in breathing) that occurs following exhalation (*bhaya kumbhaka*) or following inhalation (*antara kumbhaka*). If one played around with trying to swim as long as possible under water in childhood, then one has practised antara kumbhaka (retention on full). Any serious practitioner of yoga knows that kumbhaka – as much or more than headstand, lotus or hanumanasana (splits) – gets close to the open secret of yoga. When one cultivates kumbhaka – a stopping – in the breath, then it becomes more possible to institute this same stopping at the level of self-ing – the behaviour we never stop doing; the very tissue of our fatigue. This is the synthesis of the living present, the reign of habit, our 'disposition relative to change, which is engendered in [our] being by the continuity or the repetition of this very same change' – as Ravaisson phrased it (OH 25).

When this self-ing pauses for a hair's breadth of time, there can be a break in the operation that is the thread constituting our interminable, our daily, our mortal-because-ceaseless selves.

Why do we need a theory of practising? We need it because the repercussions of how practising works and what it does are widespread, crucial and generative. Practising is always about the space we make in life for our next life as the next unrelated, unimaginable instant – the anonymous, unknowable future.

Practising holds open the possibility that this next is not just a continuation of the logic of our present and this present's past of retention and memory, but that it has the possibility to be something entirely new, as yet unthought. This is why the future proper – the third synthesis – by necessity, is time's empty form. It does not make sense at first glance how structuring the living present, or inserting other intended structures into its relentless flow, might *in practice* ontologically enable the future-as-gap, courting its thrumming emptiness. One has to burrow down very precisely into the operations of time – Deleuze's gift to practising theory – in order to appreciate the strategies and genius of practising, as they have functioned for millennia.

If we return to the reflections that opened this volume, practising by necessity involves tarrying with desire, withstanding the break it requires and with which it is synonymous. Practising – cultivating as it does steadiness and temporal caesura (that is, transformation that carries nothing forward, that 'causes neither the *condition* nor the *agent* to return', DR 113[5]) – is that methodology that risks desire's arrival, its shock and affront, its rewriting of everything, its capacity to make us entirely new to ourselves.

Practising, then, is not for the faint of heart (although it may cultivate a 'heart'[6]), but it is also the very texture of our longing – our longing to be strong enough for longing itself, to not shirk its ride. When we practise, we fashion a context – a body, a site, a situation, a rhythm – that can survive its own falling away, that can bear intensity, and which is also discerning with regard to intensities.

The paradox of this production – as in theatre, as in a framed unfolding – is that nothing carries forward, and that this nothing is rich and unrecognisable, thrilling, humbling and *enough*.

[5] Emphasis original.
[6] See Deleuze, *Nietzsche and Philosophy*, p. 73.

Afterword

The modes of practising that have provided the most enduring laboratory for the inquiries that animate the current work have been shikantaza and yoga (the latter within a very specific tradition). Shikantaza is the practice, in the lineage of Soto Zen, which translates most simply as 'just sitting'. It distinguishes itself – if one is splitting hairs – from meditation per se, because in shikantaza one doesn't 'meditate' on anything, arguably not even the breath. One 'sits', and that's all. (Chapter 1 explores this practice closely, as providing a way into the sheer structures that mark practising in all other modes.) I was lucky enough, when I began 'sitting' practice in the mid-1990s, to have encountered a very serious group of 'sitters', which meant that I immediately began practising in a regular, nuanced and intensive (but not rigid or extreme) way. The yoga that has informed much of the exploration of the current volume has been within the Vijnana tradition.[1] I began practising this form in 2006, after a decade or so of various other modalities (Oki-Do Japanese yoga, Iyengar yoga, and a more general Hatha practice, in which I did my first teacher-training). Vijnana yoga was a serendipitous discovery for me for two obvious reasons. Of its four crucial limbs, the first was effectively 'sitting', thus building on and incorporating the practice I'd already been encountering for more than a decade. Then, along with the second and third aspects, which are breathing and asana (or the posture curriculum) respectively, the final limb was *study*.

[1] Indeed, over half of this book's first draft was written on a writing/practising retreat (during research leave supported by Deakin University's School of Communication and Creative Arts) over six weeks in Jerusalem in 2015, in the company of the style's founder and my teacher, Orit Sen-Gupta. We wrote and practised for ten hours a day – five hours of the practising curriculum outlined above, five hours writing/reading. It was quiet, restful and concentrated, but non-straining.

As a reader of philosophy, I'd encountered either mumbled or more explicit resistances *to*, or suspicions *of*, thought proper, in my yoga travels. This had made me quite sad, since I wasn't convinced that yoga was antithetical to thinking in a lived sense. In fact, when studied in its history, it engages closely and with much curiosity with thought's very mechanism. When I encountered Vijnana and its founder's personal ease with the history of both Eastern and Western philosophy, a fluency in psychoanalysis, and a general open disposition to all modes of skilful and careful thinking, I was relieved and in good company. My teacher is also a very serious practitioner (as opposed to enthusiast). In other words, she did the practice without fail, daily, and often twice daily.

Vijnana yoga, which has roots in the Ch'an (Zen), as well as the Iyengar and Ashtanga traditions, while modifying them skilfully, has a six-day curriculum of practices. Each day (except one, weekly), if things go well, one sits, one does pranayama, one works with a group from the posture repertoire, and (ideally) one reads and engages in study (whether of historical texts in yoga, or other philosophical or wisdom texts). The practice itself, then, is marked by difference and repetition in both explicit and more subterranean ways. One does certain movements or breath practices daily, over and over in a relaxed mode of awake repetition – and one notes the inevitable differences that attend this gross repetition. Some days the same movement is heavy and difficult, the next very light. The matter of the body changes; there is much to listen to. One practises gently when sick or injured, or more jubilantly and vigorously when well and capable. Indifferent to these tones, the practising itself prevails. One also comes to know the breath intimately – its moods and limits – as barometer for a number of layers in the organism. Alongside this differing, one also lives the temporal shifts, slides and timbres that rise up in the wake of repetition's stranger logics. All this is possible because the practice isn't really about getting something done (it isn't an item on a checklist); it is a sincere laboratory where measured processes are set in motion.

Works Cited

Al-Saji, Alia, 'The Memory of Another Past: Bergson, Deleuze and a New Theory of Time', *Continental Philosophy Review*, 37 (2004): 203–39.

Andrews, Chris, 'Constraint and Convention: The Formalism of the Oulipo', *Neophilogus*, 87.2 (2003): 223–32.

Aranya, Swami Hariharananda, *Yoga Philosophy of Patanjali*, trans. P. N. Mukerji (Albany: State University of New York Press, 1983).

Ardoin, Paul, S. E. Gontarski and Laci Mattison (eds), *Understanding Bergson, Understanding Modernism* (New York: Bloomsbury, 2013).

Arendt, Hannah, *The Human Condition*, 2nd edn (Chicago: University of Chicago Press, [1958] 1998).

Attiwill, Suzie, Terri Bird, Andrea Eckersley, Antonia Pont, Jon Roffe, and Philipa Rothfield, *Practising with Deleuze* (Edinburgh: Edinburgh University Press, 2017).

Badiou, Alain, *Being and Event*, trans. Oliver Feltham (New York and London: Continuum, [1988] 2007).

Badiou Alain, *Logics of Worlds*, trans. Alberto Toscano (New York and London: Continuum, [2006] 2009).

Badiou, Alain, *The Century*, trans. Alberto Toscano (London: Polity Press, [2005] 2007).

Bergson, Henri, *Matter and Memory*, trans. N. M. Paul and W. S. Palmer (New York: Zone Books, [1896] 1991).

Bergson, Henri, *La pensée et le mouvant – essais et conférences*, 4th edn (Paris: Librarie Félix Alcan), numerical and PDF version by Pierre Hildalgo (La Gaya Scienza, 2011).

Butler, David S. and G. Lorimer Moseley, *Explain Pain* (Adelaide: Noigroup Publications, 2013).

Calasso, Roberto, *Ka*, trans. Tim Parks (New York: Vintage, 1999).

Carlisle, Clare, 'Becoming and Un-becoming: The Theory and Practice of Anatta', *Contemporary Buddhism*, 7.1 (2006): 75–89.

Carlisle, Clare, 'Between Freedom and Necessity: Félix Ravaisson on Habit and the Moral Life', *Inquiry*, 53.2 (2010): 123–45.

Cleary, Thomas, *The Taoist Classics: The Collected Translations of Thomas Cleary*, vol. 2 (Boulder: Shambhala Publications, 2003).

Deleuze, Gilles, *Bergsonism*, trans. Hugh Tomlinson and Barbara Habberjam (New York: Zone Books, [1966] 1991).

Deleuze, Gilles, *Difference and Repetition*, trans. Paul Patton (New York and London: Continuum, [1968] 2004).

Deleuze, Gilles, *Nietzsche and Philosophy*, trans. Hugh Tomlinson (New York and London: Continuum, [1962] 1986).

Deleuze, Gilles, *Spinoza: Practical Philosophy*, trans. Robert Hurley (San Francisco: City Lights Books, [1970] 1988).

Deleuze, Gilles, *The Logic of Sense*, trans. Mark Lester (with Charles Stivale) (New York and London: Continuum, [1969] 2004).

Deleuze, Gilles and Félix Guattari, *What is Philosophy?*, trans. Graham Burchilland and Hugh Tomlinson (New York and London: Verso, [1991] 1994).

Derrida, Jacques, *Of Grammatology*, trans. Gayatri Chakravorty Spivak (Baltimore and London: Johns Hopkins University Press, [1967] 1997). Corrected Edition.

Derrida, Jacques, 'Plato's Pharmacy', in *Dissemination*, trans. Barbara Johnson (Chicago: Chicago University Press, [1972] 1981).

Derrida, Jacques, *Psyché – Inventions de l'autre* (Paris: Editions Galilée, 1987).

Derrida, Jacques, *Specters of Marx*, trans. Peggy Kamuf (New York: Routledge Classics, [1993] 1994).

Dogen, Eihei, *Enlightenment Unfolds*, ed. Kazuaki Tanahashi (Boston, MA and London: Shambhala Publications, 2000).

Franke, William and Nahum Brown (eds), *Immanence, Transcendence and Intercultural Philosophy* (London: Palgrave Macmillan, 2017).

Grosz, Elizabeth, 'Habit Today: Ravaisson, Bergson, Deleuze and Us', *Body and Society*, 19.2&3 (2013): 217–39.

Han, Byung-Chul, *Die Austreibung des Anderen* (Frankfurt: S. Fischer, 2016).

Han, Byung-Chul, *Müdigkeitsgesellschaft Burnoutgesellschaft Hoch-Zeit* (Berlin: Matthes and Seitz, 2016).

Han, Byung-Chul, *The Agony of Eros*, trans. Erik Butler (London: MIT Press, 2017).

Heller, Agnes, *A Theory of Feelings* (Lanham, MD: Lexington Books, 2009).

Hofstadter, Douglas, *I am a Strange Loop* (New York: Basic Books, 2007).

James, William, *Psychology* (American Science Series, Briefer Course) (New York: Henry Holt & Company, 1893).

Jones, Graham, 'Marcel Proust', in *Deleuze's Philosophical Lineage II*, ed. Graham Jones and Jon Roffe (Edinburgh: University of Edinburgh Press, 2019).

Kasulis, Thomas P., *Zen Action, Zen Person* (Honolulu: University of Hawaii Press, 1985).

Kierkegaard, Søren, *Journals and Papers*, vol. II, ed. and trans. Howard V. Hong and Edna H. Hong (Bloomington and London: Indiana University Press, 1967–78).

Koren, Leonard, *Wabi-Sabi: Further Thoughts* (Point Reyes, CA: Imperfect Publishing, 2015).

Kristeva, Julia, *Life Is a Narrative*, trans. F. Collins (Toronto: University of Toronto Press, 2001).

Lanier, Jaron, *Ten Arguments for Deleting Your Social Media Accounts Right Now* (New York: Henry Holt & Company, 2018).

Loori, John Daido, *The Art of Just Sitting: Essential Writings on the Zen Practice of Shikantaza* (Boston, MA: Wisdom Publications, 2002).

Lundy, Craig, 'Tracking the Triple Form of Difference: Deleuze's Bergsonism and the Asymmetrical Synthesis of the Sensible', *Deleuze Studies*, 11.2 (2017): 174–94.

MacIntyre, Alasdair, *After Virtue* (Notre Dame: University of Notre Dame Press, 2007).

Mann, Thomas, *Der Zauberberg* (Berlin: Fischer Verlag, 1991).

Meillassoux, Quentin, 'History and Event in Alain Badiou', *Parrhesia*, 12 (2011): 1–11.

Mishra, Vachaspati, *The Yoga System of Patanjali*, trans. James Haughton Woods (Delhi: Motilal Banarsidass, 1914) (by arrangement with Harvard University Press).

Murphy, Ann V., *Violence and the Philosophical Imaginary* (New York: State University of New York Press, 2013).

Nietzsche, Friedrich, *Untimely Meditations*, trans. R. J. Hollingdale (Cambridge: Cambridge University Press, 1997).

Phillips, Adam, *One Way and Another* (London: Hamish Hamilton, 2013).

Pont, Antonia, 'Practising Poetry: Thinking Form, Emulation and Formal Invention', *Making It New: Finding Contemporary Meanings for Creativity* (Special Issues Series No. 40), *TEXT: Journal of Writing and Writing Programs* (2017): 1–17.

Pont, Antonia, 'That Tender Discipline: Spacing, Structured Nothingness & Kumbhaka', in Lenart Škof and Emily Holmes (eds), *Breathing with Luce Irigaray* (London: Bloomsbury, 2013).

Powers, Richard, *The Overstory* (London: William Heinemann, 2018).

Ravaisson, Félix, *Of Habit*, trans. and ed. Clare Carlisle and Mark Sinclair (New York and London: Continuum, 2008).

Riedelsheimer Thomas (dir.), *Rivers and Tides – Working with Time* (Mediopolis Film – und Fernsehproduktion GmbH, Germany, 2001).

Roffe, Jon, *The Works of Gilles Deleuze – Volume I 1953–1969* (Melbourne: re:press, 2020).

Sen-Gupta, Orit, *Patanjali's Yoga Sutras* (Jerusalem: Vijnana Books, 2013).

Sen-Gupta, Orit, *The Heart of Practice* (Jerusalem: Vijnana Books, 2012).

Sinclair, Mark, 'Ravaisson and the Force of Habit', *Journal of the History of Philosophy*, 49.1 (2011): 65–85.

Springer, Simon, 'REPLY: Space, Time, and the Politics of Immanence', *Global Discourse*, March (2014): 1–4.

Thrift, Nigel, *Non-Representational Theory: Space, Politics, Affect* (Oxford: Routledge, 2008).

Wahrig, Gerhard, *Wahrig Deutsches Wörterbuch* (Munich: Bertelsmann Leixcon, 2000)

Williams, James, *Gilles Deleuze's Difference and Repetition: A Critical Introduction and Guide* (Edinburgh: Edinburgh University Press, 2013)

Williams, James, *Gilles Deleuze's Philosophy of Time* (Edinburgh: Edinburgh University Press, 2011).

Zubhoff, Shoshana, *The Age of Surveillance Capitalism: The Fight for a Human Future at the New Frontier of Power* (New York: Public Affairs, 2019).

Index